MW01100537

OFFICE DESIGN

daab

Introduction

In Western countries, one of the consequences of the globalization of the economy has been the concentration of workers in the tertiary sector; more than half the population works in offices, a percentage very similar to that of the population living in the world's big cities. This has given rise to a social class that, despite have very disparate purchasing powers, moves in very similar environments: the city and the office. Although the technological revolution of the last thirty years may have changed our way of understanding the world, the work space continues to be the same as it was two centuries ago: a table, a chair, a space for storing information, writing material and artificial lighting for working when there is little or no natural light. Paradoxically, the technological revolution has altered the domestic space more than that of offices, and these days it is quite normal to find a workspace in most homes. Whereas it seemed in the early nineties that the Internet would lead to the gradual disappearance of offices, now that its implementation has turned into a reality and it is possible to work anywhere, offices have become domestic, the relationship between workmates has become closer and their workplace seems increasingly like a club or house in which they spend the greater part of the day. At the beginning of the 19th century, Charles Fourrier observed that citizens' lives were marked not by the home but by the office; 200 years later, this somewhat eccentric statement expresses the reality of post-industrial society. Using very different languages and solutions, today's architects are designing places for living and working. Schmidt and Hammer's volumes are spaces that put a special emphasis on the relationship between workers and create spectacular but functional environments; the elegant building drawn up by Carme Pinós, using a very different approach, offers offices flooded with light that project into the landscape. This, in turn, is different from Tele Design's robust project a highly functional piece that solves a very complex program with simplicity and clarity. In short, this is a series of projects intent on creating a more pleasant working environment.

Eine der Auswirkungen der wirtschaftlichen Globalisierung in den westlichen Industrieländern ist die Konzentration von Tätigkeiten im Dienstleistungsbereich. Inzwischen arbeitet mehr als die Hälfte der Beschäftigten in Büros. Vergleichbar sieht die Situation weltweit in den großen Städten aus. Obwohl die so entstandene gesellschaftliche Klasse über jeweils sehr unterschiedliche Kaufkraft verfügt, bewegt sie sich in sehr ähnlichen Lebensumwelten: Stadt und Büro. Die technologische Revolution der letzten dreißig Jahre hat unser Weltbild entscheidend verändert, doch der Arbeitsplatz umfasst seit zweihundert Jahren die gleichen Grundelemente: einen Tisch, einen Stuhl, eine Möglichkeit Informationen aufzubewahren, Schreibmaterial und künstliche Beleuchtung, um auch dann arbeiten zu können, wenn das natürliche Licht ausfällt oder nicht ausreicht. Kurioserweise hat der technologische Wandel den Wohnbereich stärker verändert als die Büros. Heutzutage findet man in fast jedem Haushalt einen Arbeitsplatz. Während es Anfang der neunziger Jahre noch so aussah, als ob das Internet das herkömmliche Büro überflüssig machen würde, ist es heute aus dem Alltagsleben nicht mehr wegzudenken, nicht zuletzt, weil es durch die weltweite Vernetzung möglich ist überall zu arbeiten. Das Büro gehört zur Wohnumwelt, die Beziehungen zwischen den Beschäftigten sind enger geworden und der Arbeitsplatz gleicht oft mehr einem Club oder Haus, in dem man die meiste Zeit des Tages verbringt. Zu Beginn des 19. Jahrhunderts hatte Charles Fourrier einmal behauptet, der Lebensraum der Stadtbewohner sei das Büro und nicht das Heim, und nun, zweihundert Jahre später, ist diese etwas exzentrische Behauptung in der postindustriellen Gesellschaft unserer Tage wahr geworden. Die heutigen Architekten greifen auf die unterschiedlichsten Formensprachen zurück um zu gestalten. Für Schmidt und Hammer stehen die Beziehungen der Beschäftigten an erster Stelle, wenn sie ihre Aufsehen erregenden funktionalen Räume entwerfen. Carme Pinós geht bei ihren Gebäude von einem anderen Grundgedanken aus und öffnet ihre lichtdurchlässigen Büros zur Landschaft hin. Ganz anders stellt sich der Entwurf von Tele Design dar, bei dem eine sehr komplexe Aufgabe mit einfachen, klaren Linien entschieden umgesetzt wird. Alle vorgestellten Projekte verfolgen eine angenehme Arbeitsatmosphäre zu schaffen.

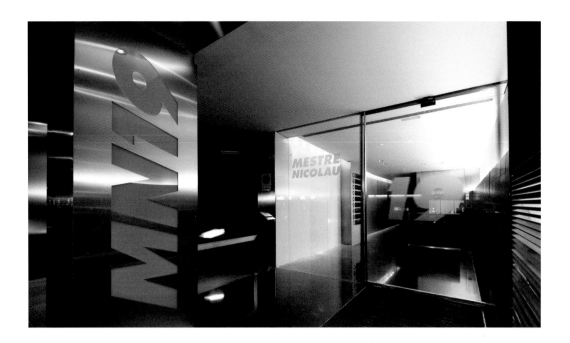

Dans les pays occidentaux, la globalisation de l'économie a notamment eu pour conséquence la concentration des travailleurs dans le secteur tertiaire : plus de la moitié de la population active travaille dans des bureaux, un pourcentage très proche de celui de l'ensemble des grandes villes de par le monde. Cet état de fait a donné naissance à une classe sociale qui, bien qu'affichant des pouvoirs d'achat disparates, se développe dans des cadres de vie très semblables : la ville et le bureau. Bien que la révolution technologique des trente dernières années ait modifié la manière d'appréhender le monde, l'espace de travail est immuable depuis deux siècles : une table, une chaise, un espace de rangement des informations, des supports d'écriture et un éclairage artificiel afin de continuer à travailler lorsque la lumière naturelle manque ou devient insuffisante. De manière paradoxale, ce changement technologique a davantage modifié l'espace domestique que celui des bureaux. Il est devenu aujourd'hui normal de découvrir un espace de travail dans la plupart des foyers. Si, à l'orée des années quatre-vingt-dix, il semblait qu'Internet allait mener à l'extinction progressive des bureaux, aujourd'hui que son implantation est devenu une réalité et qu'il est possible de travailler depuis tout endroit, les bureaux sont devenus domestiques, les relations entre les travailleurs plus étroites et le lieu de travail ressemble chaque jour davantage à un club ou une maison où se déroule l'essentiel de la journée. Au début du XIXème, Charles Fourrier signalait que le cadre de vie des citoyens était le bureau et non plus le foyer. Deux cents ans plus tard, cette affirmation quelque peu excentrique s'est transformée en la réalité de la société postindustrielle. Avec des langages et des solutions très différentes, les architectes actuels conçoivent des lieux pour vivre et travailler. Les volumes de Schmidt et Hammer sont des espaces où prime la relation entre les travailleurs et créant des environnements fonctionnels et spectaculaires. L'élégant immeuble de Carme Pinós, avec un questionnement très différent, dessine des bureaux diaphanes se projetant vers le paysage. Très distinct, en revanche, le solide projet de Tele Design est une pièce très fonctionnelle qui résout un programme relativement complexe avec simplicité et clarté. Une série de projets qui tentent, en définitive, de créer une atmosphère de travail très agréable.

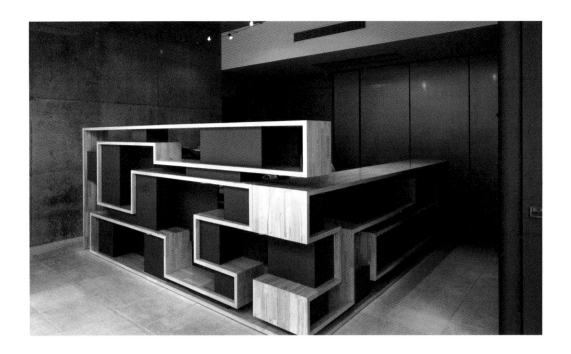

En los países occidentales, una de las consecuencias de la globalización de la economía ha sido la concentración de los trabajadores en el sector terciario; más de la mitad de la población trabaja en despachos, un porcentaje muy parecido al de las grandes ciudades de todo el mundo. Esto ha dado lugar a una clase social que, aunque con poderes adquisitivos dispares, se desenvuelve en entornos muy parecidos: la ciudad y la oficina. Aunque la revolución tecnológica de los últimos treinta años haya cambiado la manera de entender el mundo, el espacio de trabajo sigue siendo el de hace dos siglos: una mesa, una silla, un espacio para almacenar la información, material para escribir e iluminación artificial para poder trabajar cuando la luz natural falte o sea insuficiente. Paradójicamente, este cambio tecnológico ha modificado más el espacio doméstico que el de las oficinas, y hoy es normal encontrar un espacio de trabajo en la mayoría de las casas. Si a principios de los años noventa parecía que internet llevaría a la progresiva desaparición de las oficinas, hoy que su implantación se ha transformado en una realidad y es posible trabajar desde cualquier lugar, las oficinas se han vuelto domésticas, las relaciones entre los trabajadores más estrechas y el lugar de trabajo se parece cada vez más a un club o una casa donde se transcurre la mayor parte del día. A principios del siglo XIX, Charles Fourrier señalaba que el marco vital de los ciudadanos era el despacho y no el hogar; al cabo de 200 años, esa afirmación un tanto excéntrica se ha transformado en la realidad de la sociedad postindustrial. Con lenguajes y soluciones muy distintos, los arquitectos actuales diseñan lugares para vivir y trabajar. Los volúmenes de Schmidt y Hammer son espacios en los que prima la relación entre los trabajadores y en los que se crean entornos funcionales y espectaculares; el elegante edificio de Carme Pinós, con un planteamiento muy diferente, ofrece oficinas diáfanas que se proyectan hacia el paisaje. Muy distinto es, en cambio, el robusto proyecto de Tele Design, una pieza muy funcional que soluciona un programa muy complejo con sencillez y claridad. Una serie de proyectos que tratan, en definitiva, de crear un ambiente de trabajo más agradable.

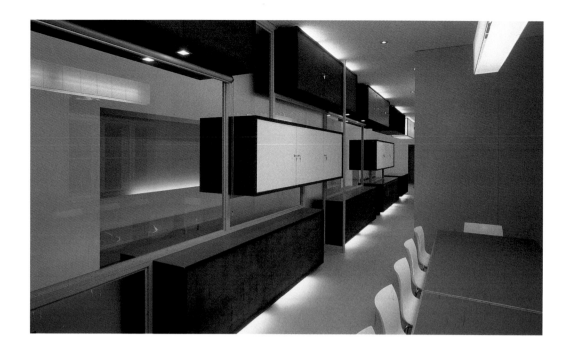

Nei paesi occidentali, una delle conseguenze della globalizzazione dell'economia è stata la concentrazione dei lavoratori nel terziario; più della metà della popolazione lavora in uffici, una percentuale molto simile a quella delle grandi città di tutto il mondo. Questo ha dato vita a una classe sociale che, sebbene con poteri acquisitivi disuguali, si muove in ambienti molto simili: la città e l'ufficio. Sebbene la rivoluzione tecnologica degli ultimi trent'anni abbia modificato il modo di intendere il mondo, lo spazio di lavoro continua ad essere quello di due secoli fa: un tavolo, una sedia, uno spazio dove conservare le informazioni, il materiale di cancelleria e illuminazione artificiale per poter lavorare in mancanza di luce naturale o quanto non ve ne è a sufficienza. Paradossalmente questo cambio tecnologico ha modificato più lo spazio domestico che quello degli uffici e oggi è normale trovare uno spazio di lavoro nella maggior parte delle abitazioni. Se agli inizi degli anni novanta sembrava che Internet avesse portato alla progressiva scomparsa degli uffici, oggi che la sua diffusione si è trasformata in realtà ed è possibile lavorare da qualsiasi posto ci si trovi, gli uffici hanno assunto un aria domestica, i rapporti tra i lavoratori sono diventati più stretti e il posto di lavoro sembra sempre più un club o una casa dove si trascorre la maggior parte del giorno. All'inizio del XIX secolo, Charles Fourrier affermava che l'ambito vitale dei cittadini era l'ufficio e non la casa; dopo 200 anni, questa affermazione alquanto eccentrica si è trasformata nella realtà della società postindustriale. Con linguaggi e soluzioni molto diversi, gli architetti attuali disegnano luoghi dove poter vivere e lavorare. I volumi di Schmidt e Hammer sono spazi in cui predomina il rapporto tra i lavoratori e che creano ambienti funzionali e spettacolari; l'elegante edificio di Carme Pinós, con un approccio davvero singolare, presenta uffici diafani che si proiettano verso il paesaggio. Molto diverso è invece il robusto progetto di Tele Design, un locale molto funzionale che risolve un programma molto complesso con semplicità e chiarezza. Una serie di progetti che in definitiva cercano di creare un ambiente di lavoro più gradevole.

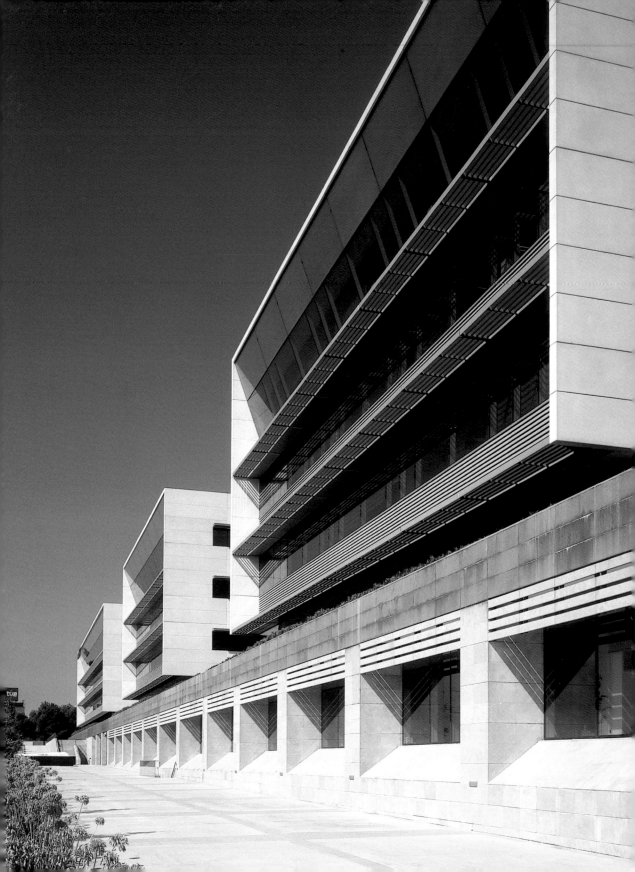

AGUIRRE & NEWMAN | **MADRID**
EDUARDO GASCÓN | **BARCELONA**
WOLF OLLINGS | **LONDON**
AFFINITY IN SANT JOAN NORD
Sant Cugat del Vallès, Spain | 2004

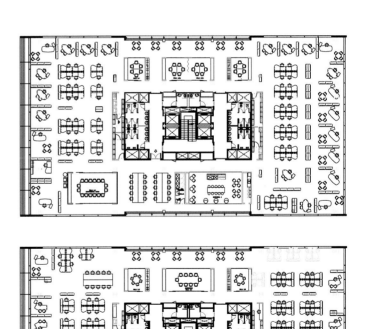

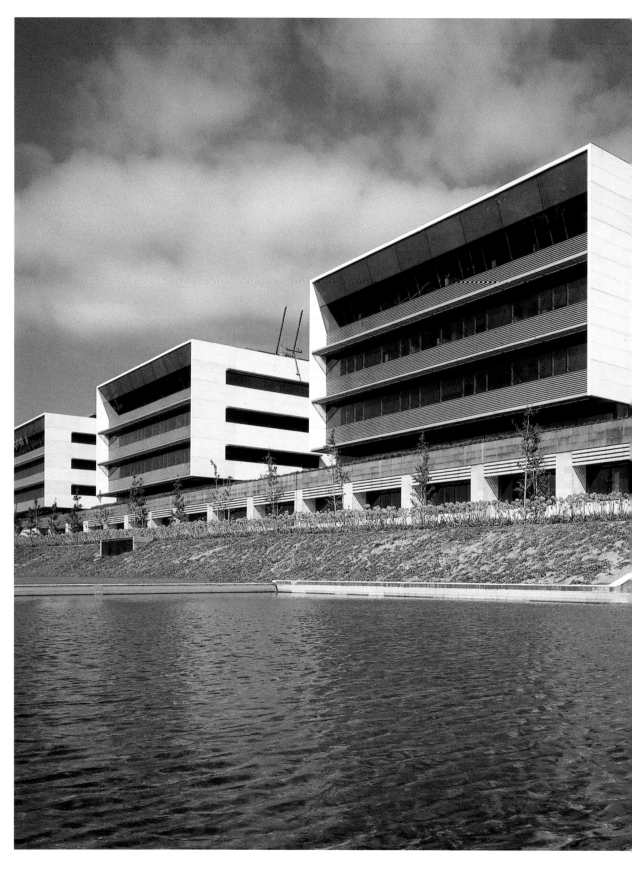

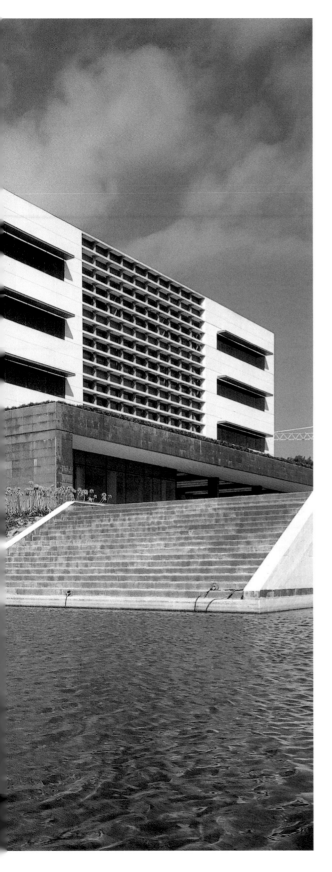

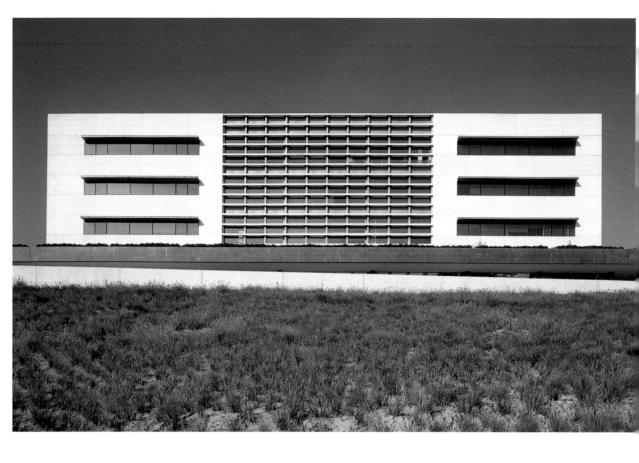

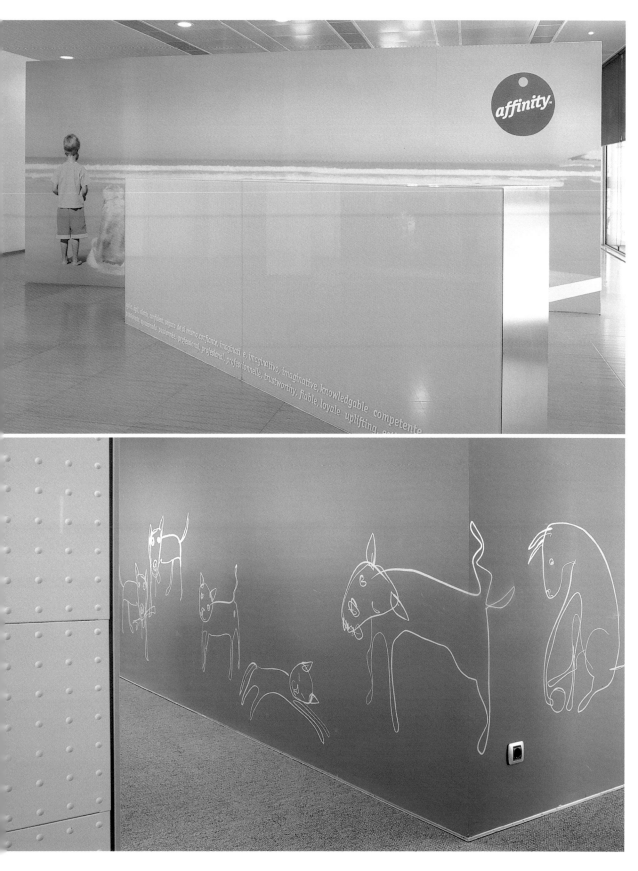

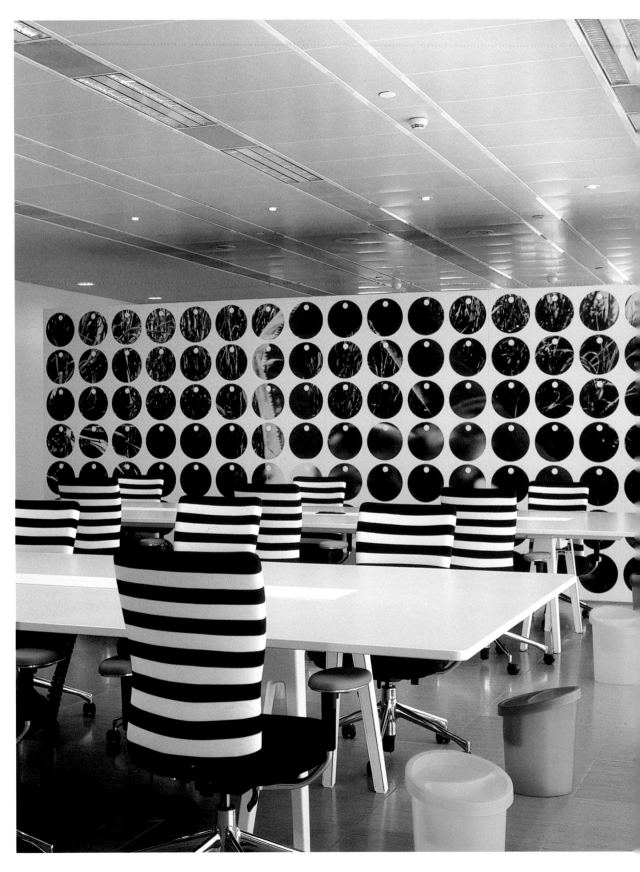

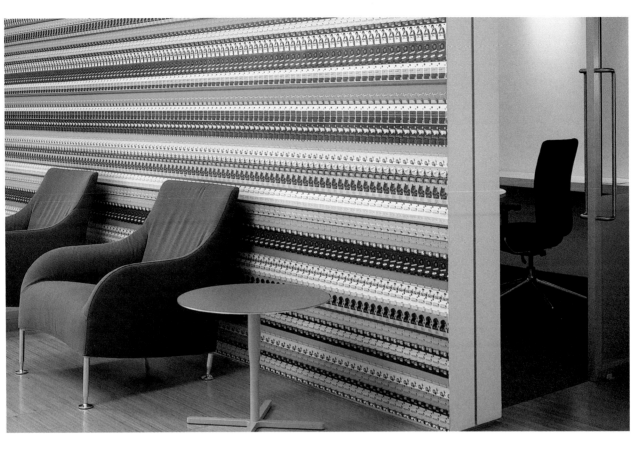

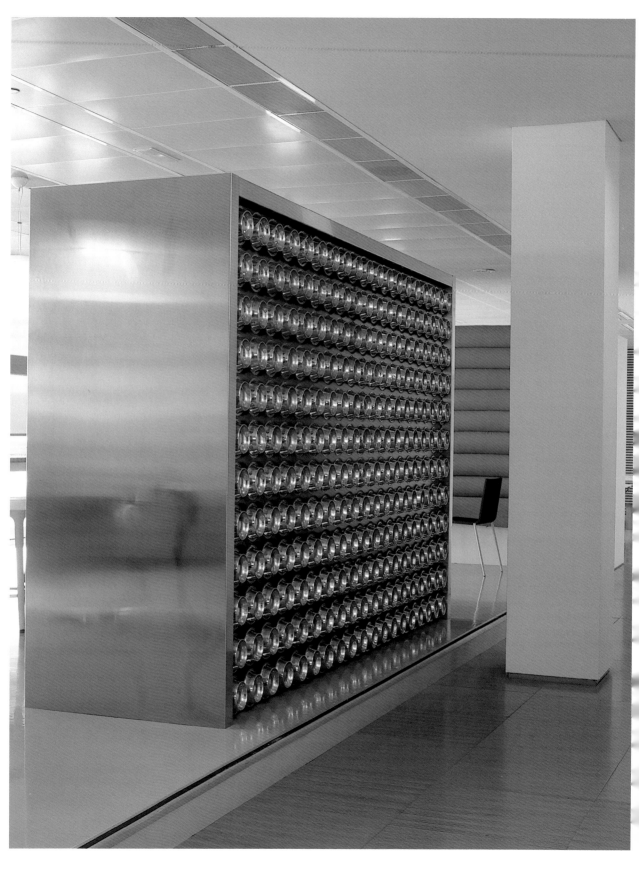

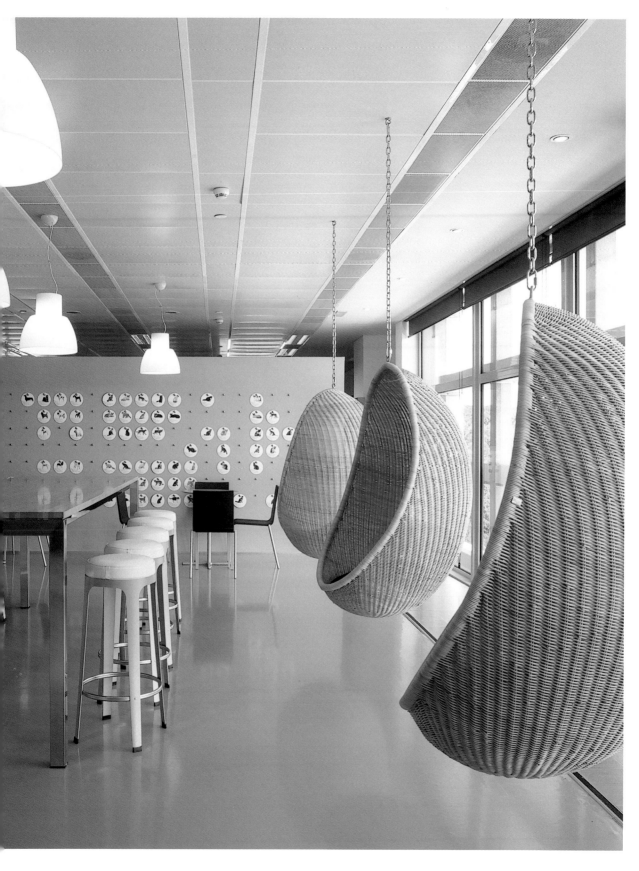

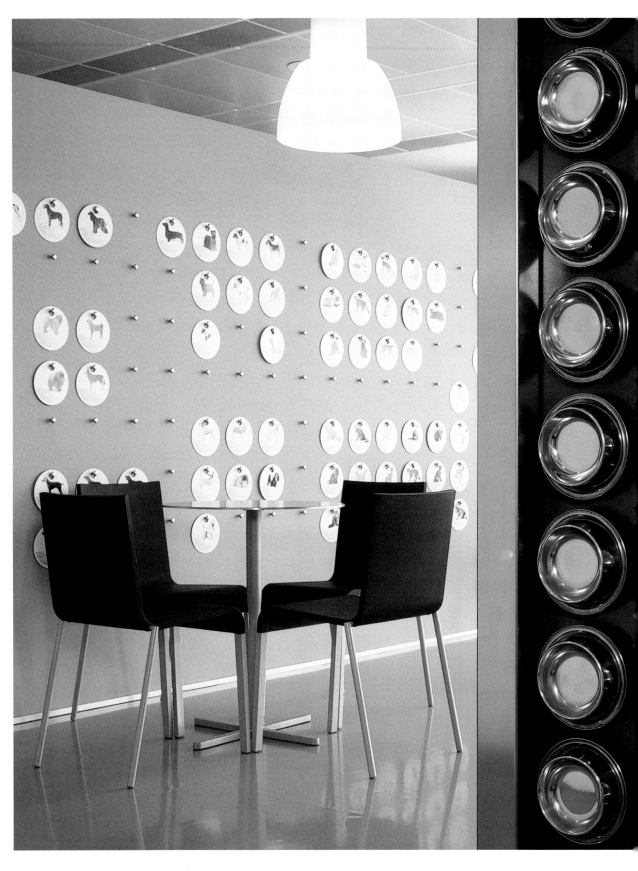

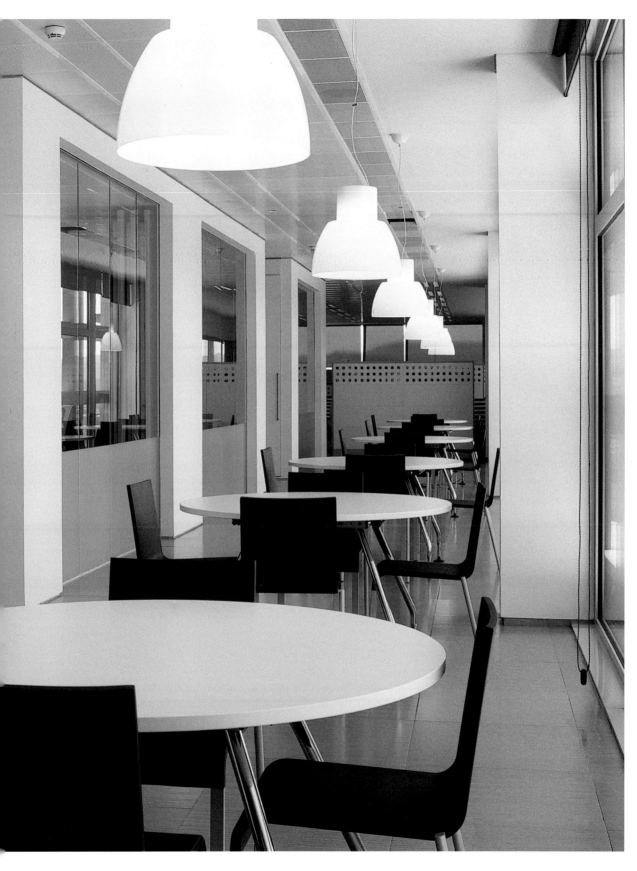

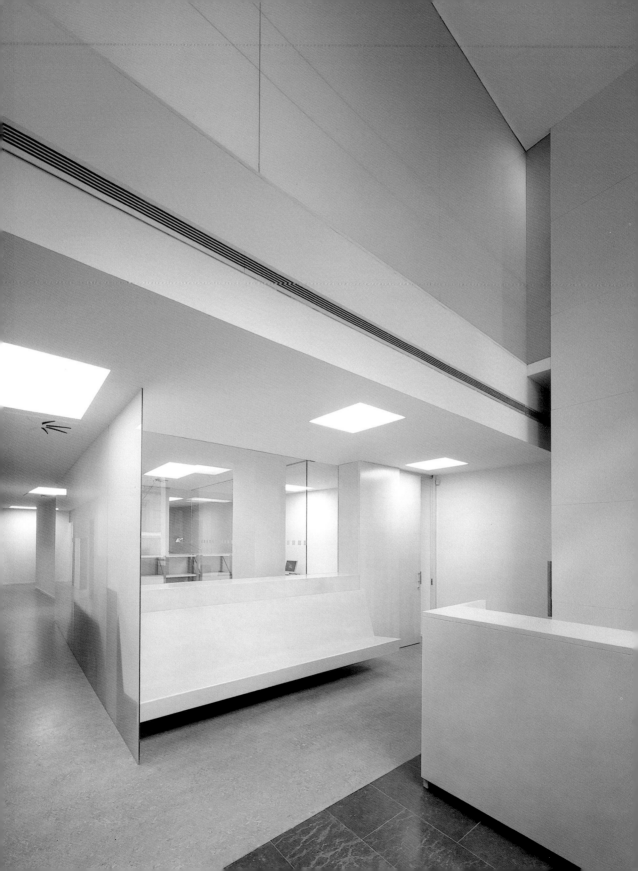

AGUSTÍ COSTA | BARCELONA
INSTITUT DE SOCIOLINGÜÍSTICA CATALANA
Barcelona, Spain | 2004

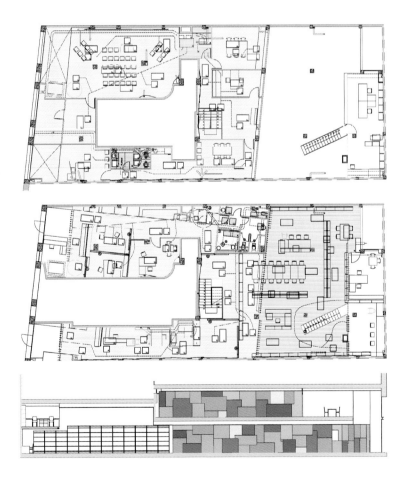

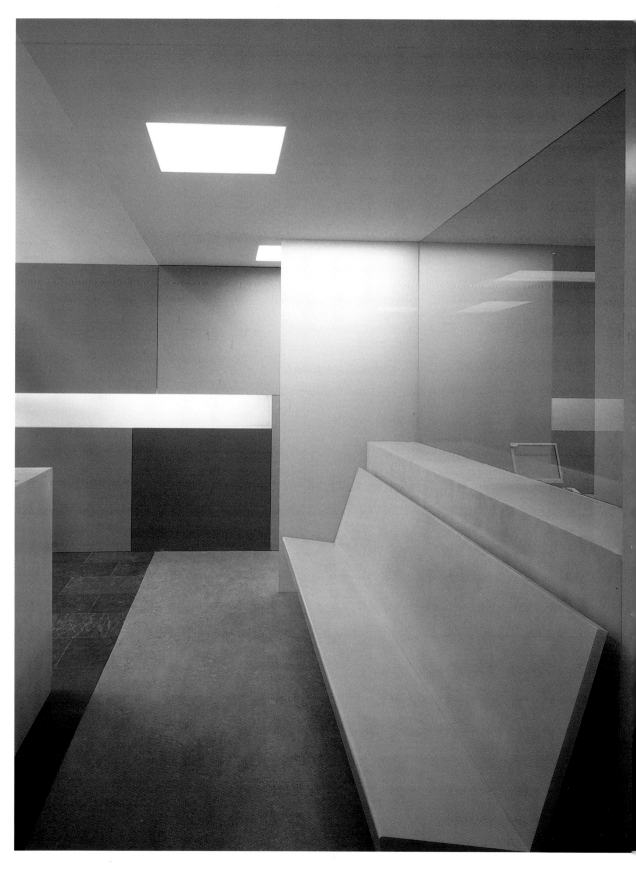

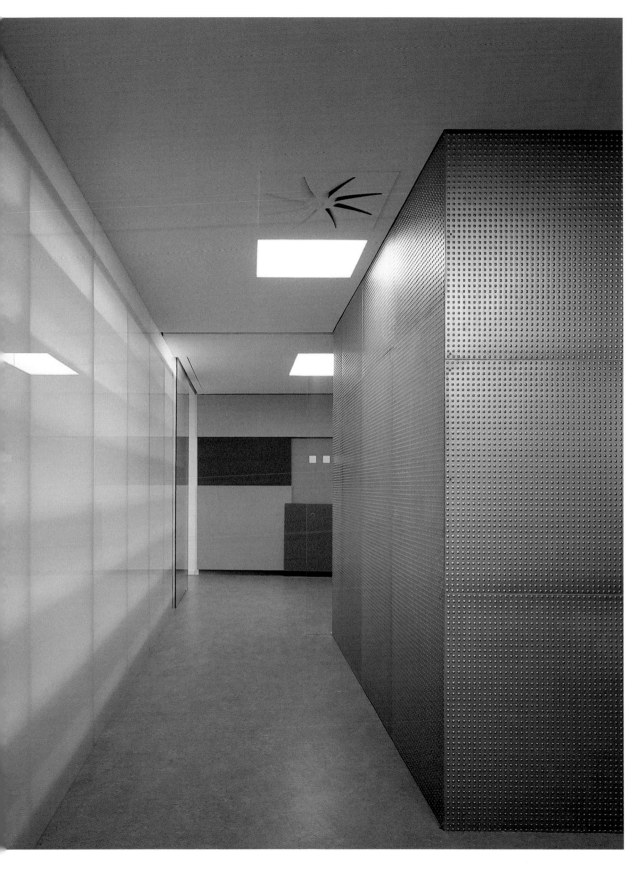

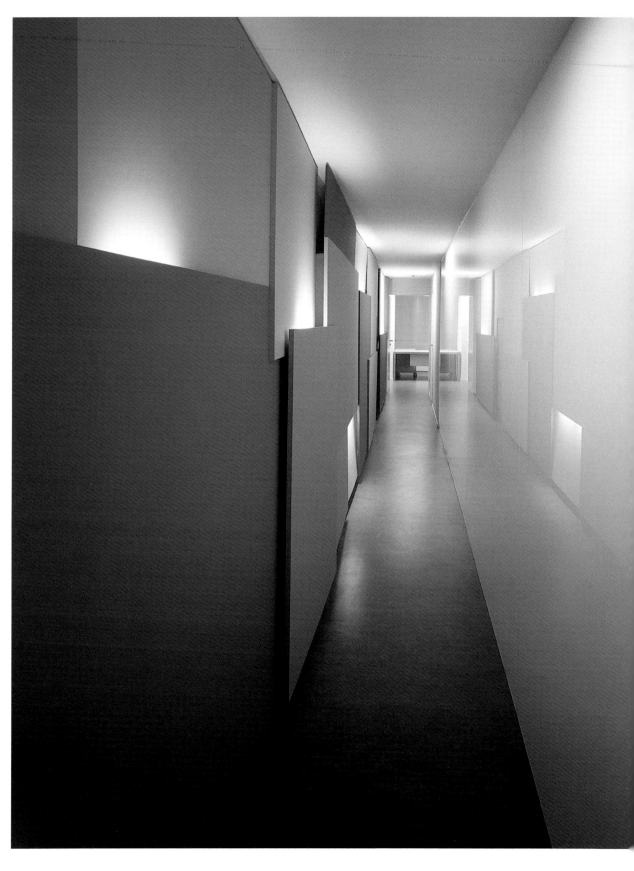

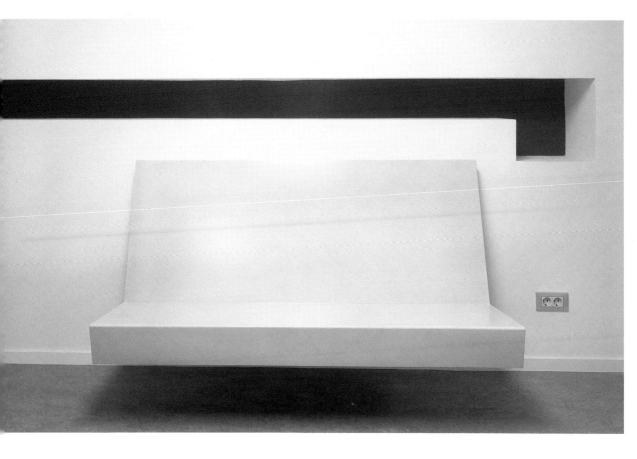

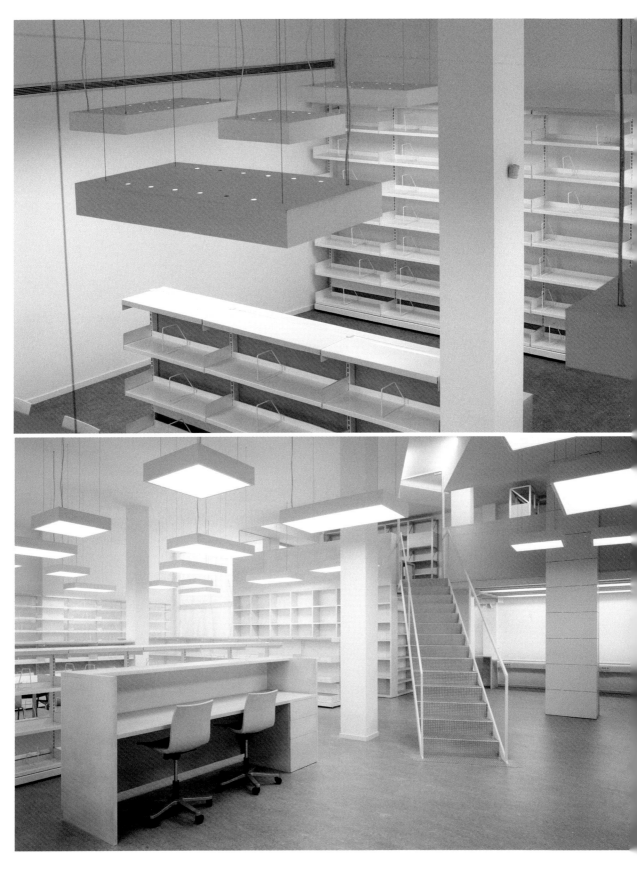

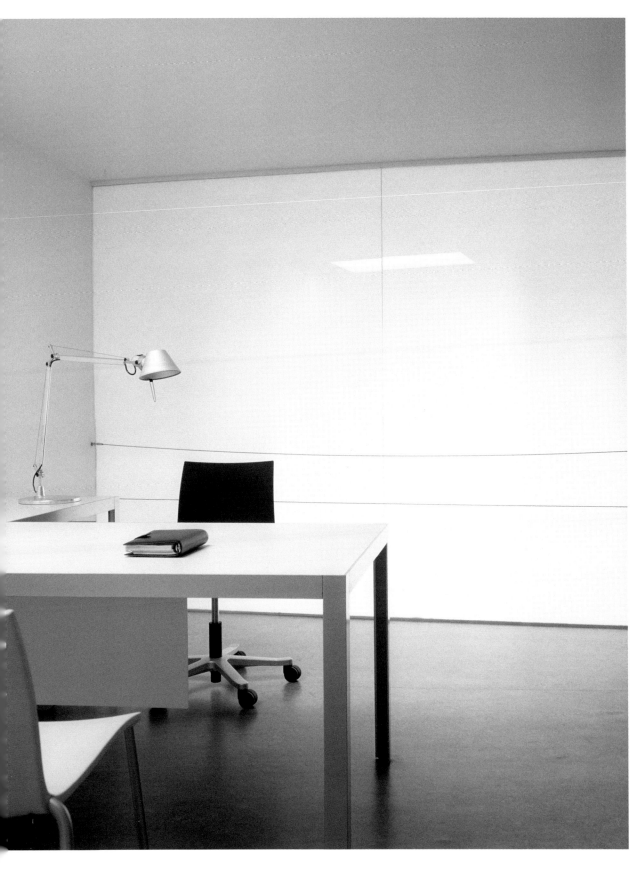

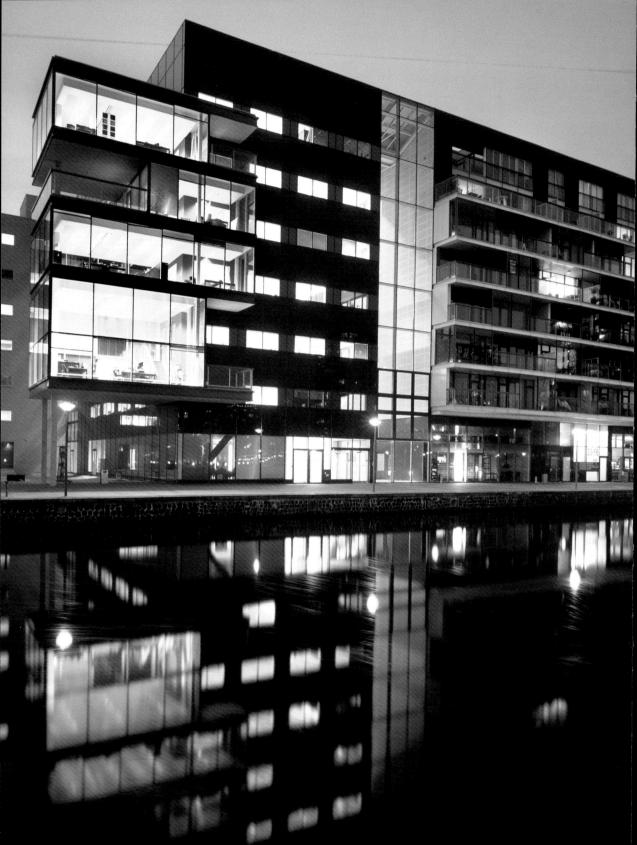

ARCHITECTENGROEP | AMSTERDAM
LAAKHAVEN DEN HAAG
The Hague, the Netherlands | 2005

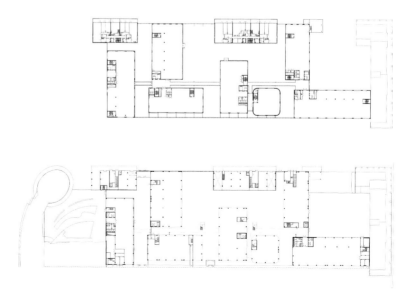

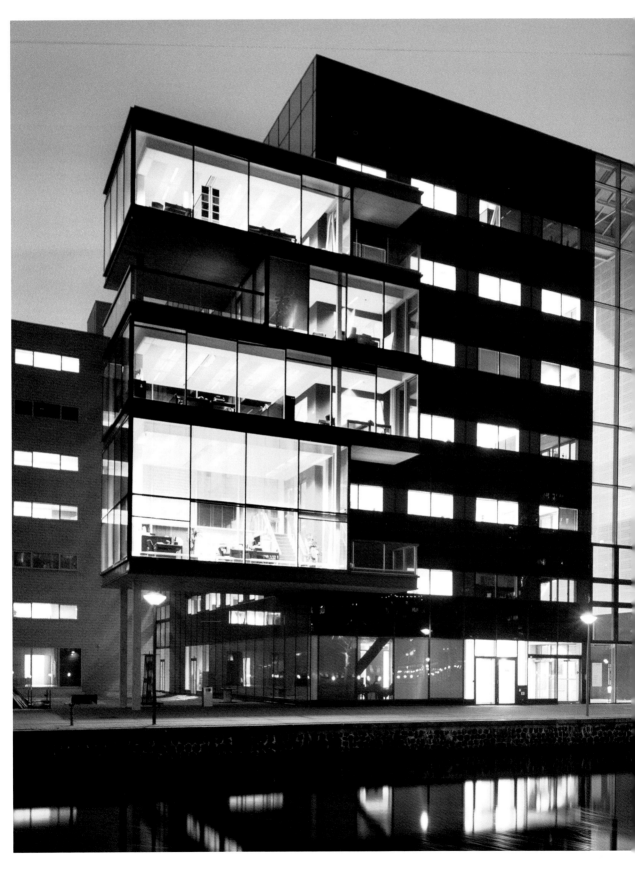

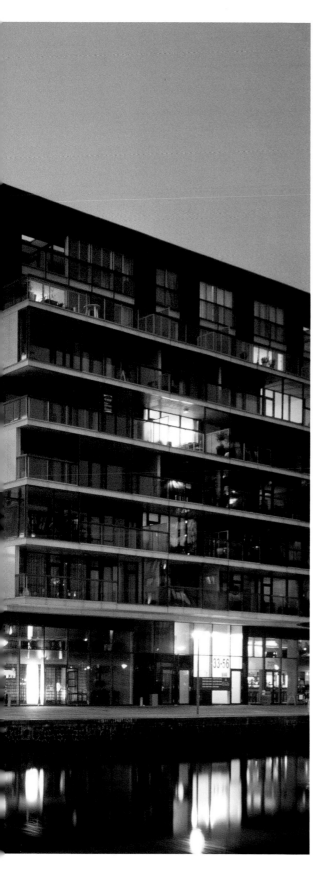

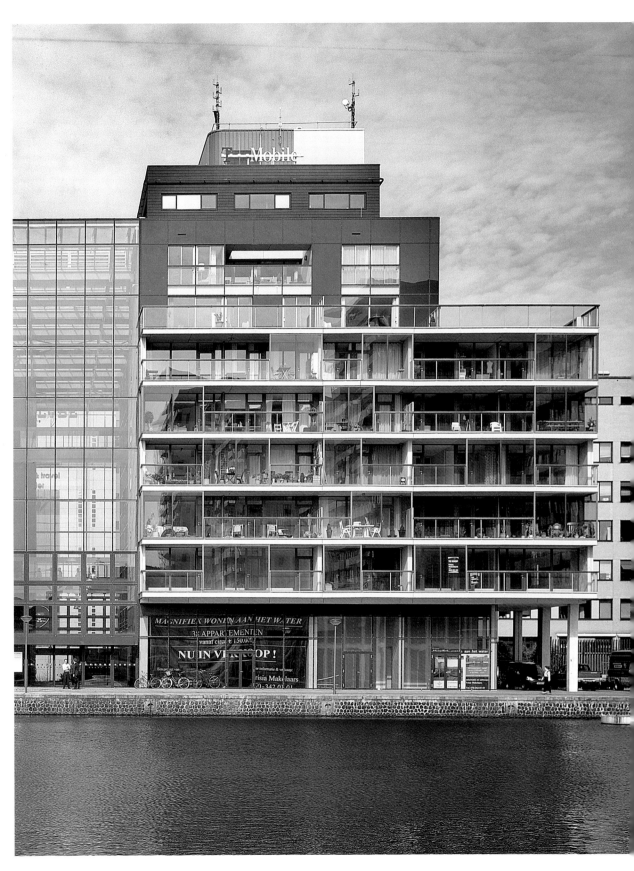

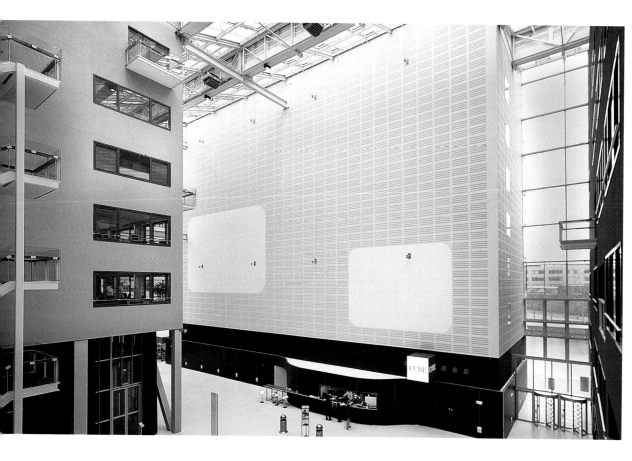

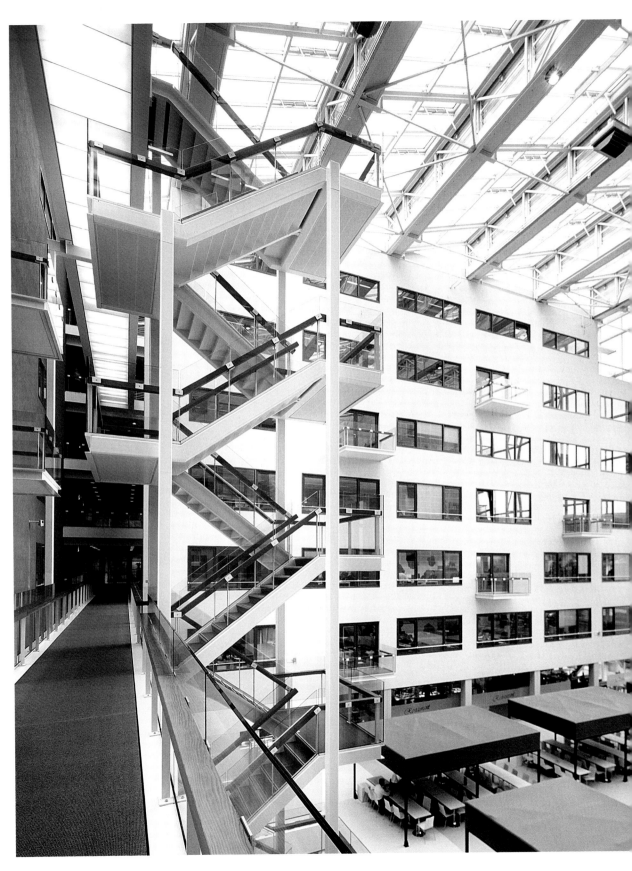

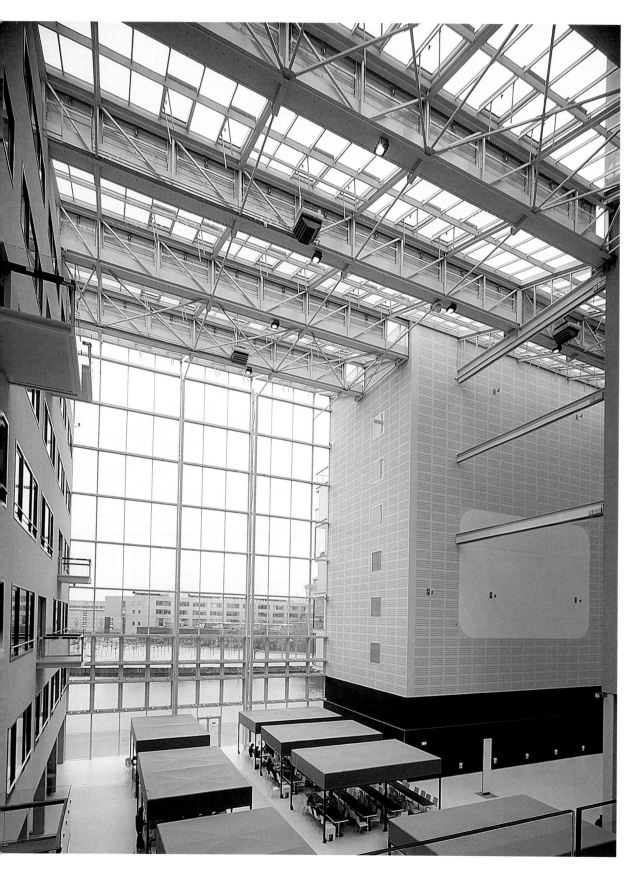

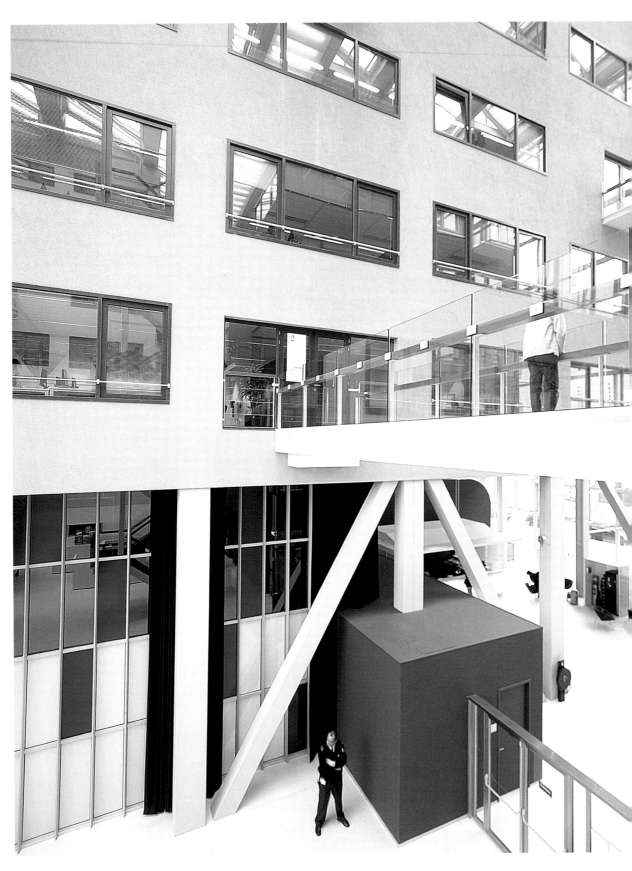

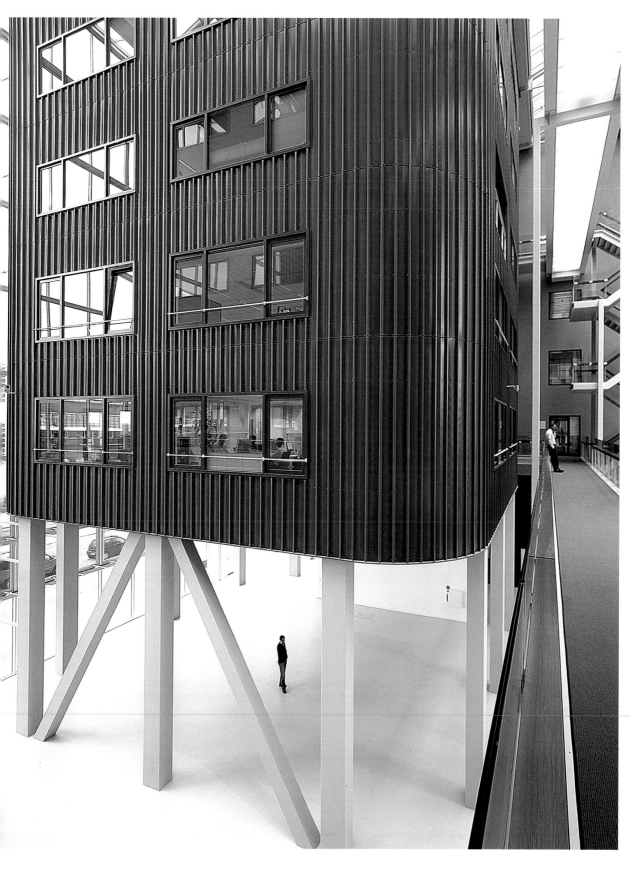

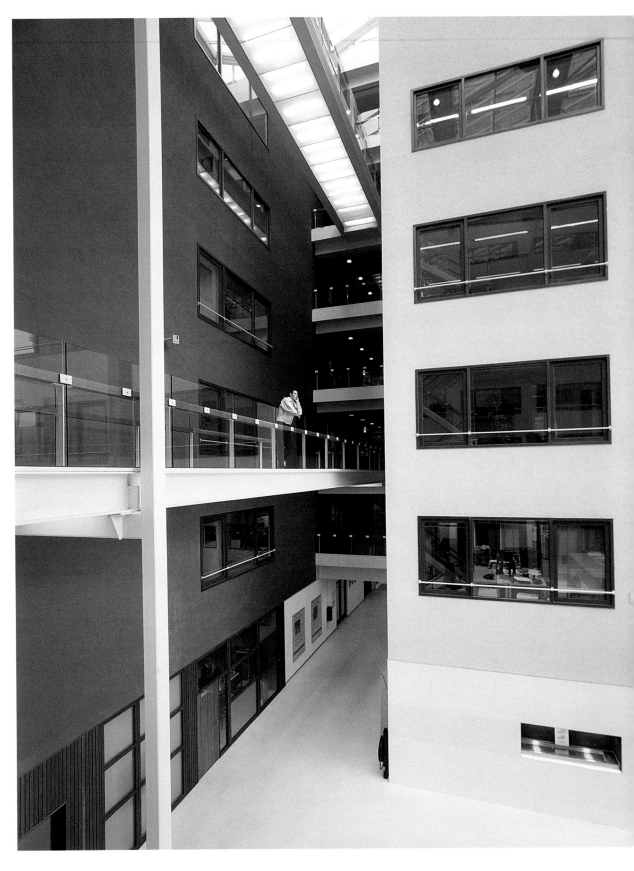

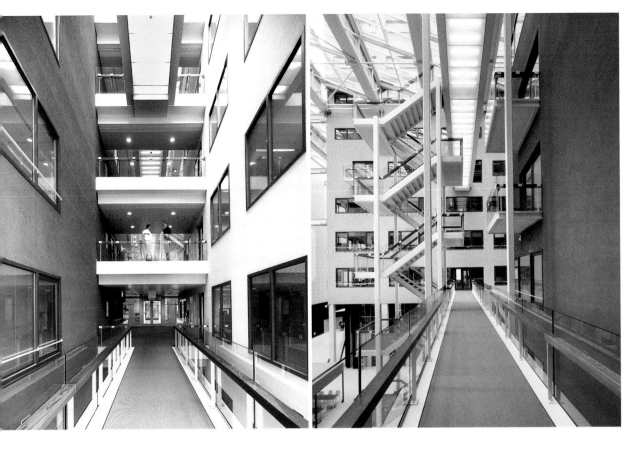

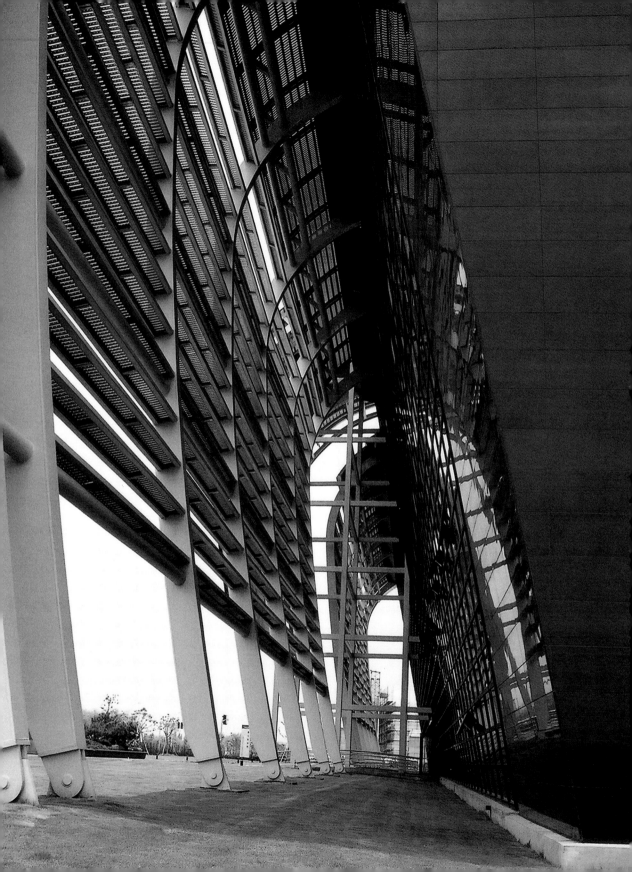

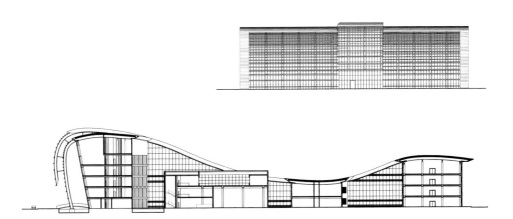

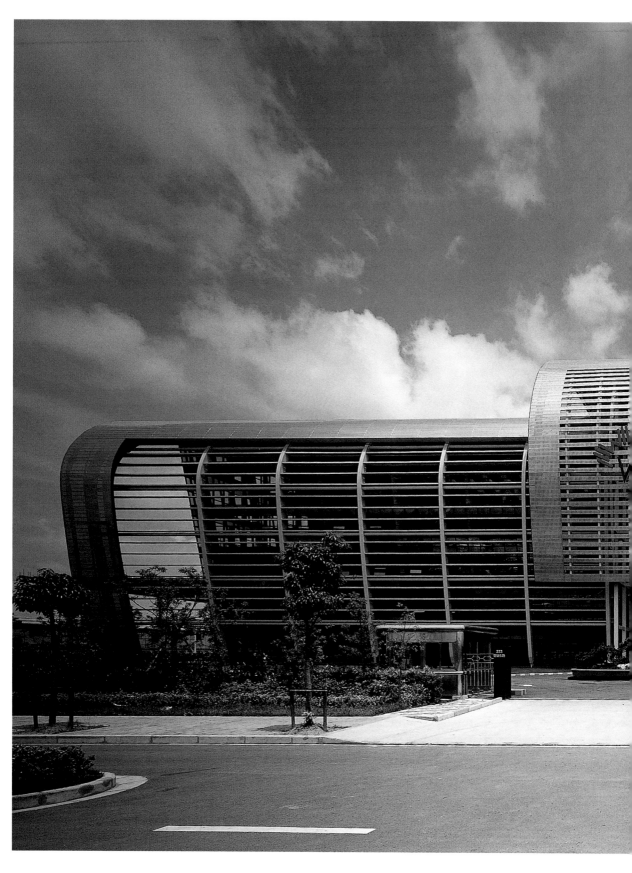

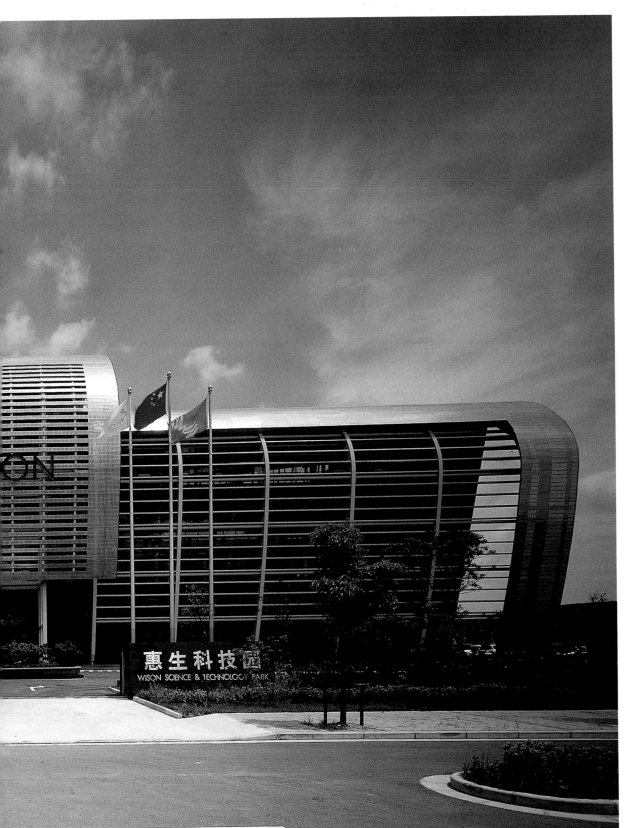

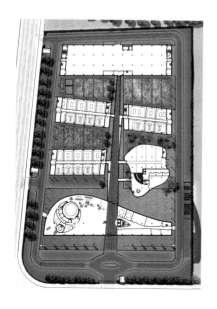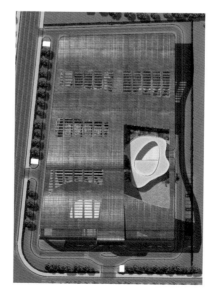

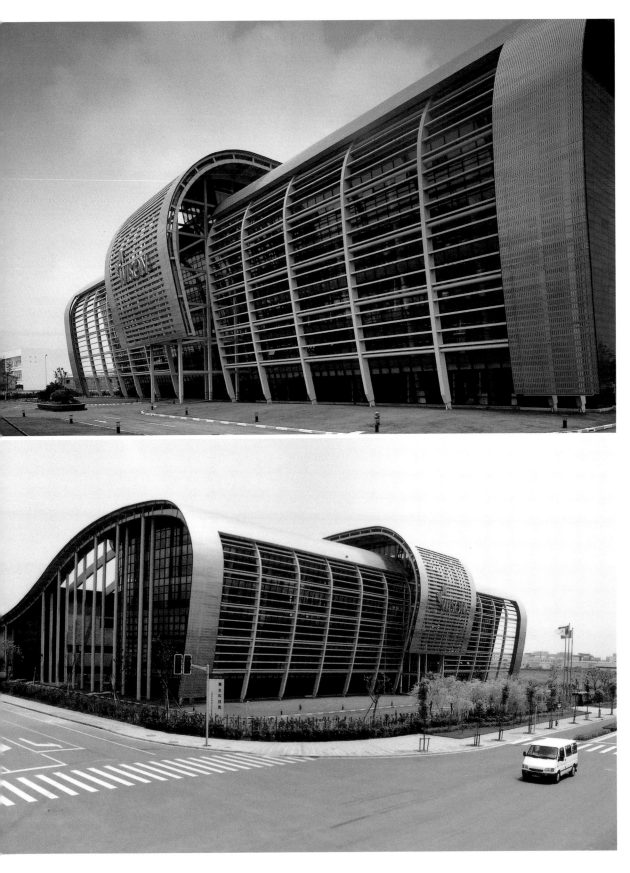

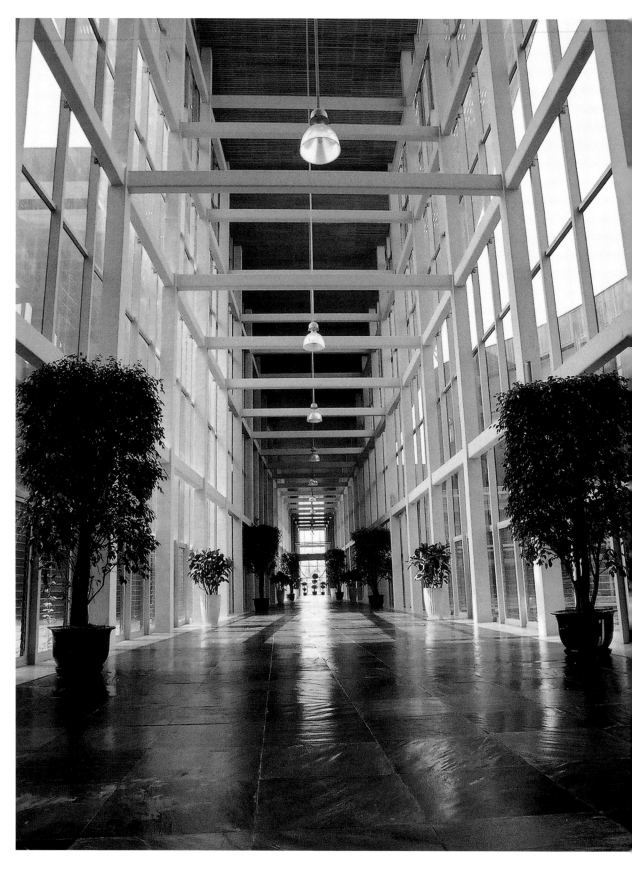

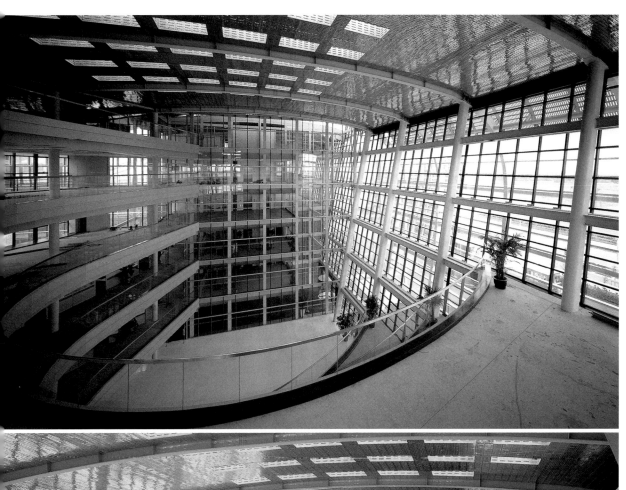
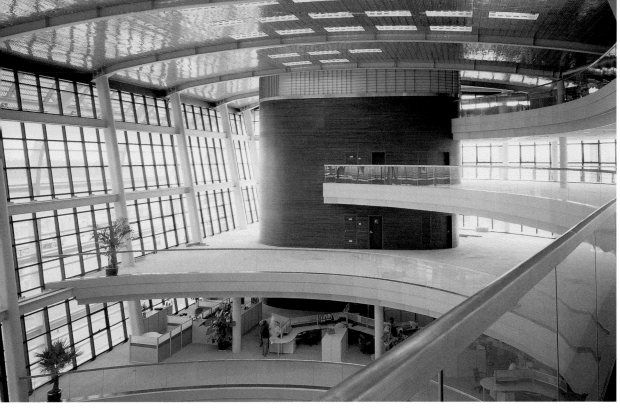

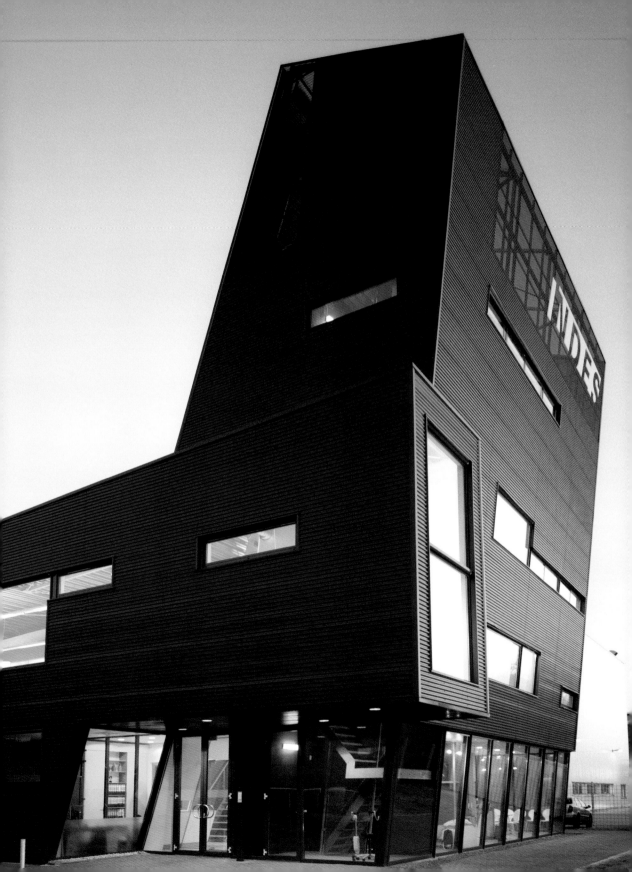

ARCONIKO ARCHITECTEN | ROTTERDAM
INDES
Enschede, the Netherlands | 2004

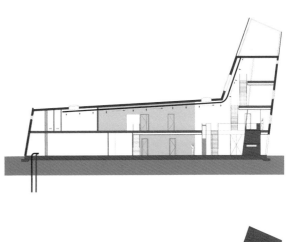

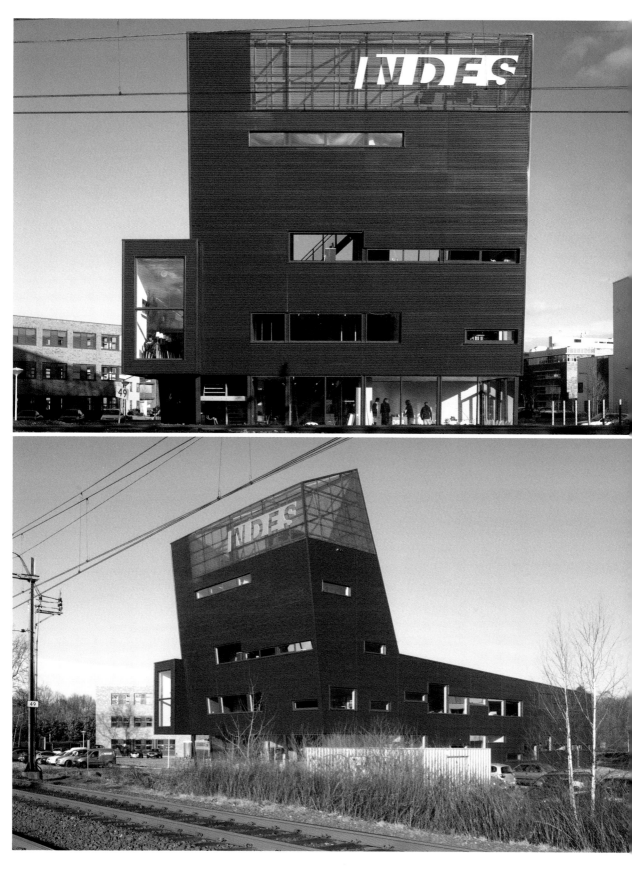

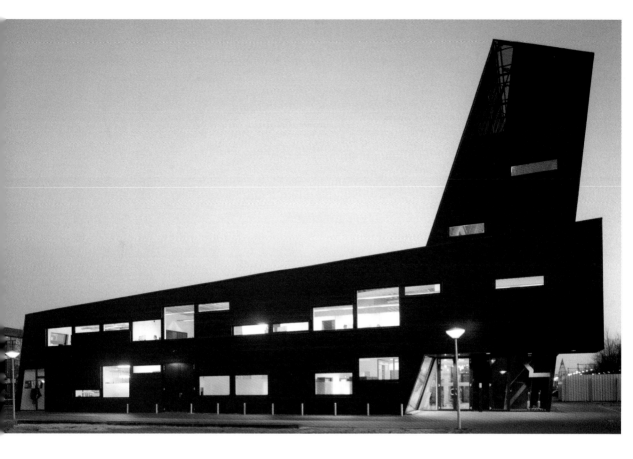

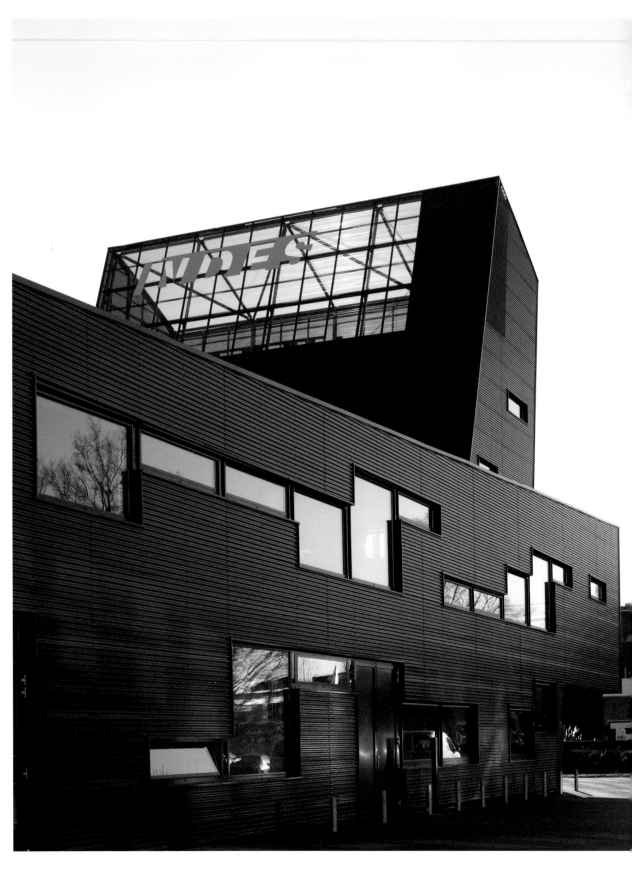

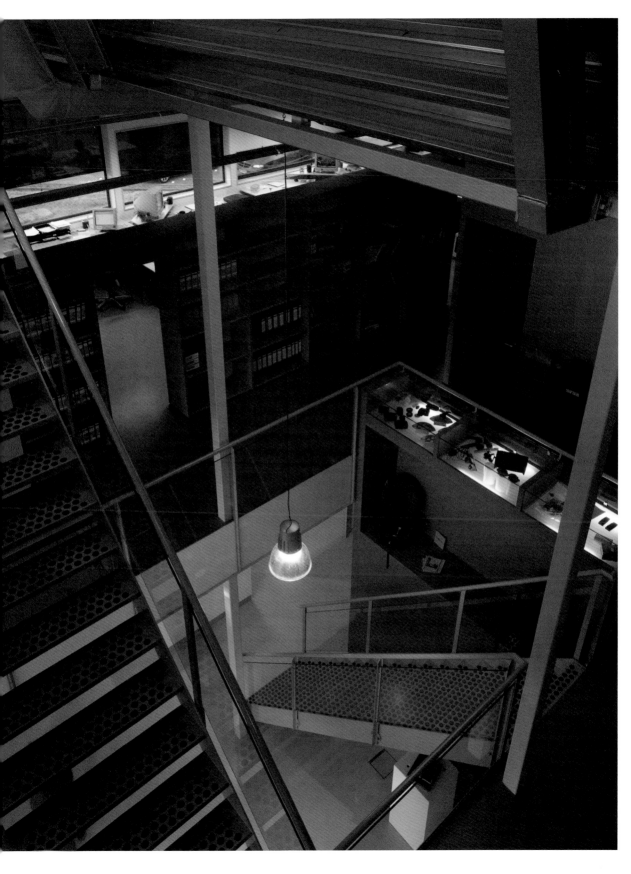

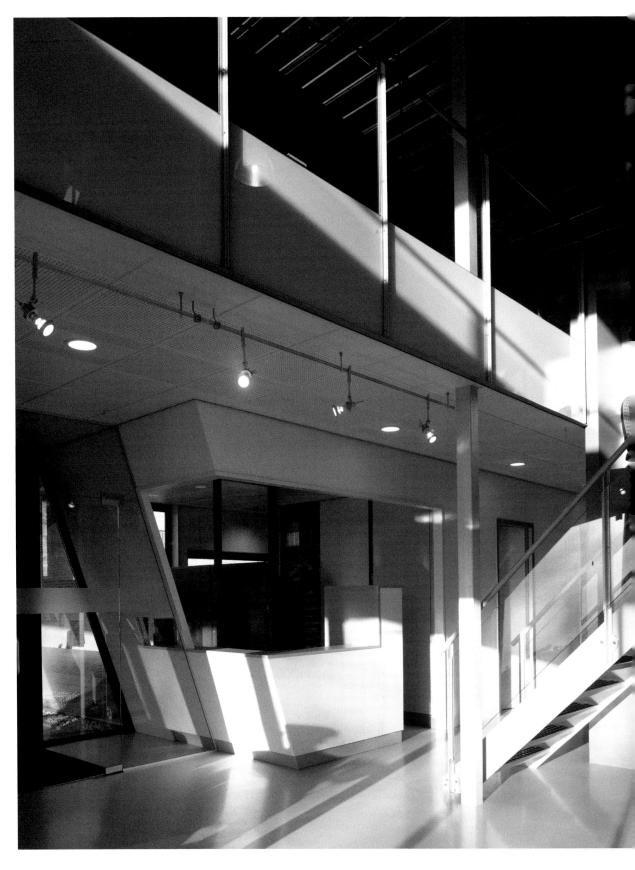

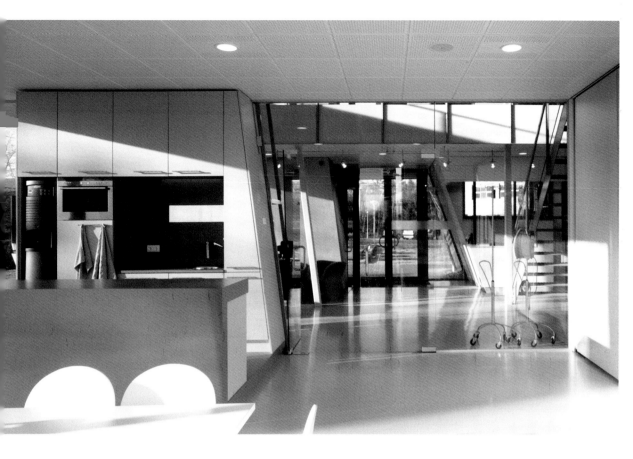

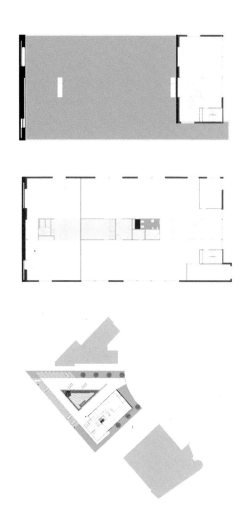

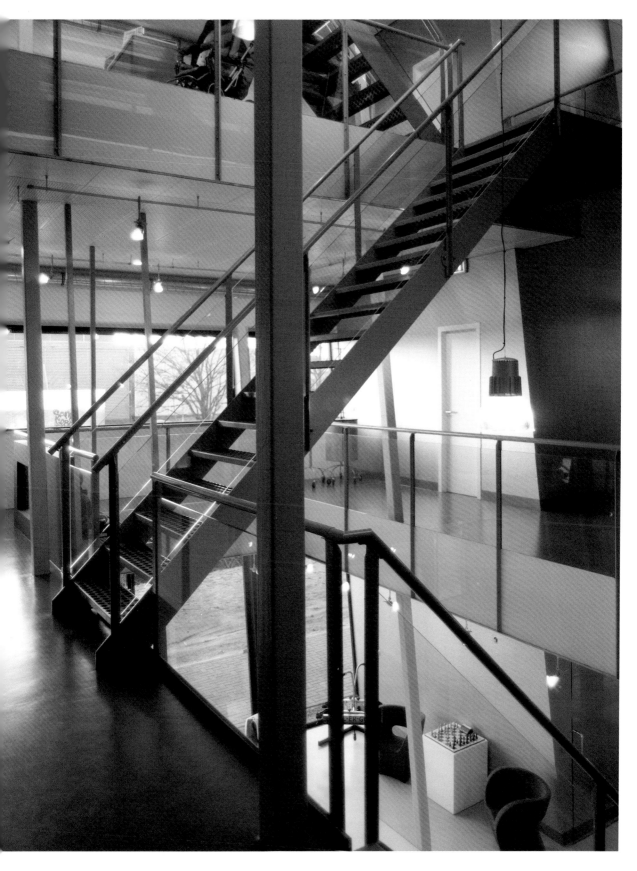

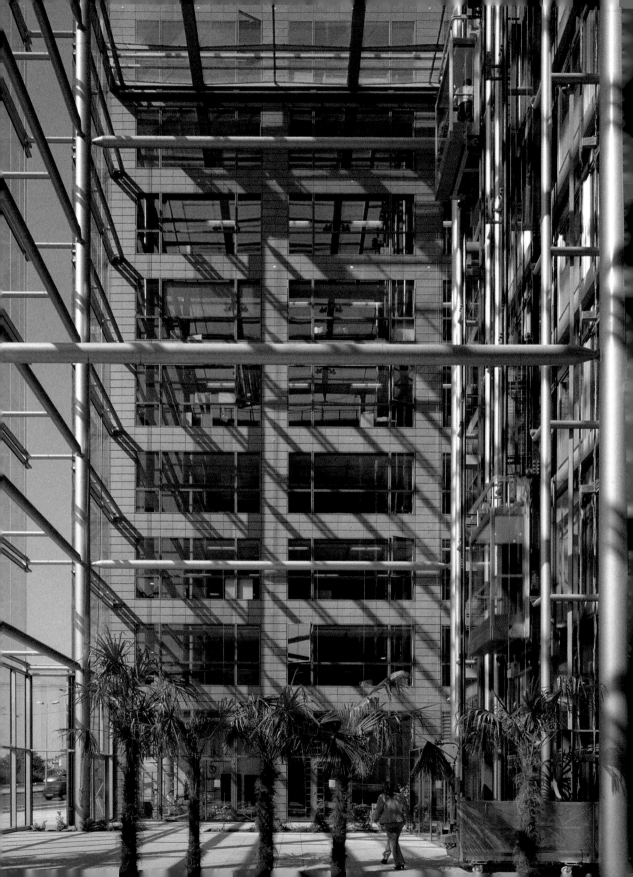

ATELIER D'ARCHITECTURE CHAIX & MOREL ET ASSOCIÉS | PARIS
CRYSTAL DÉFENSE
Nanterre, France | 2003

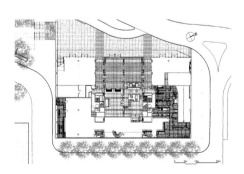

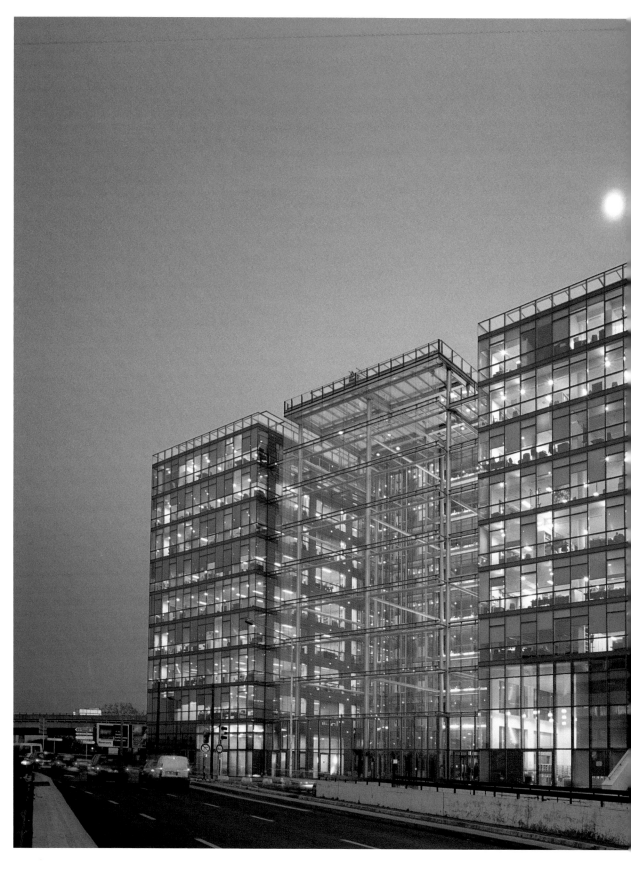

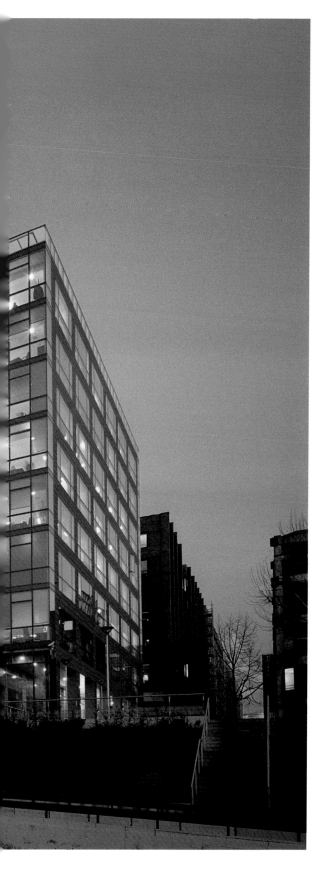

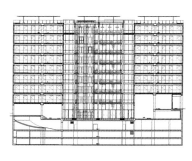

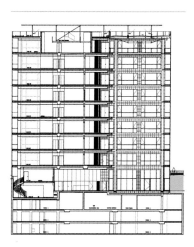

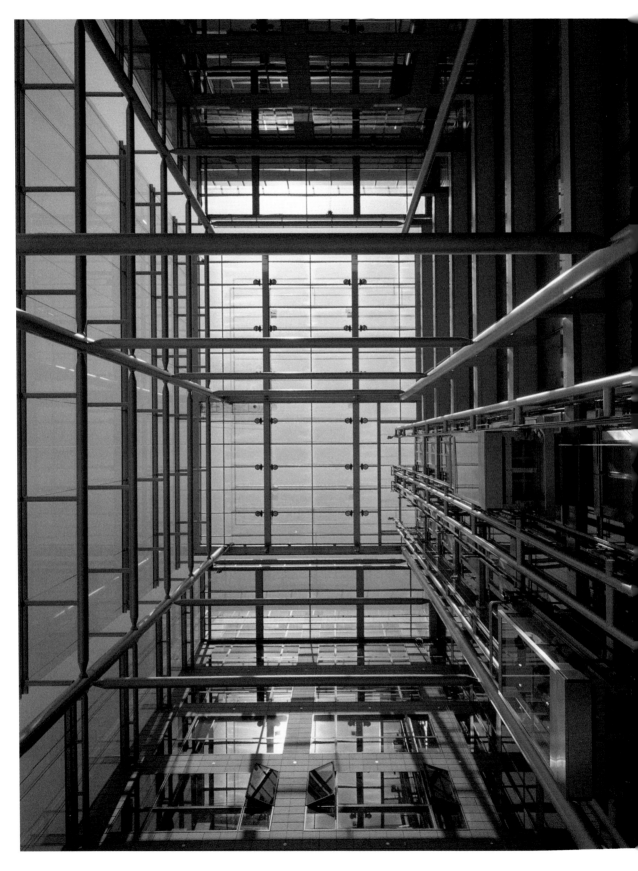

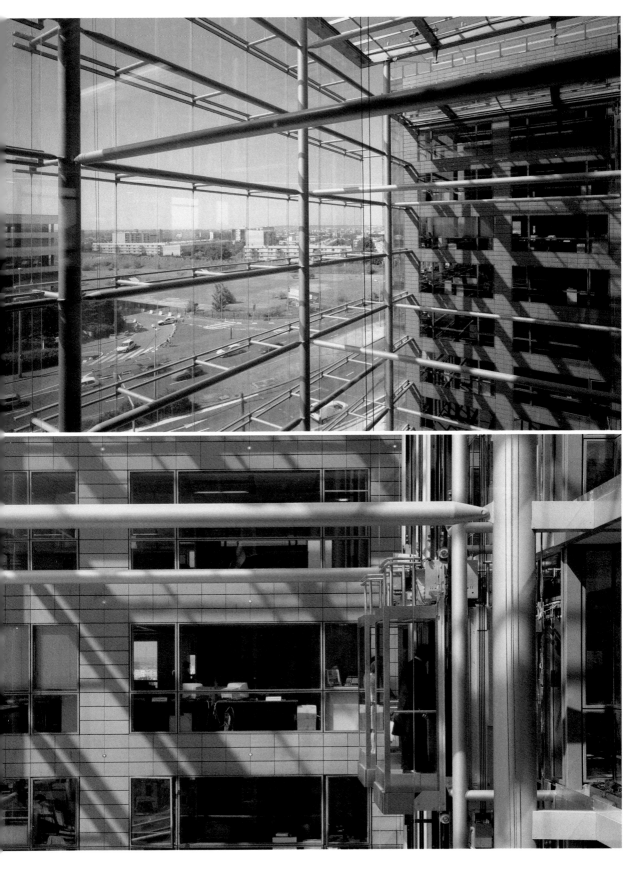

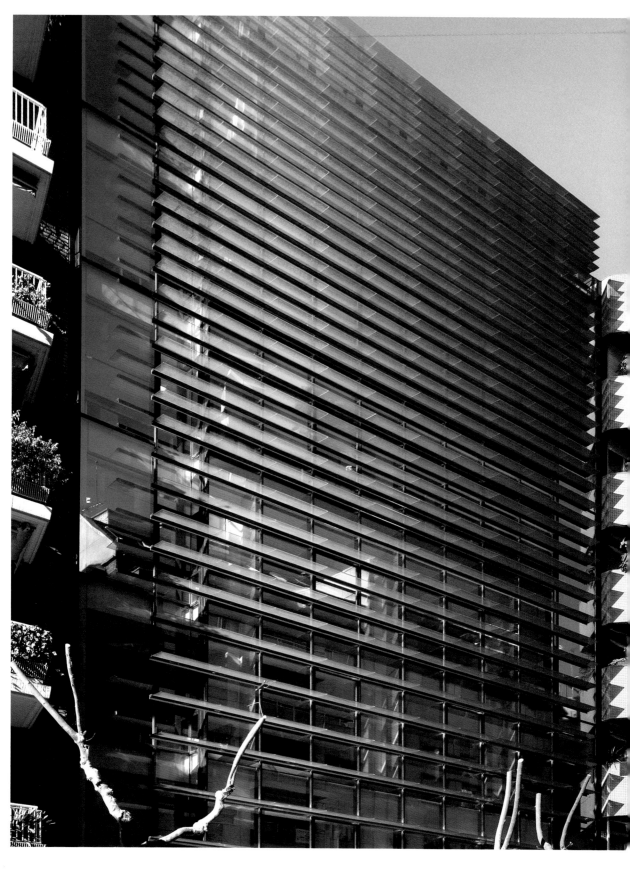

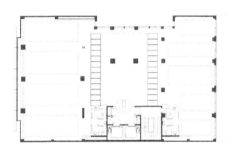

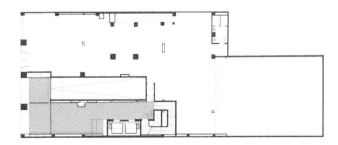

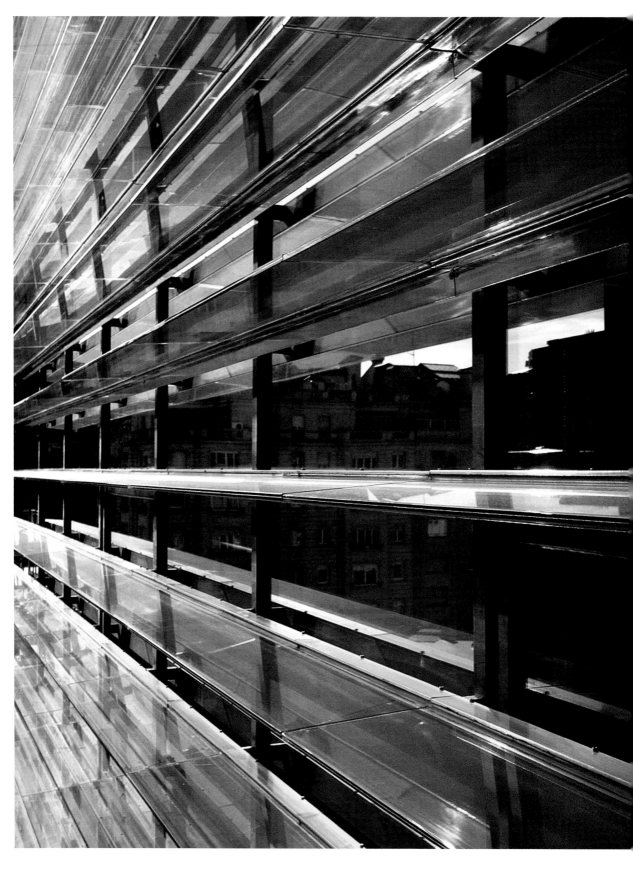

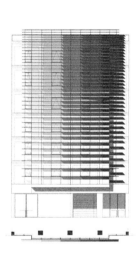

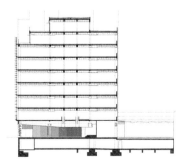

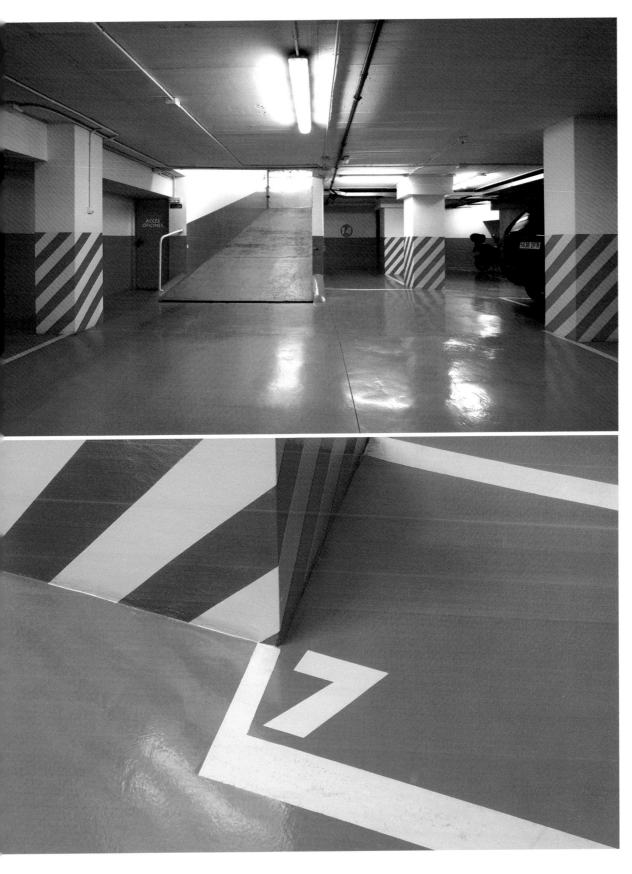

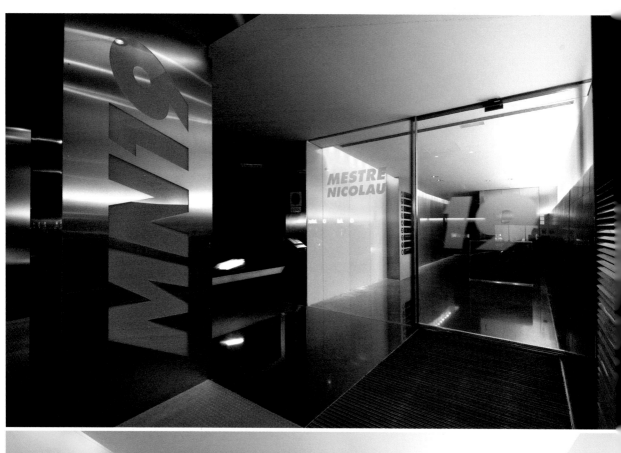
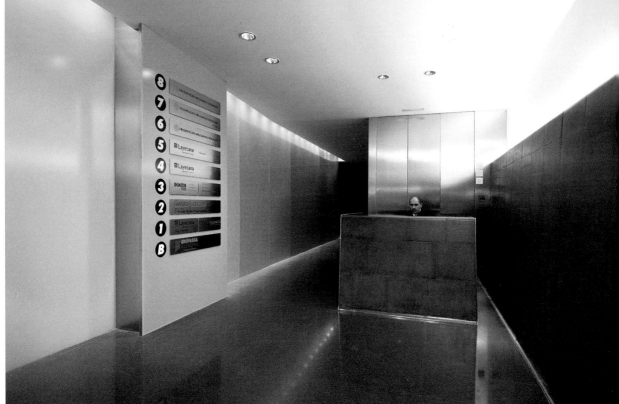

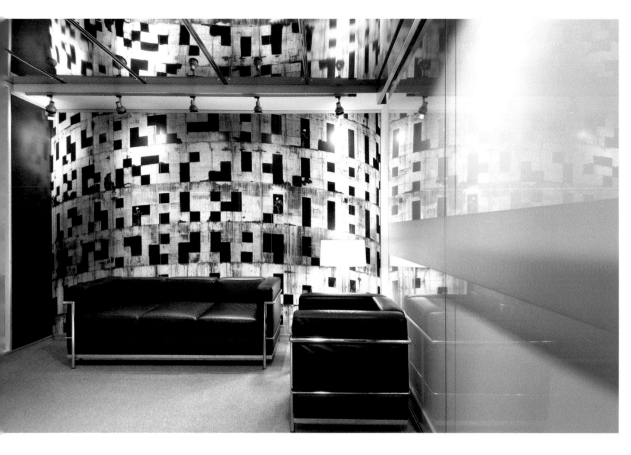

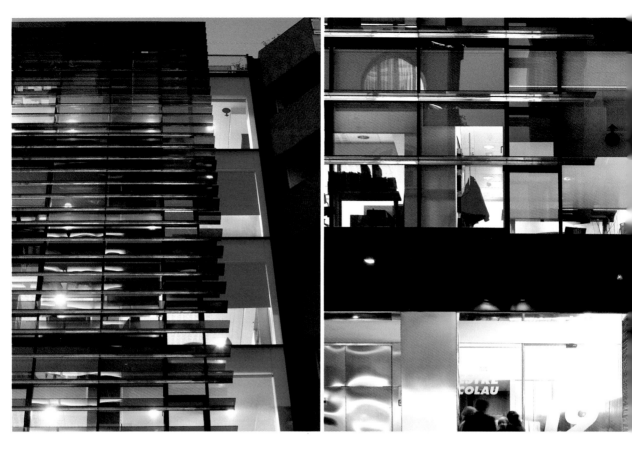

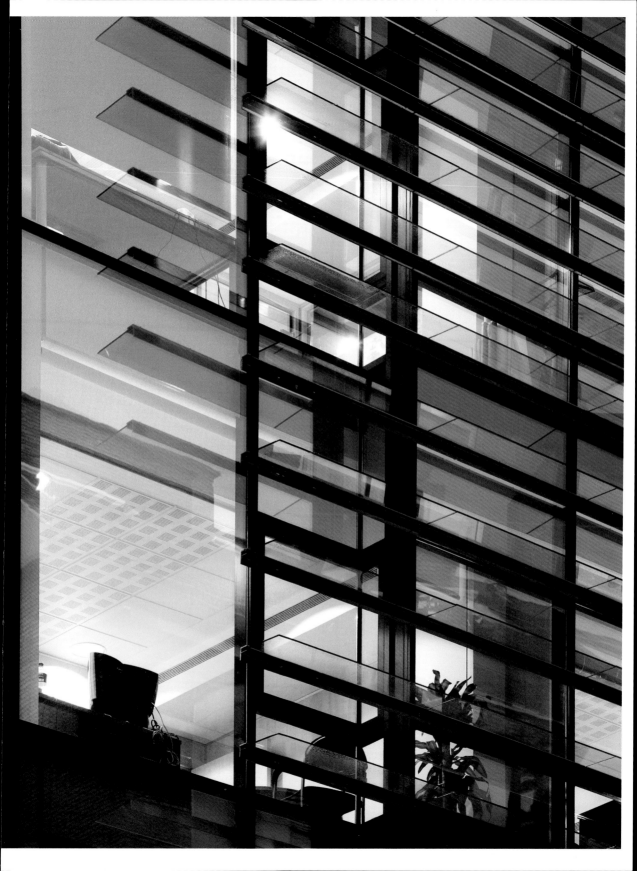

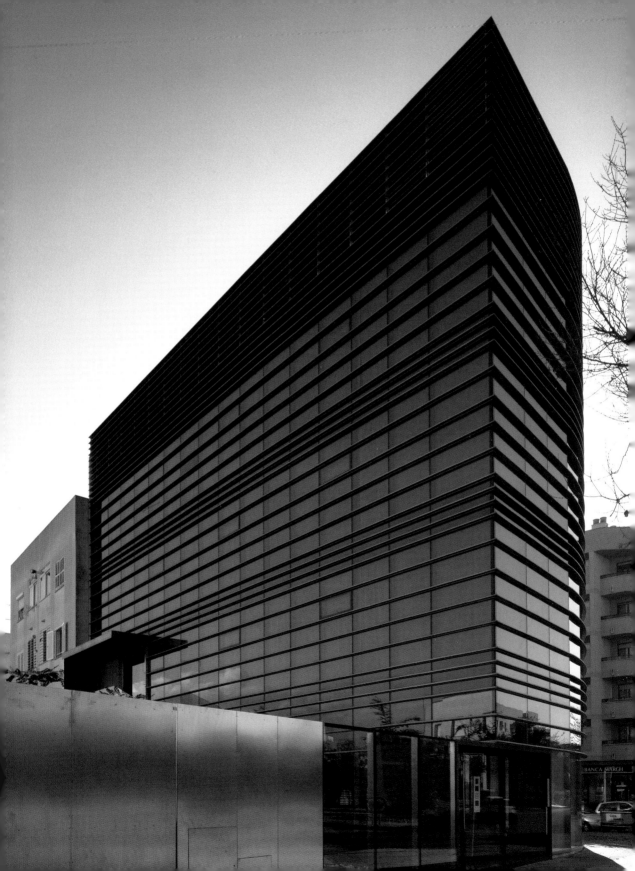

BAAS ARQUITECTES | BARCELONA
IBERCON
Palma de Majorca, Spain | 2004

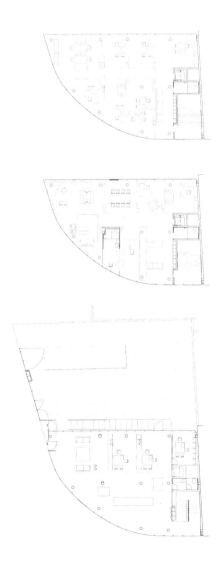

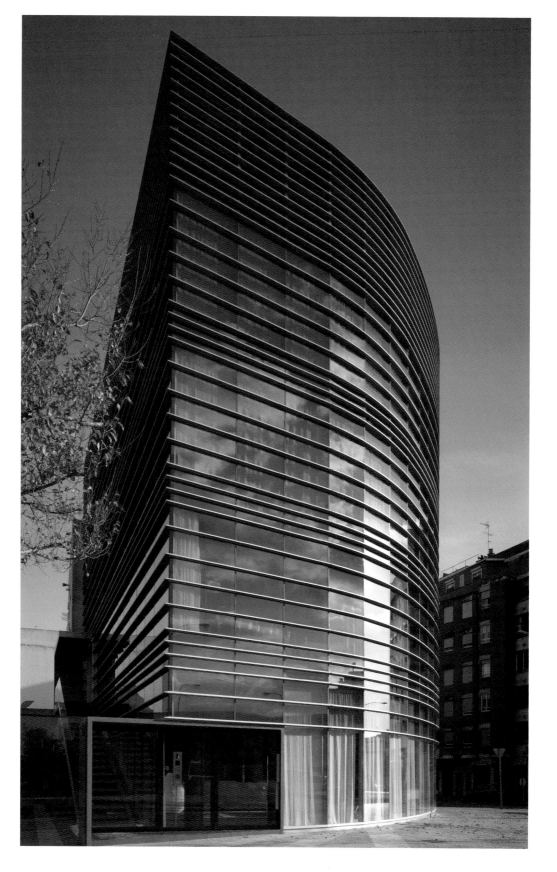

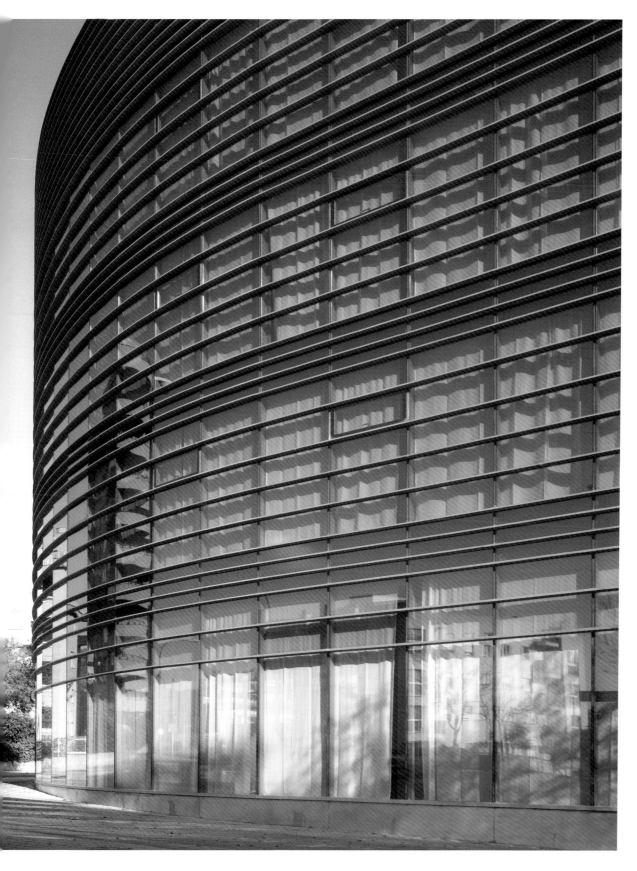

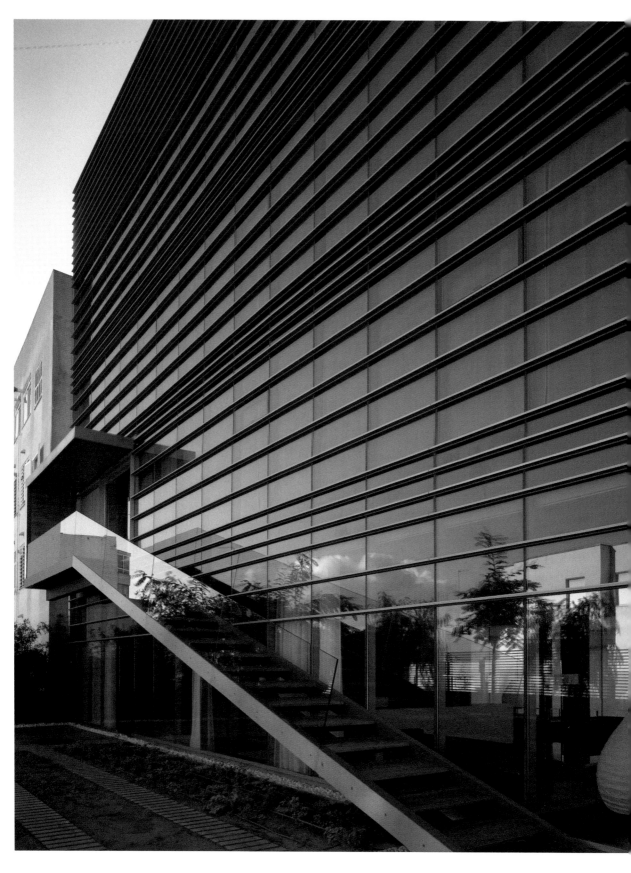

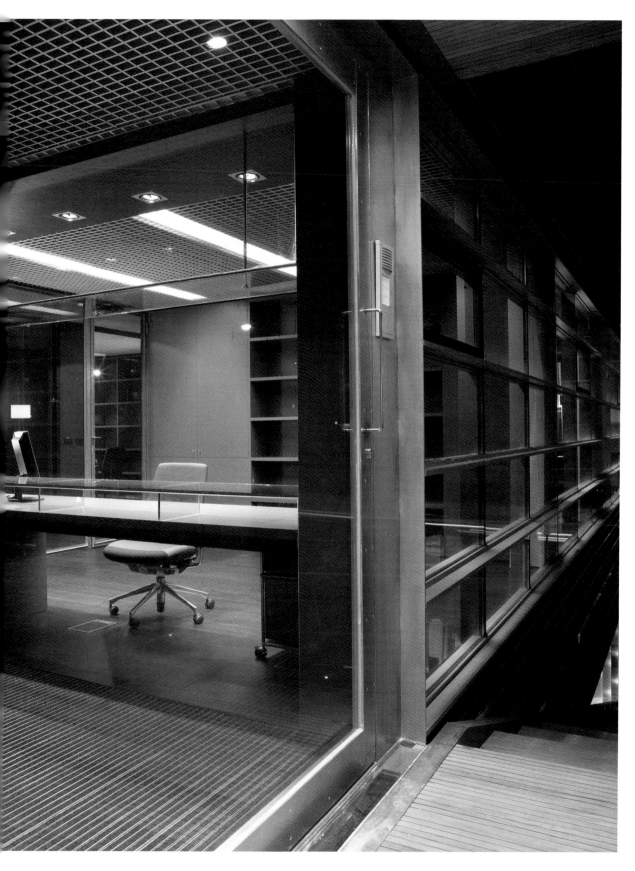

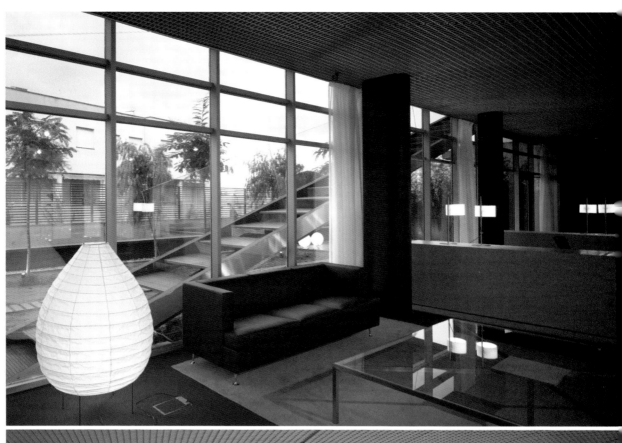
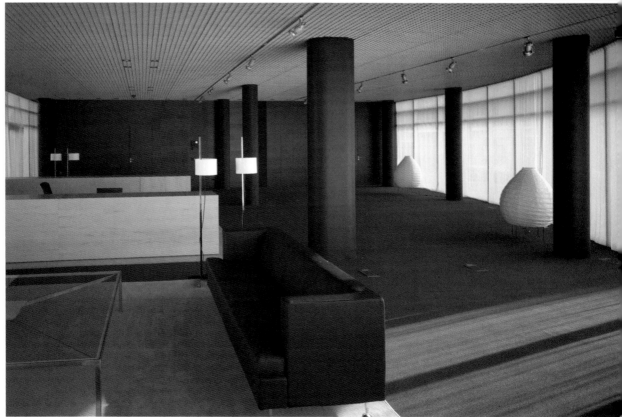

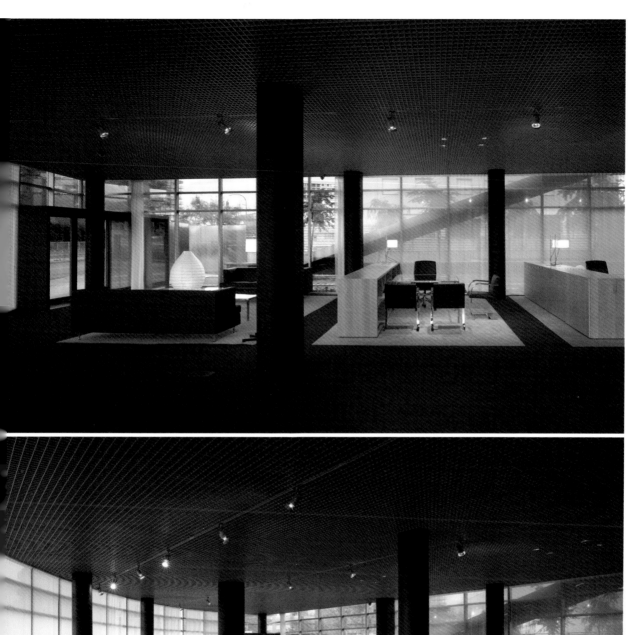
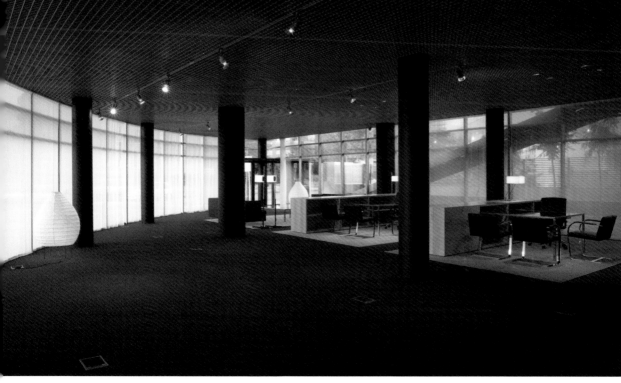

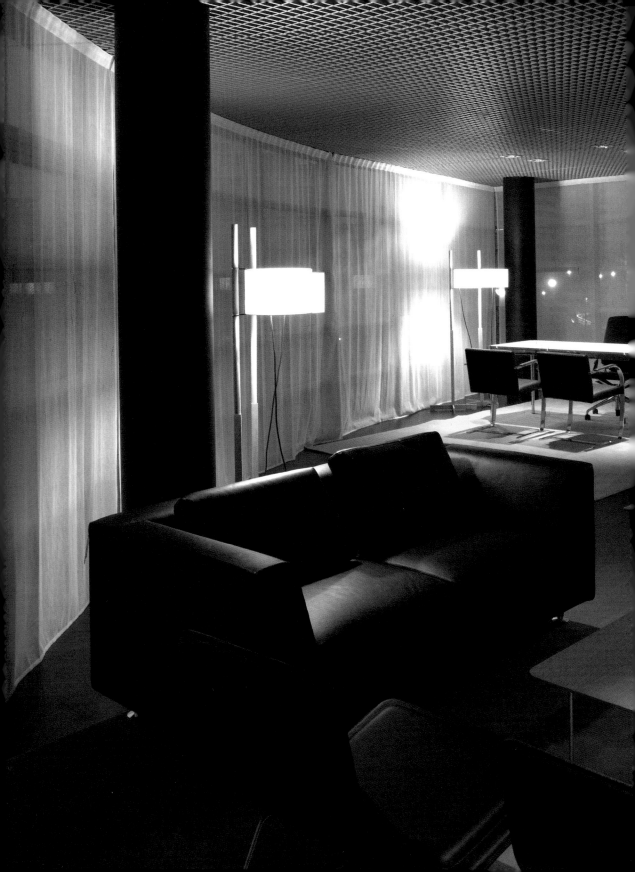

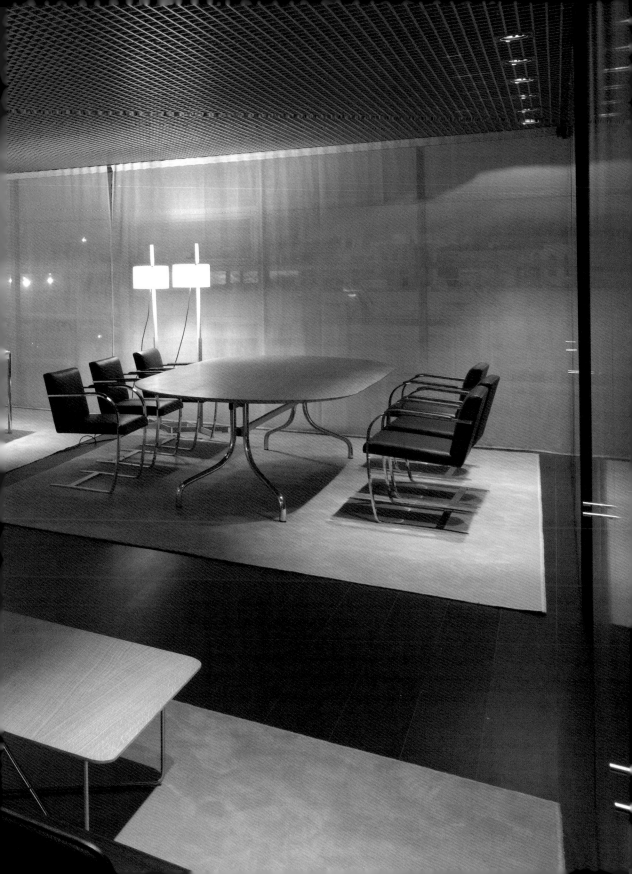

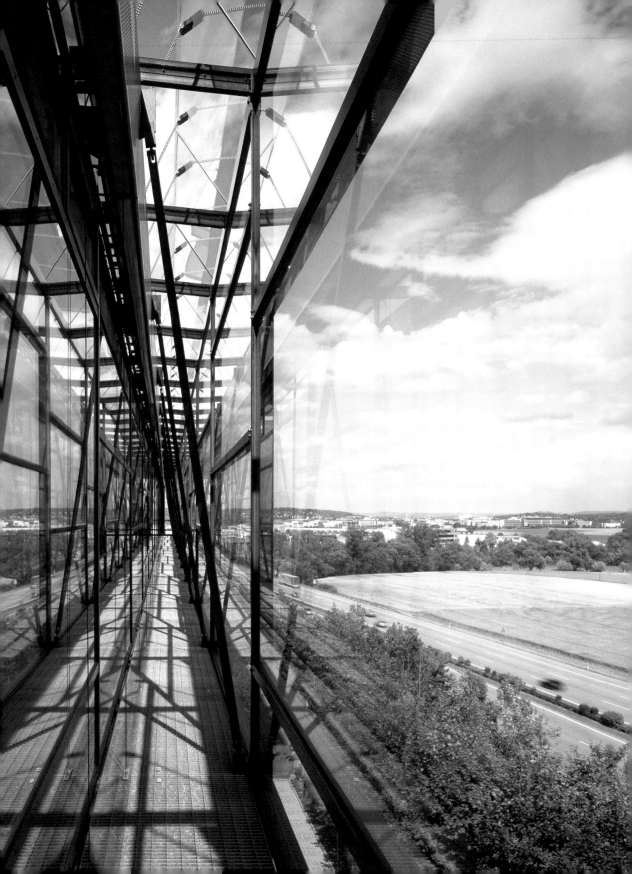

BARKOW LEIBINGER ARCHITECTS | BERLIN
TRUMPF
Stutgart, Germany | 2004

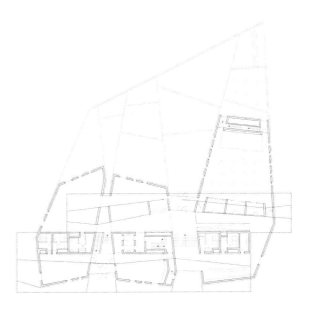

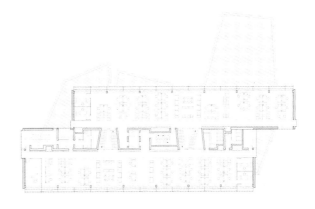

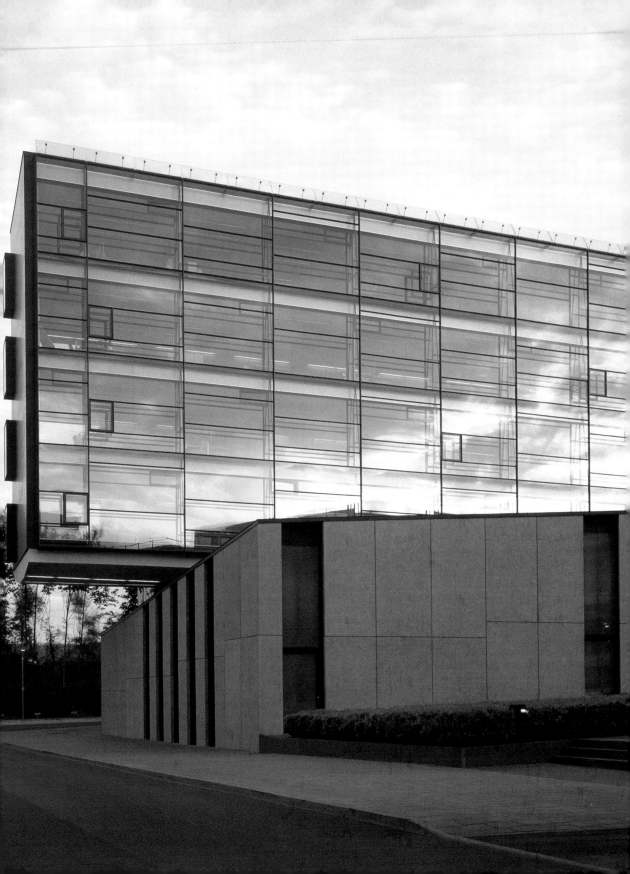

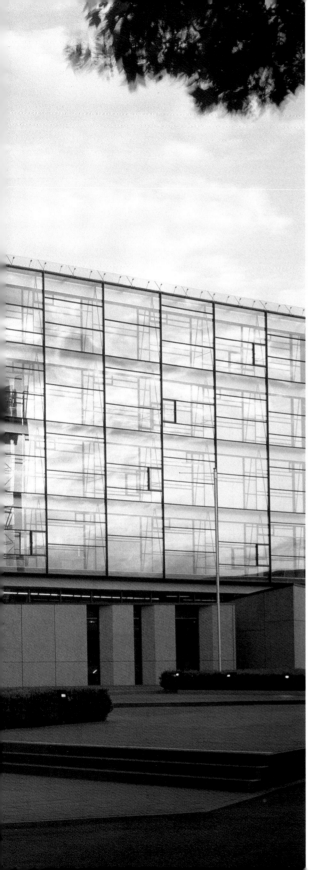

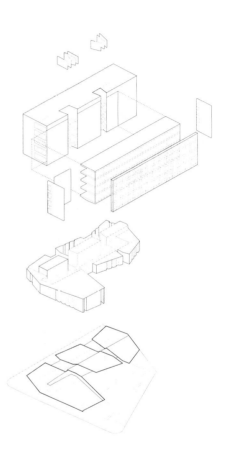

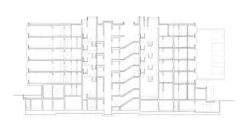

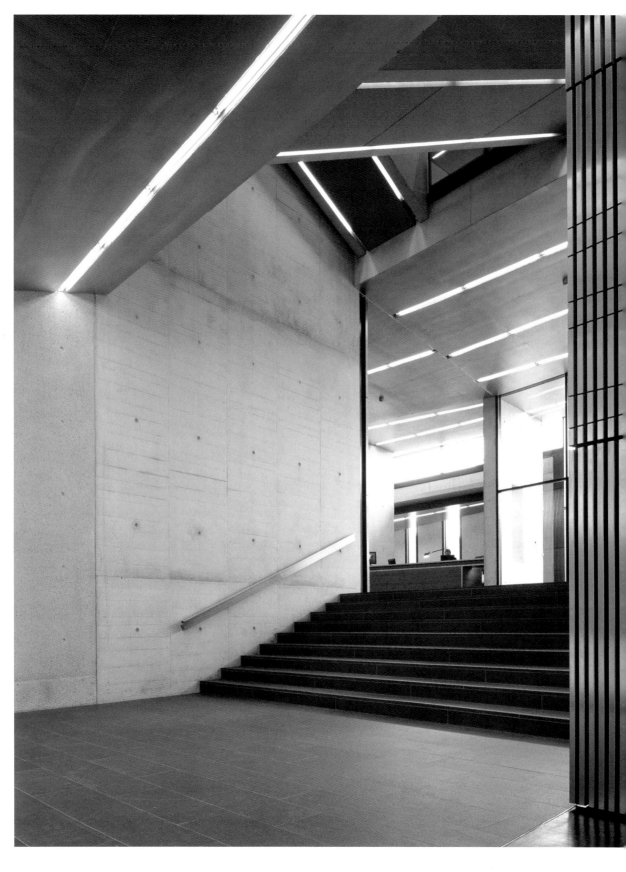

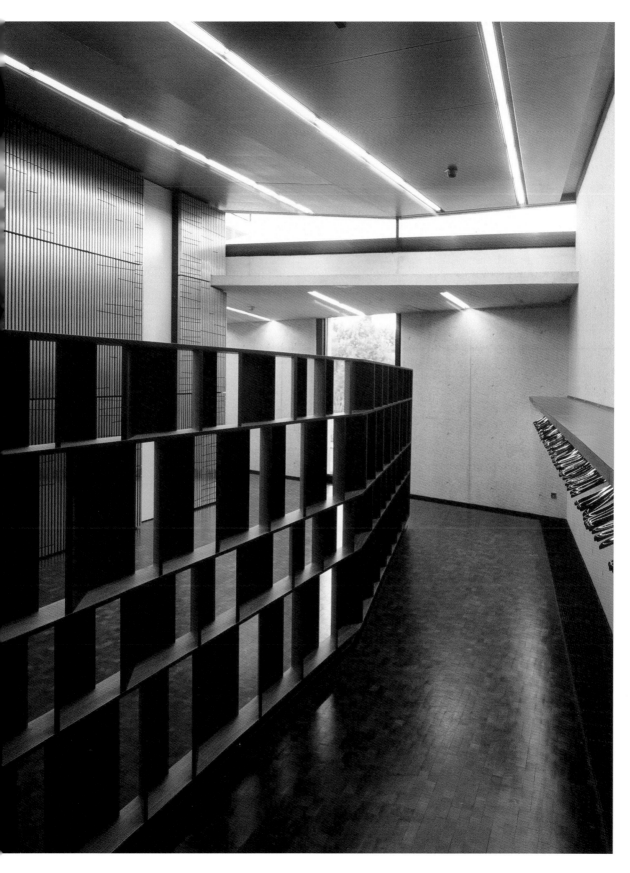

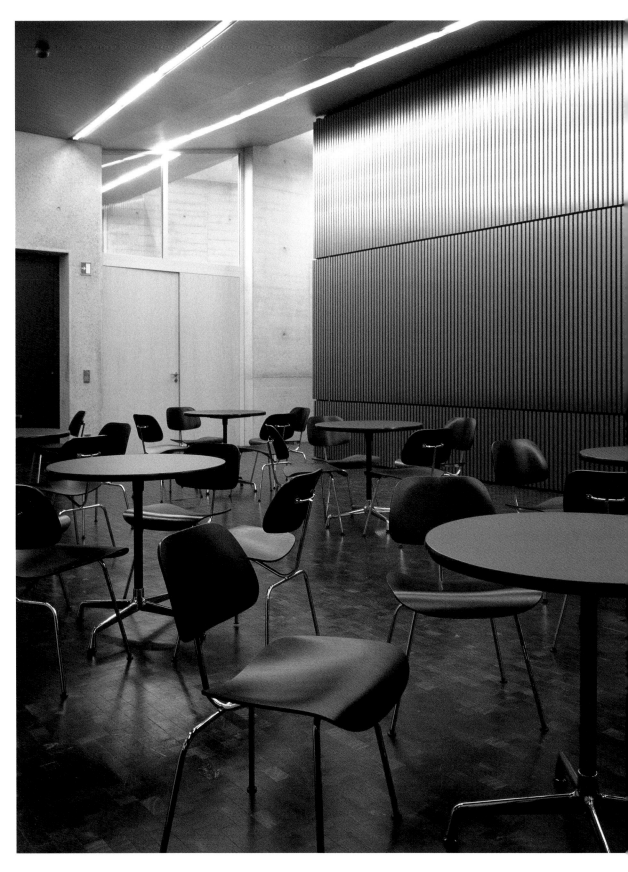

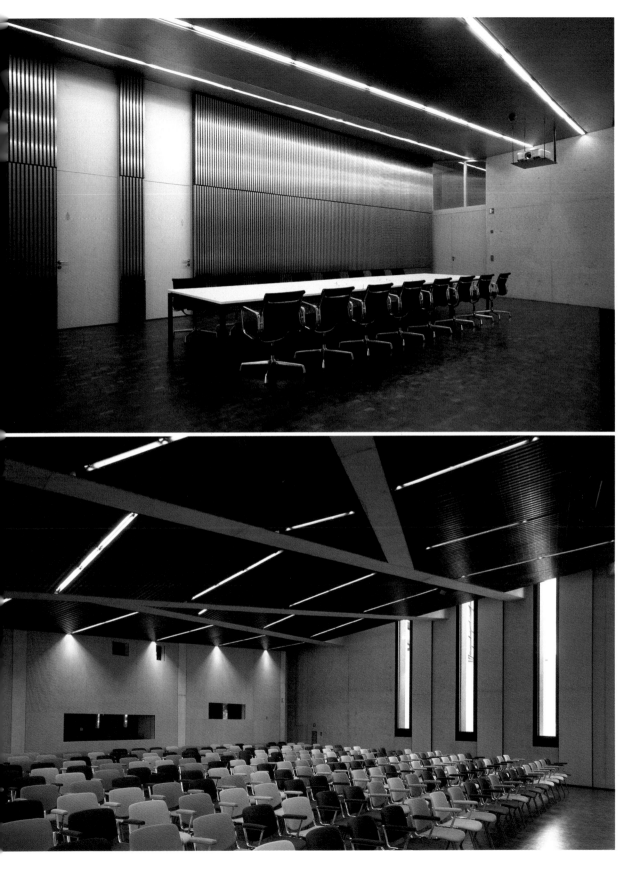

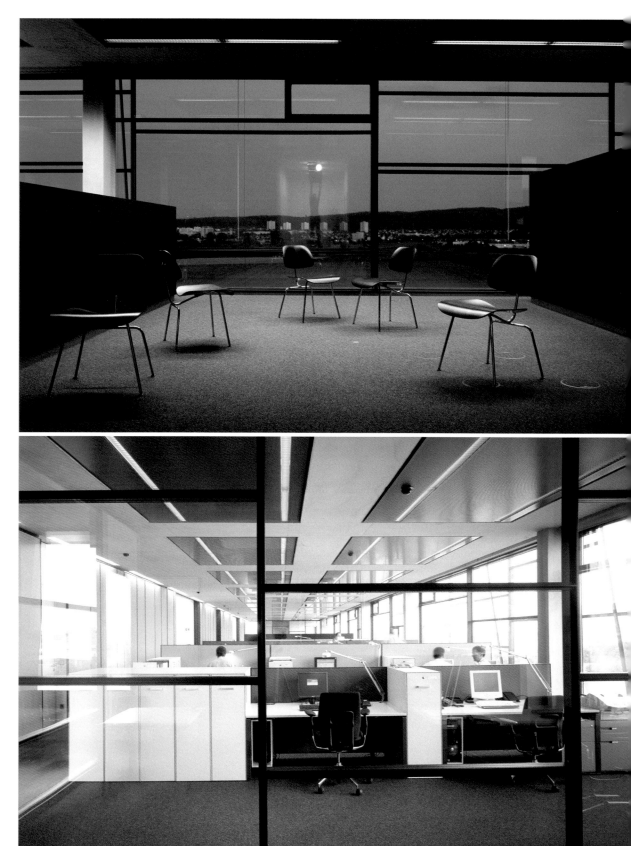

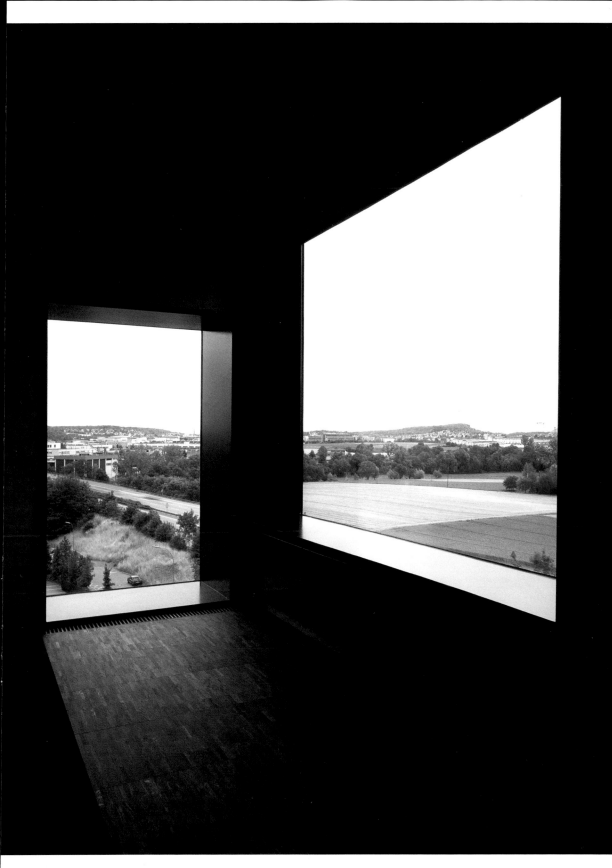

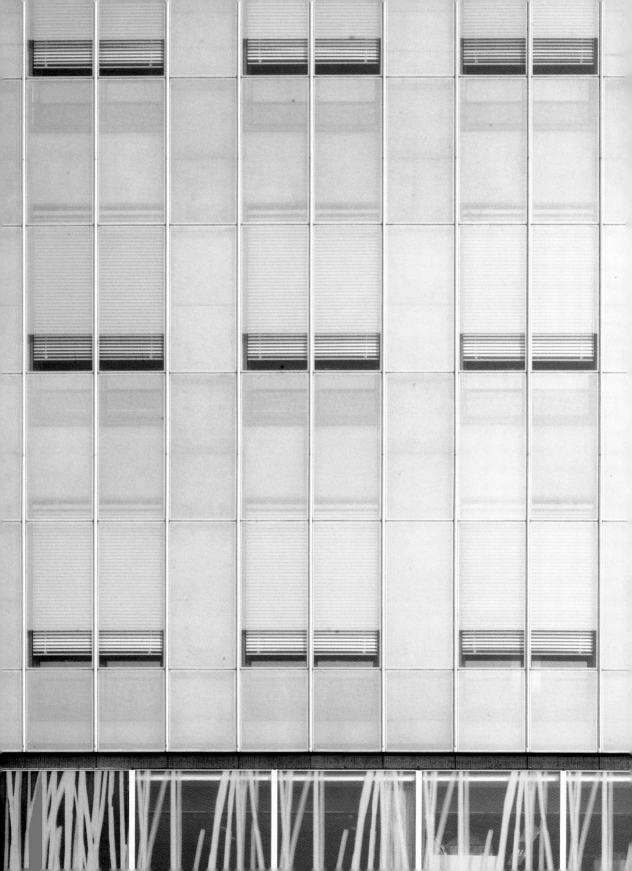

BROEK EN BAKEMA | ROTTERDAM
KROPMAN
Utrech, the Netherlands | 2005

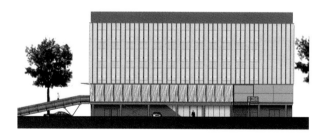

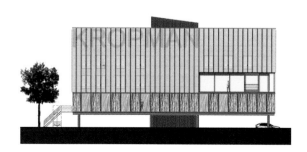

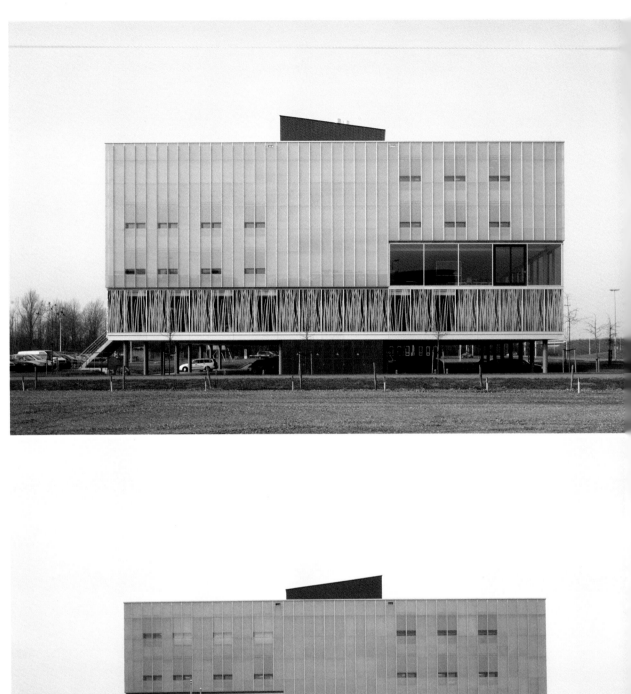
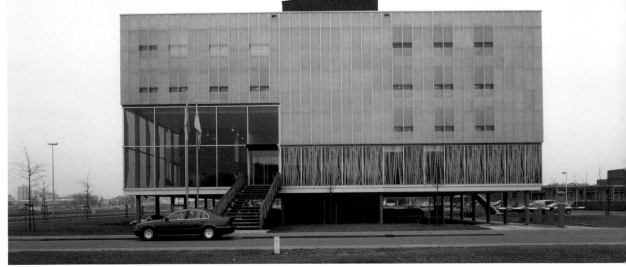

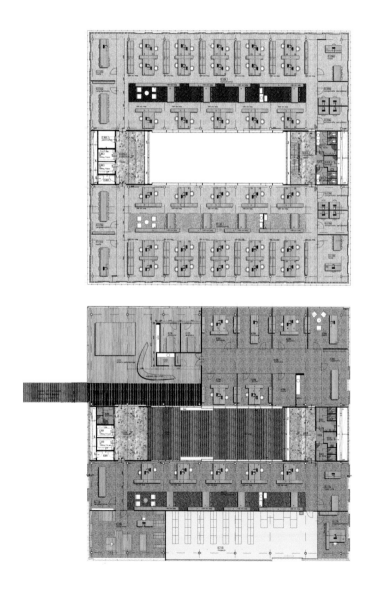

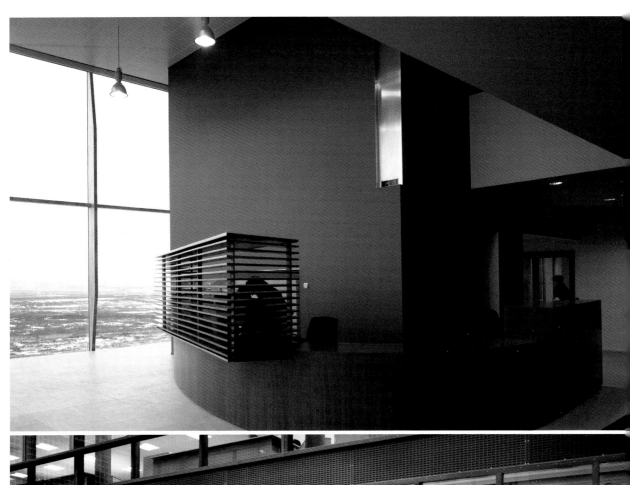

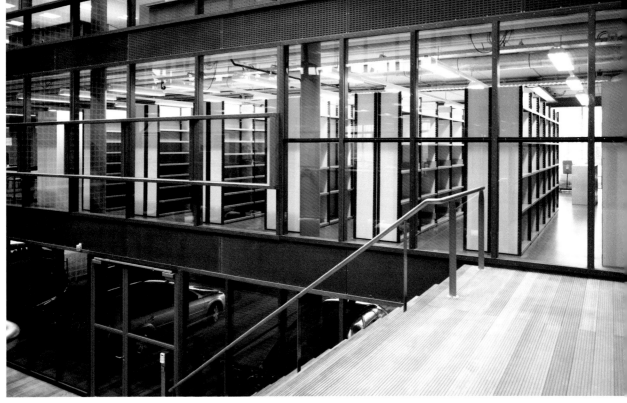

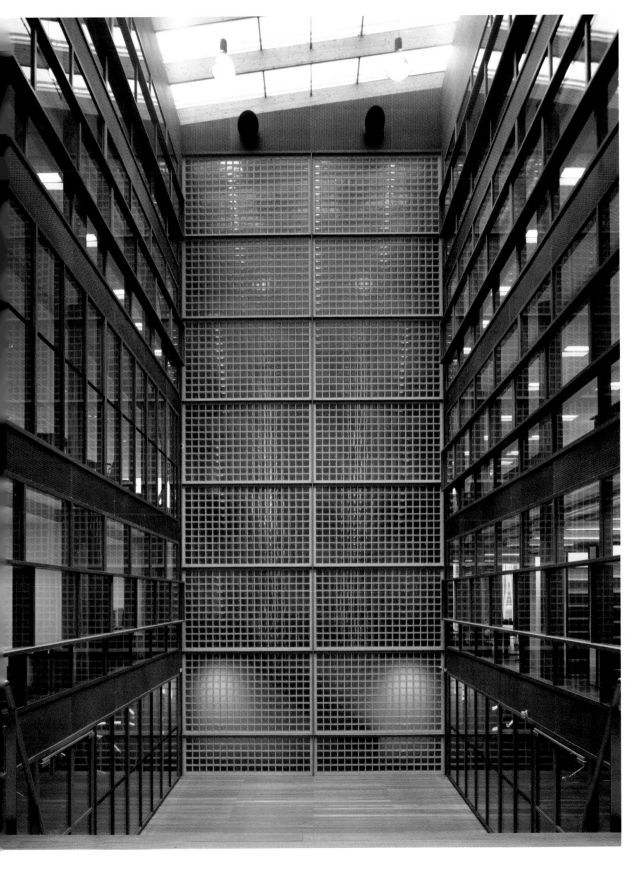

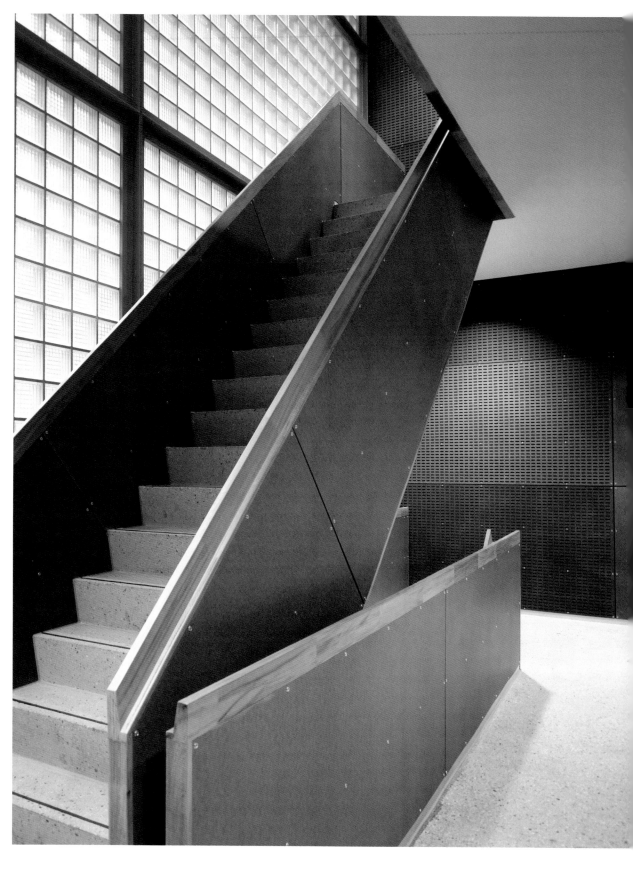

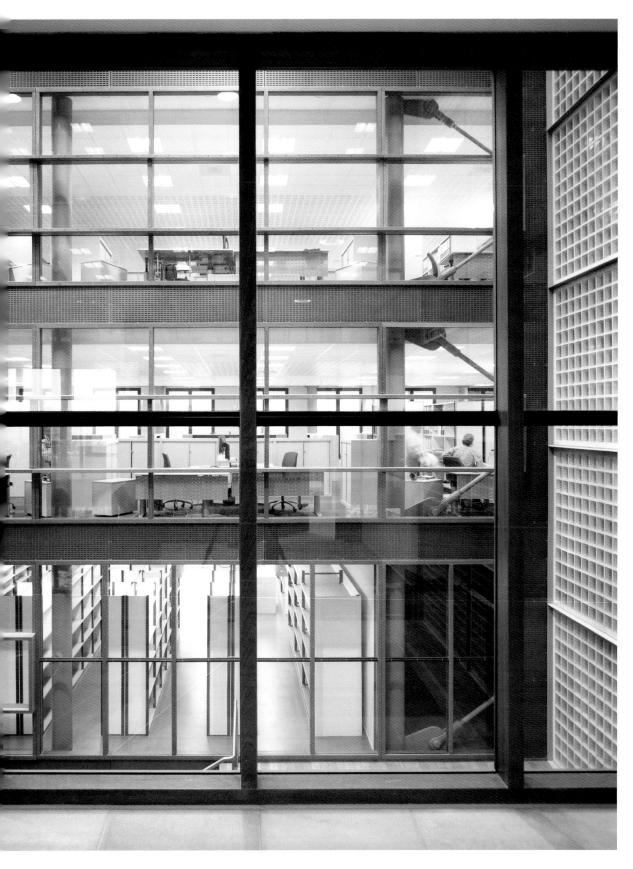

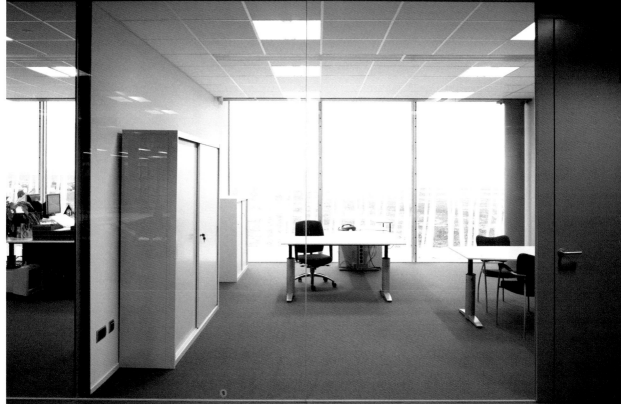

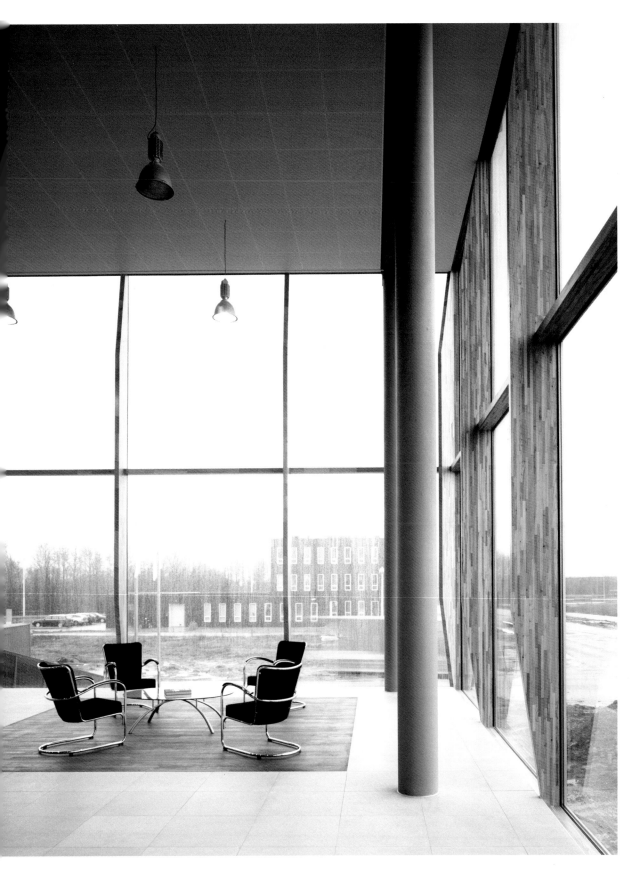

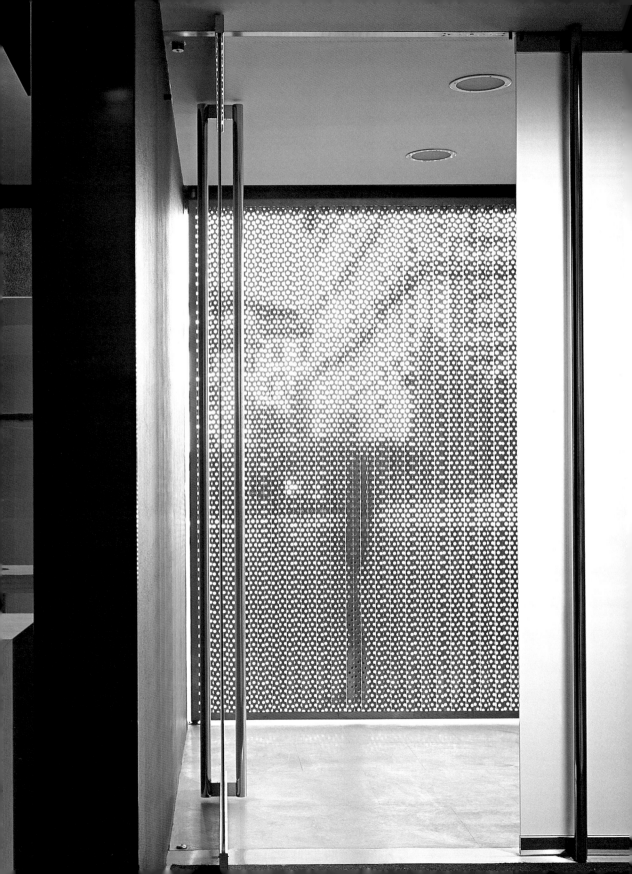

BURATTI + BATTISTON ARCHITECTS | MILAN
UNIONE DEGLI INDUSTRIALI DELLA PROVINCIA DI BERGAMO
Bergamo, Italy | 2004

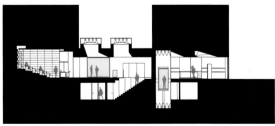

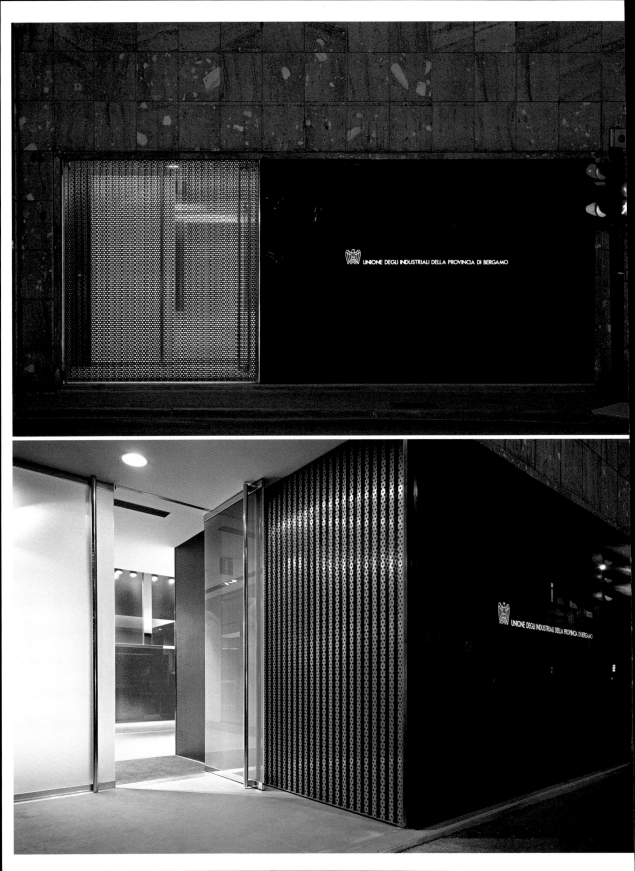

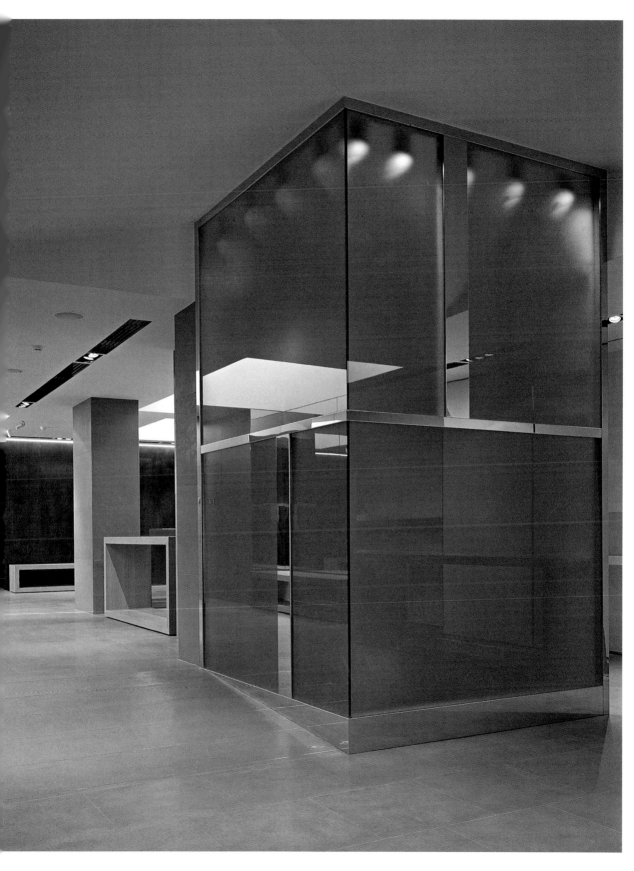

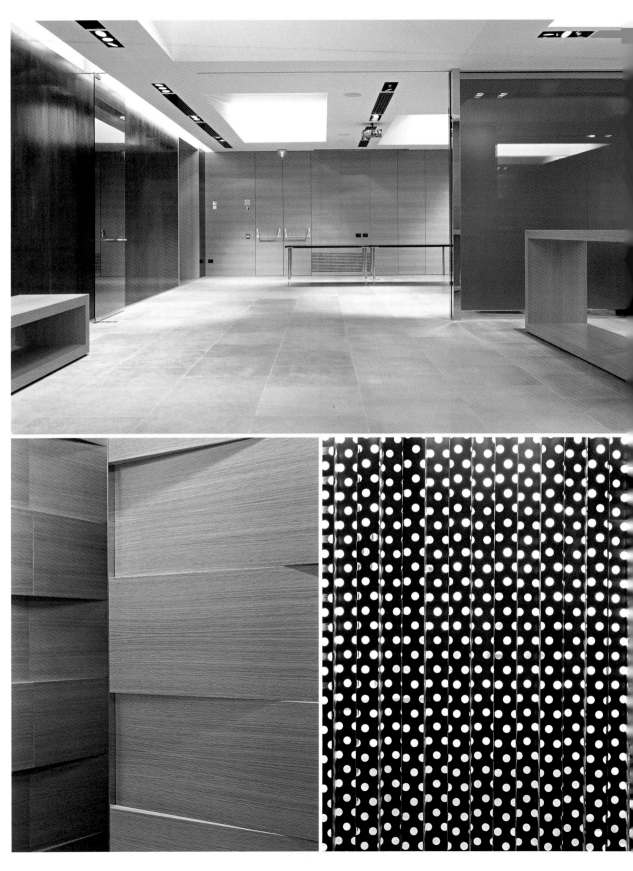

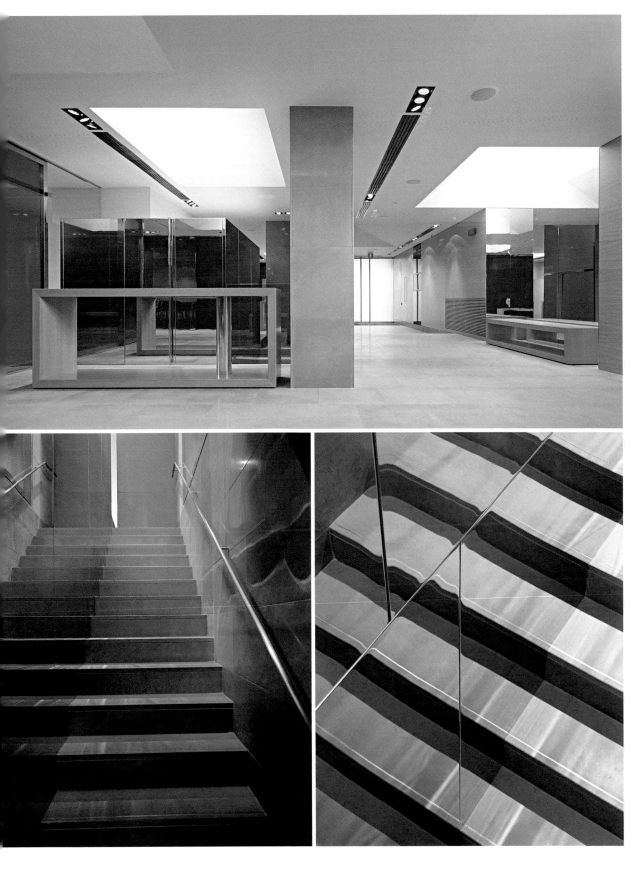

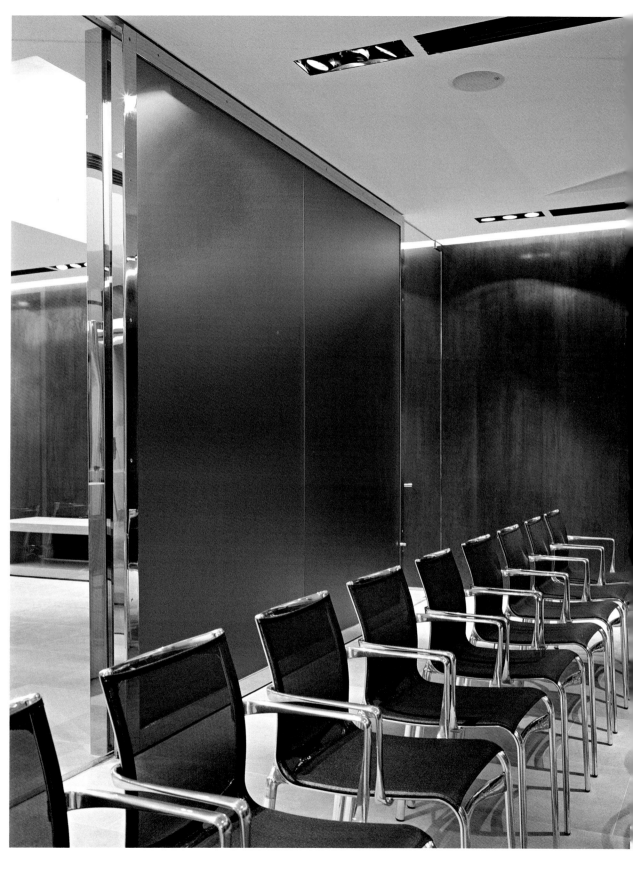

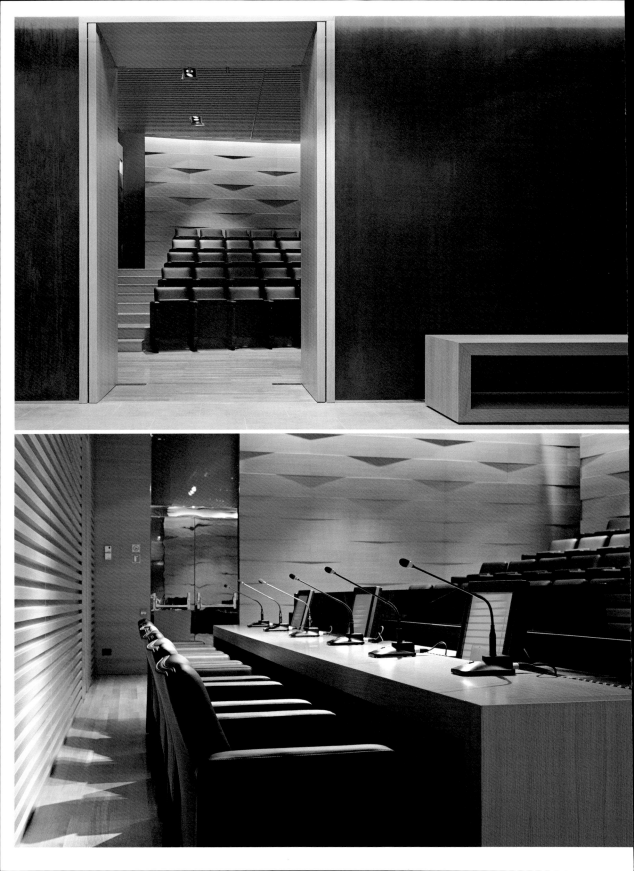

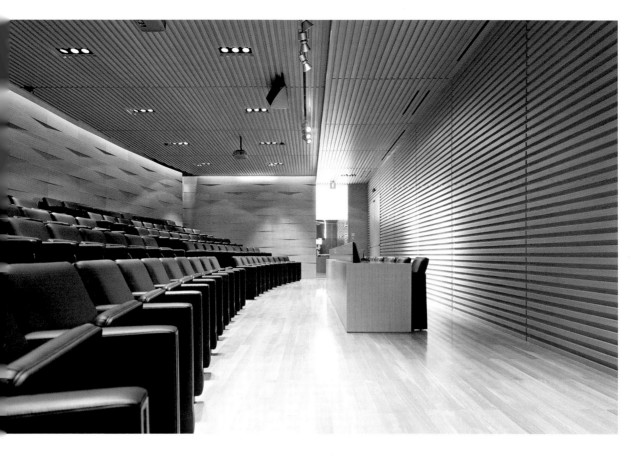

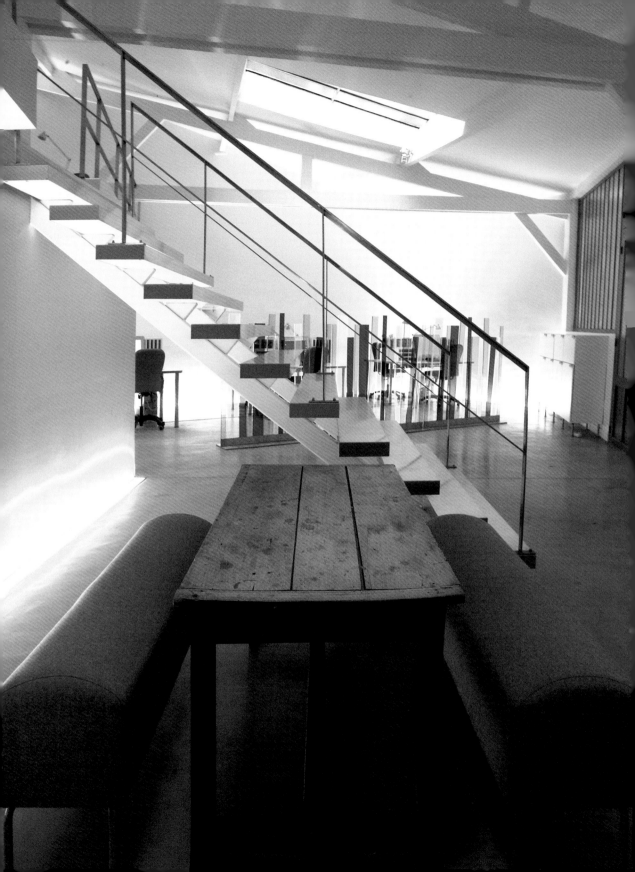

CHEEEEESE | **PARIS**
CHEEEEESE
Paris, France | 2005

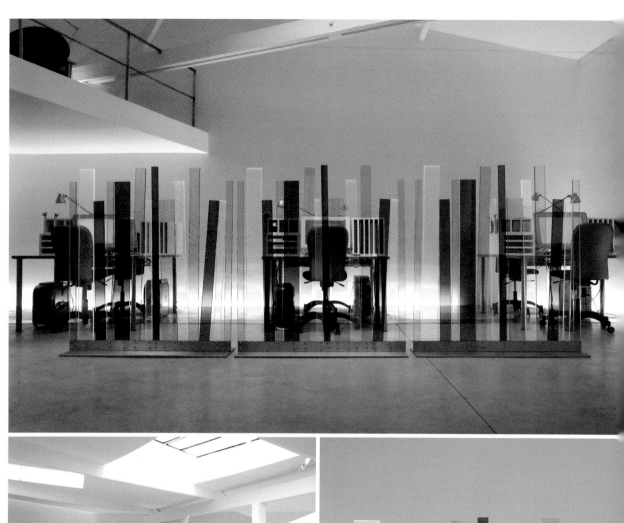

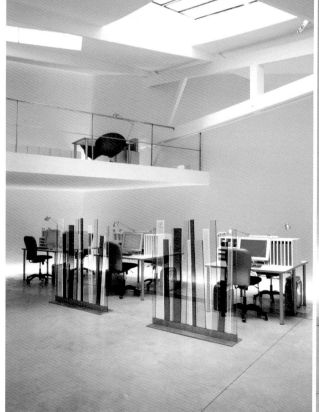

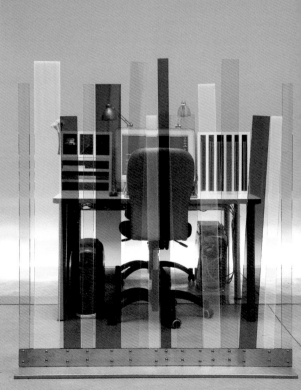

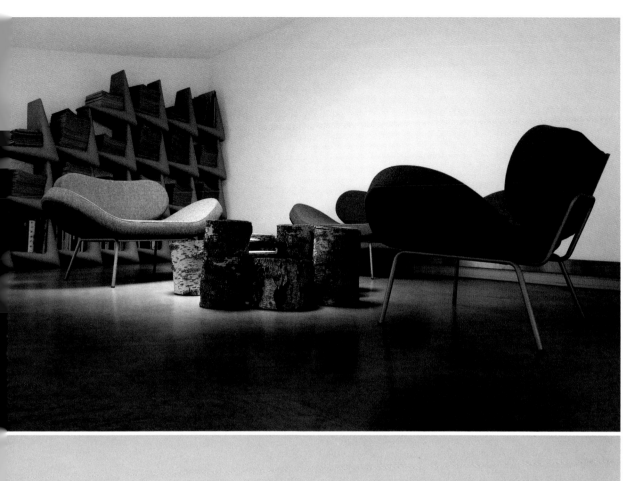

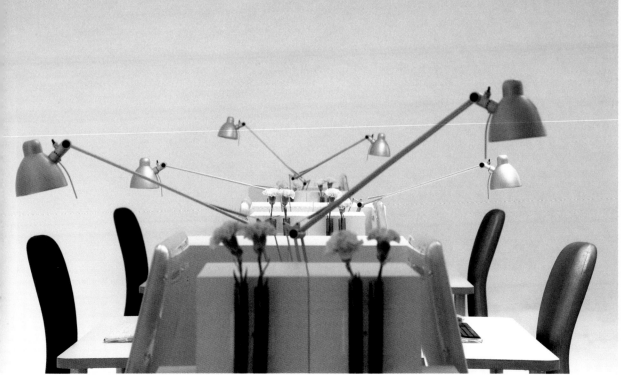

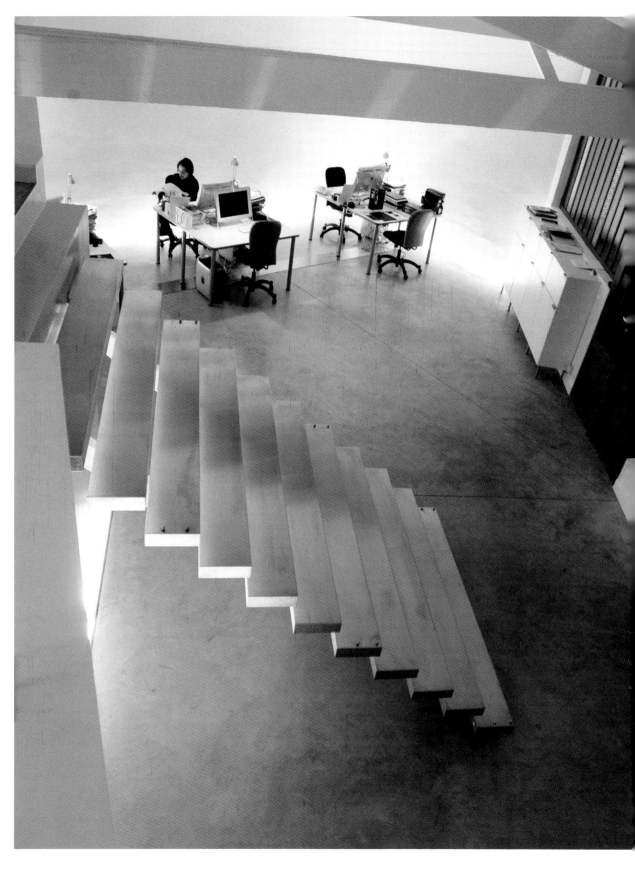

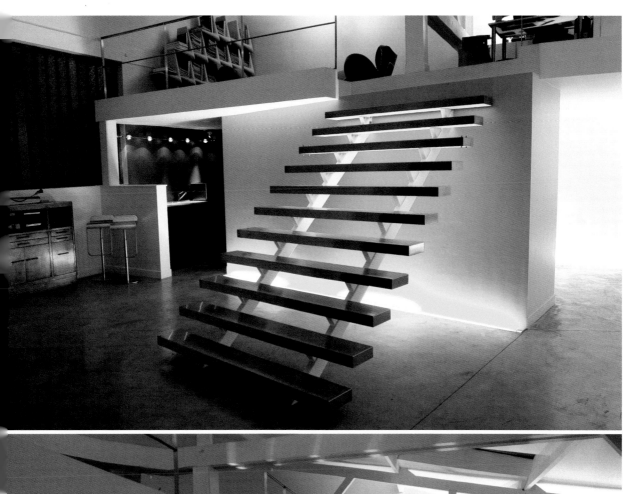
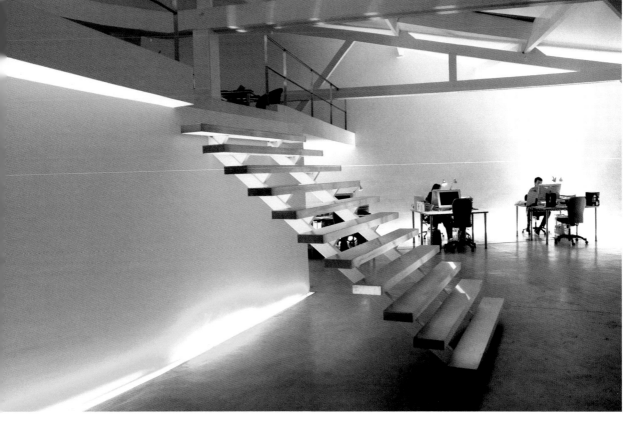

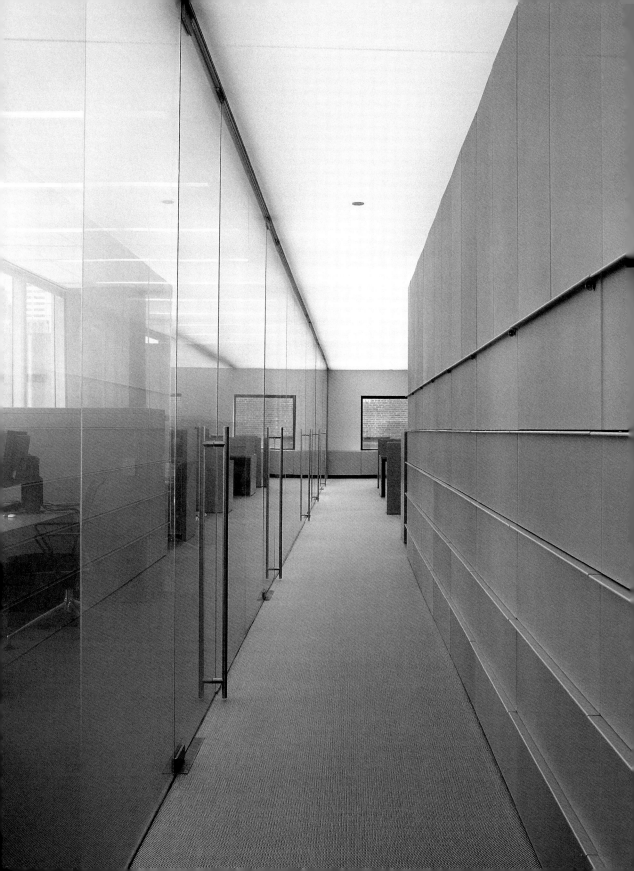

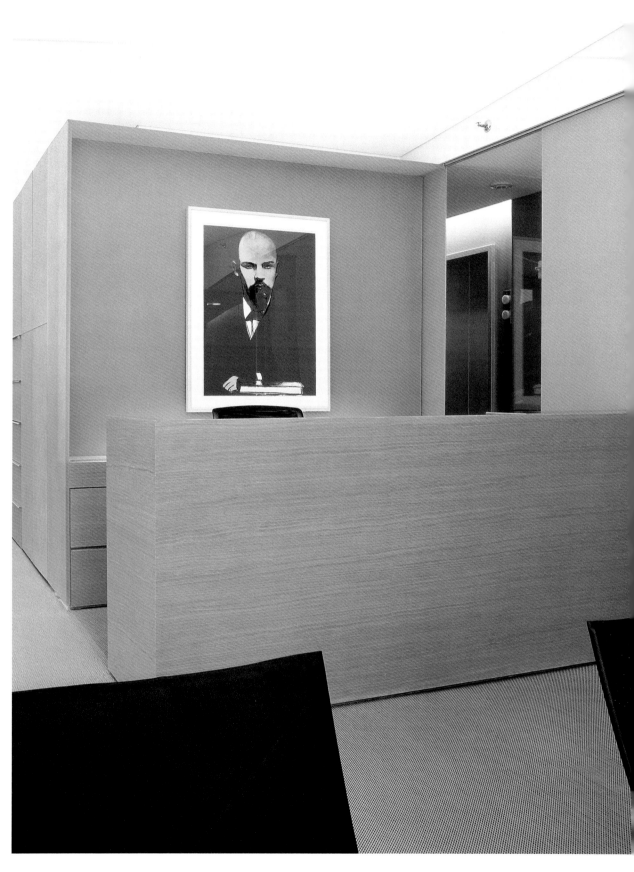

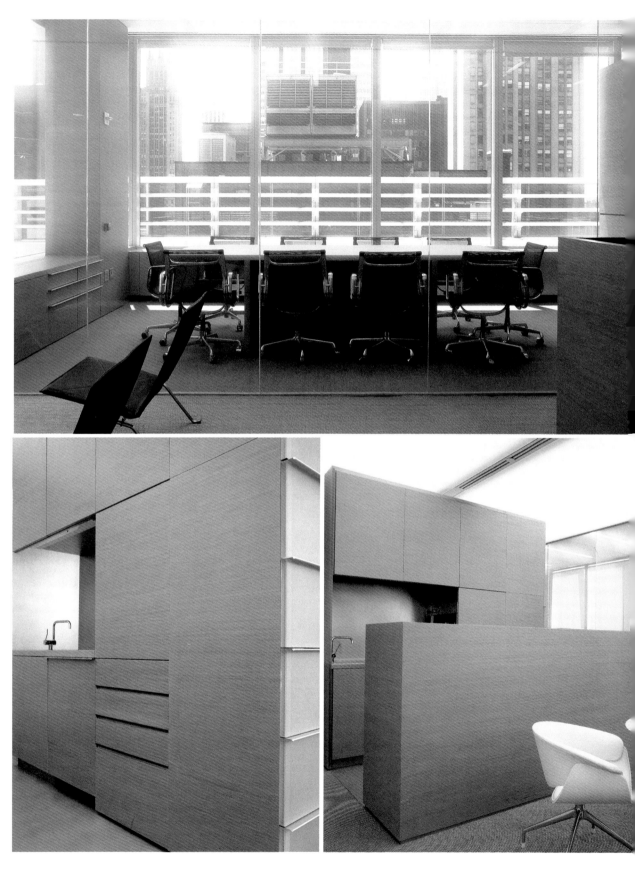

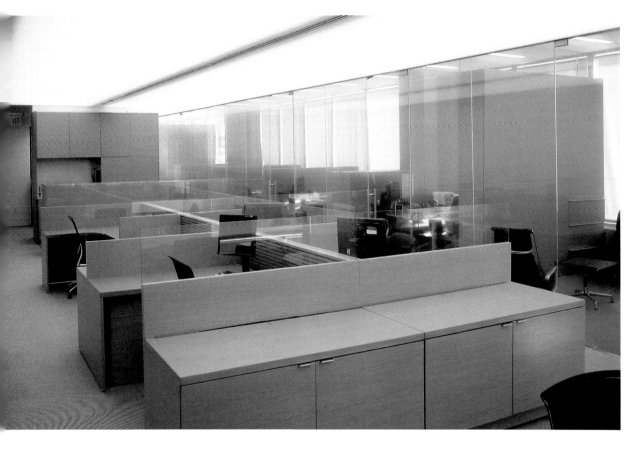

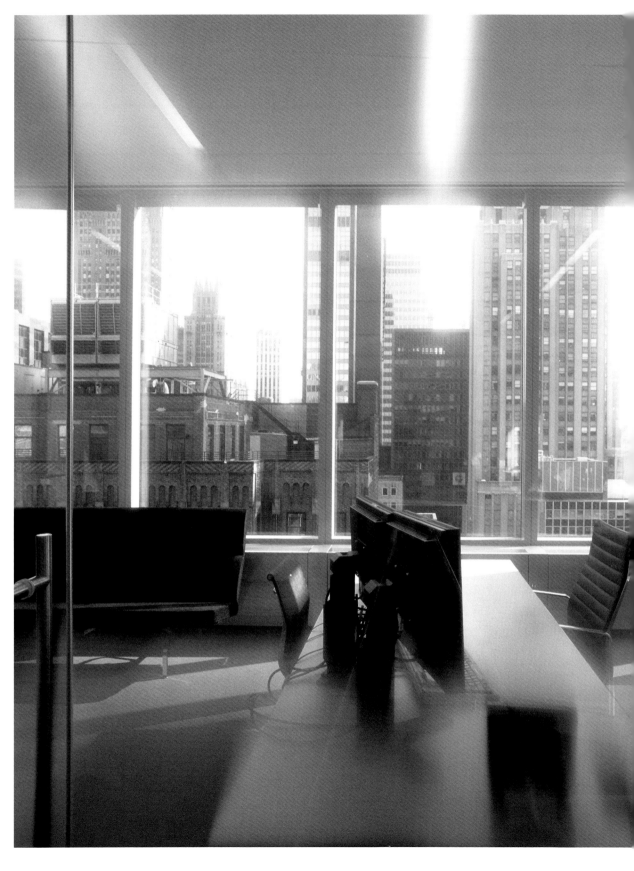

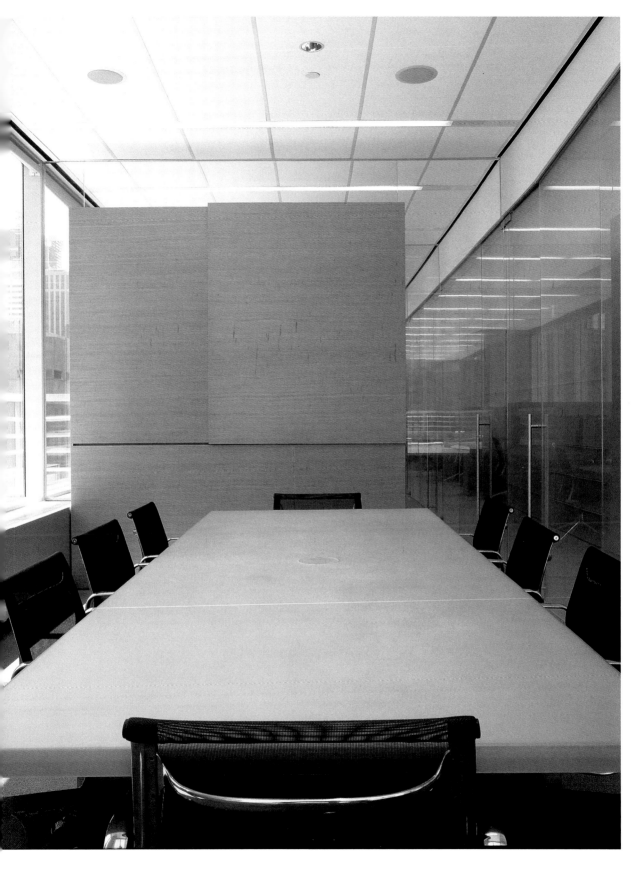

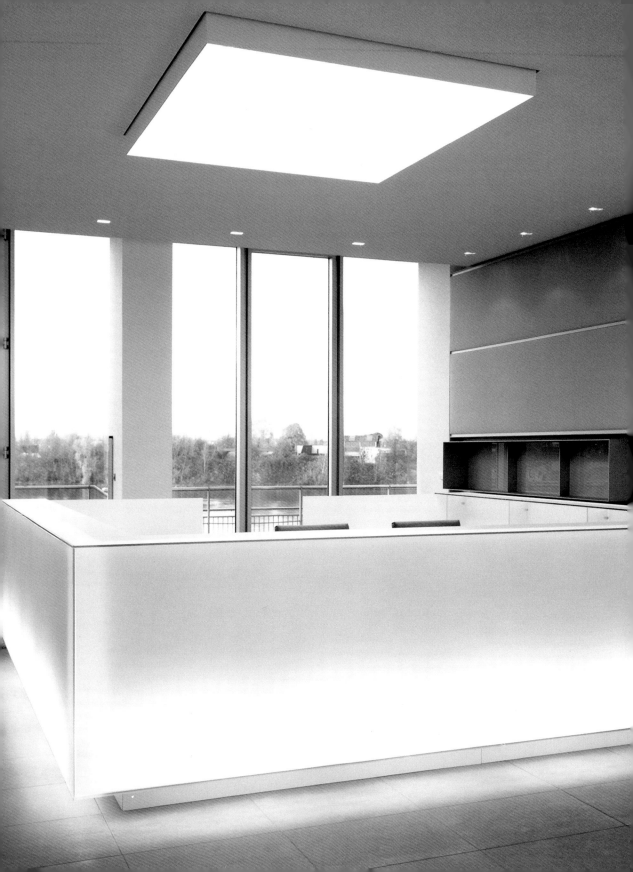

COSSMANN DE BRUYN | DÜSSELDORF
A.T. KEARNEY
Düsseldorf, Germany | 2004

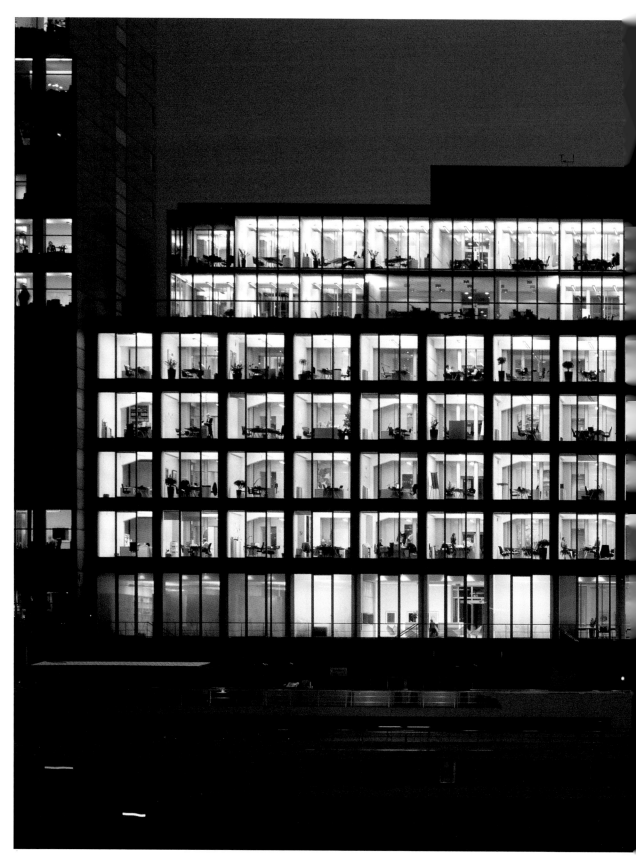

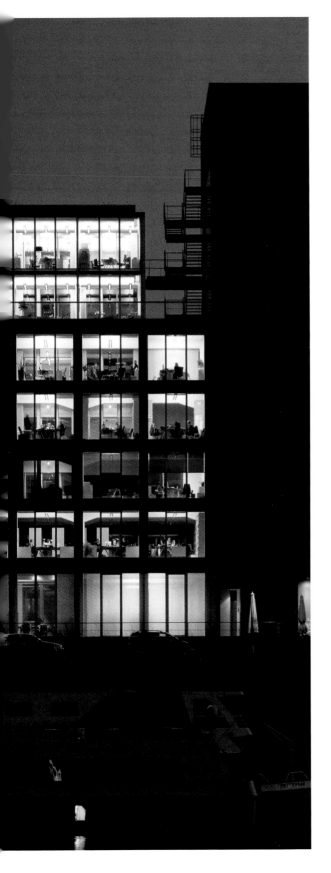

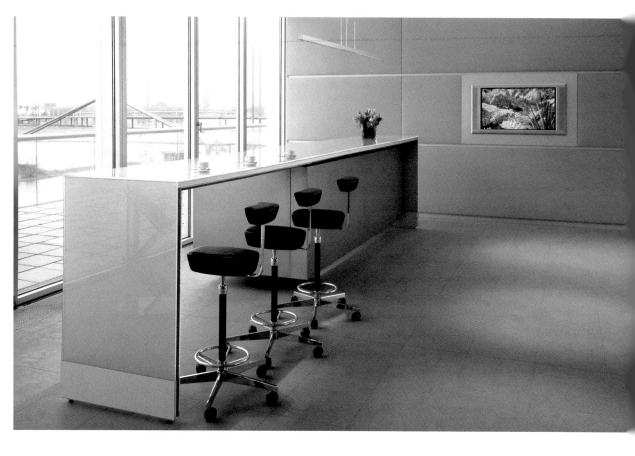

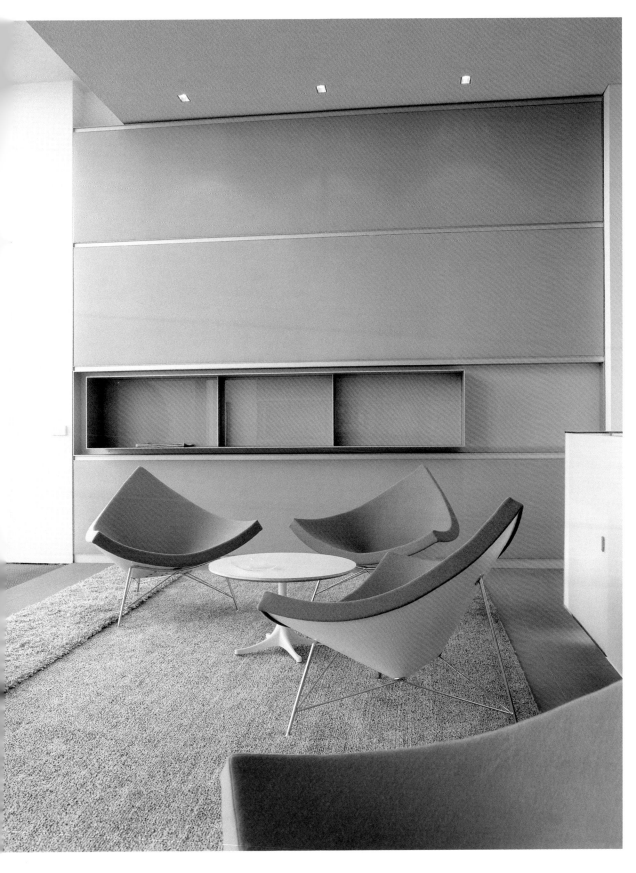

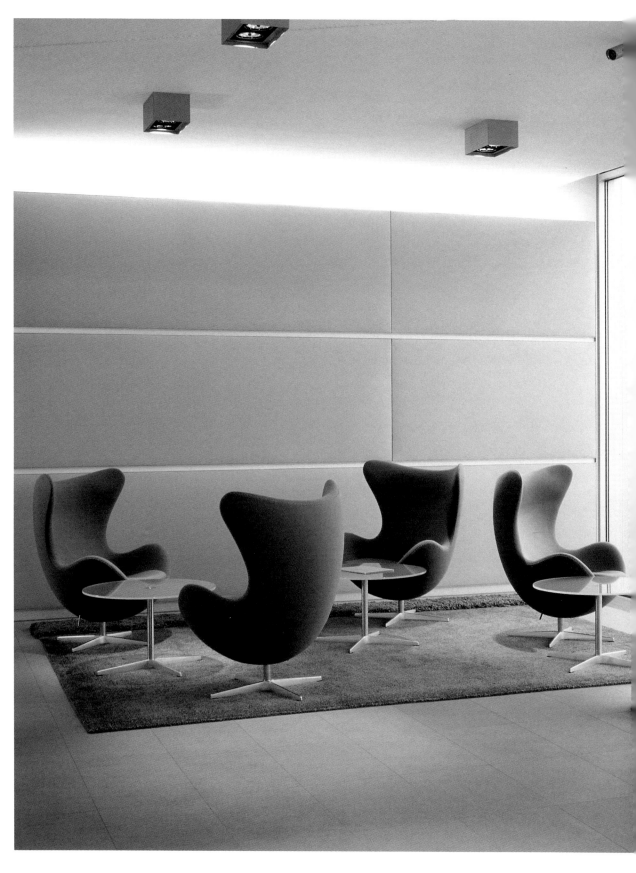

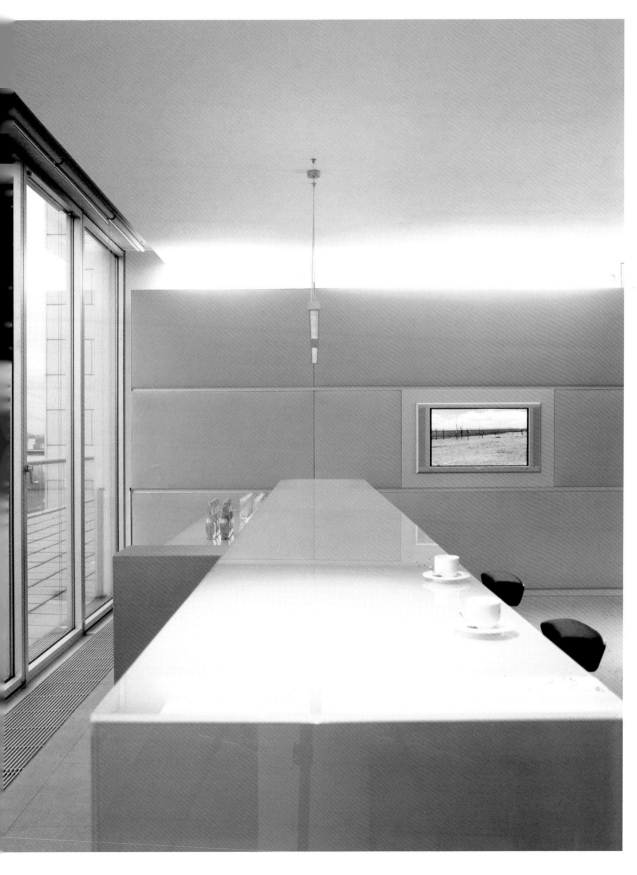

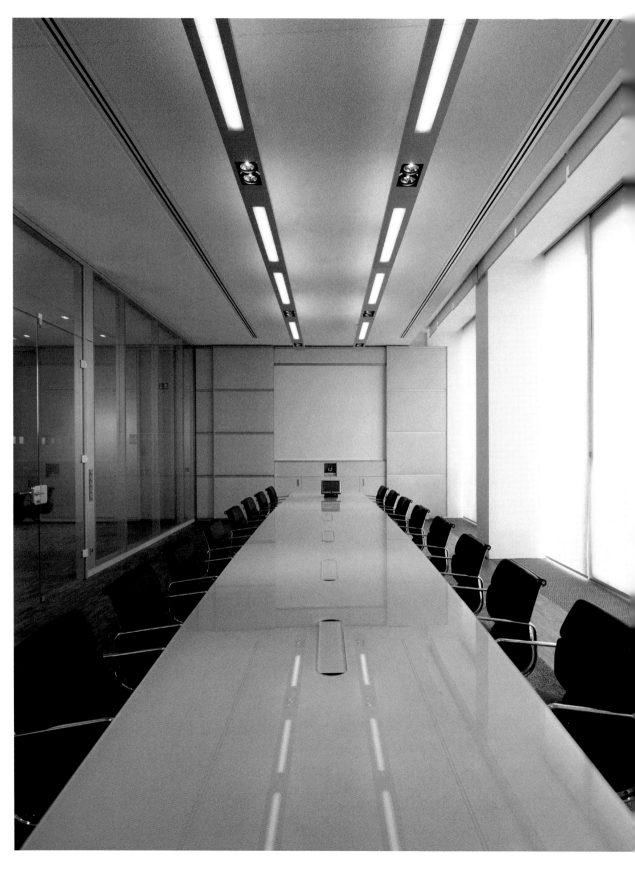

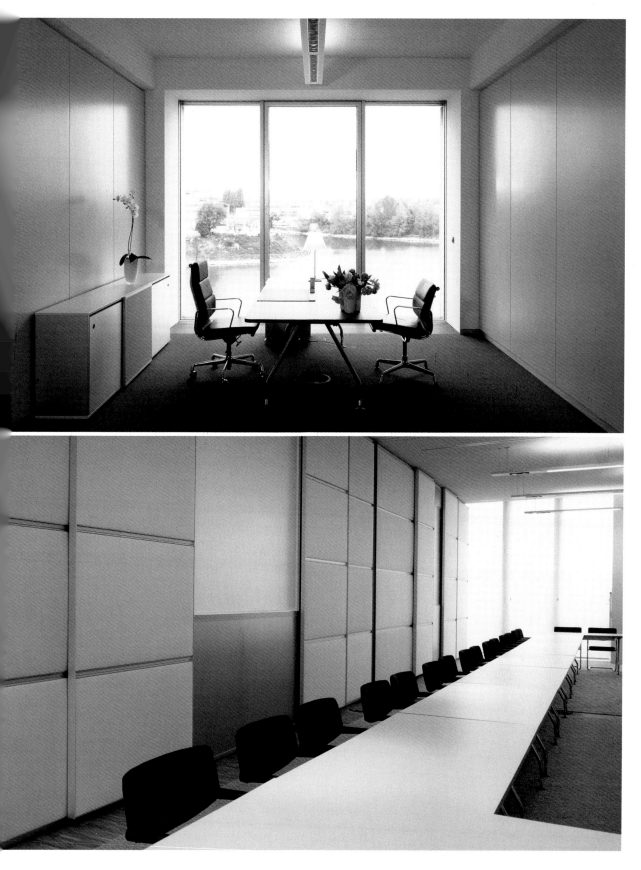

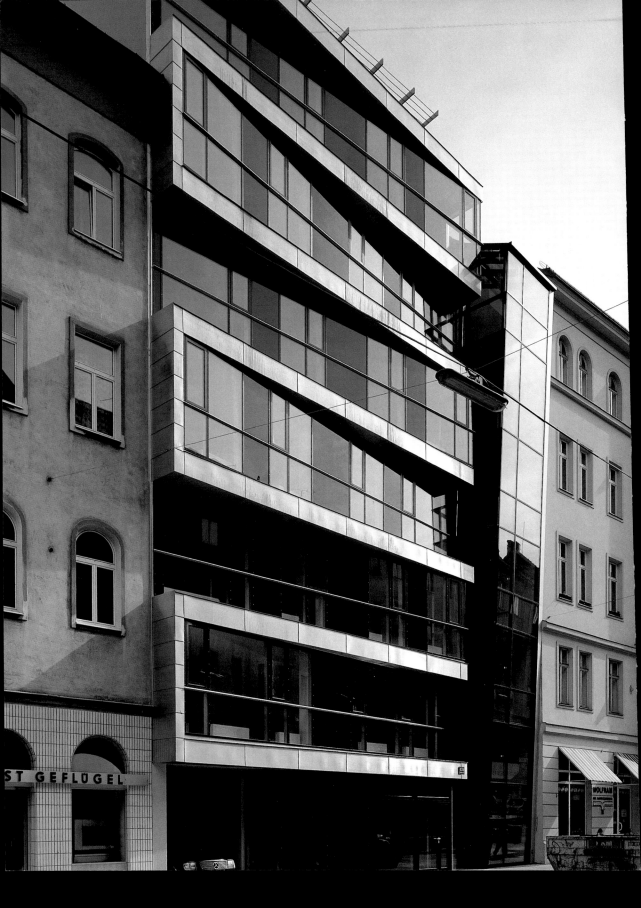

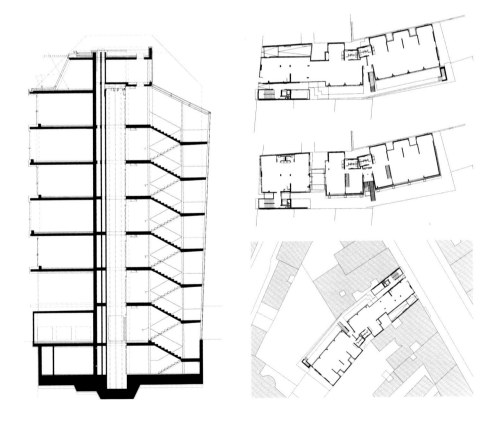

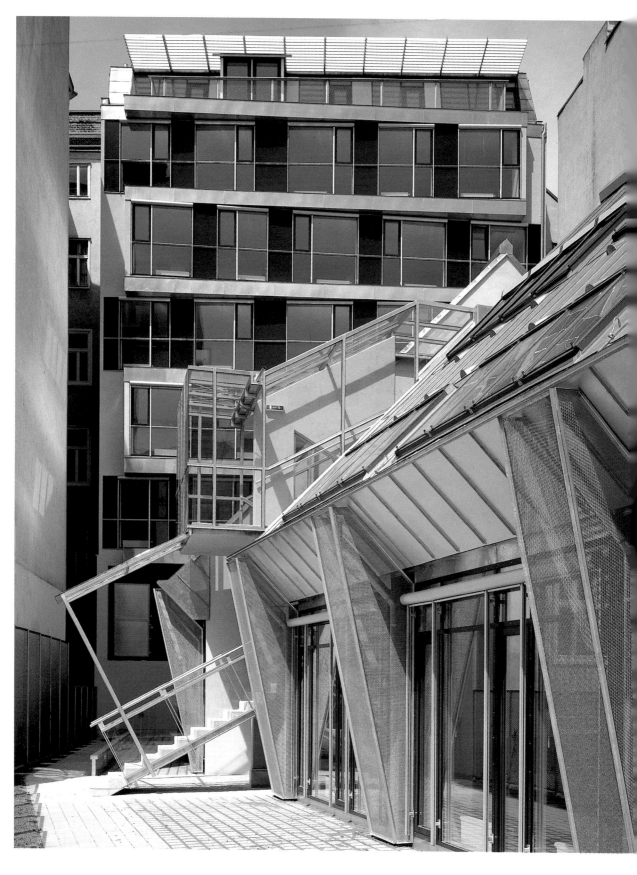

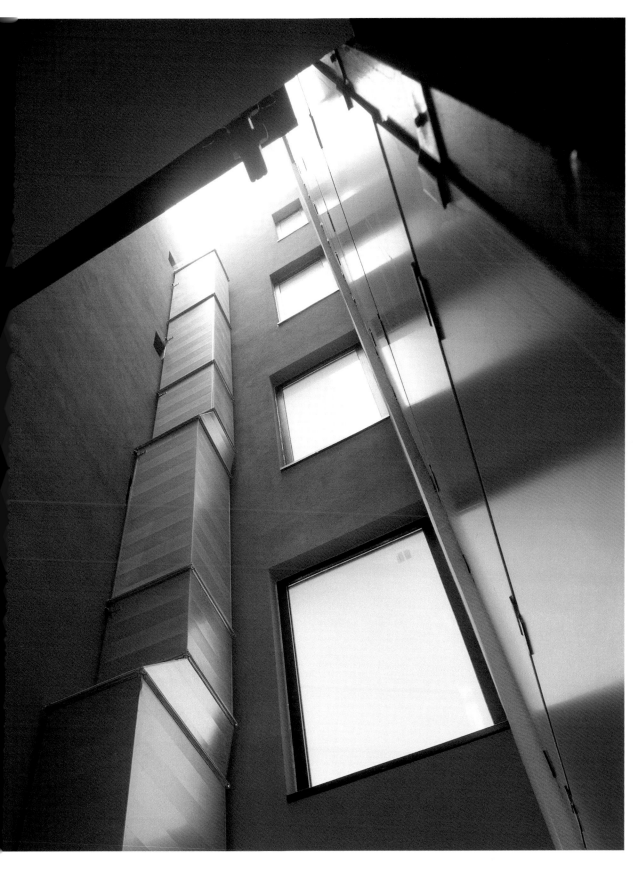

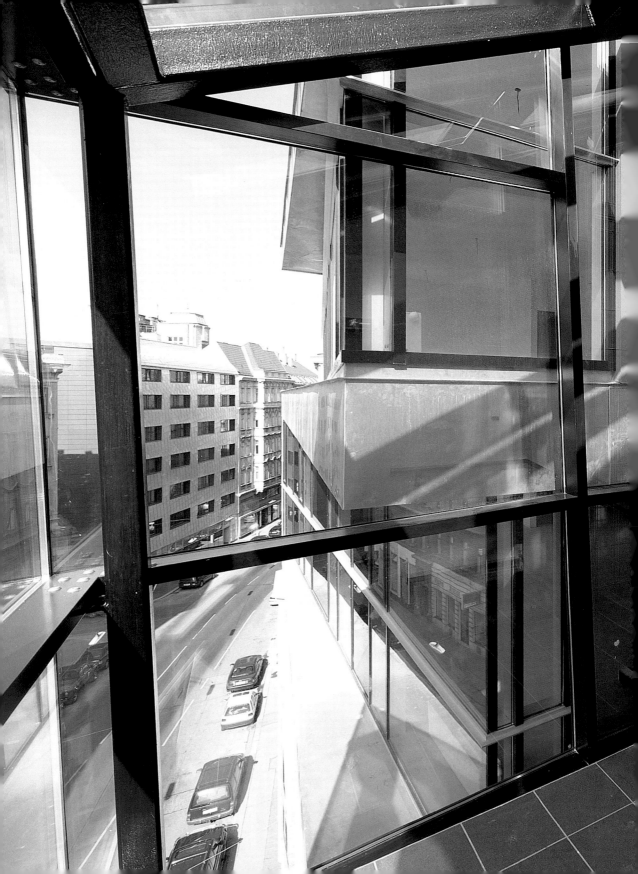

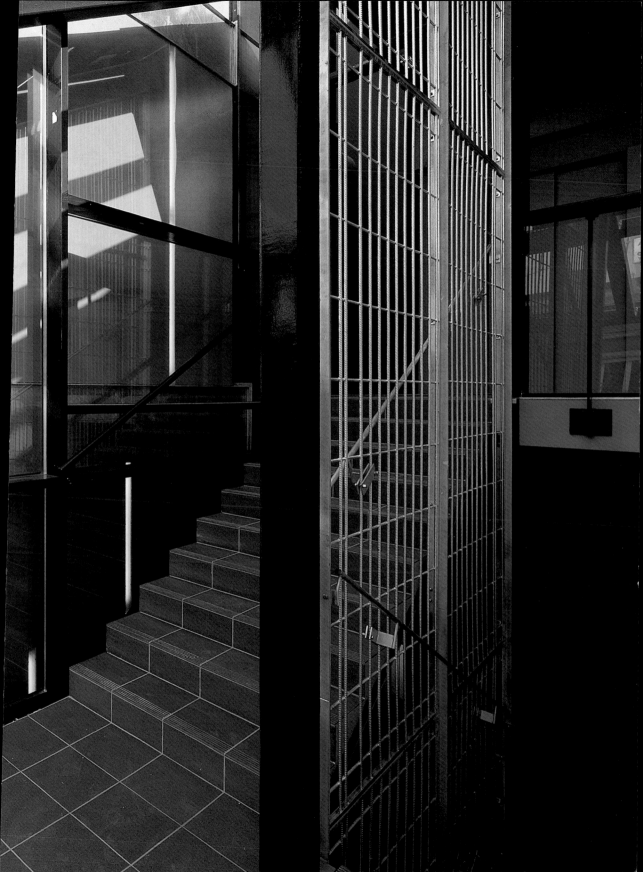

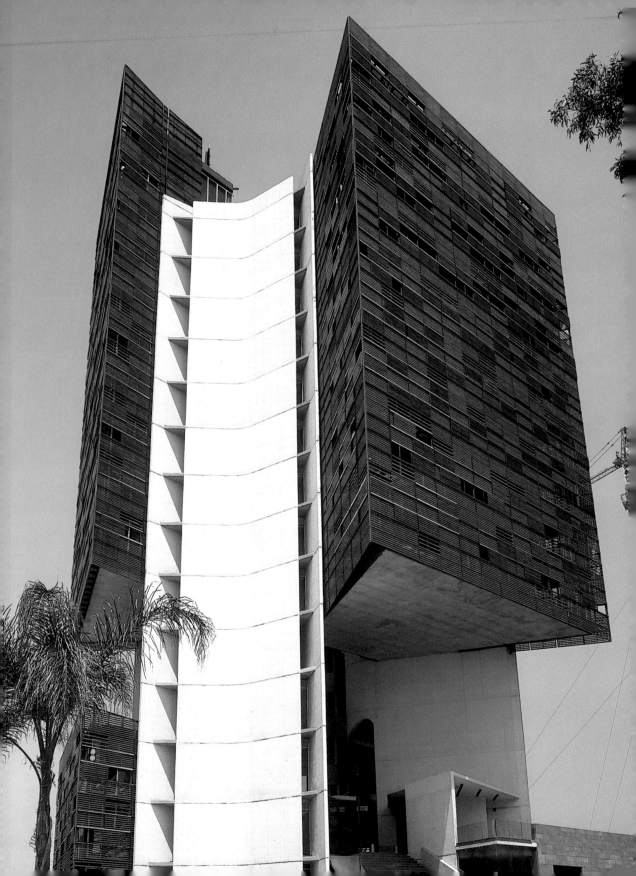

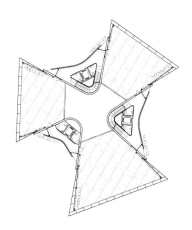

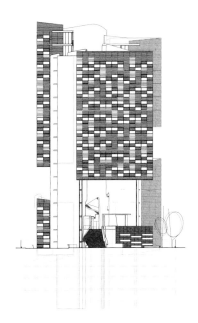

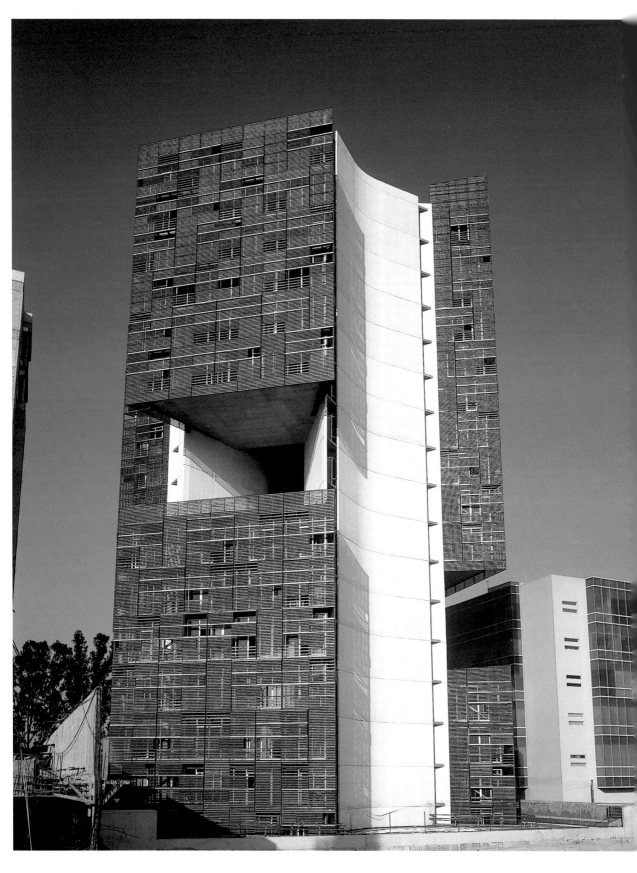

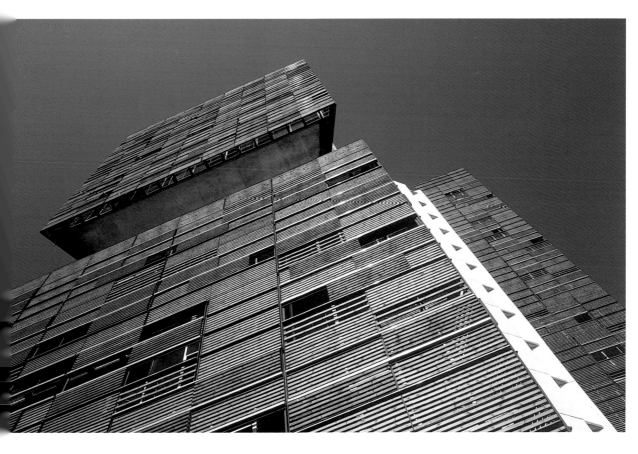

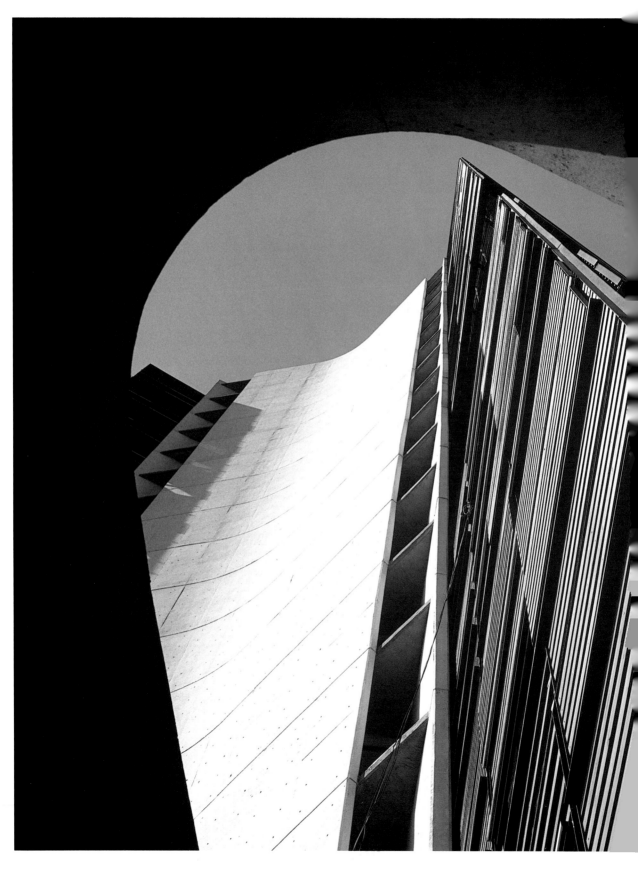

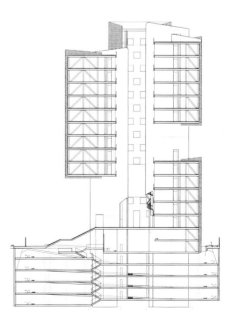

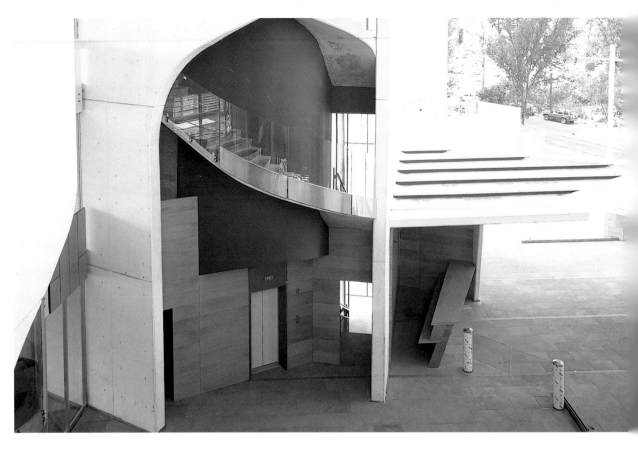

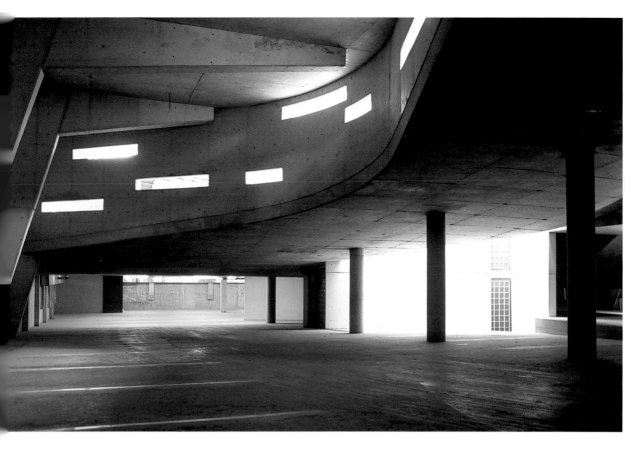

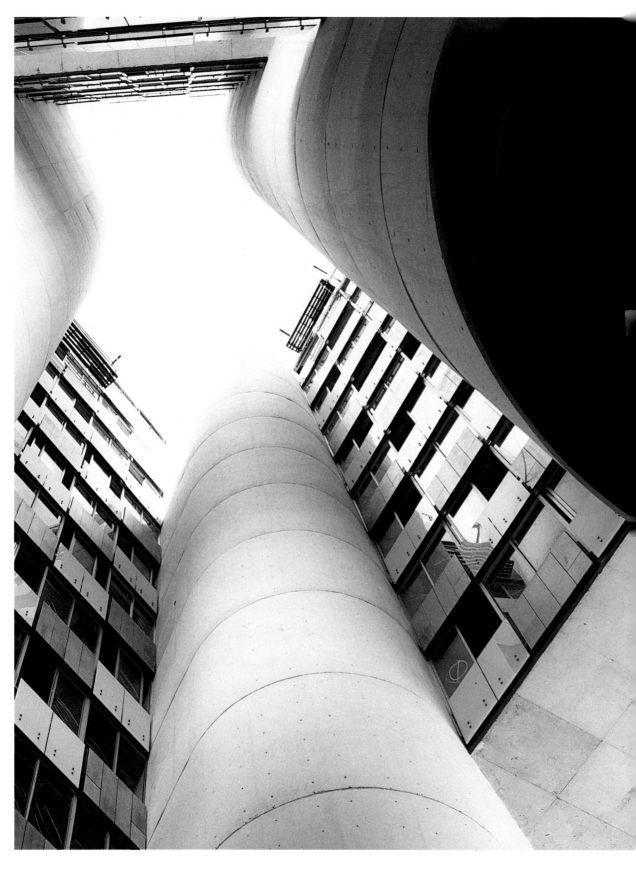

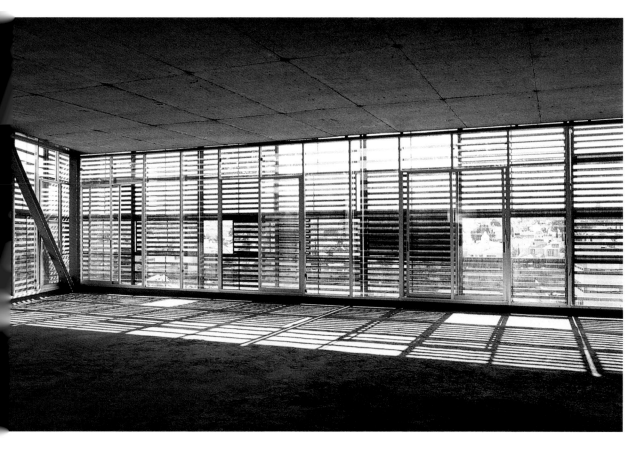

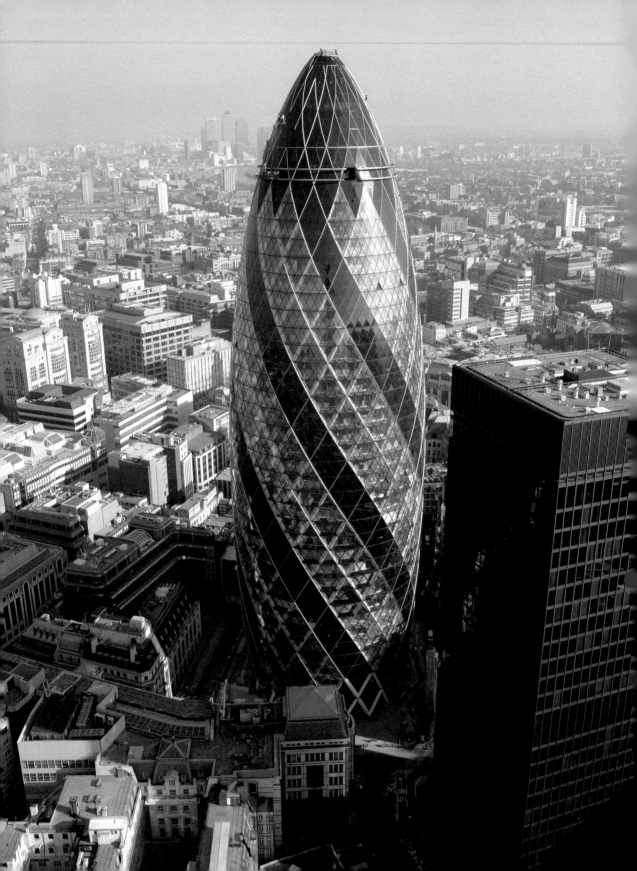

FOSTER AND PARTNERS | LONDON
30 ST MARY AXE
London, United Kingdom | 2004

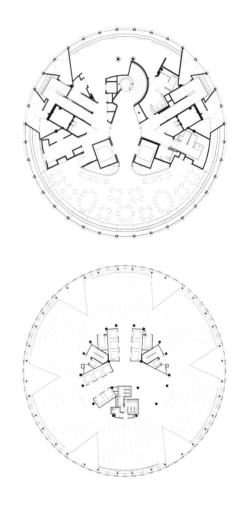

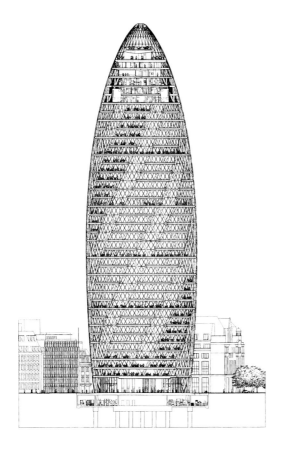

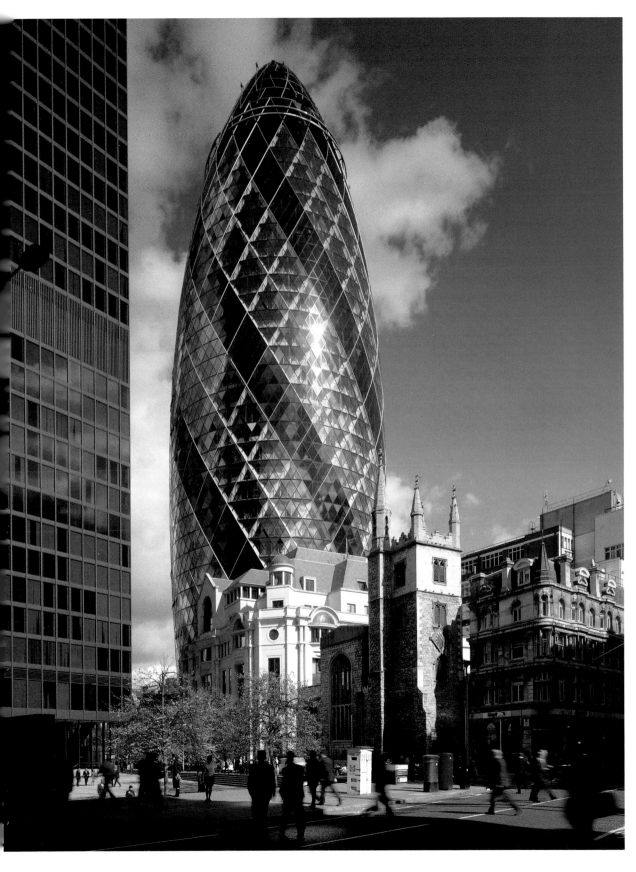

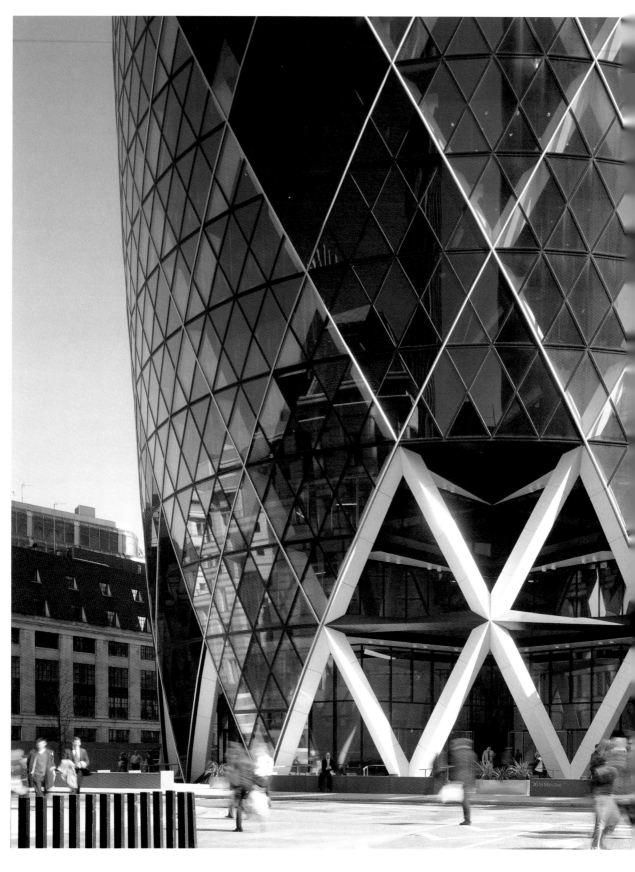

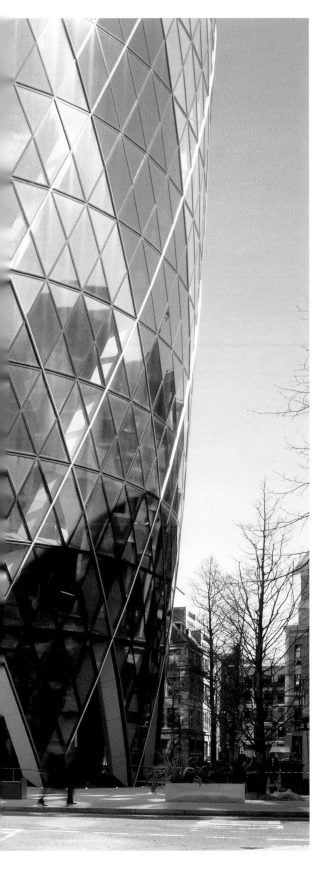

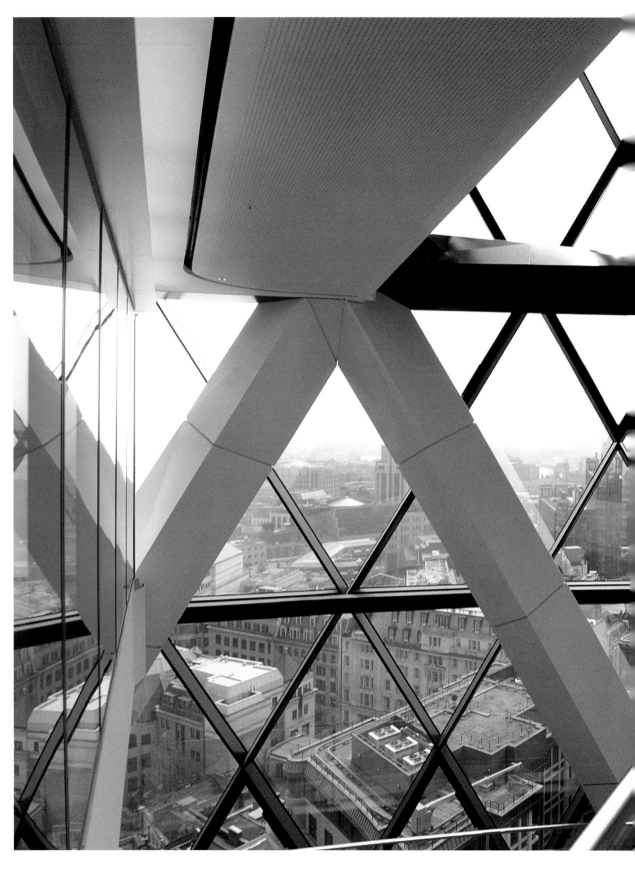

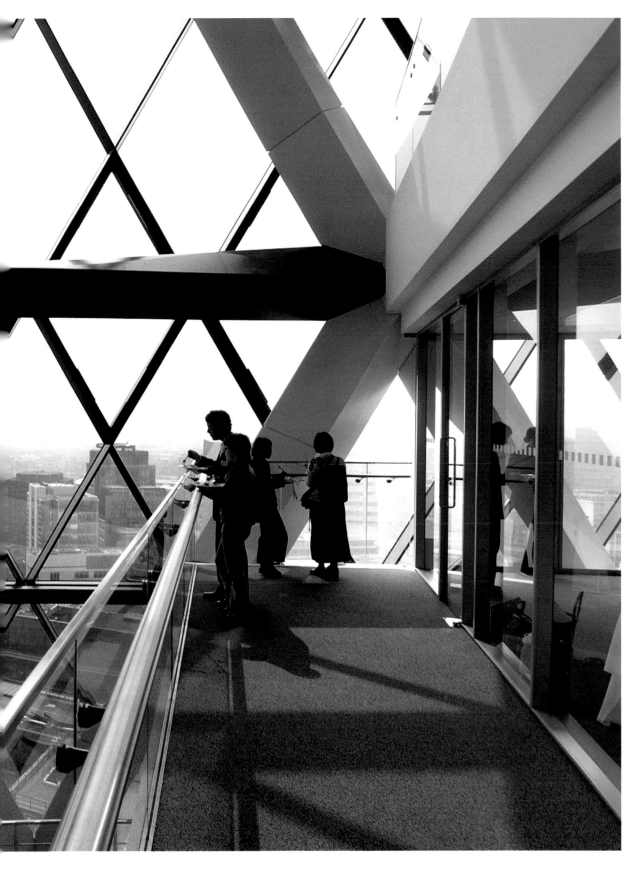

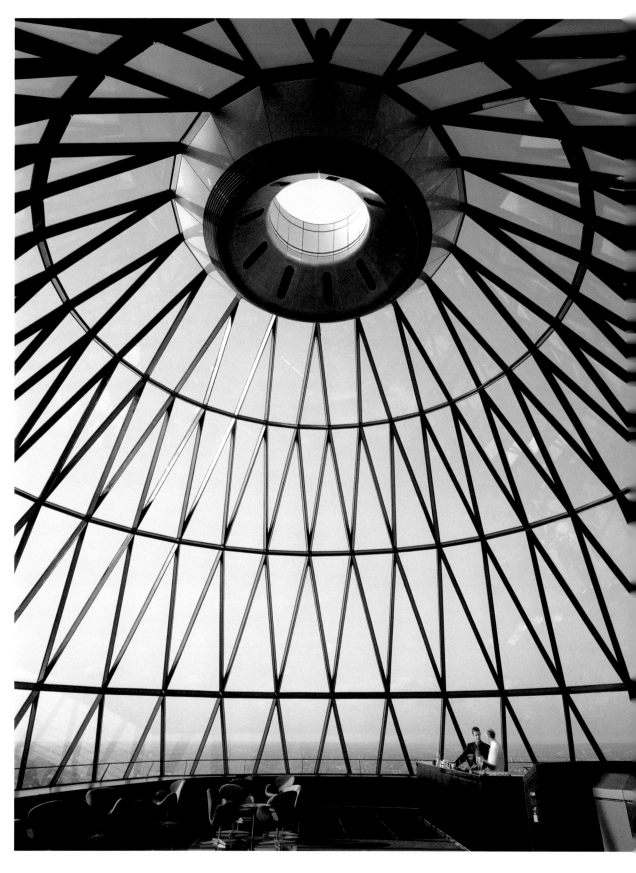

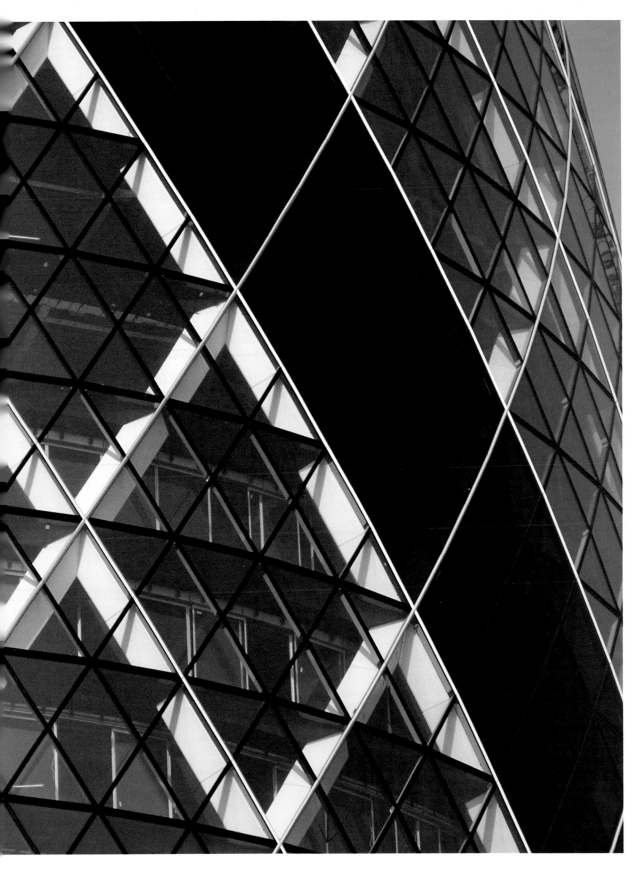

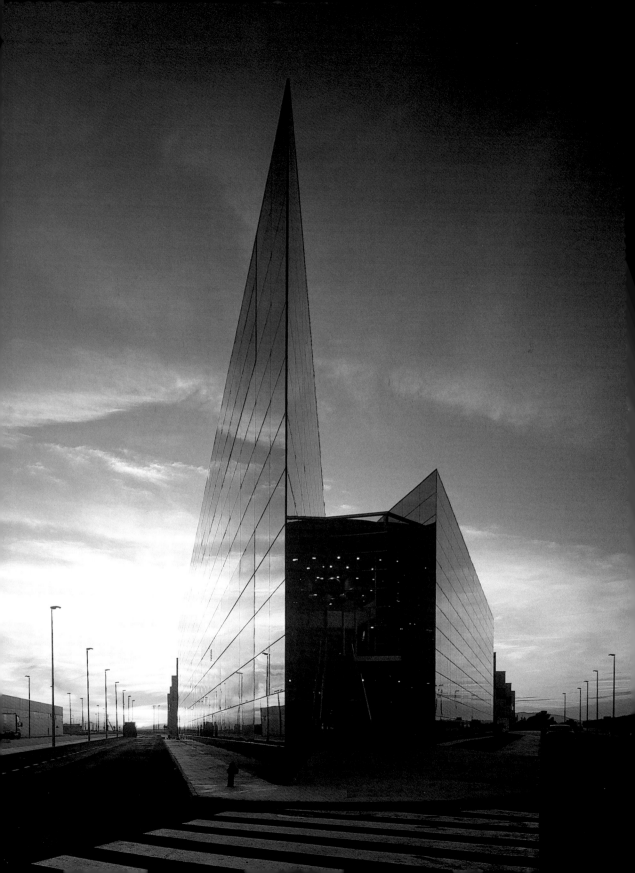

FRANCISCO CAVAS | MURCIA
POLARIS
Murcia, Spain | 2004

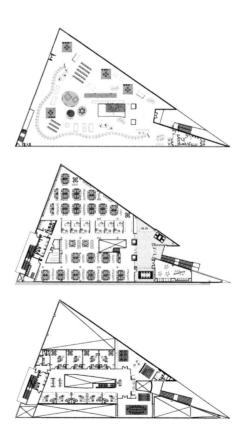

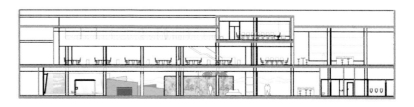

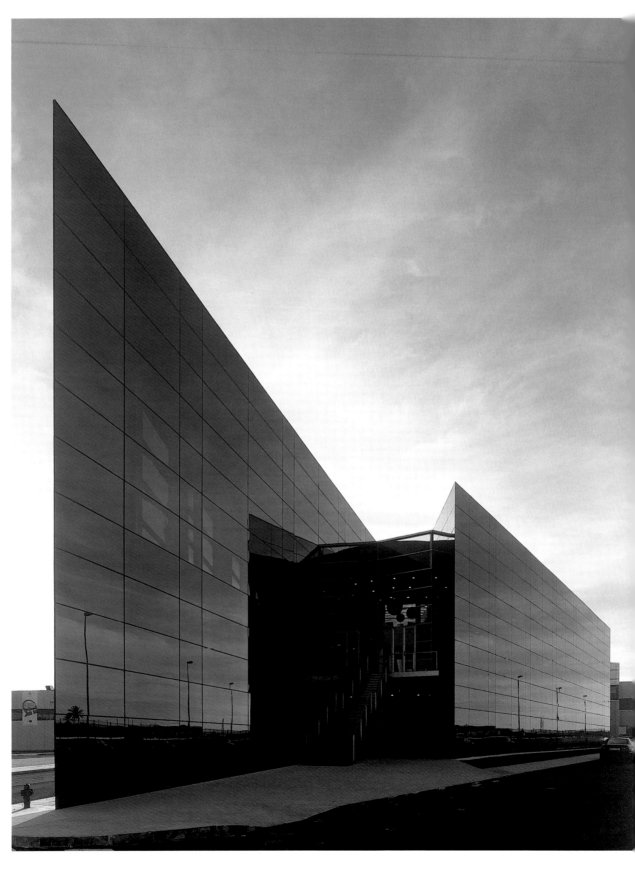

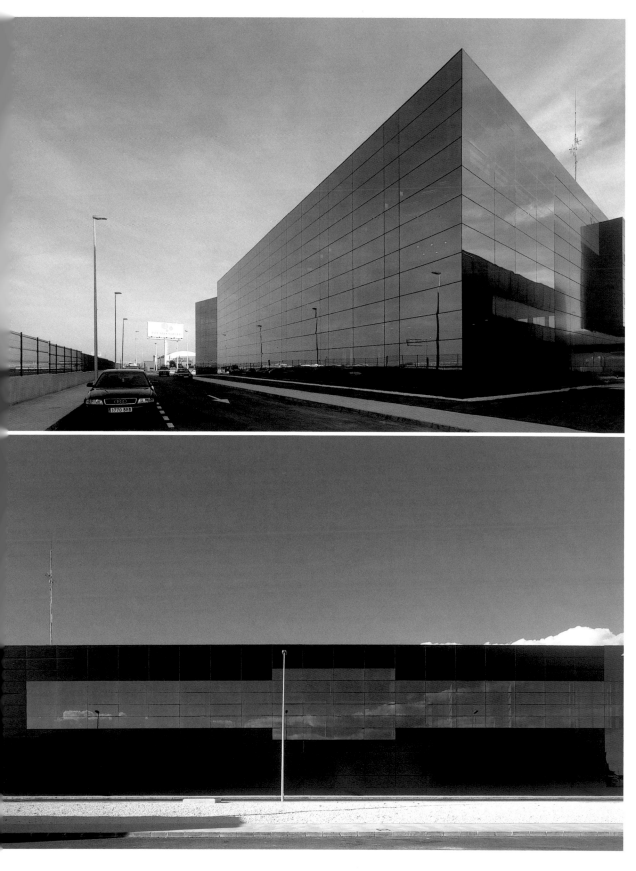

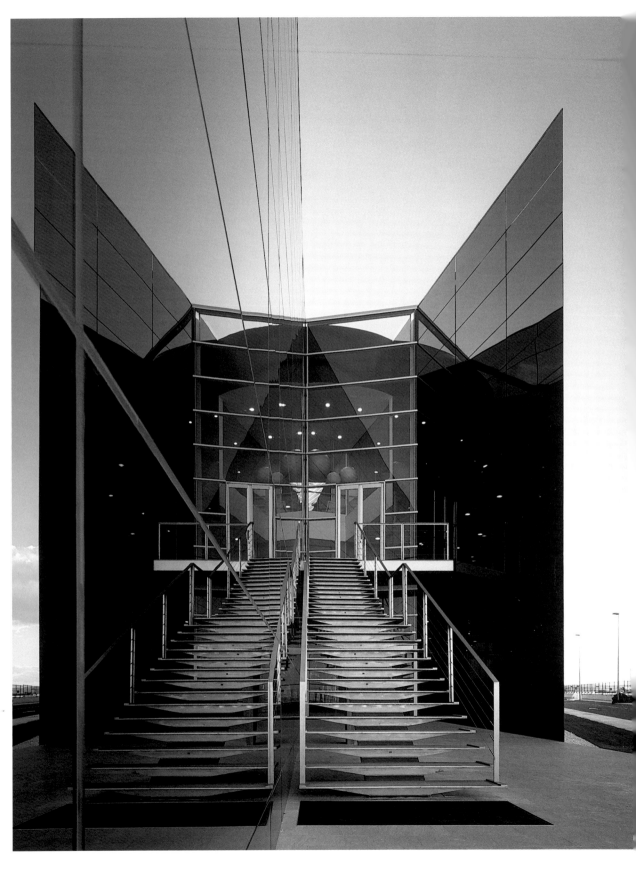

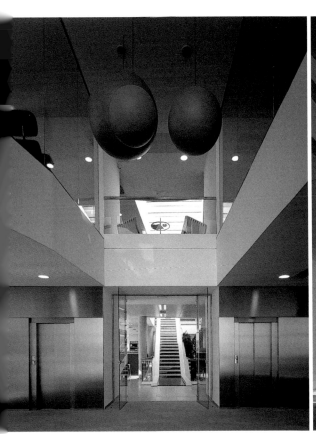
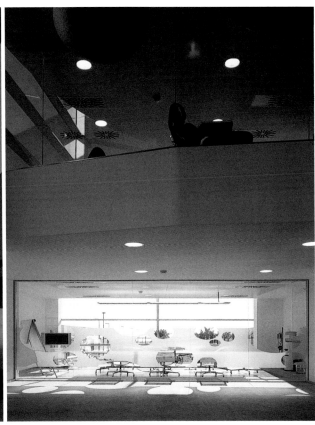

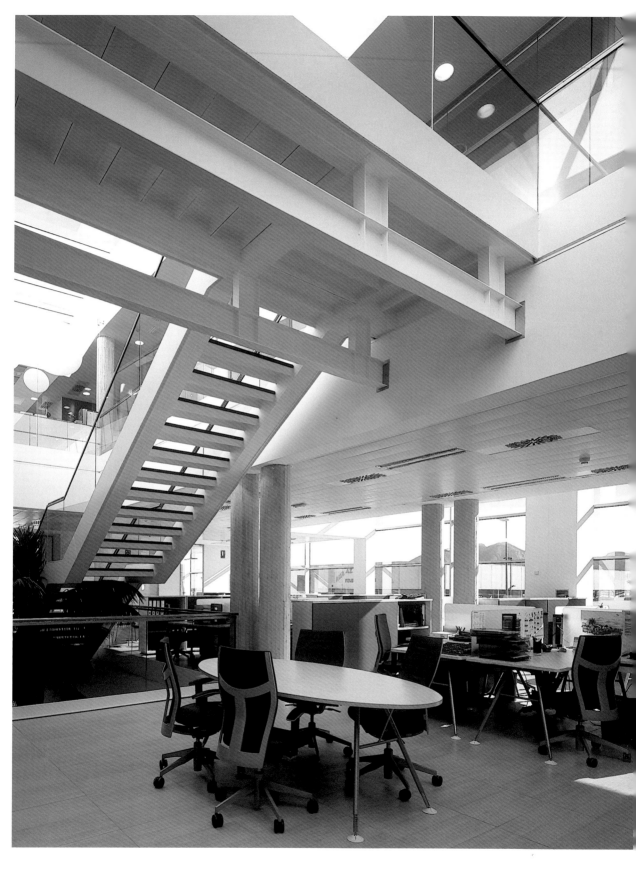

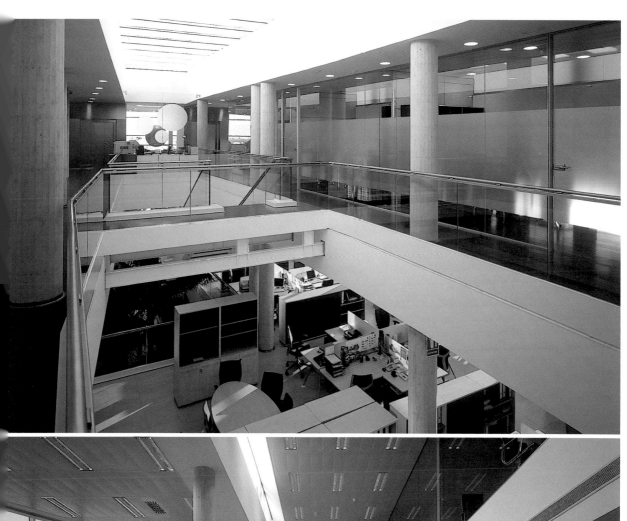
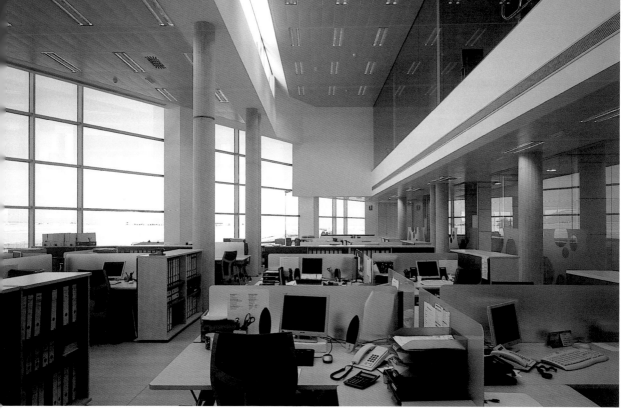

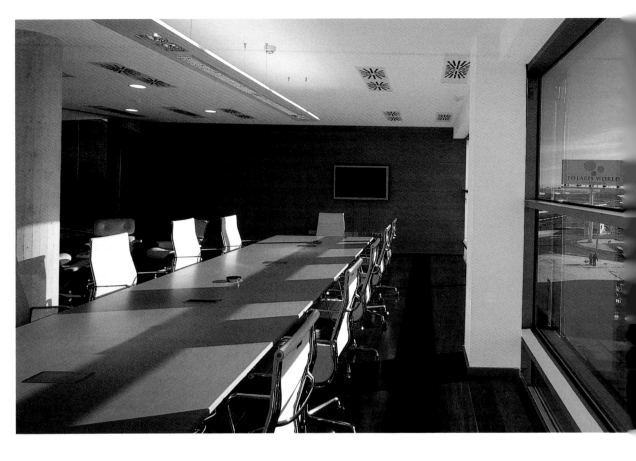

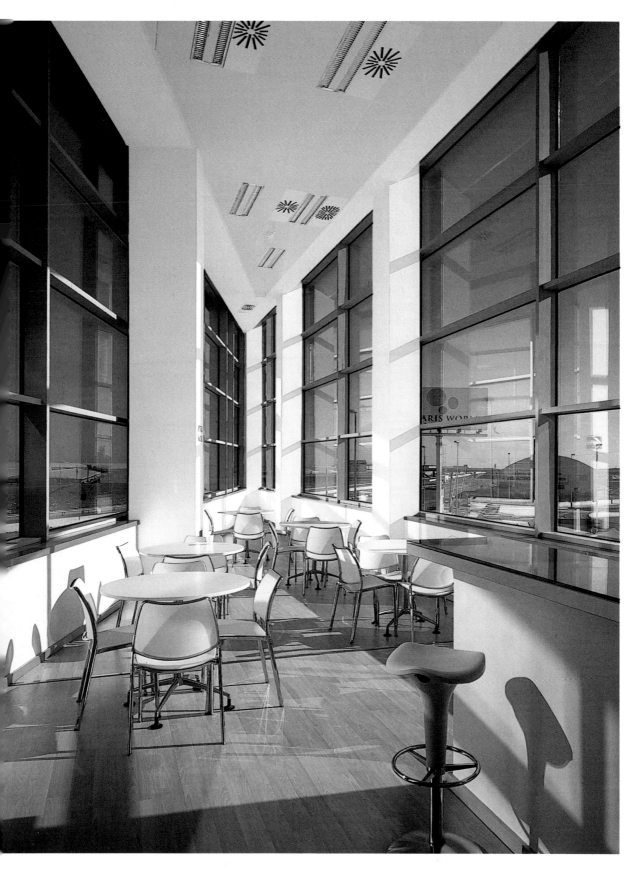

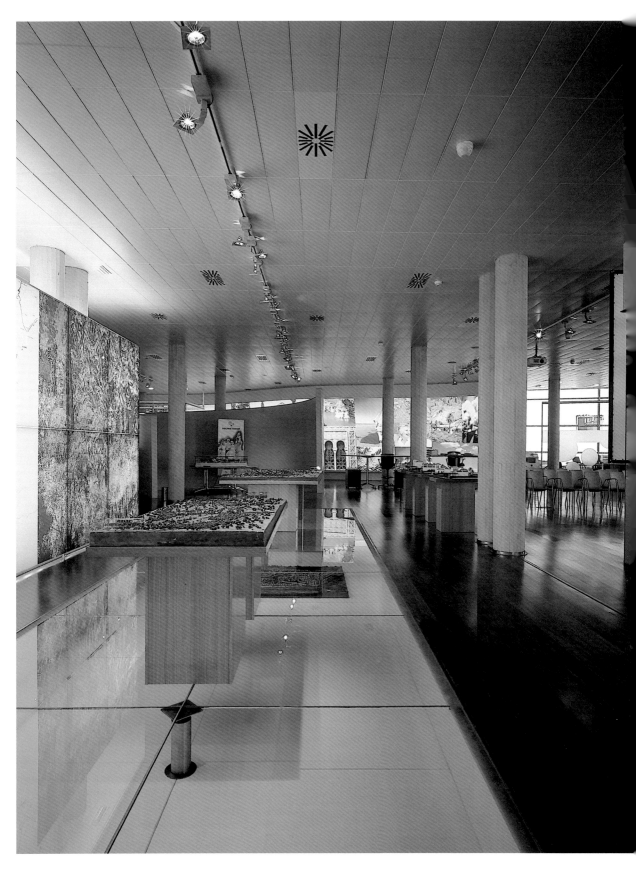

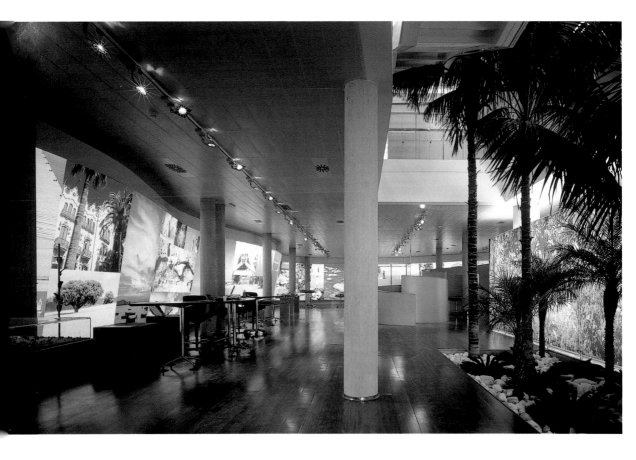

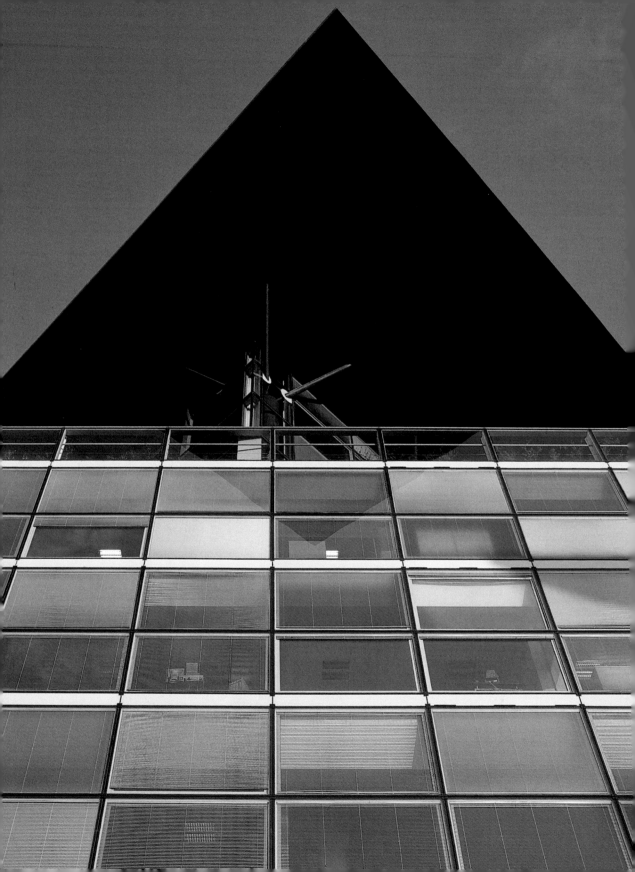

GCA ARQUITECTES ASSOCIATS | BARCELONA
ACESA
Barcelona, Spain | 2002

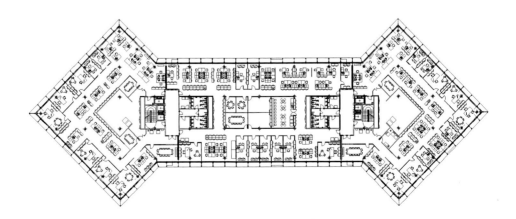

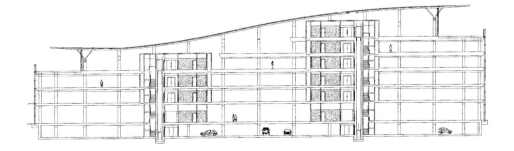

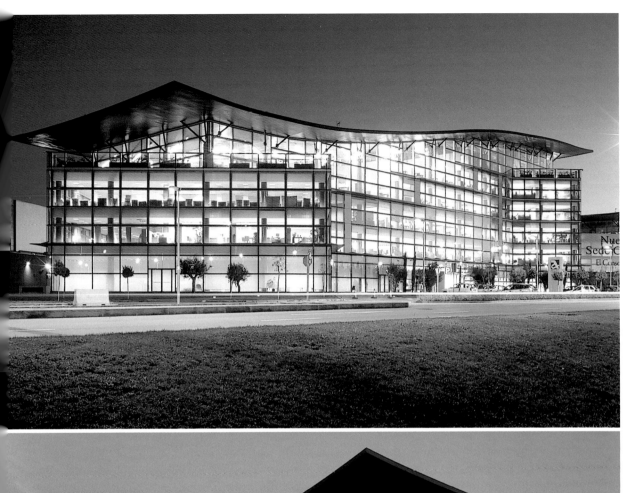

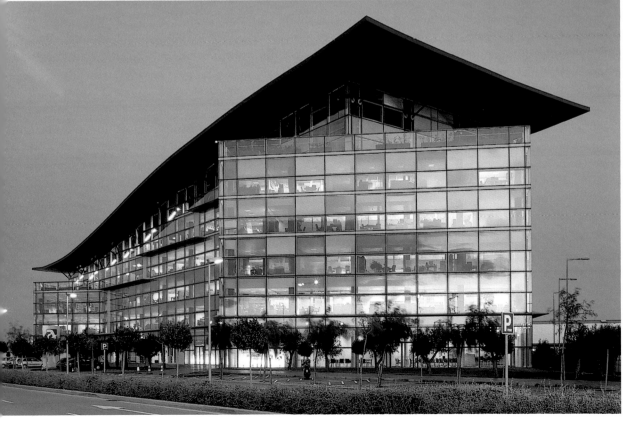

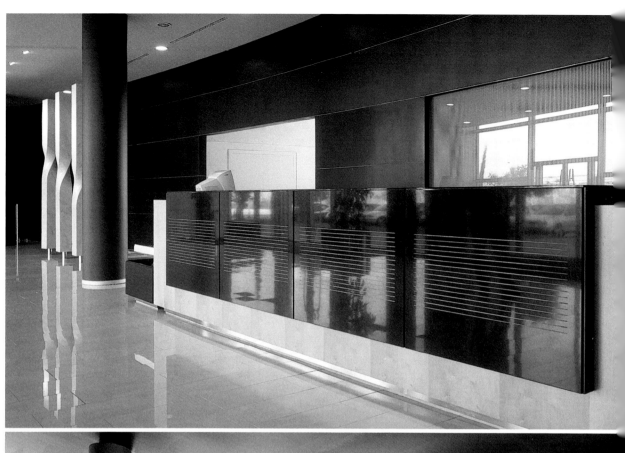

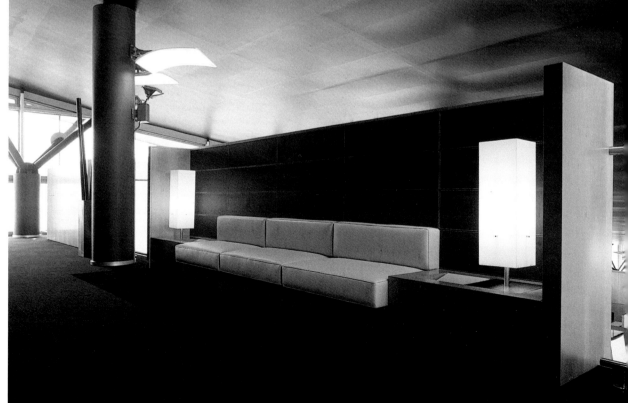

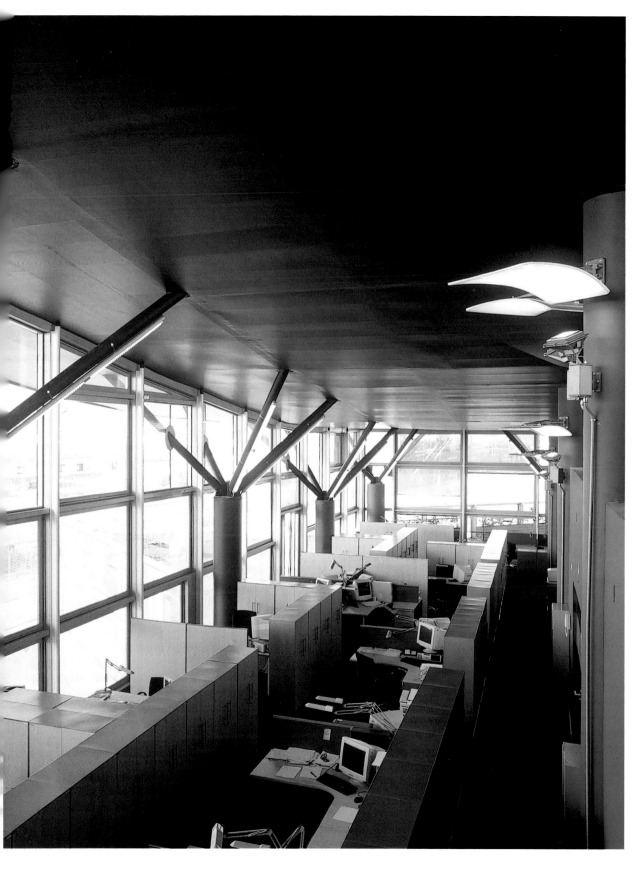

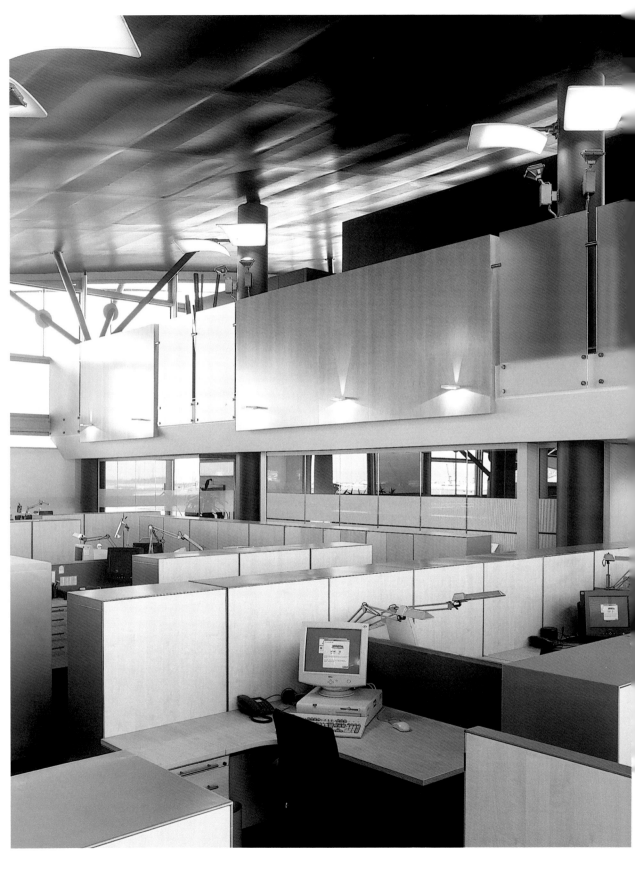

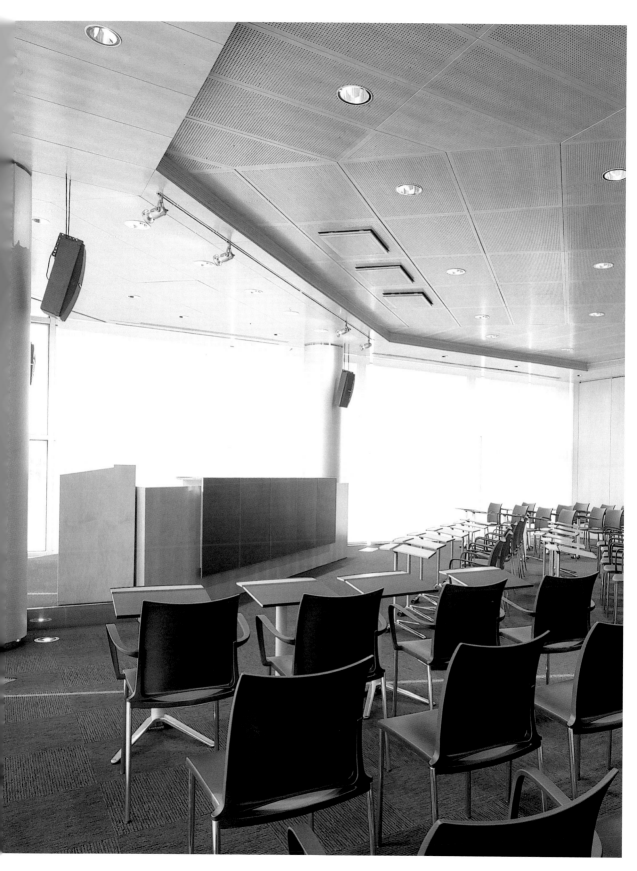

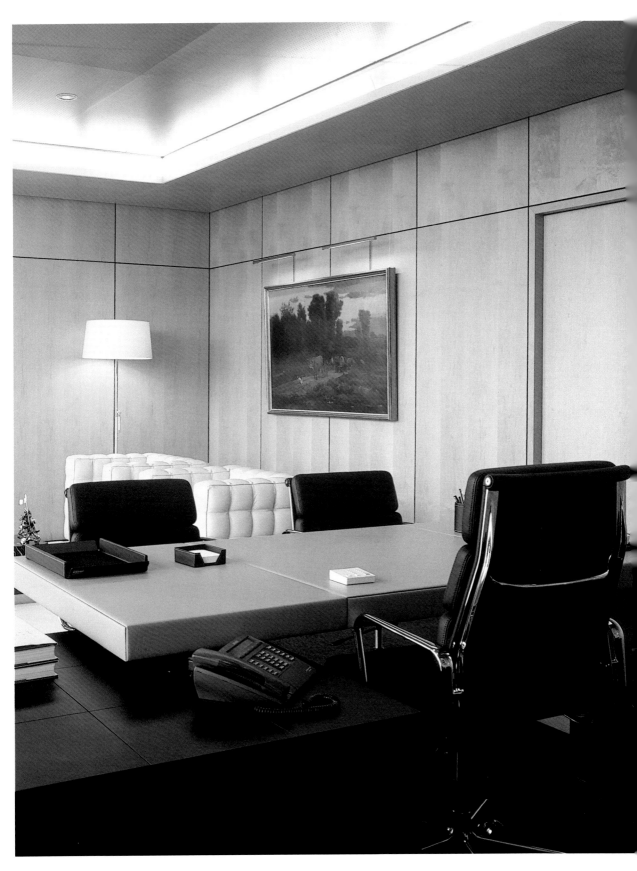

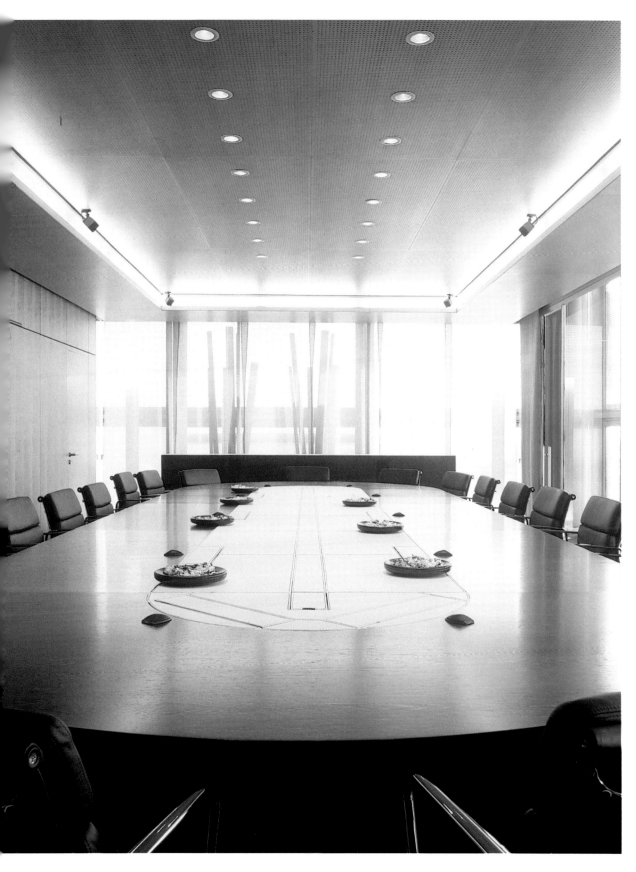

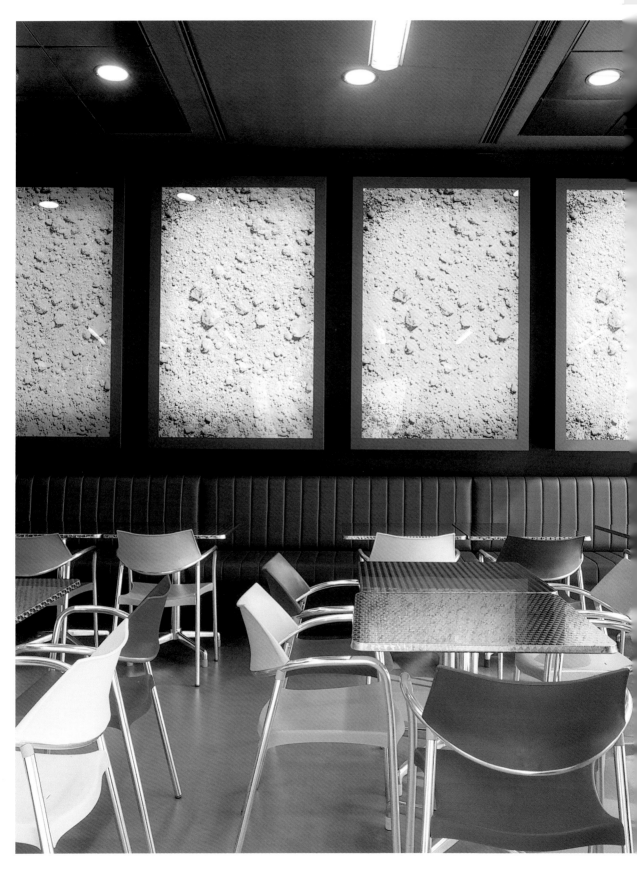

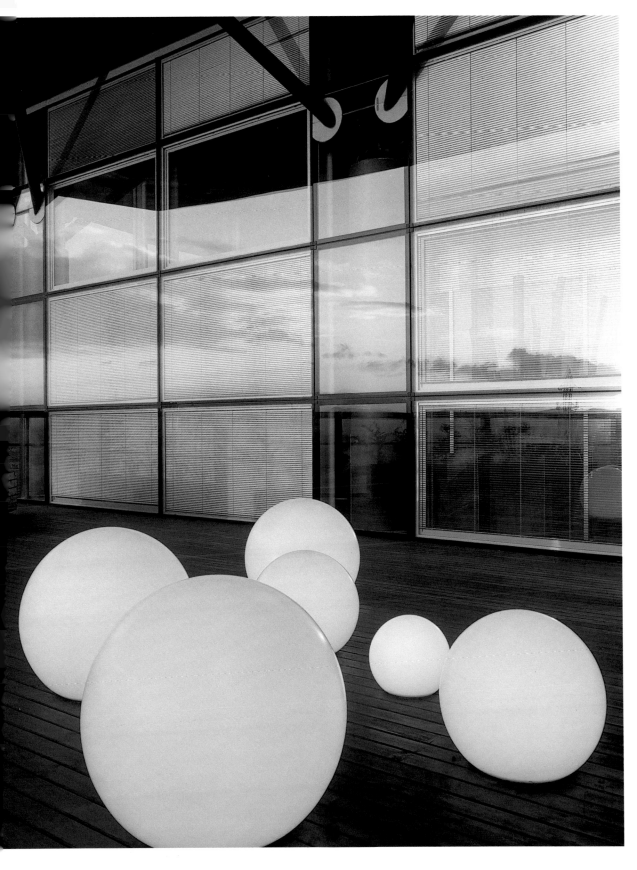

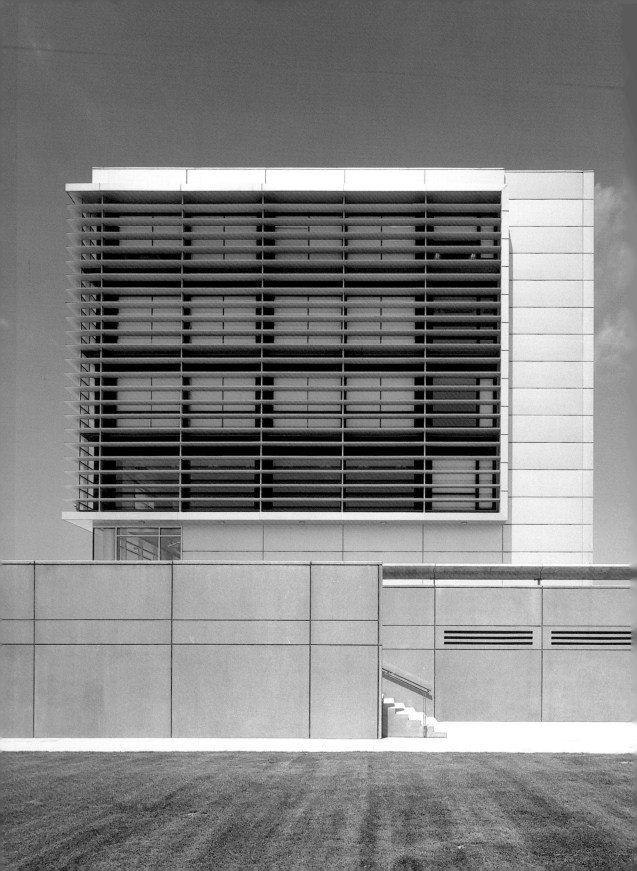

GCA ARQUITECTES ASSOCIATS | BARCELONA
ZAL
Barcelona, Spain | 2001

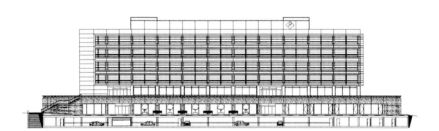

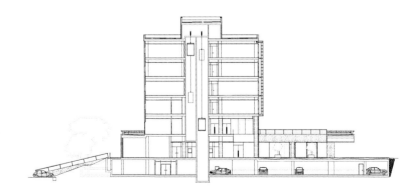

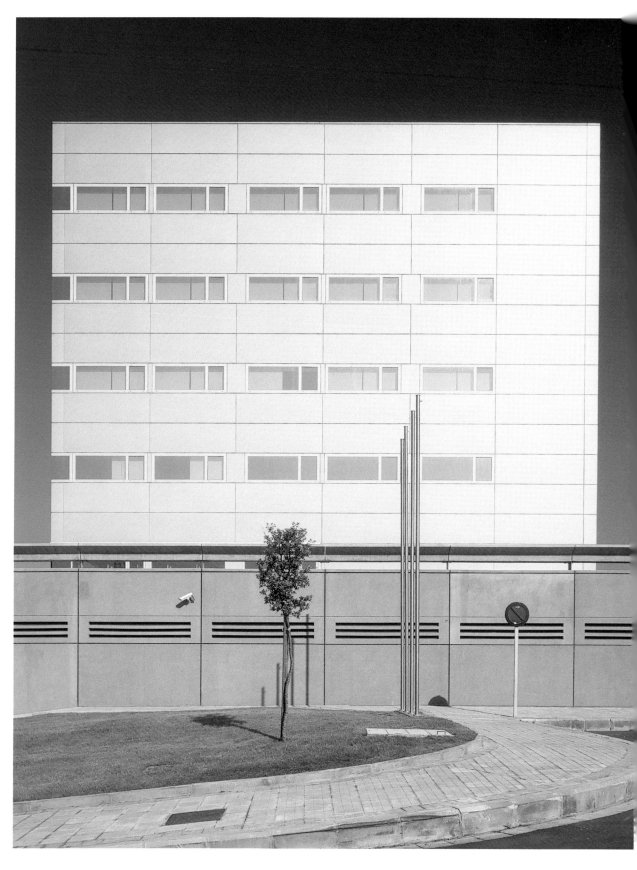

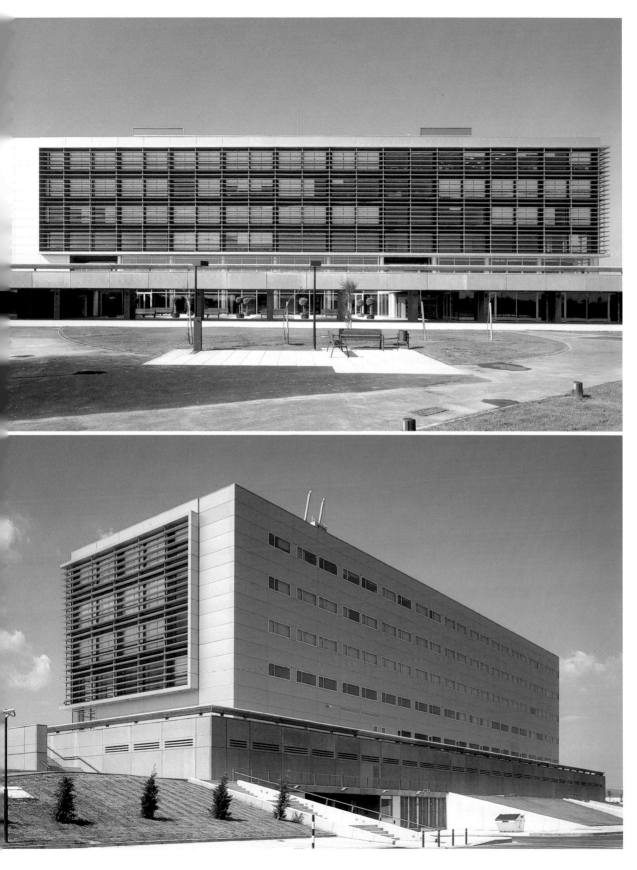

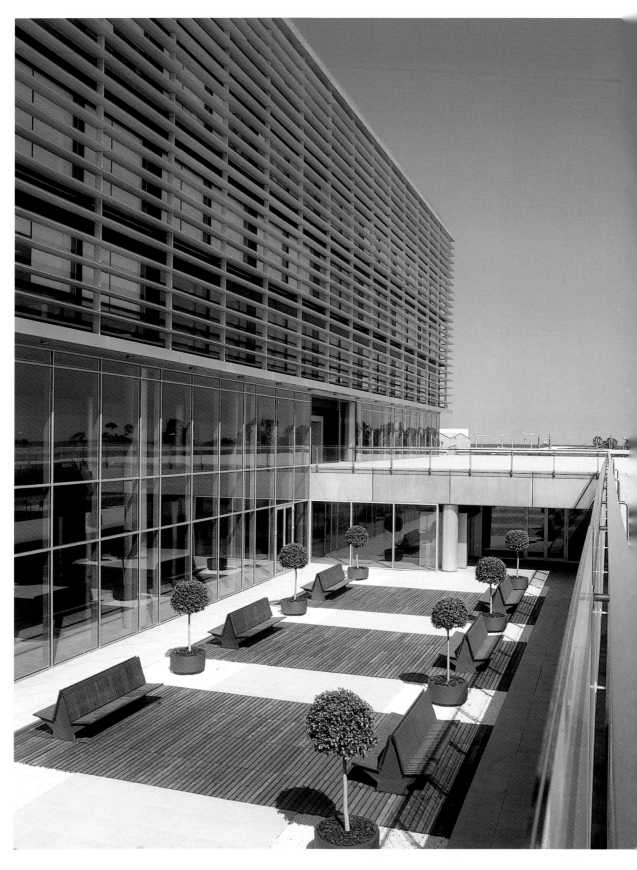

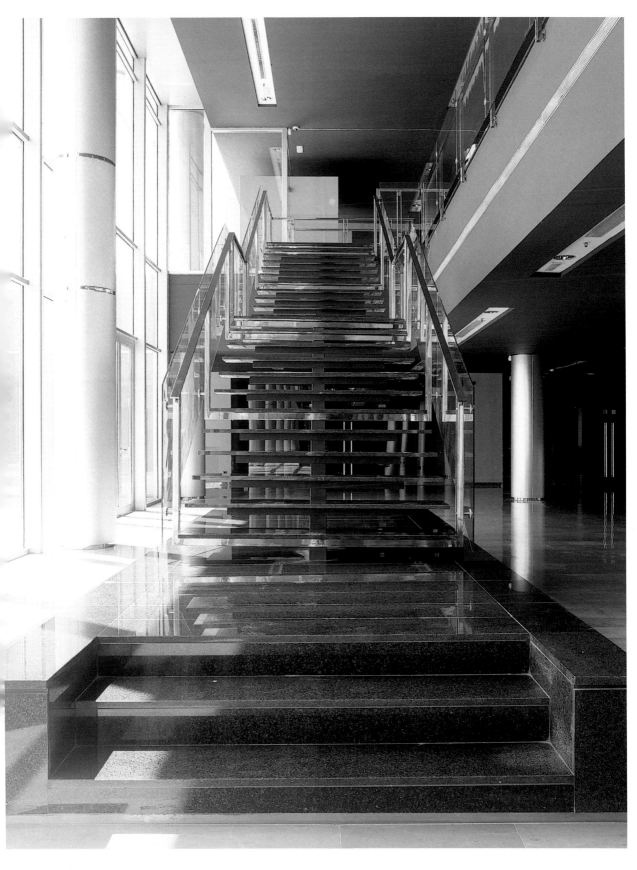

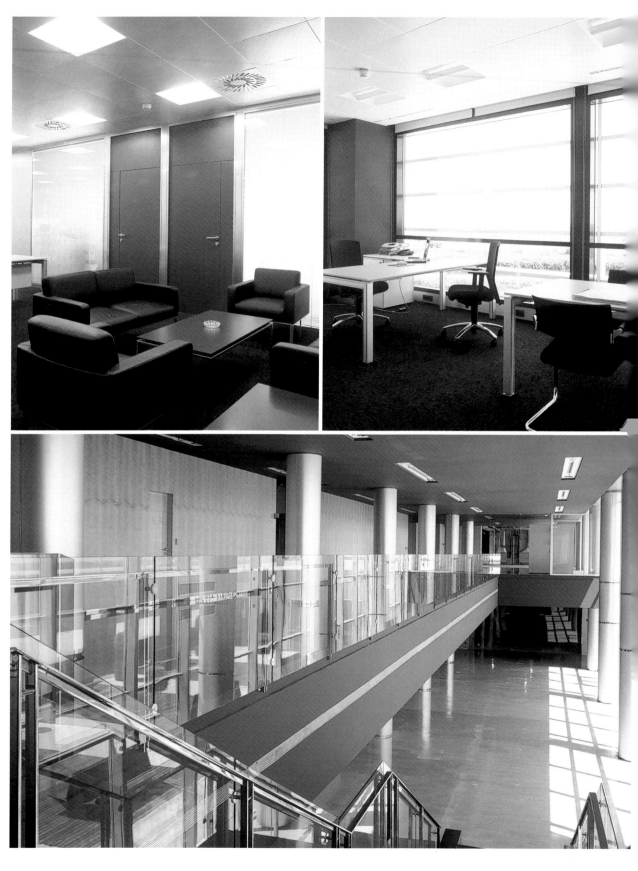

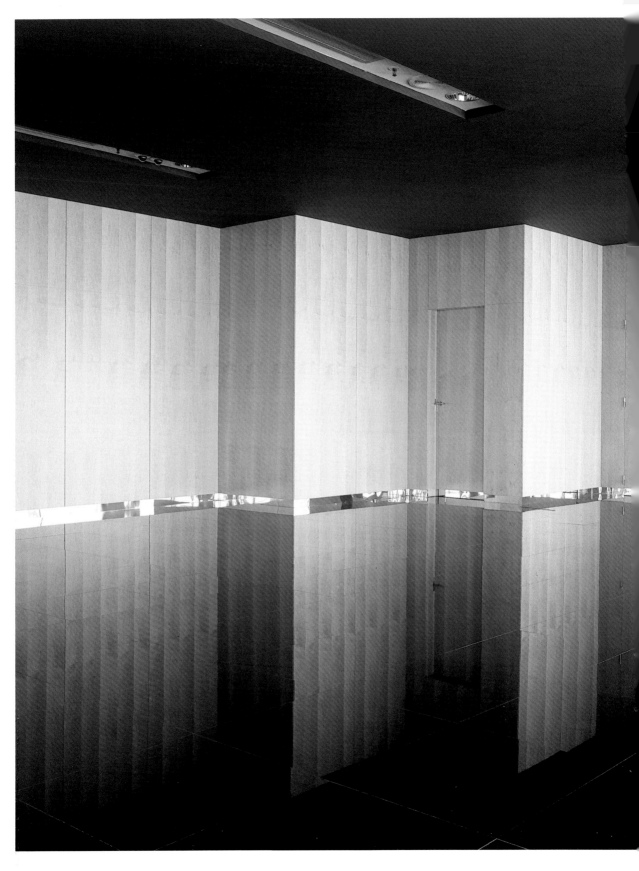

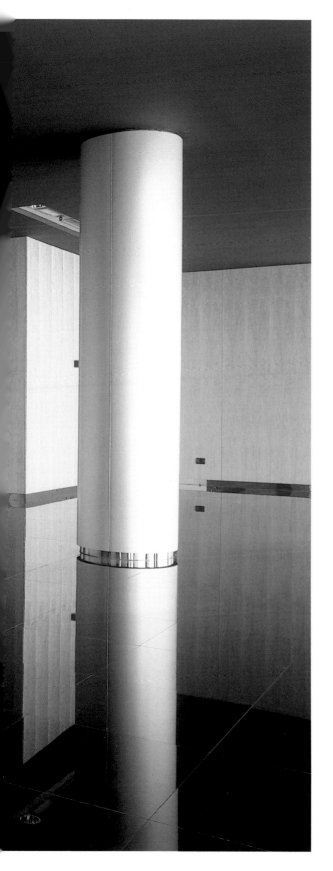

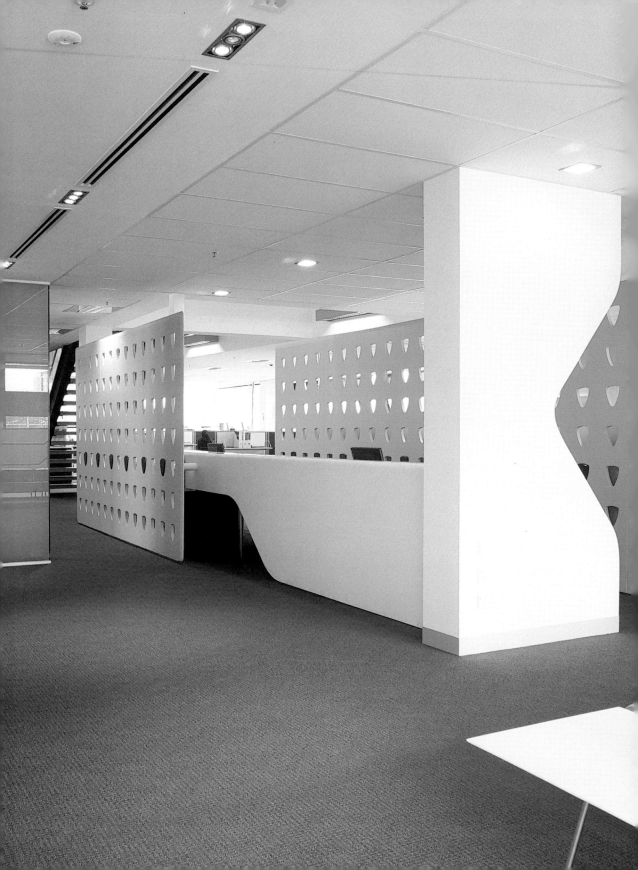

GRAY PUKSAND | **MELBOURNE**
BOURKE PLACE STUDIO
Melbourne, Australia | 2004

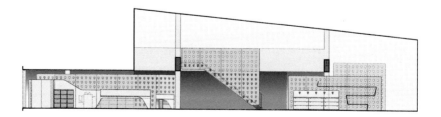

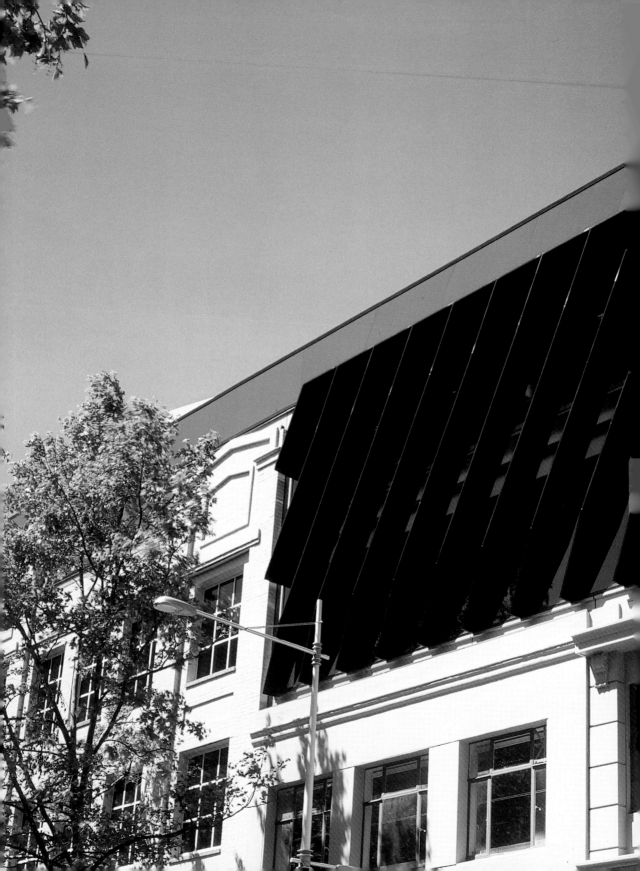

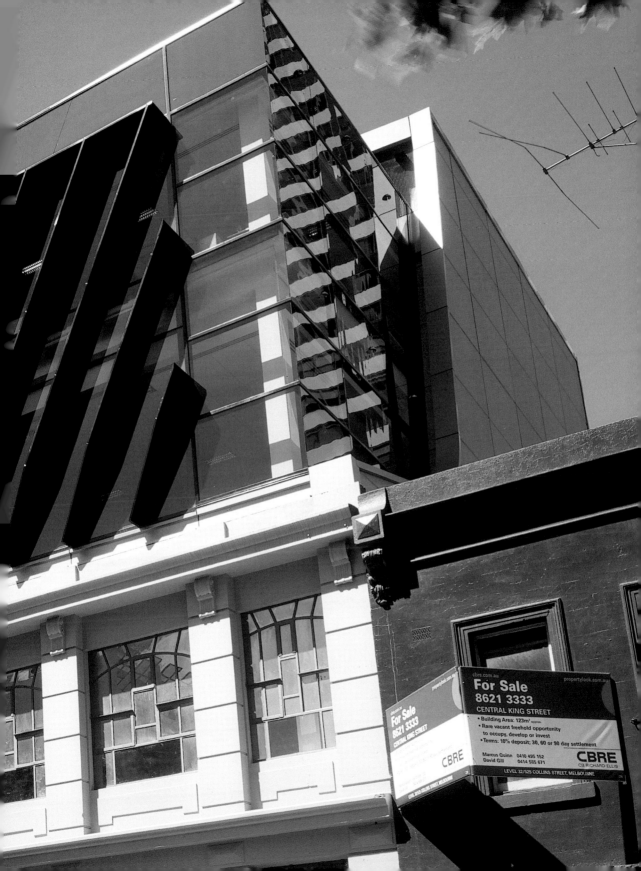

For Sale
8621 3333
CENTRAL KING STREET

cbre.com.au propertylook.com.au

For Sale
8621 3333

CENTRAL KING STREET

• Building Area: 123m² approx.
• Rare vacant freehold opportunity
 to occupy, develop or invest
• Terms: 10% deposit; 30, 60 or 90 day settlement

Marcus Quinn 0410 495 152
David Gill 0414 585 671

CBRE
CB RICHARD ELLIS

LEVEL 32/525 COLLINS STREET, MELBOURNE

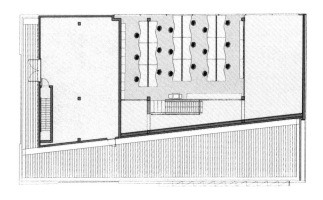

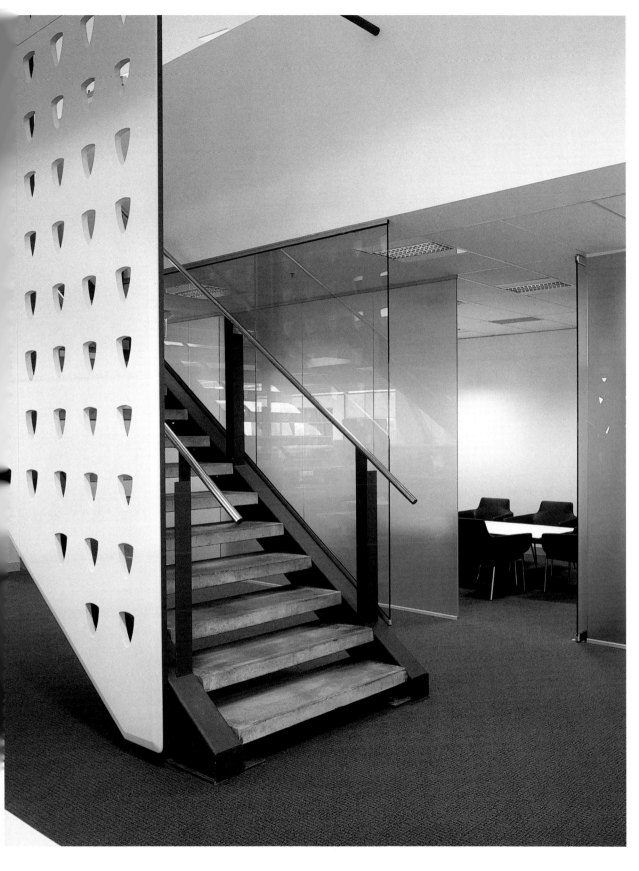

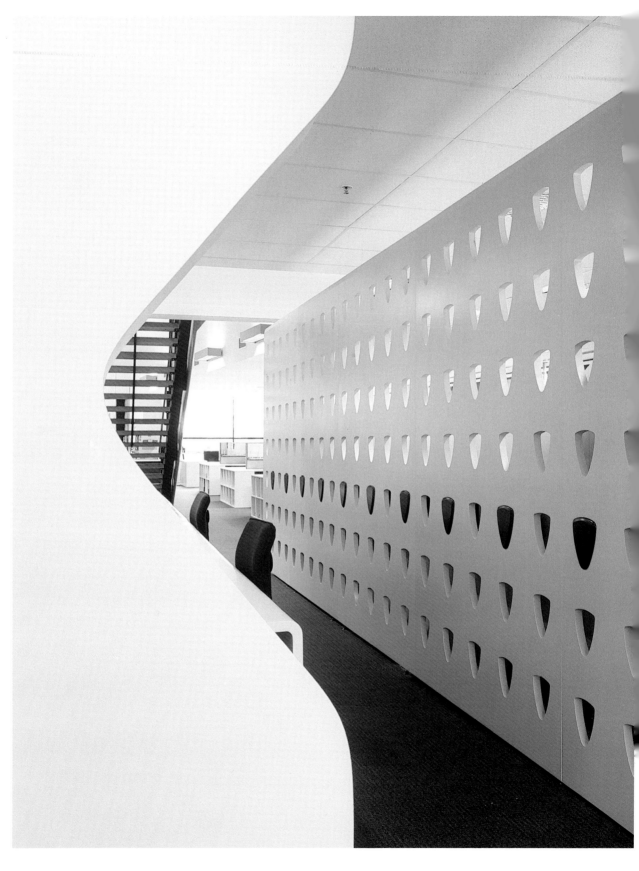

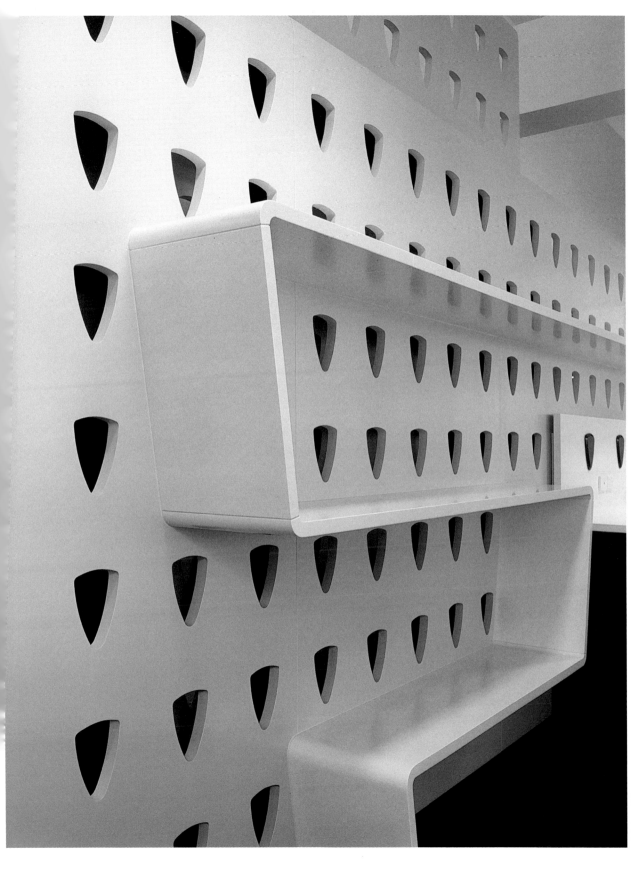

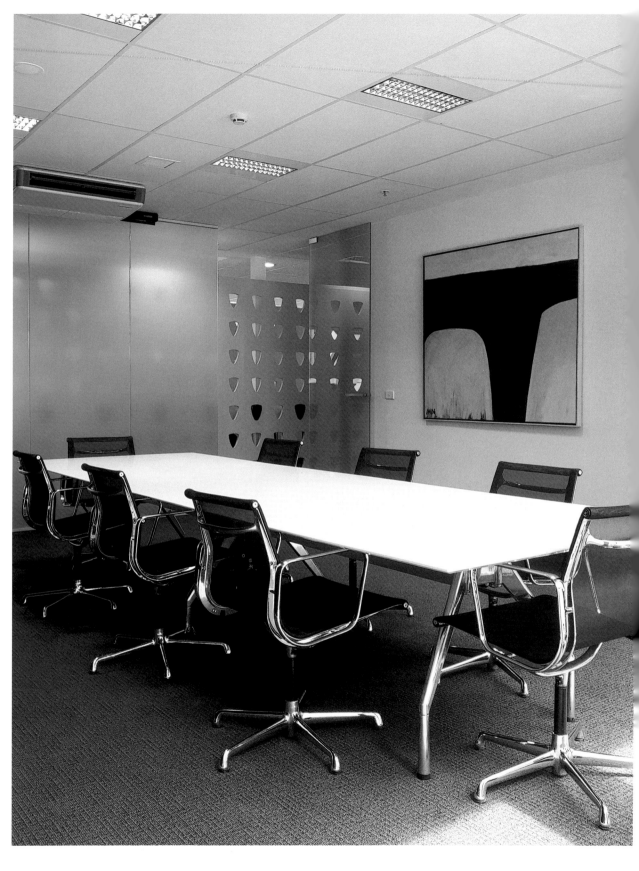

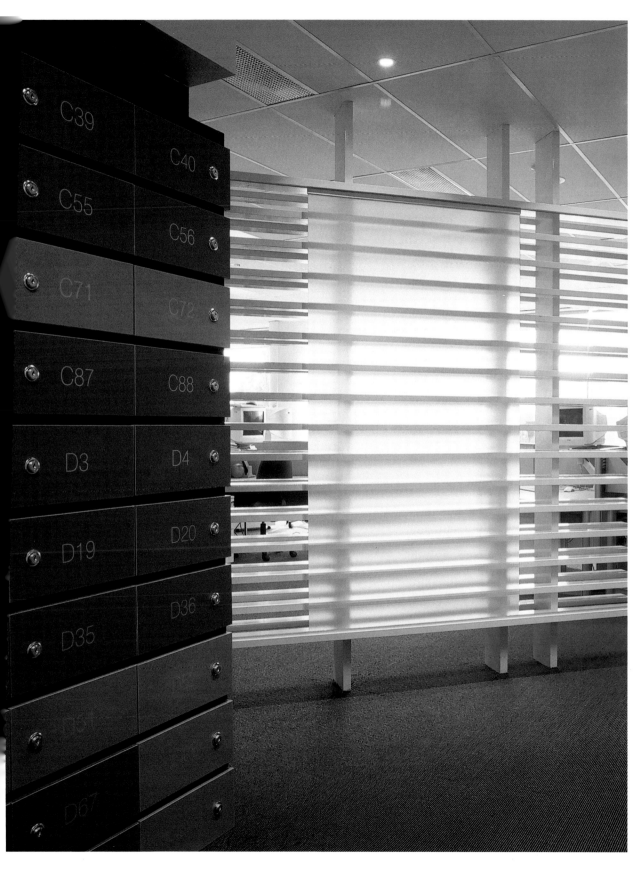

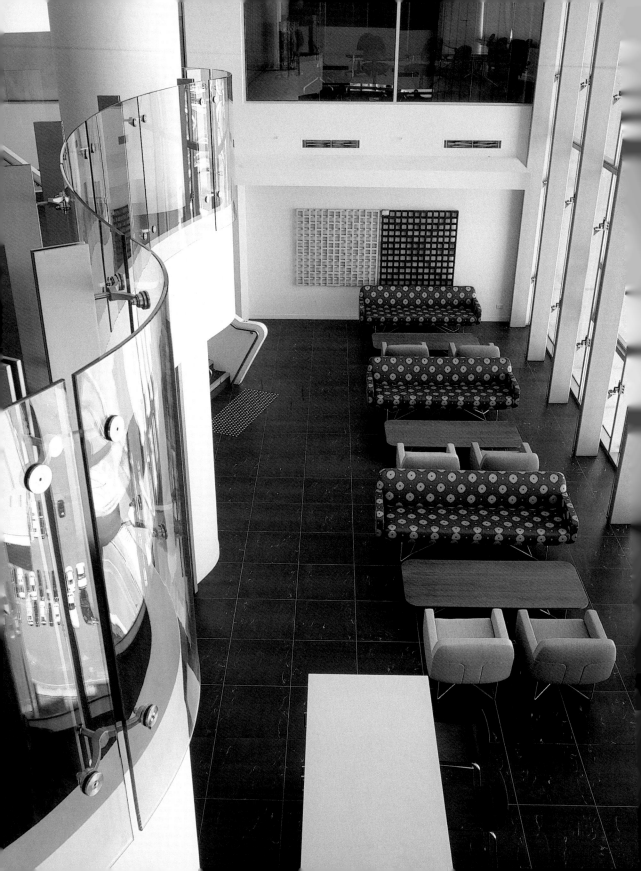

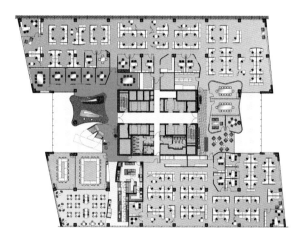

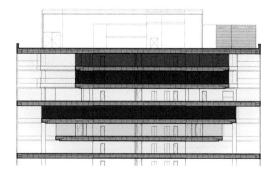

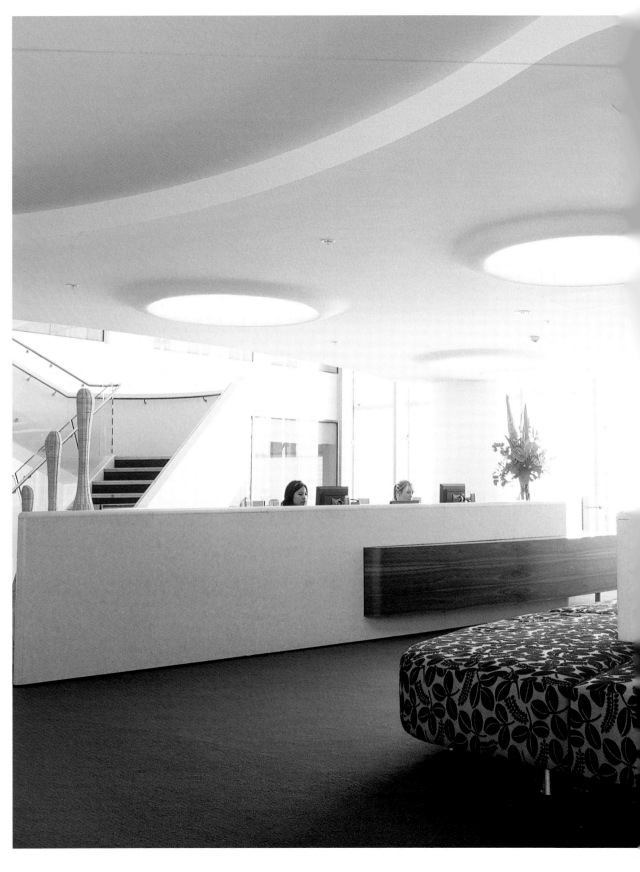

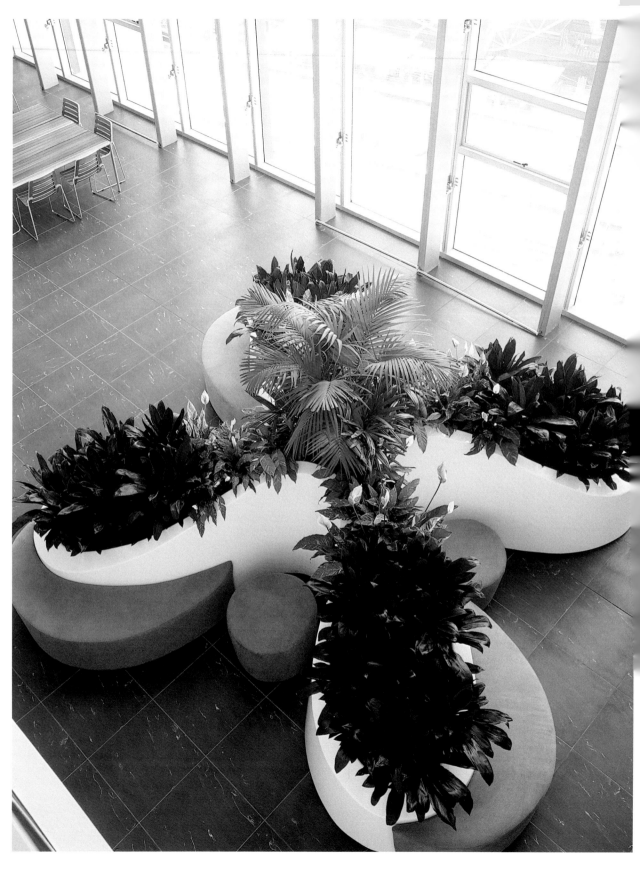

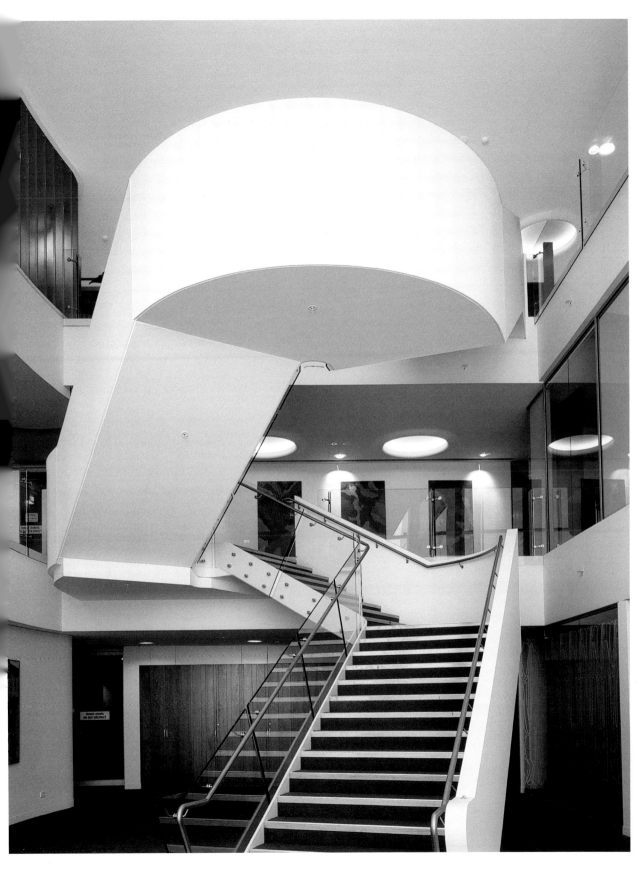

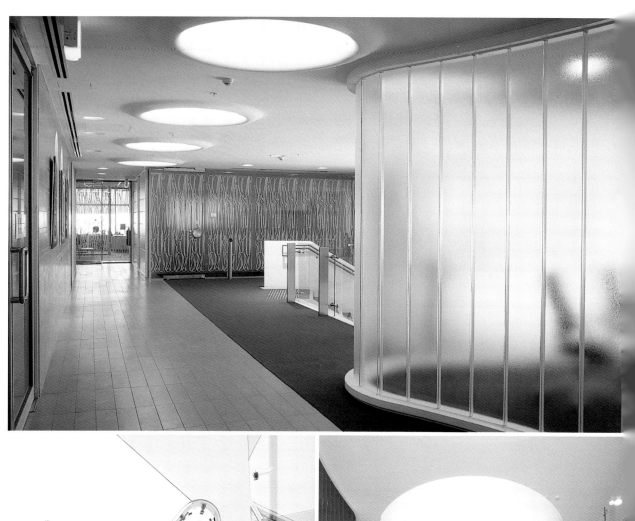
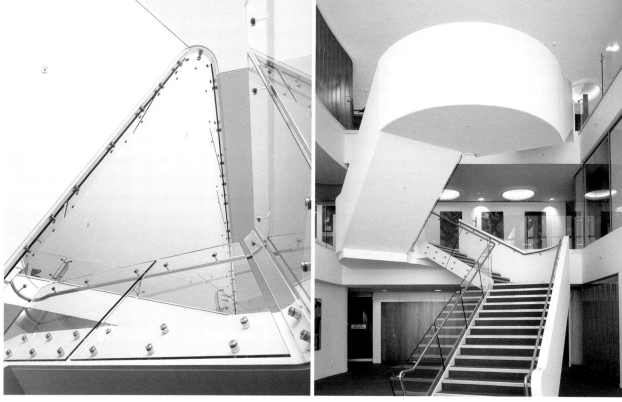

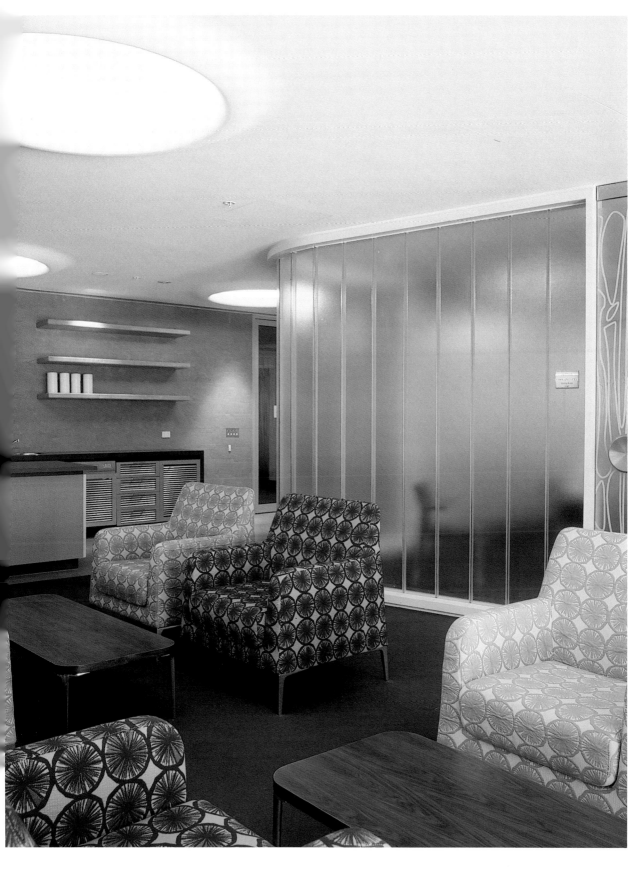

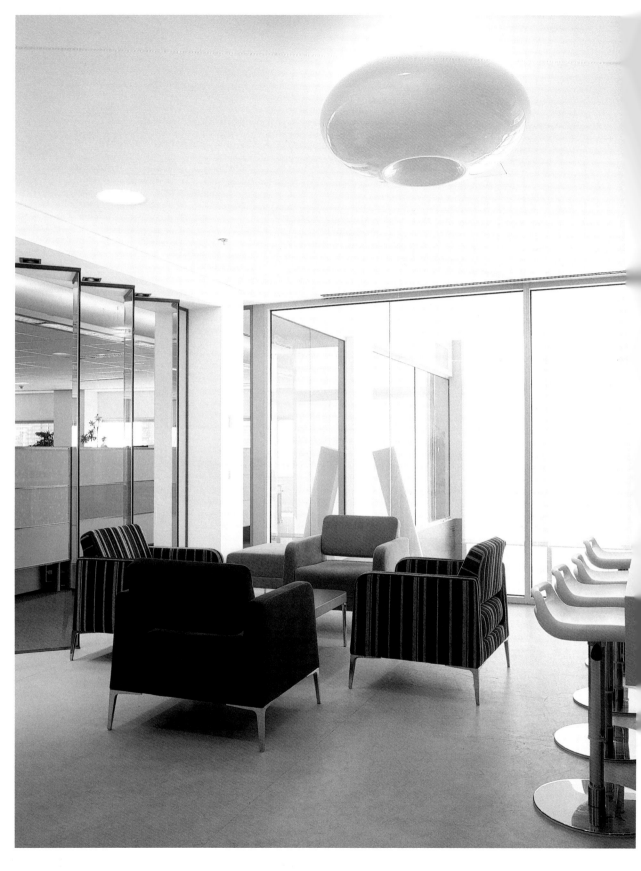

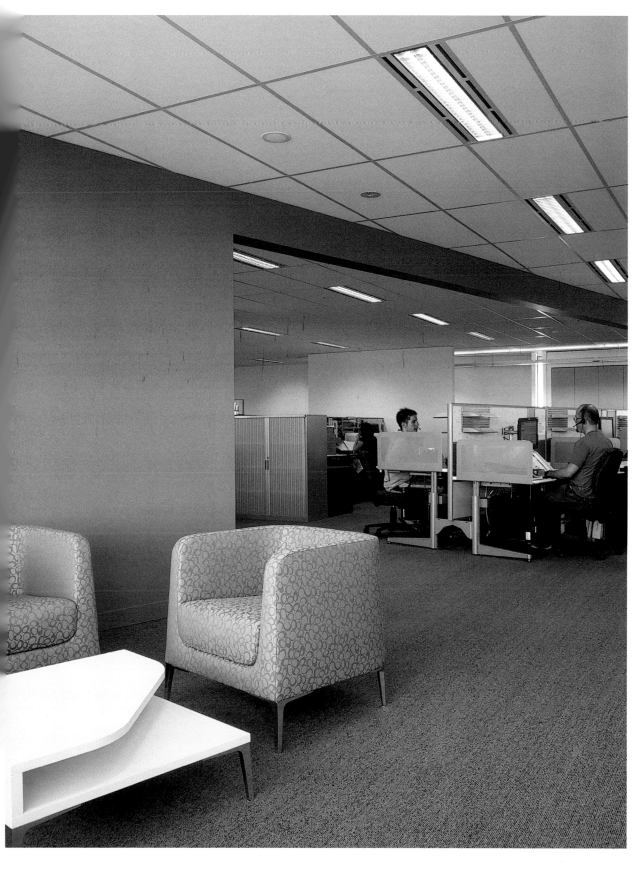

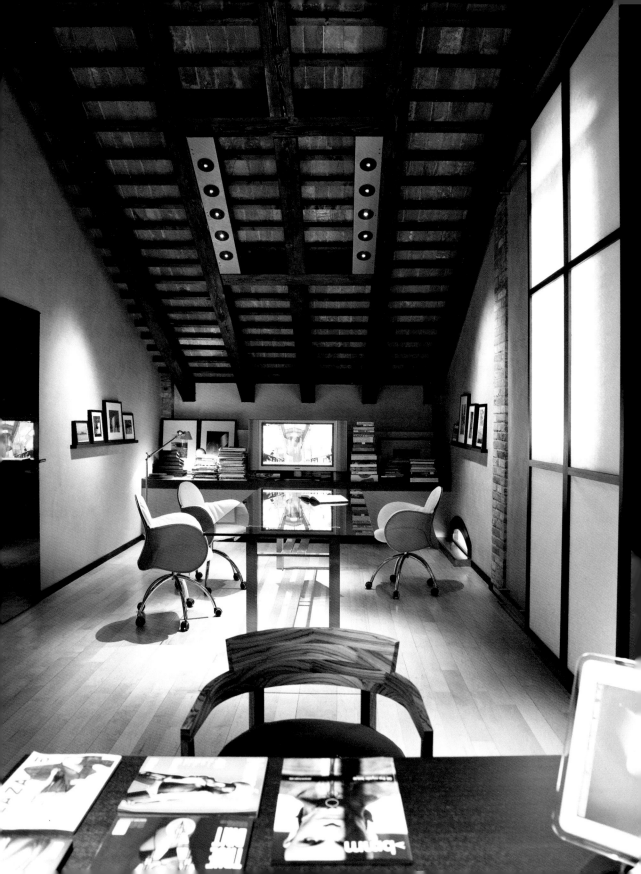

HANGAR DESIGN GROUP | MOGLIANO VENETO
HANGAR HOUSE
Mogliano Veneto, Italy | 2003

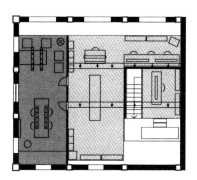

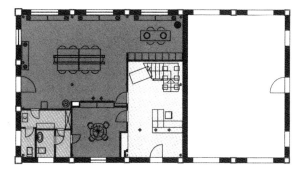

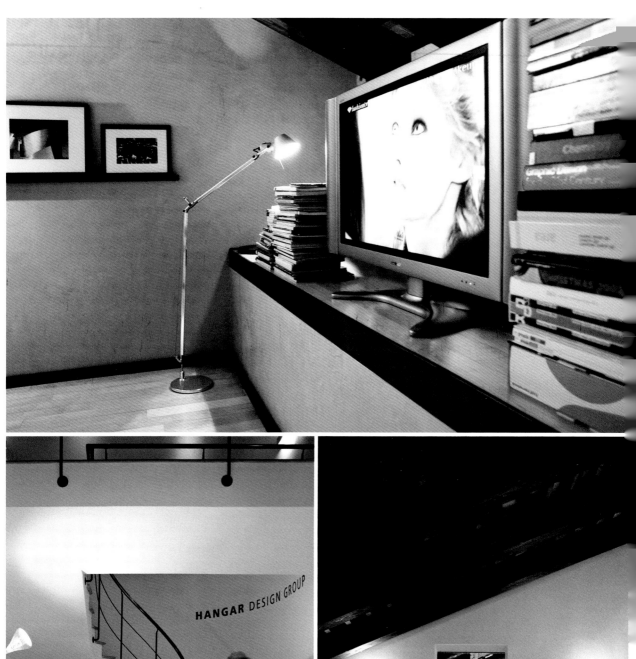

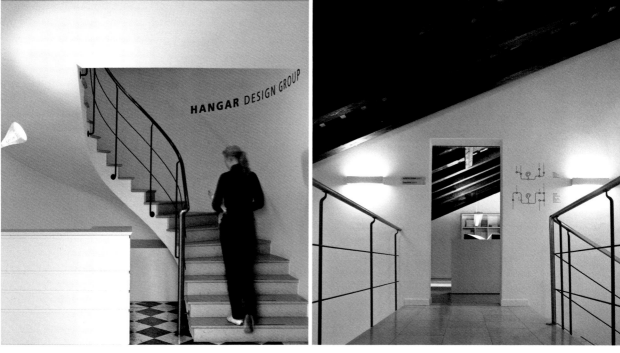

HANGAR DESIGN GROUP

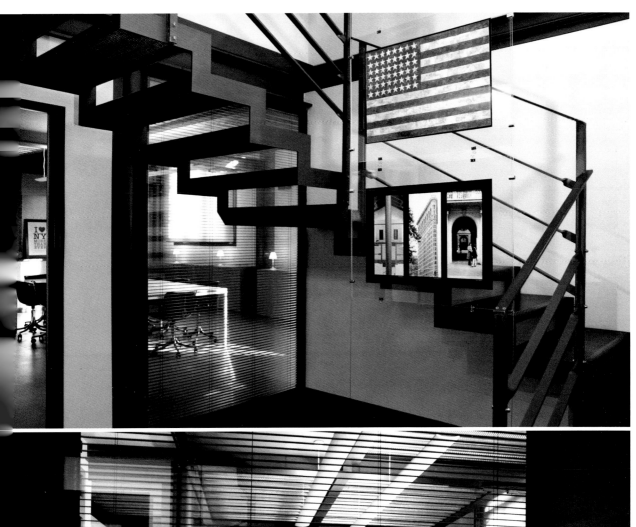
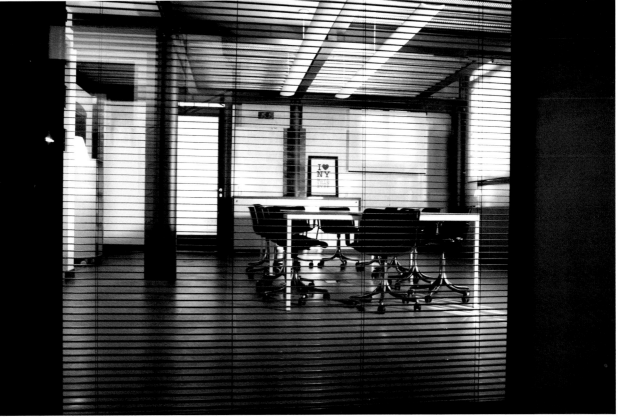

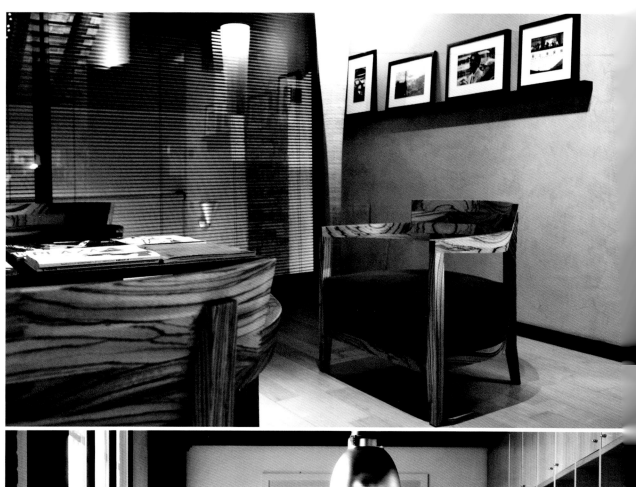
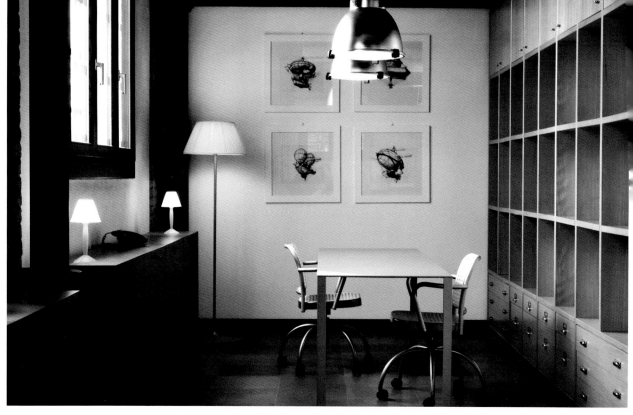

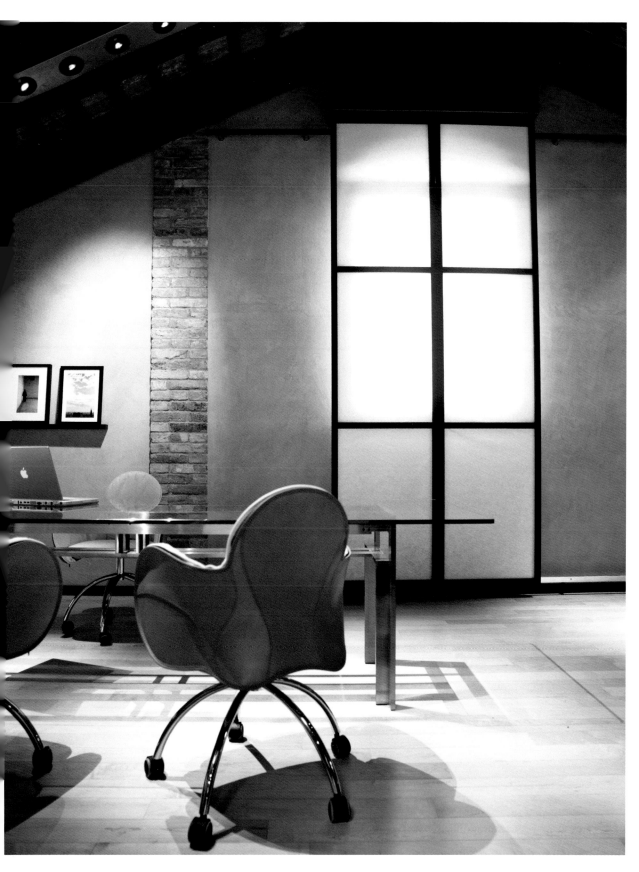

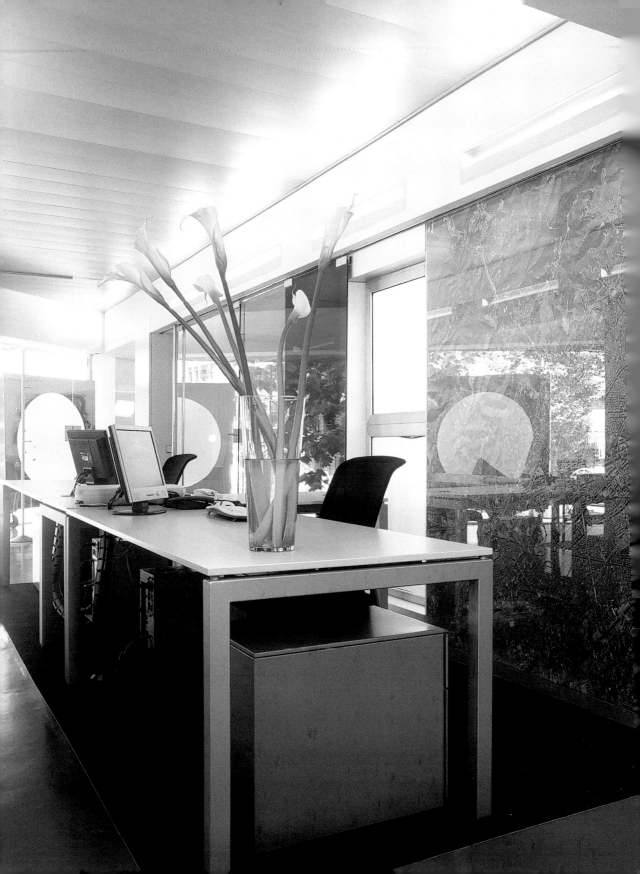

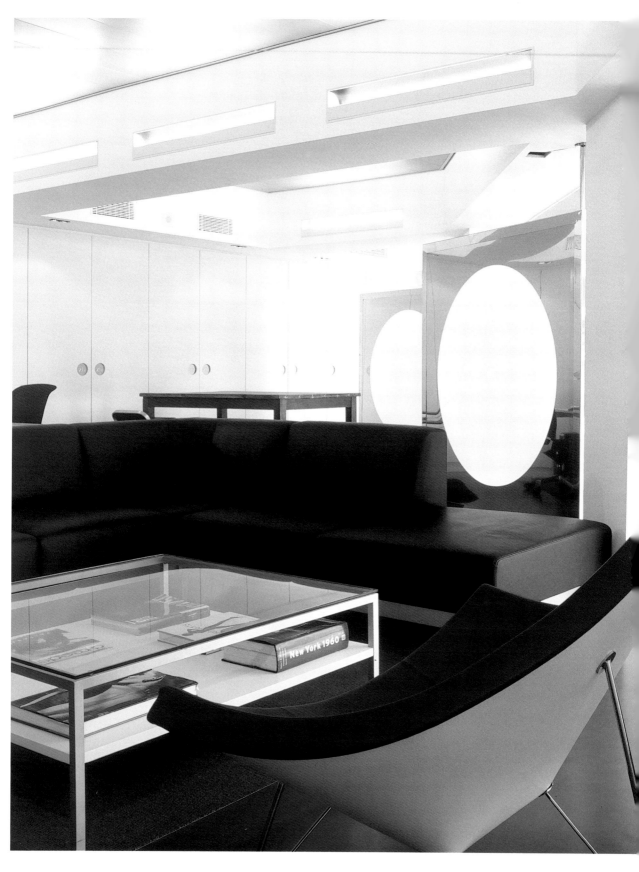

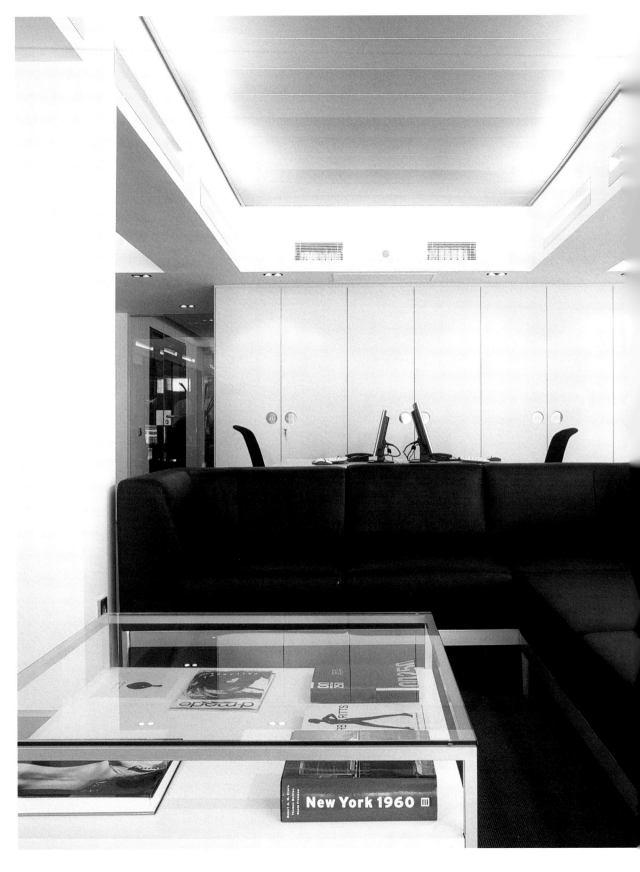

New York 1960 III

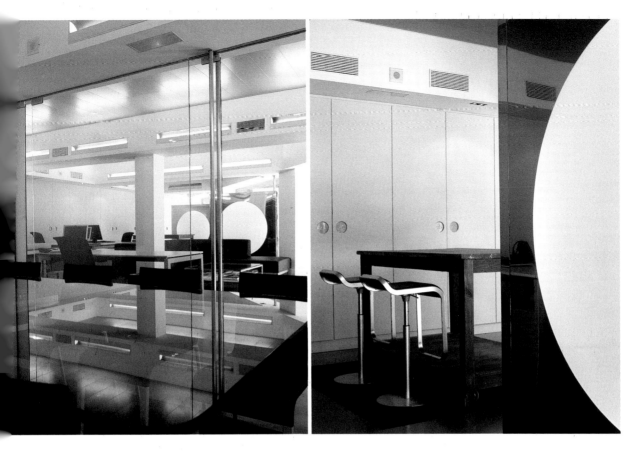

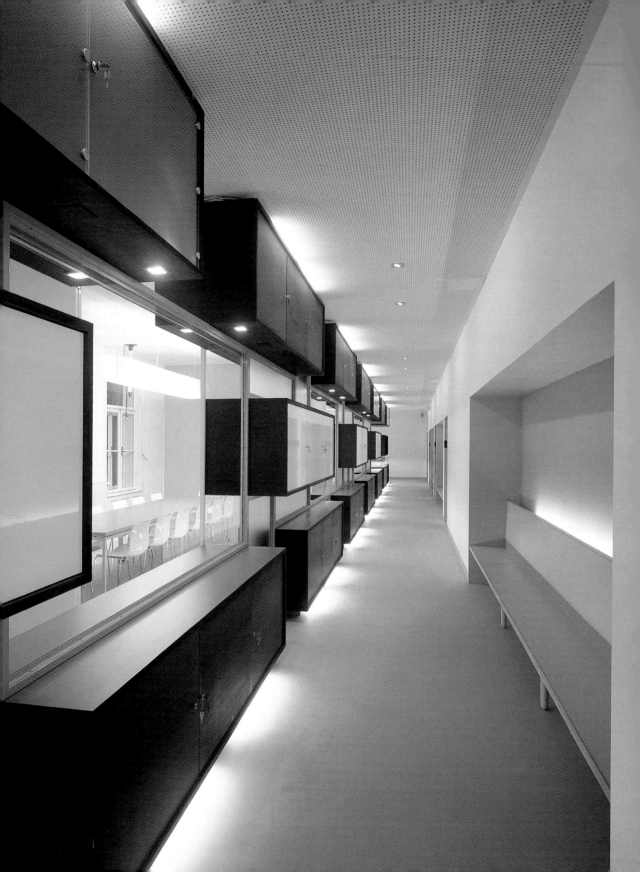

KUNATH TRENKWALDER ARCHITECTS | VIENNA
EDUCATION CENTER OF THE SOCIALIST DEMOCRATIC PARTY
Vienna, Austria | 2004

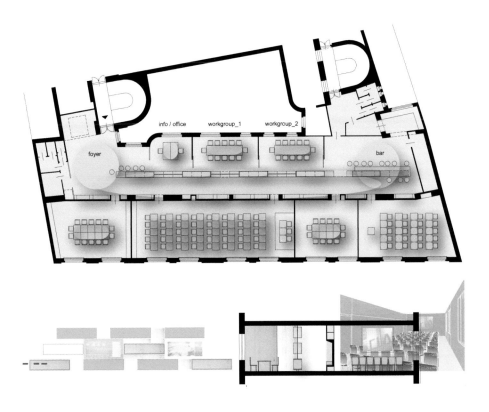

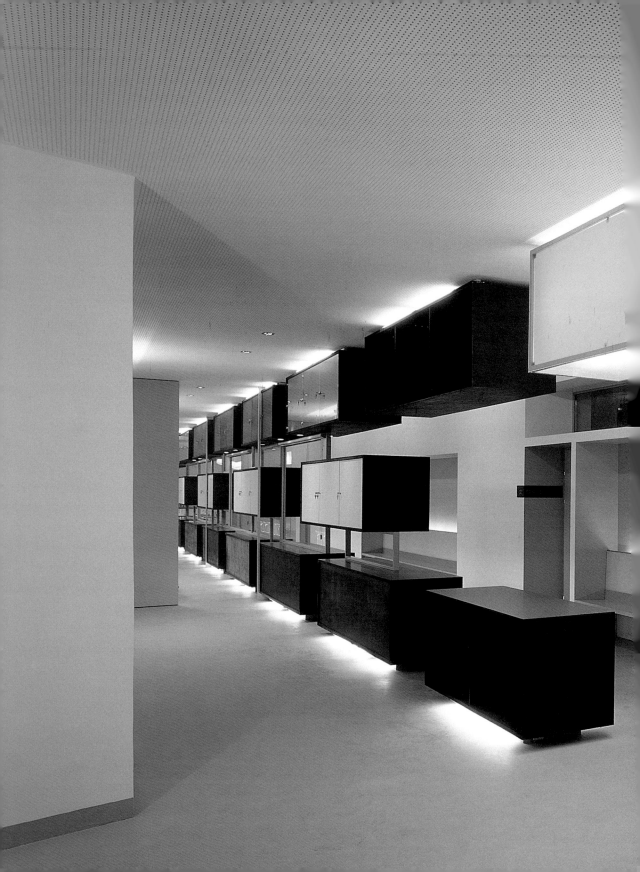

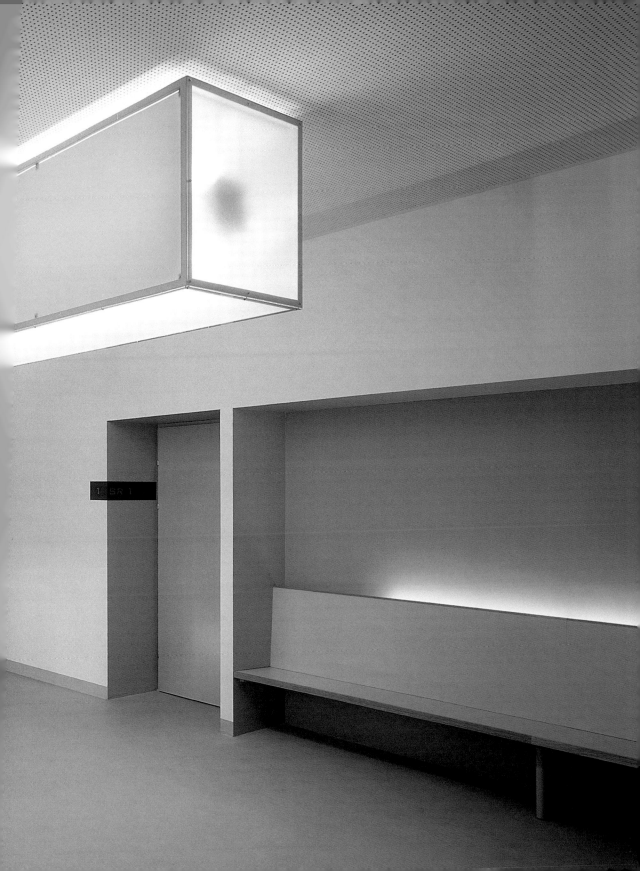

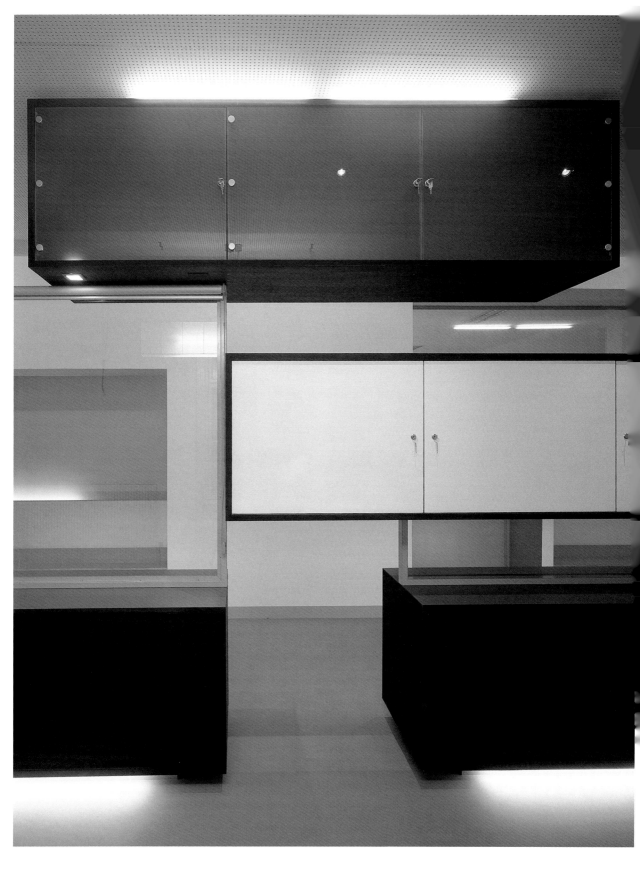

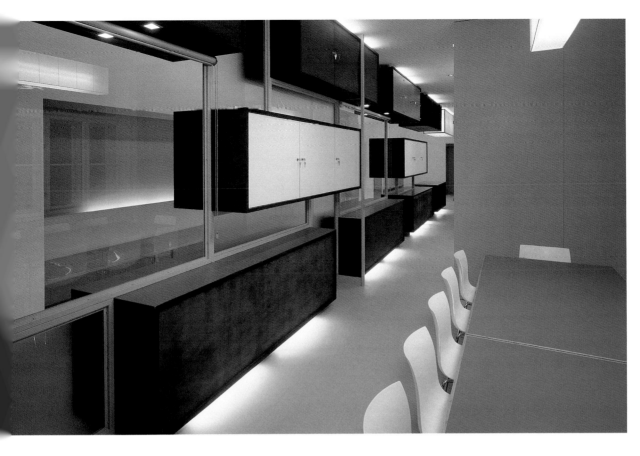

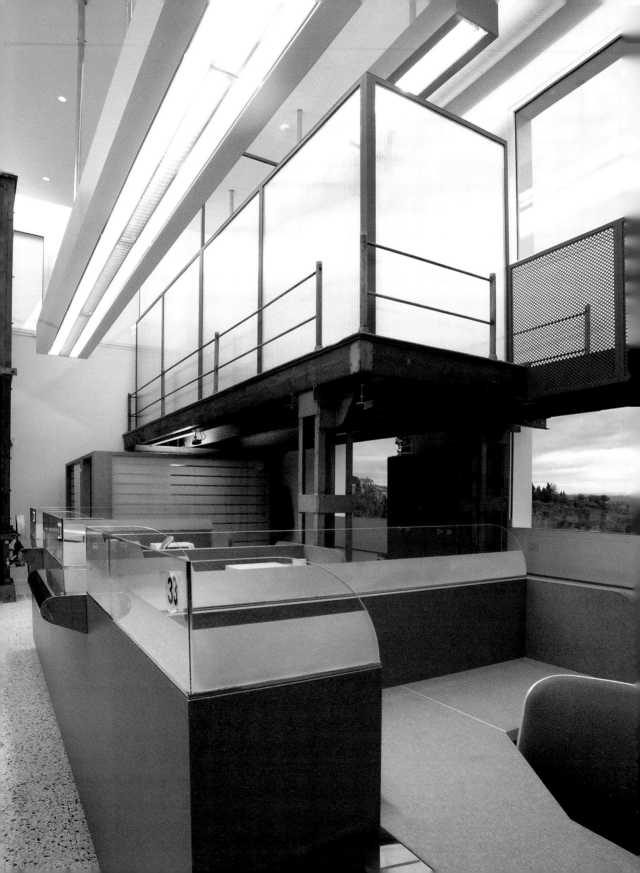

MASSIMO MARINI ARCHITETTO | PISTOIA
BANK BRANCH OFFICE IN CERRETO GUIDI
Florence, Italy | 2004

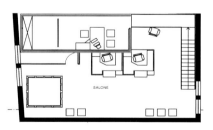

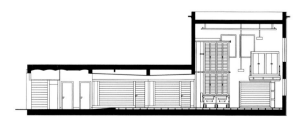

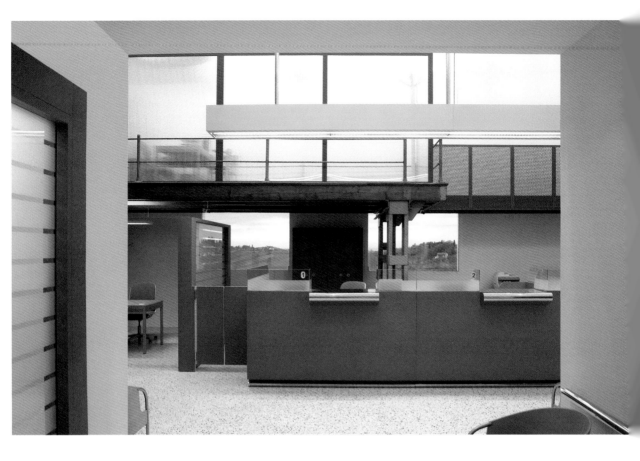

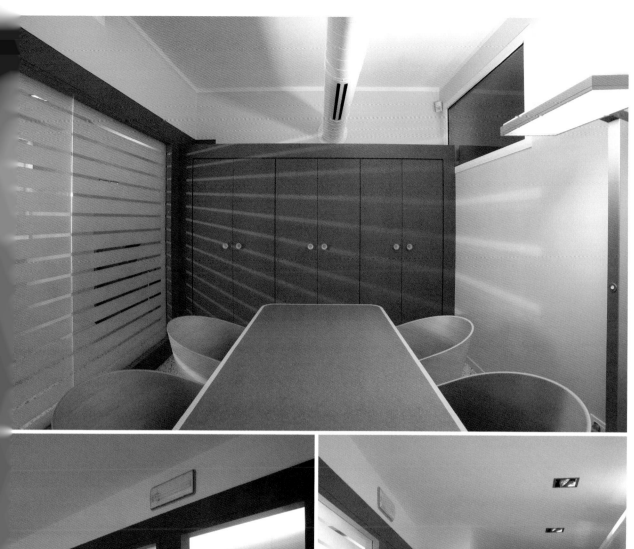
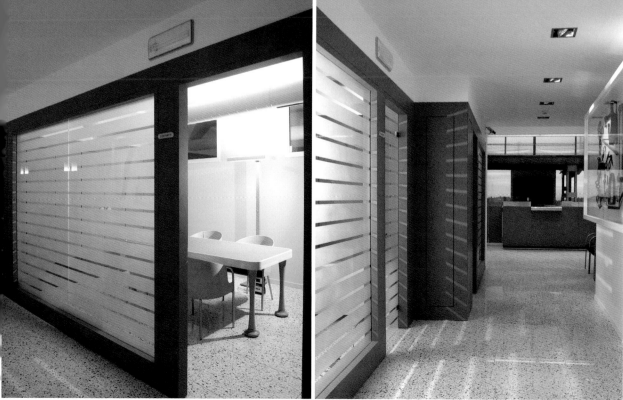

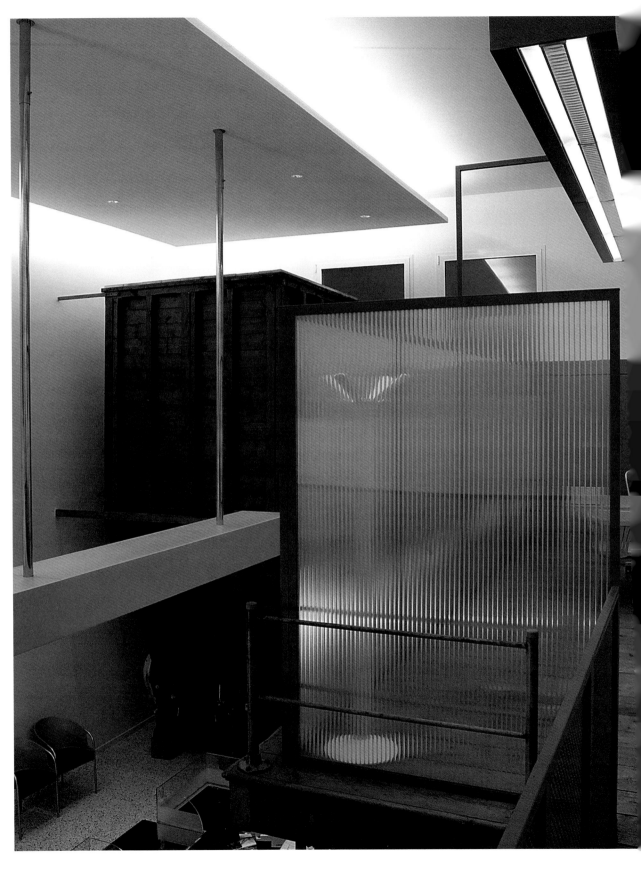

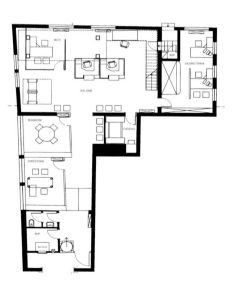

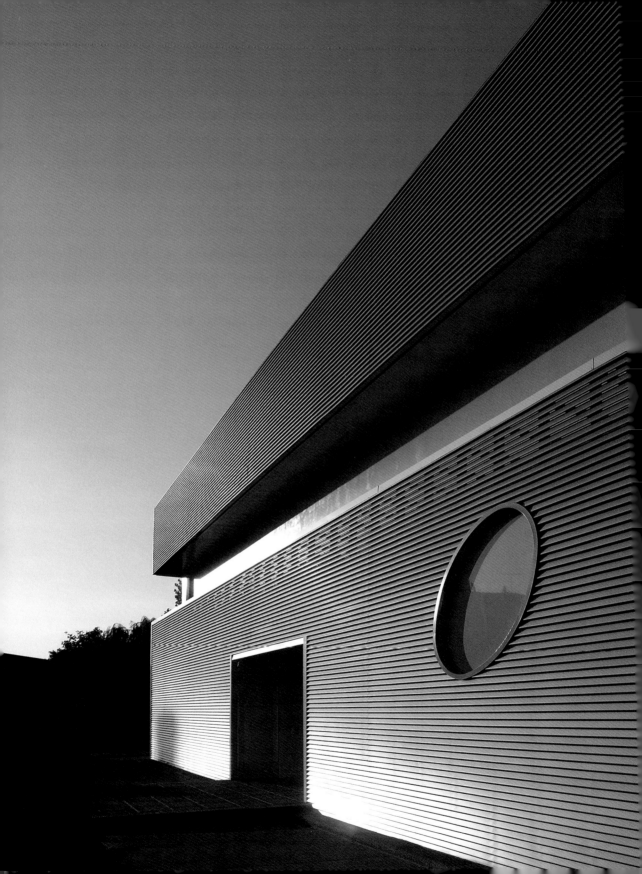

MASSIMO MARINI ARCHITETTO | PISTOIA
BCC FORNACETTE BRANCH OFFICE IN PONTEDERA
Pisa, Italy | 2003

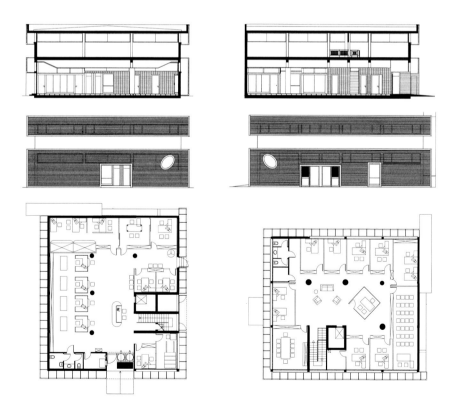

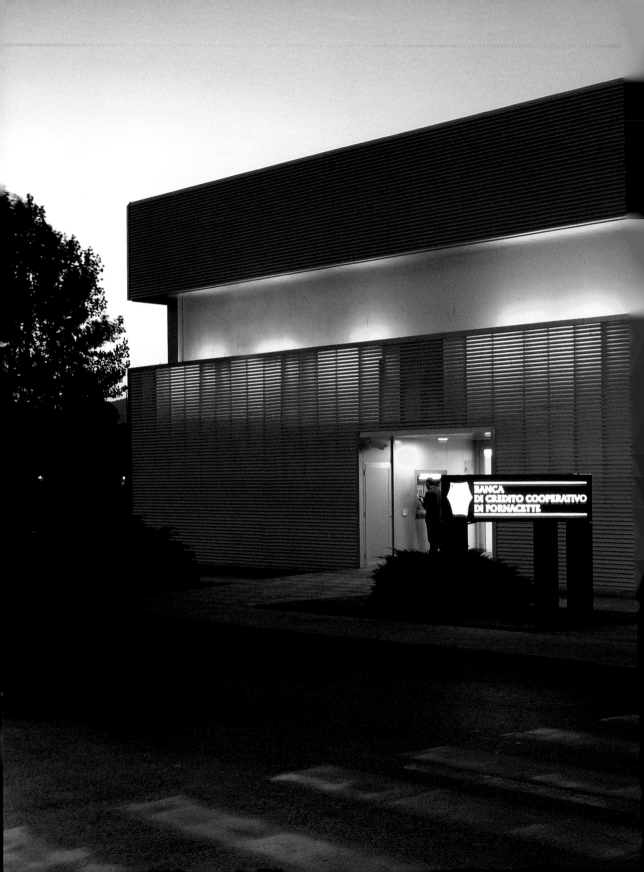

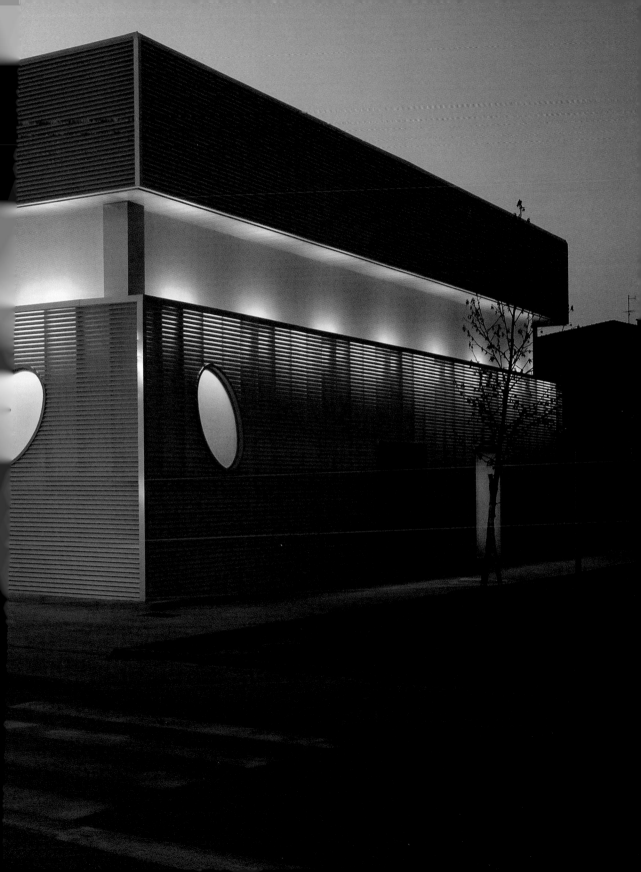

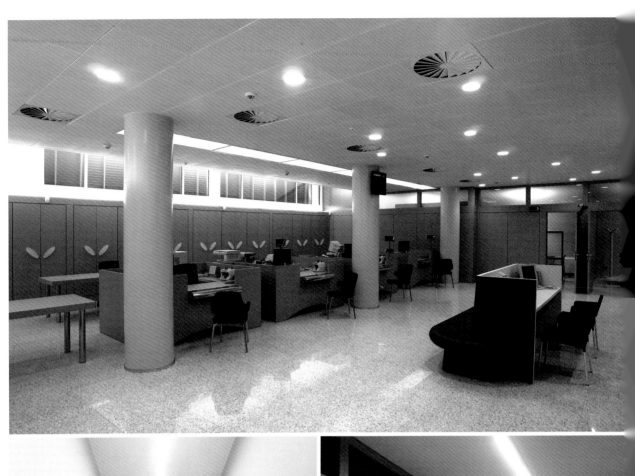

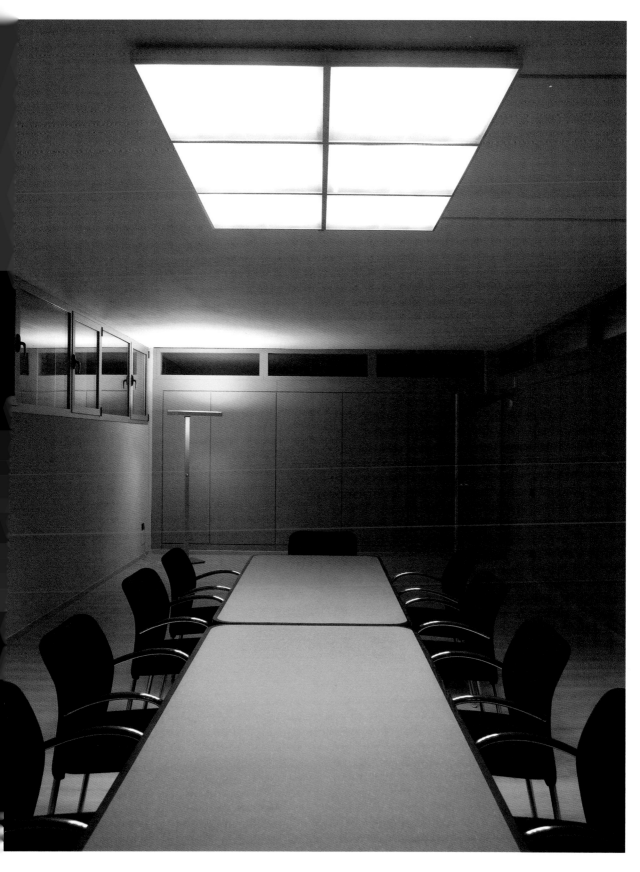

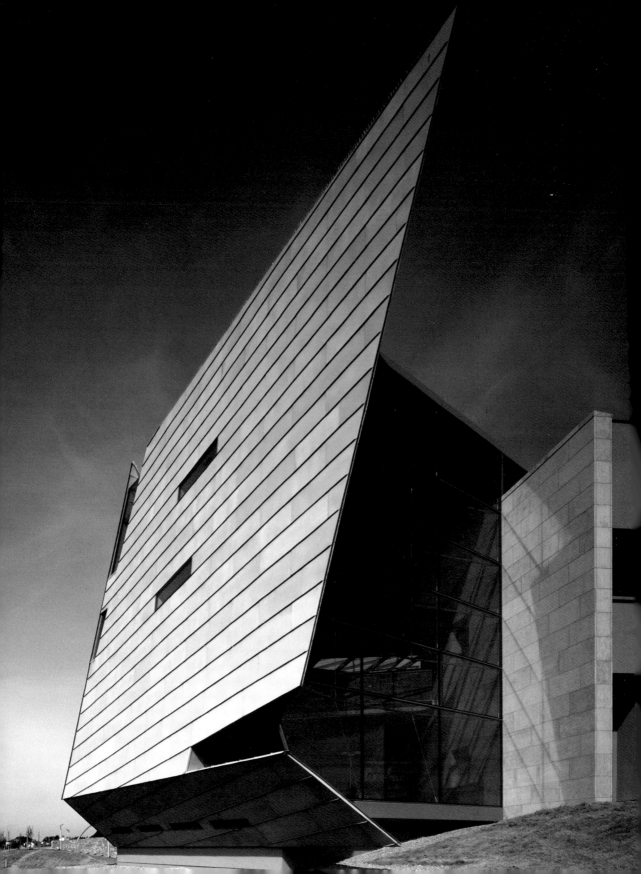

MURRAY O'LAOIRE ARCHITECTS | LIMERICK AND DUBLIN
MAYO INSTITUTE OF TECHNOLOGY
Galway, Ireland | 2004

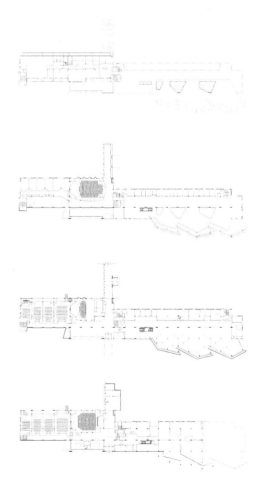

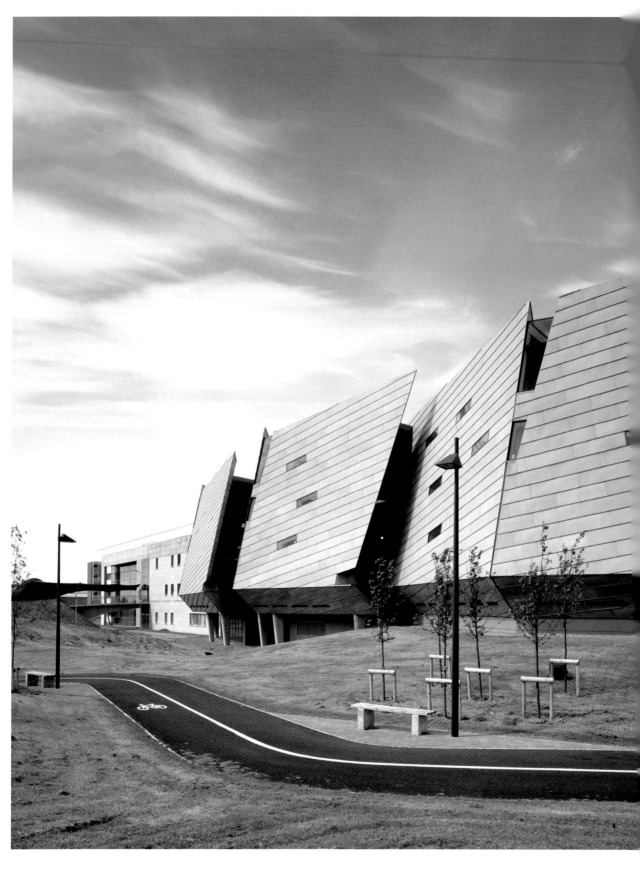

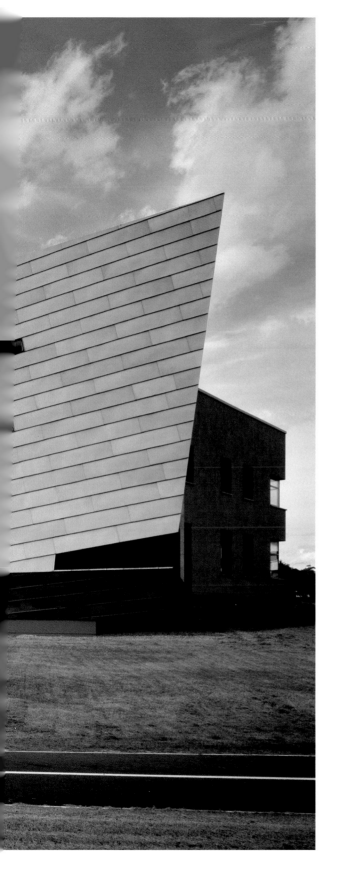

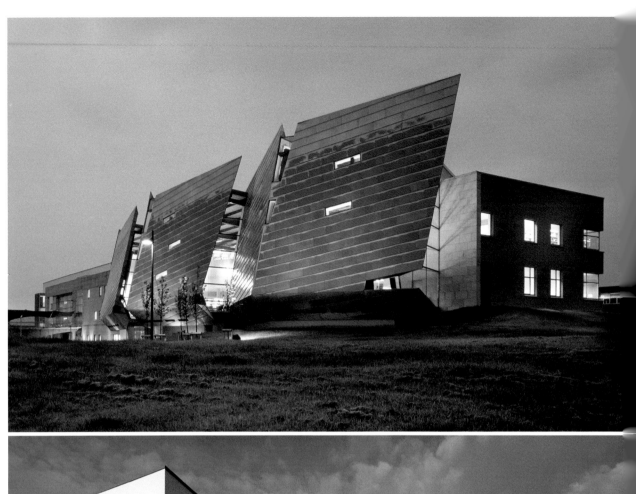
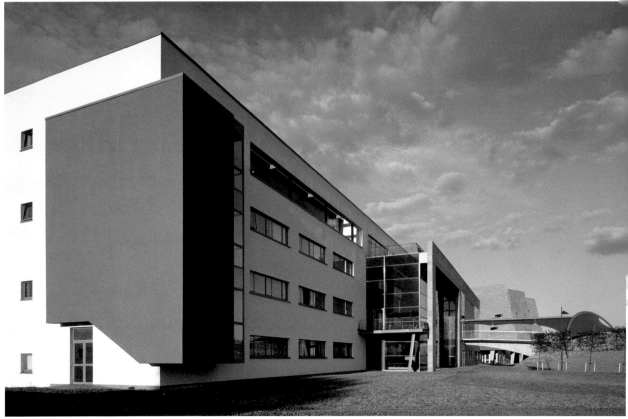

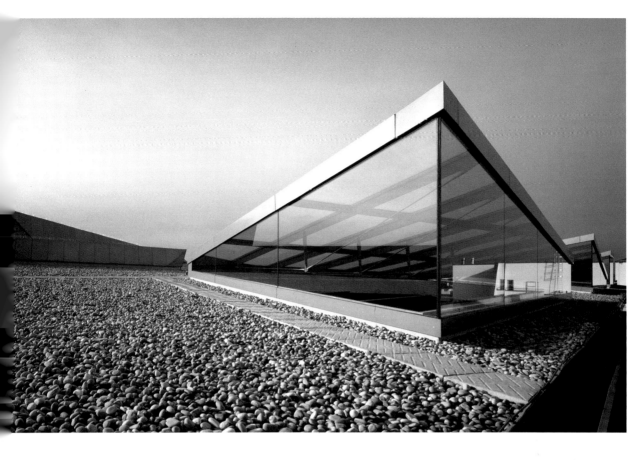

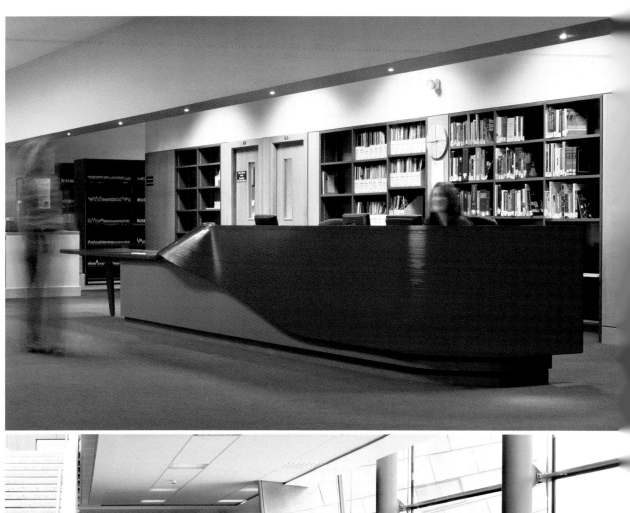
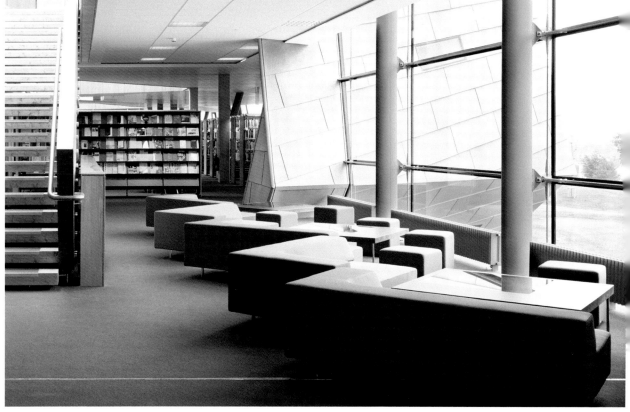

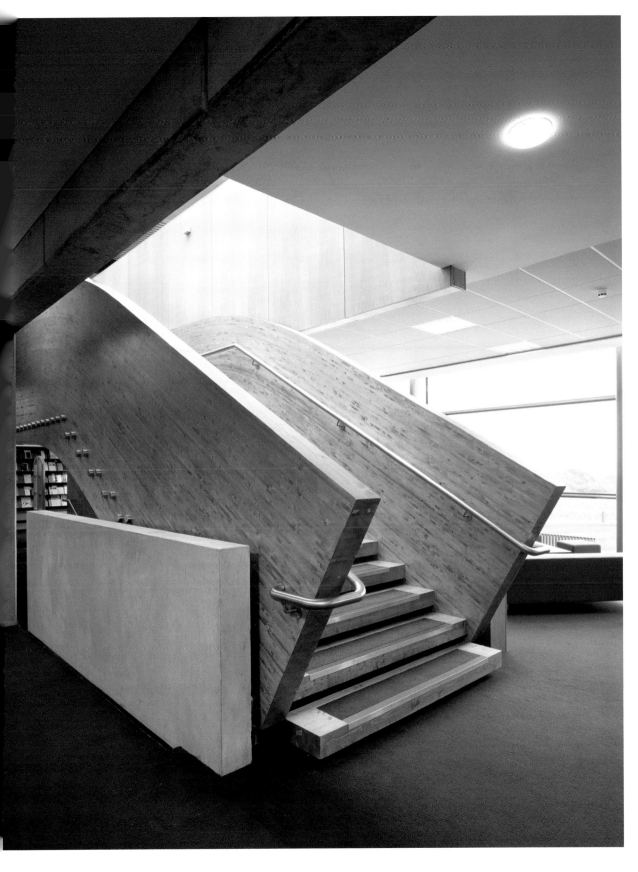

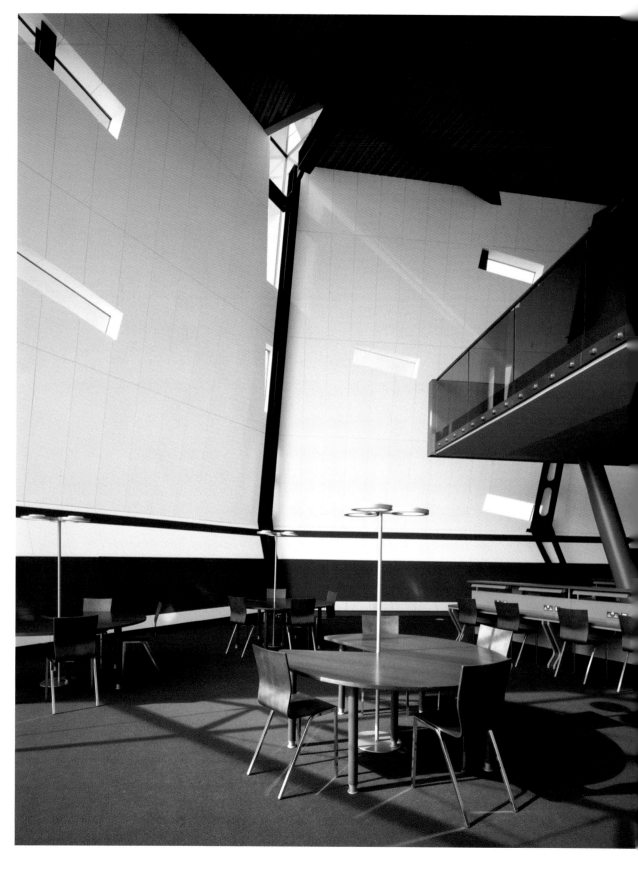

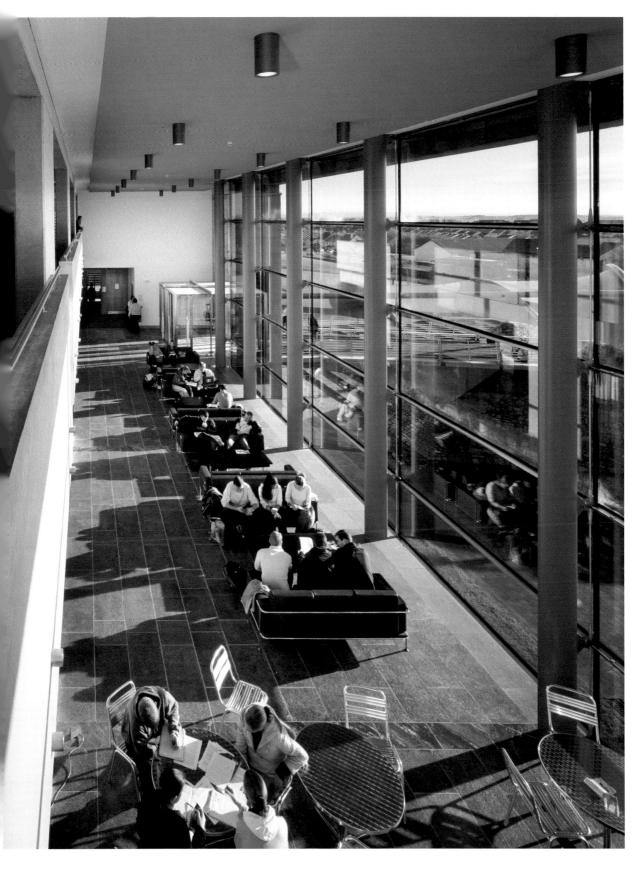

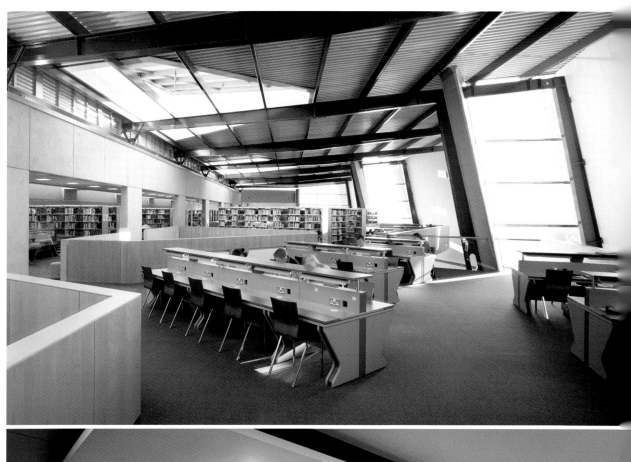

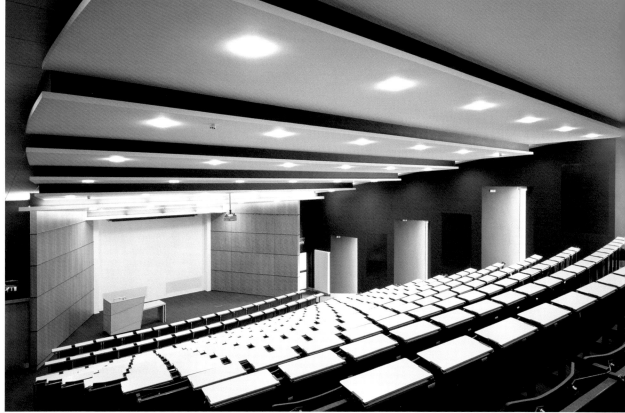

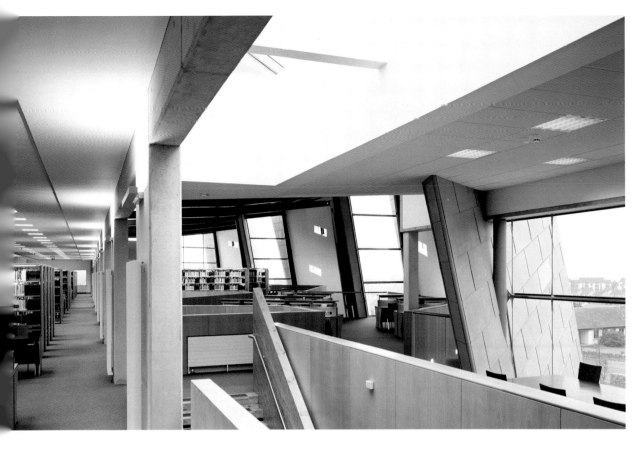

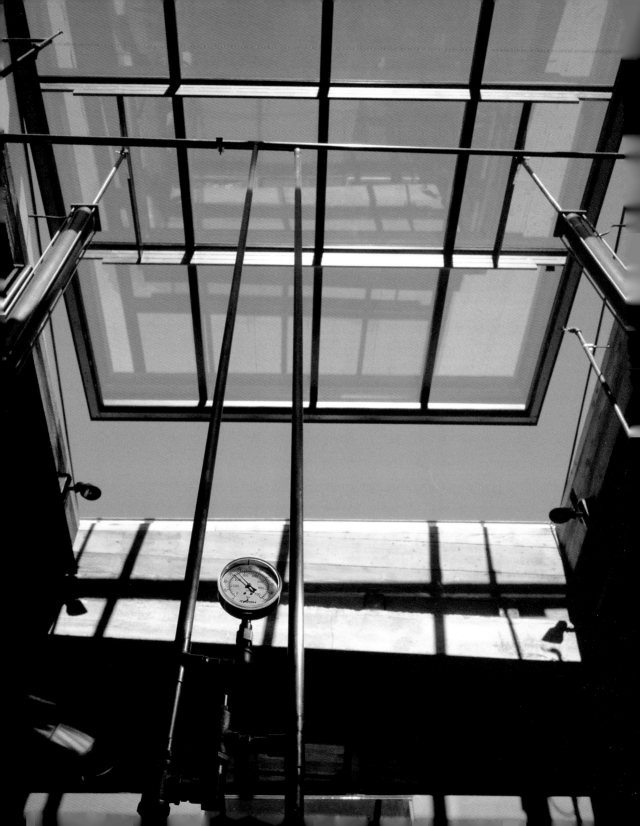

OLSON SUNDBERG KUNDIG ALLEN ARCHITECTS | SEATTLE
OLSON SUNDBERG KUNDIG ALLEN ARCHITECTS OFFICE
Seattle, WA, USA | 2004

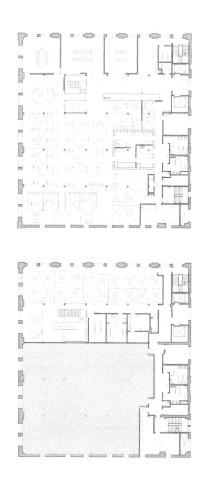

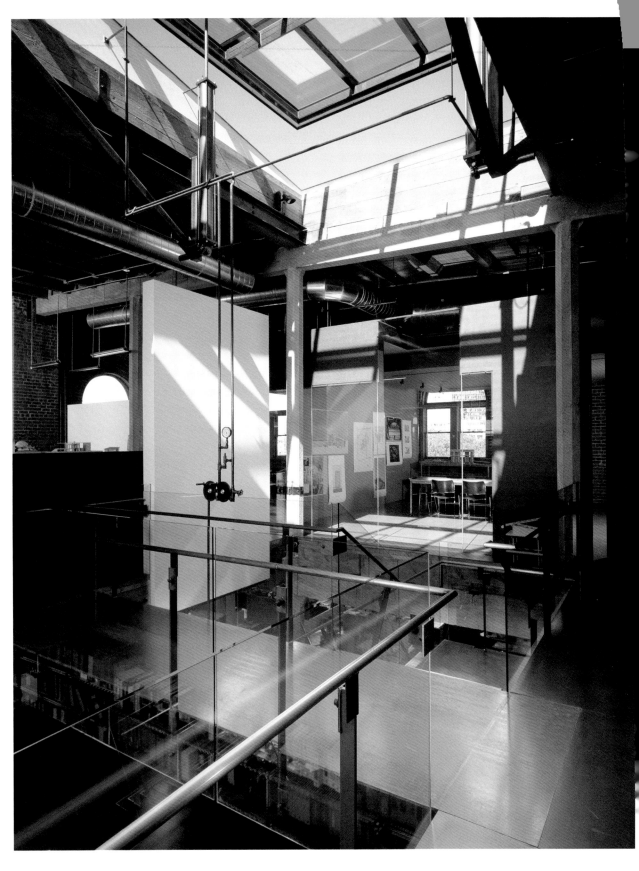

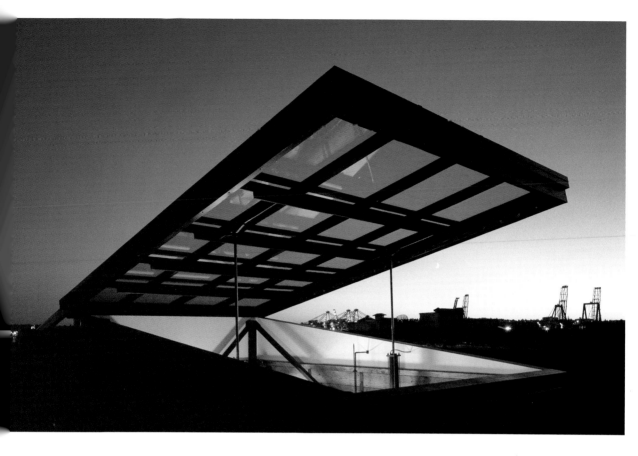

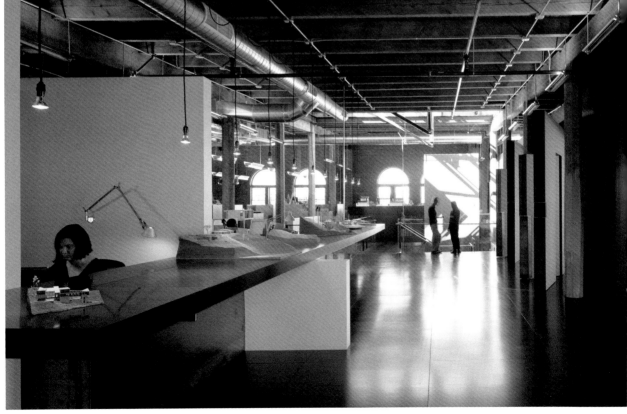

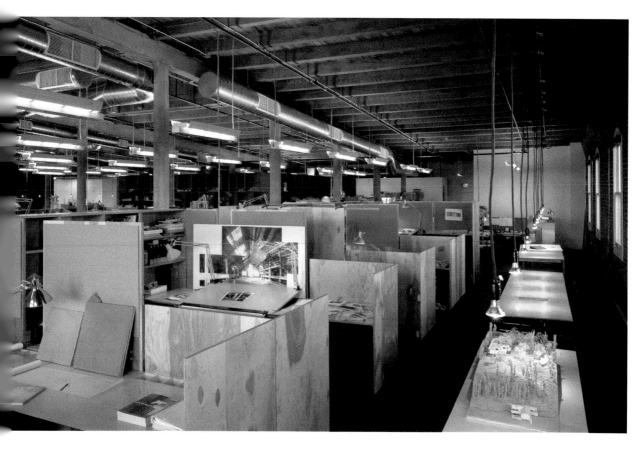

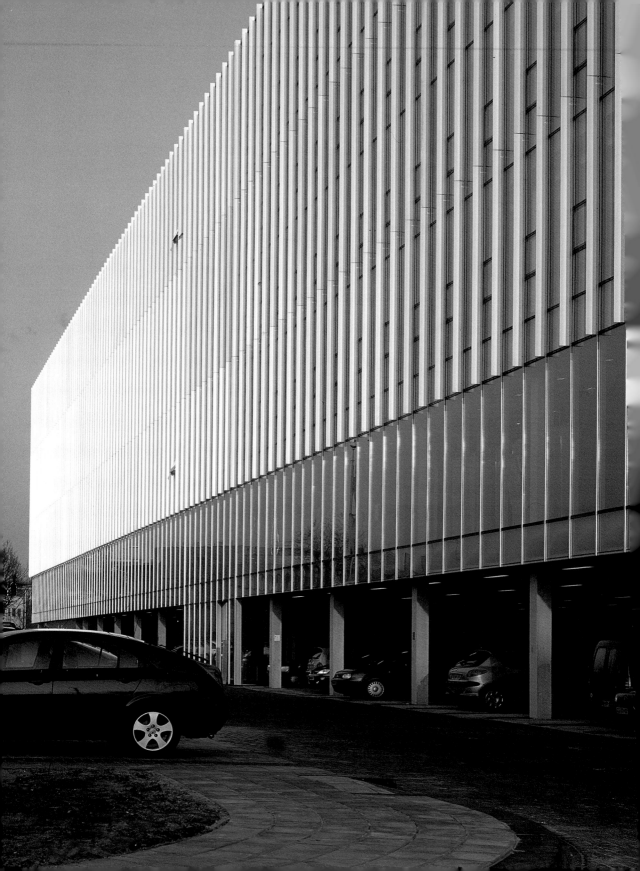

PAUL DE RUITER | AMSTERDAM
HEAD OFFICE DEPARTMENT OF WATER MANAGEMENT AND TRAFFIC
Middelburg, the Netherlands | 2004

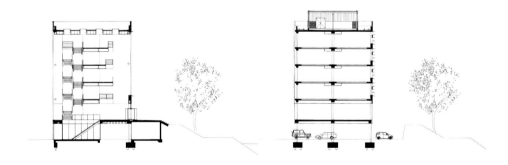

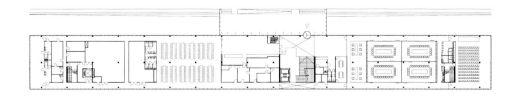

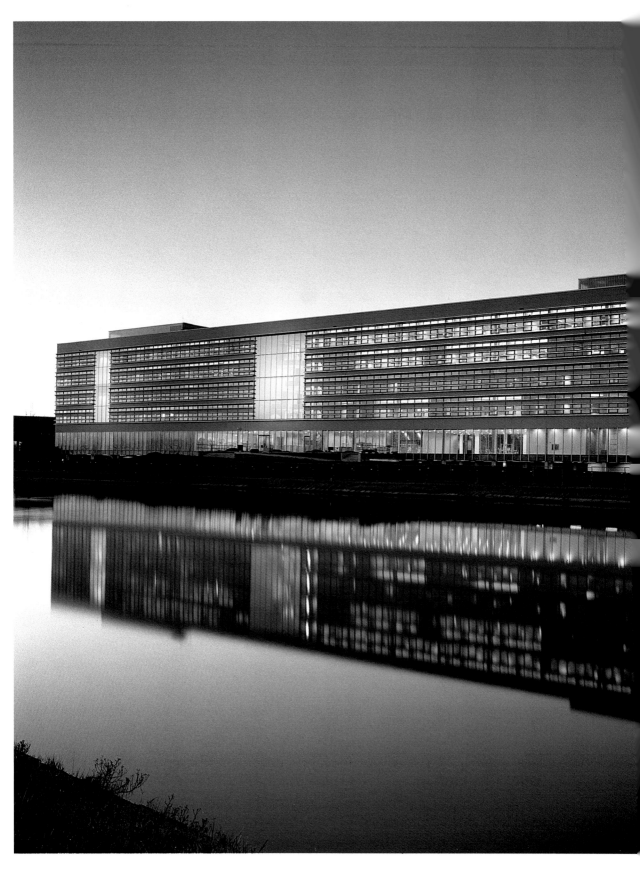

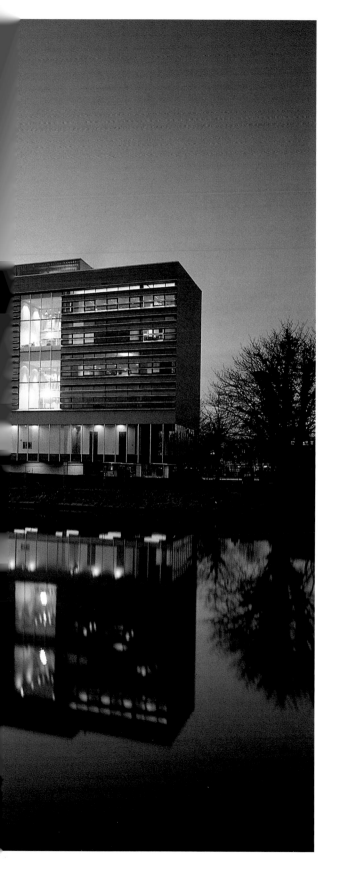

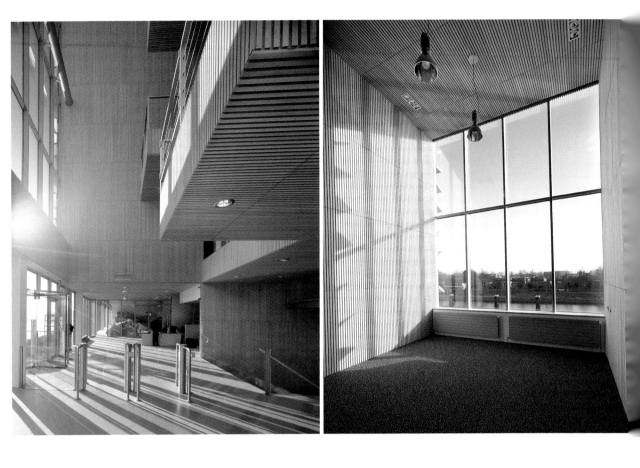

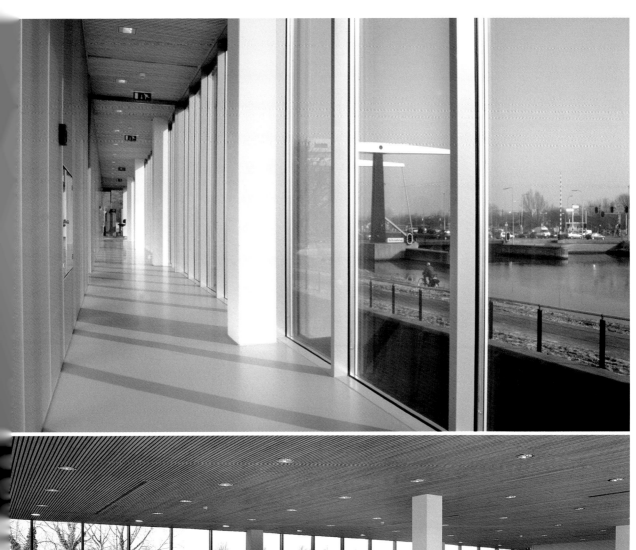
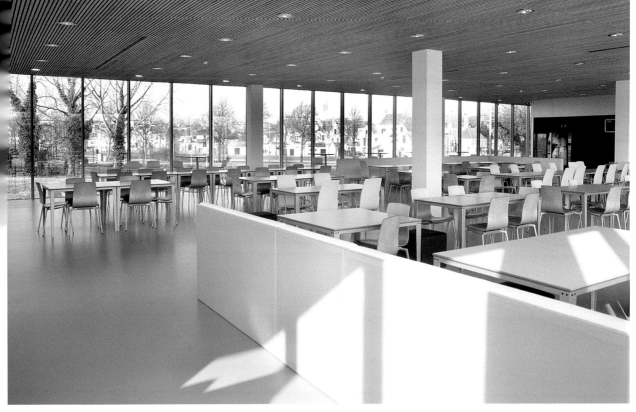

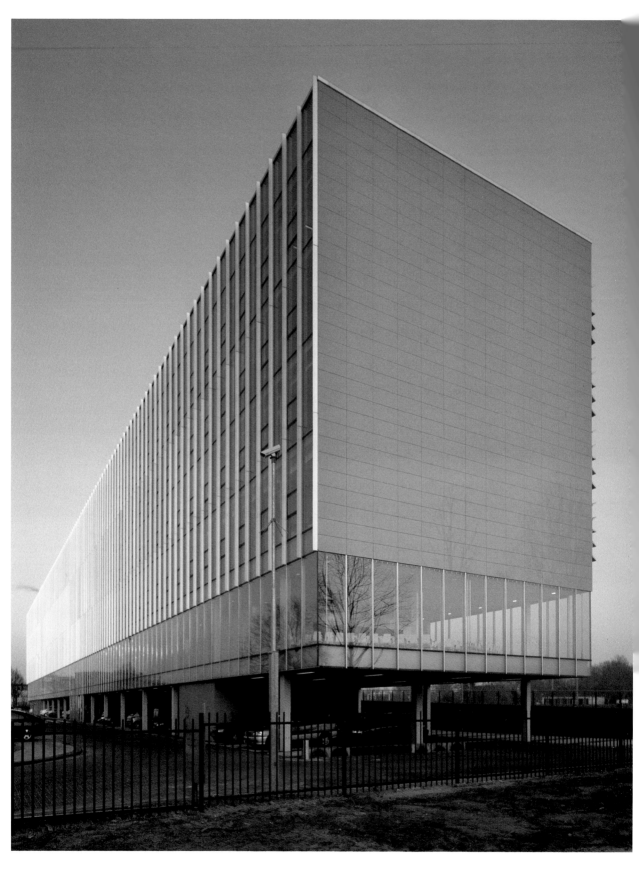

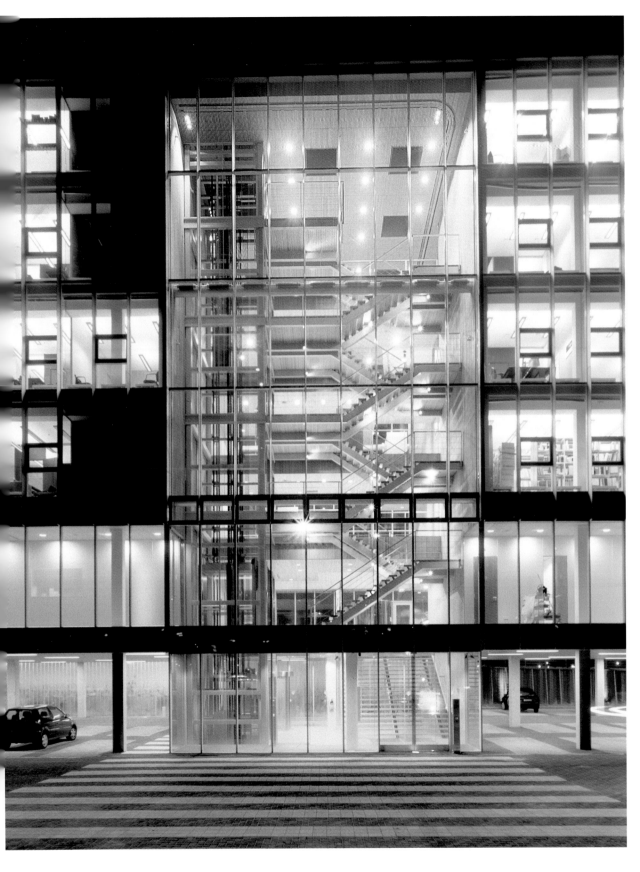

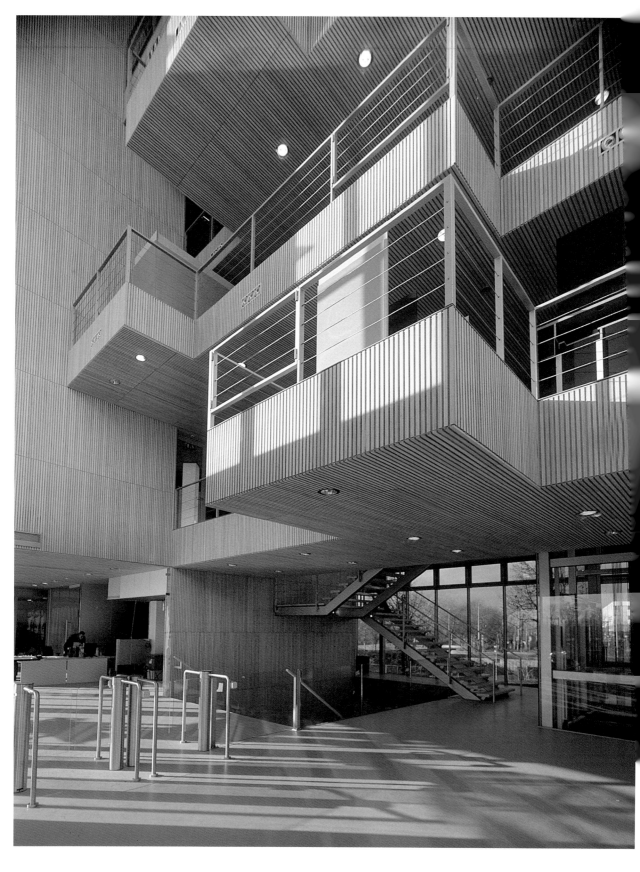

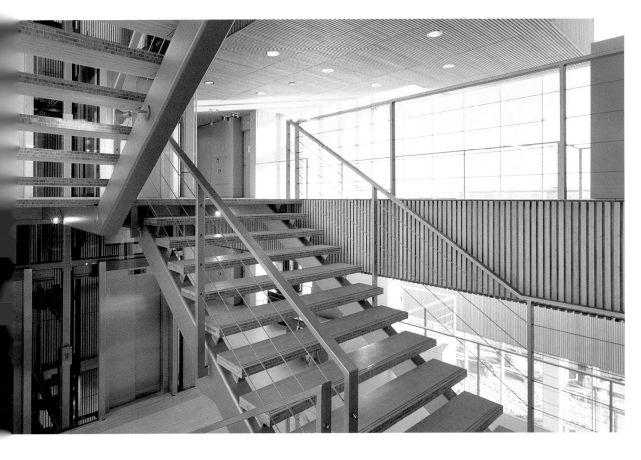

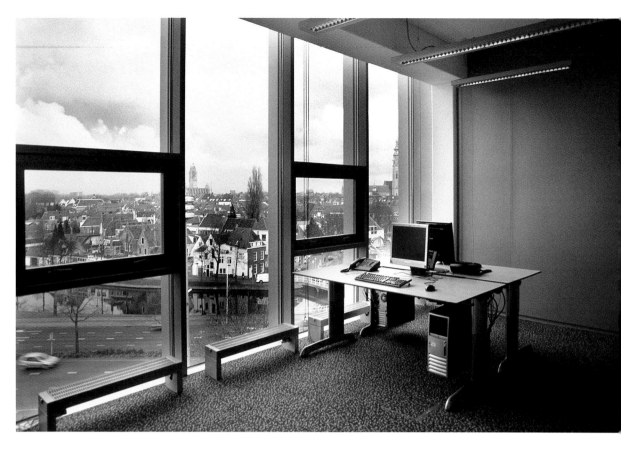

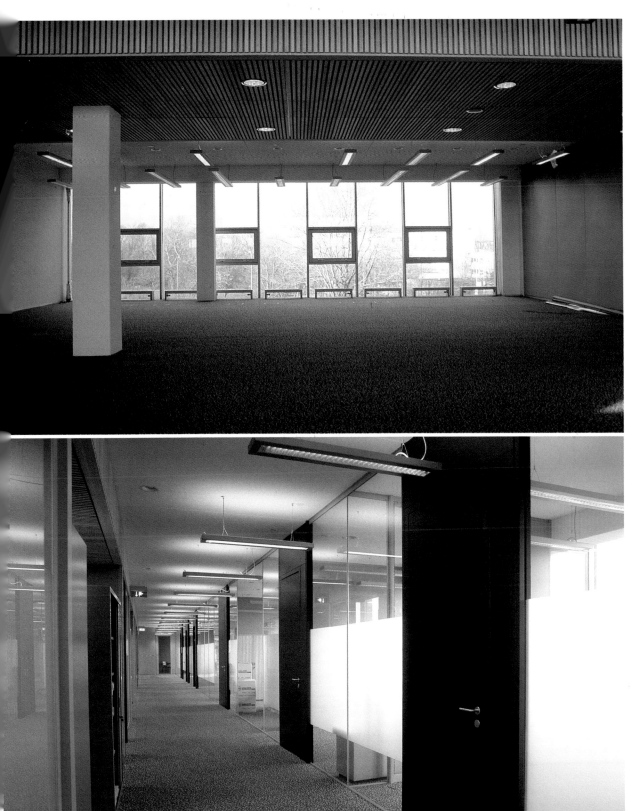

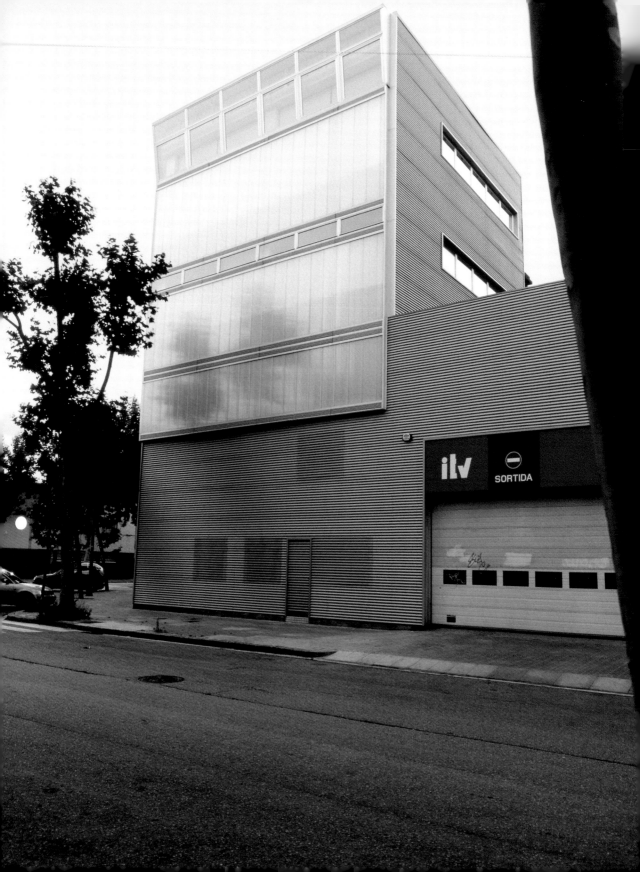

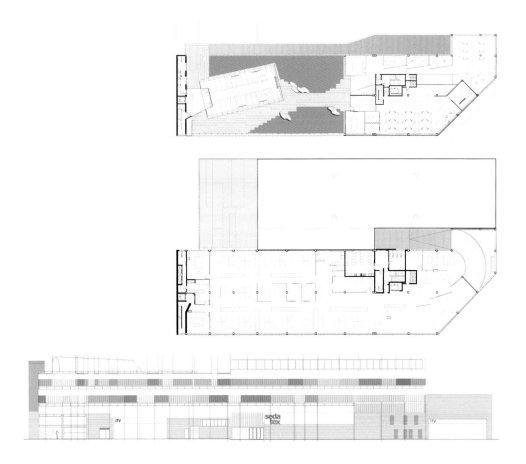

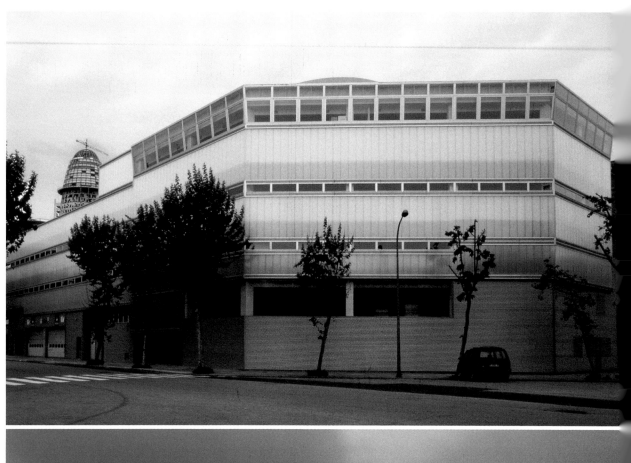
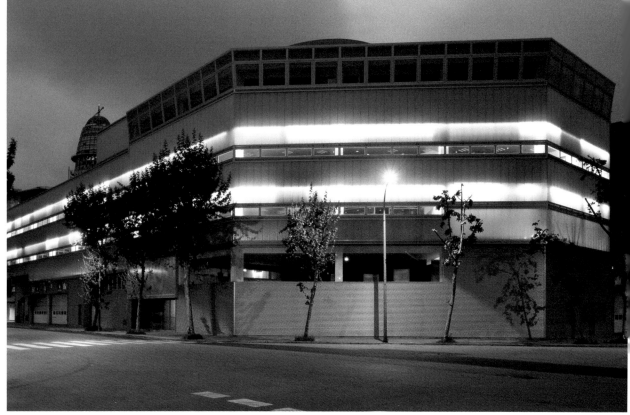

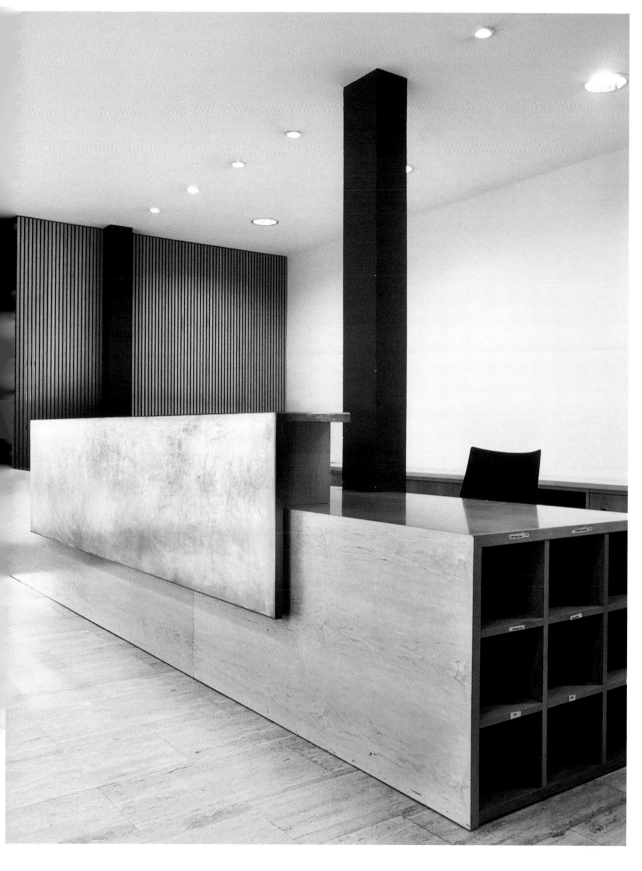

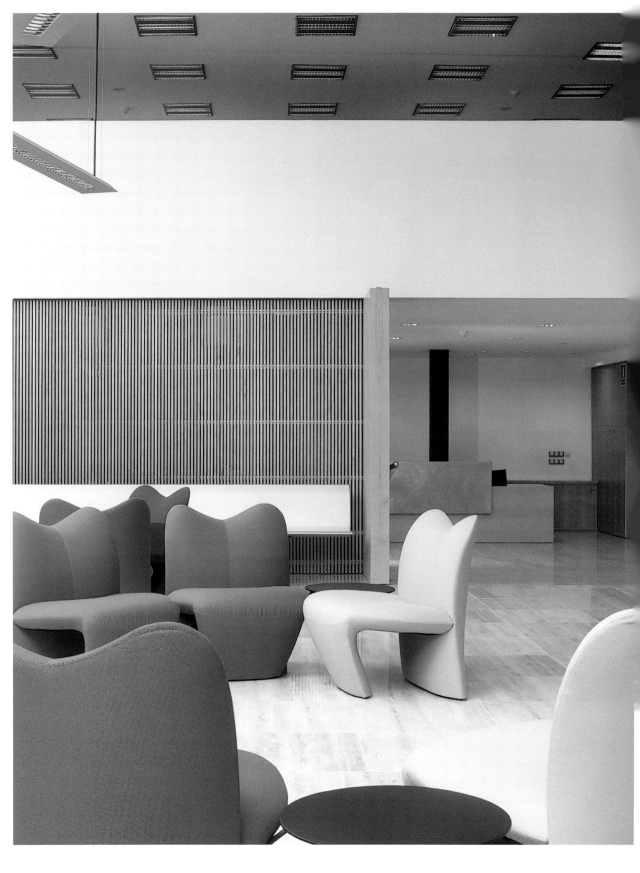

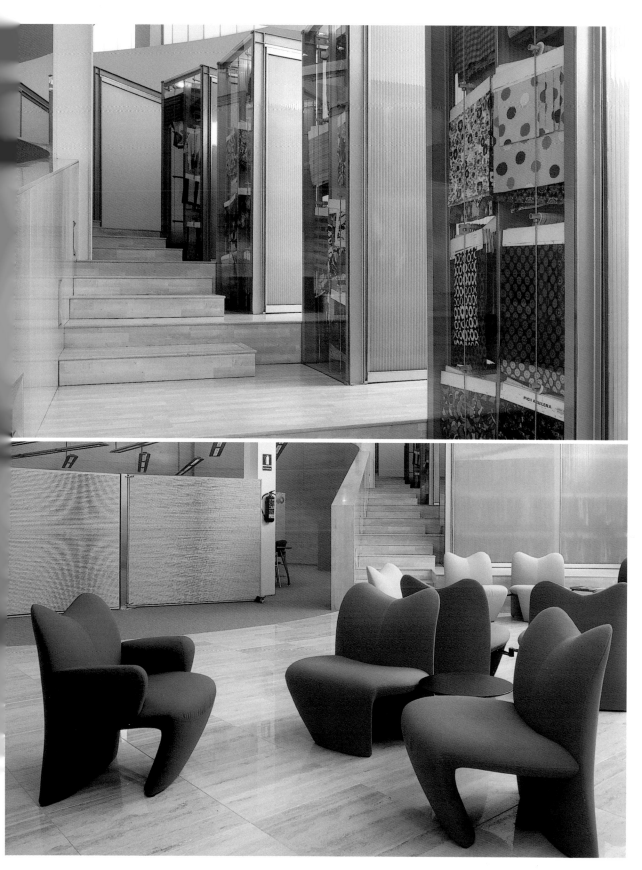

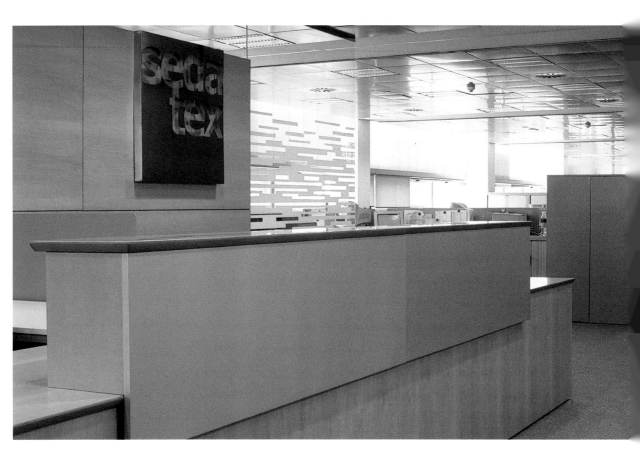

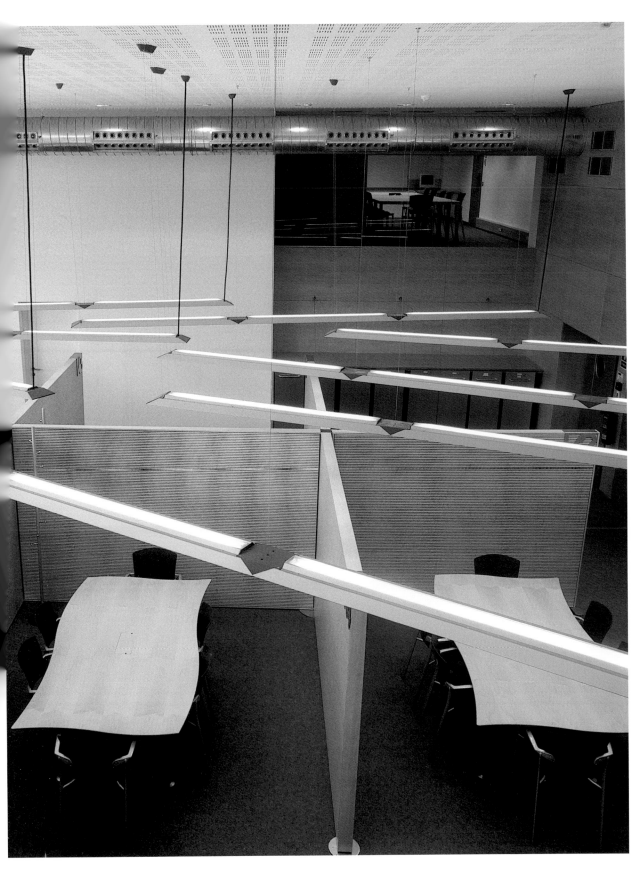

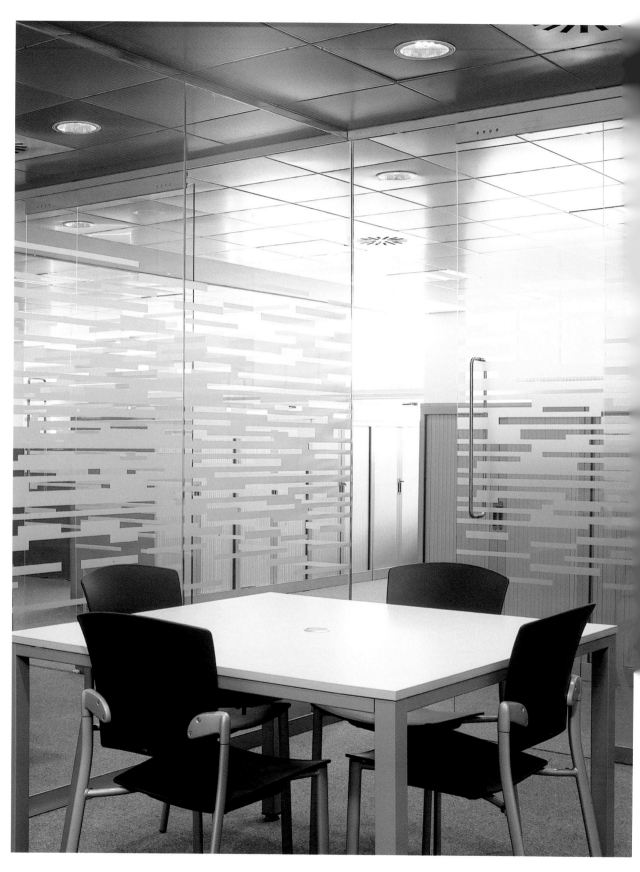

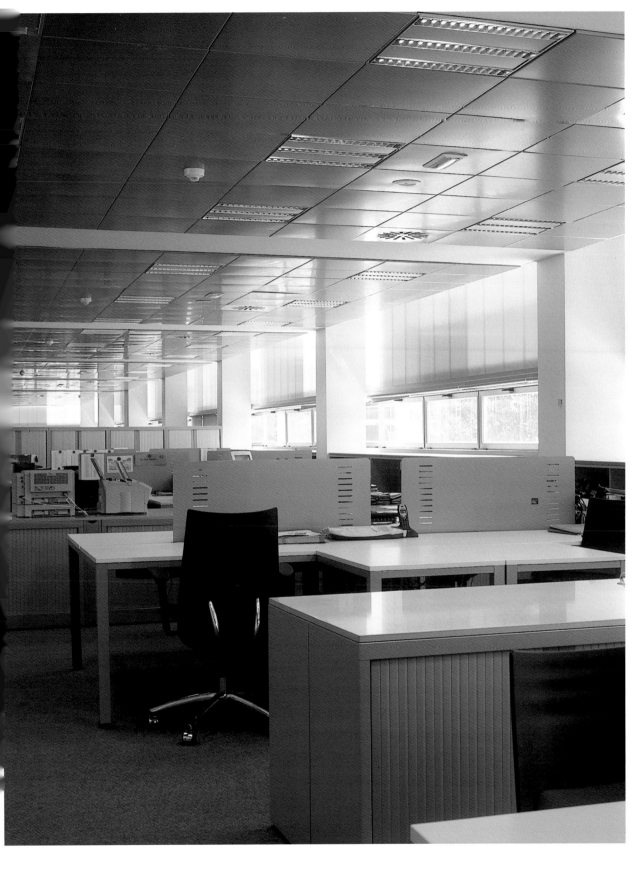

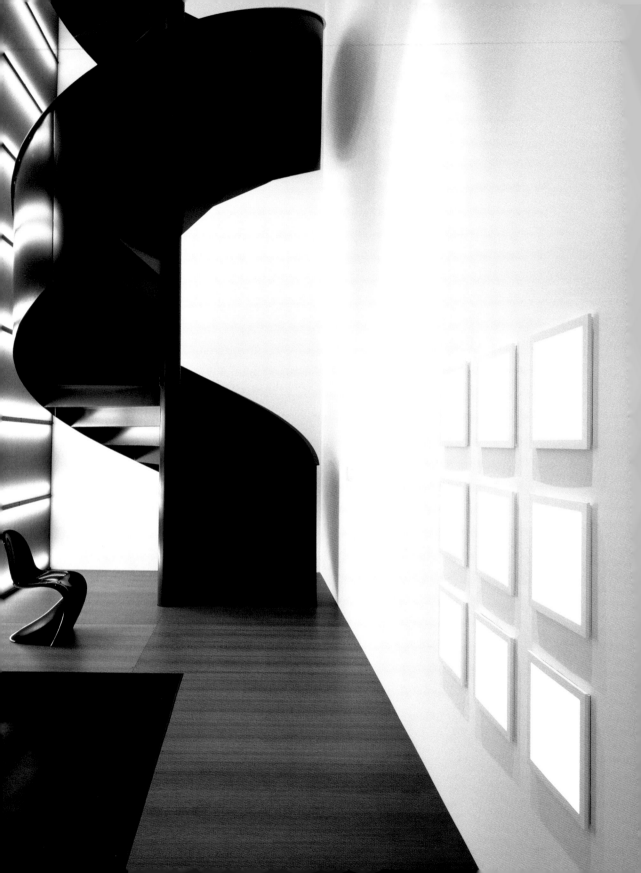

FRANCESC RIFÉ | BARCELONA
DURAVIT
Parets del Vallès, Spain | 2004

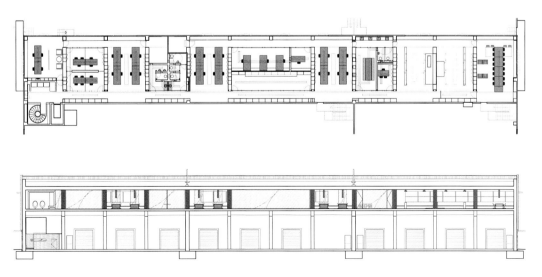

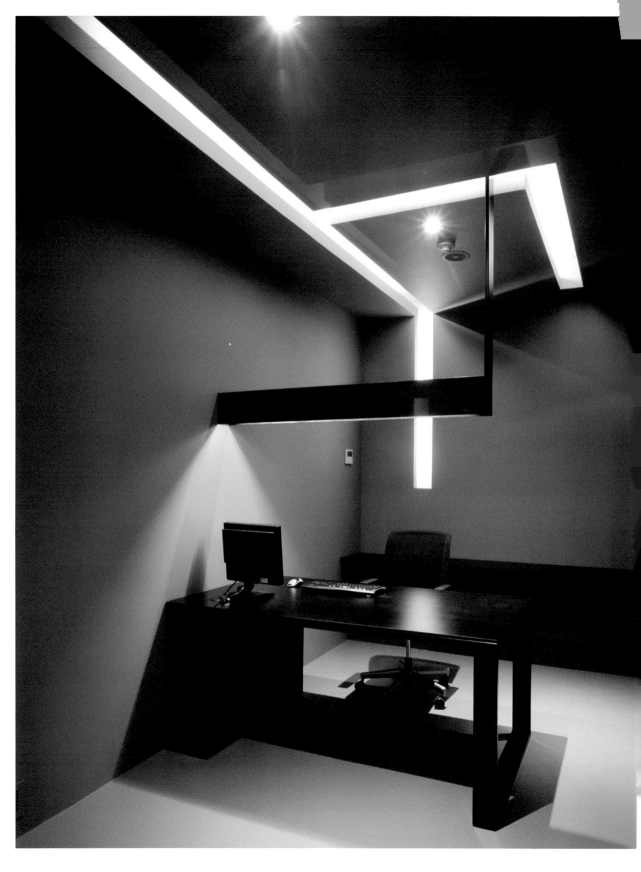

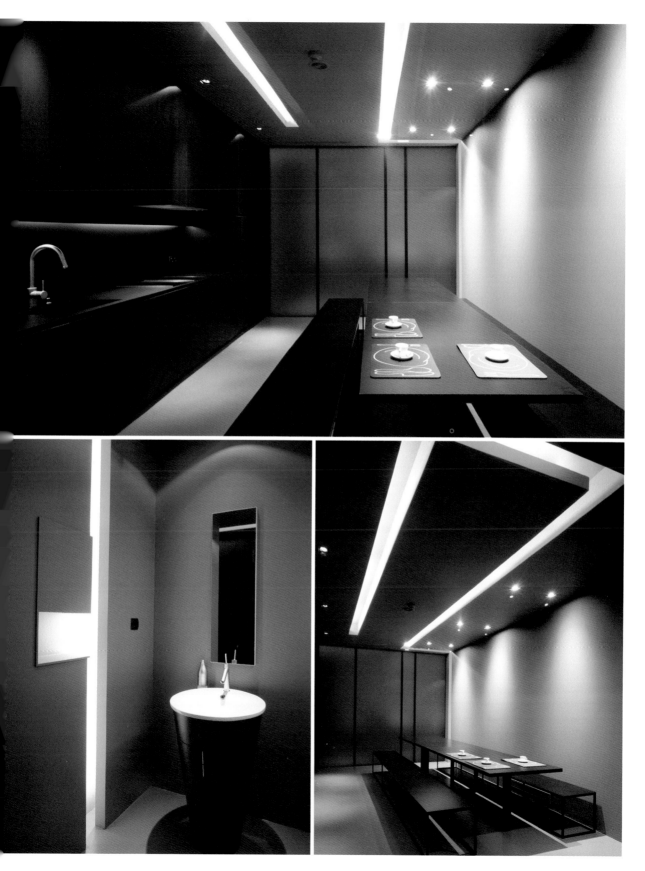

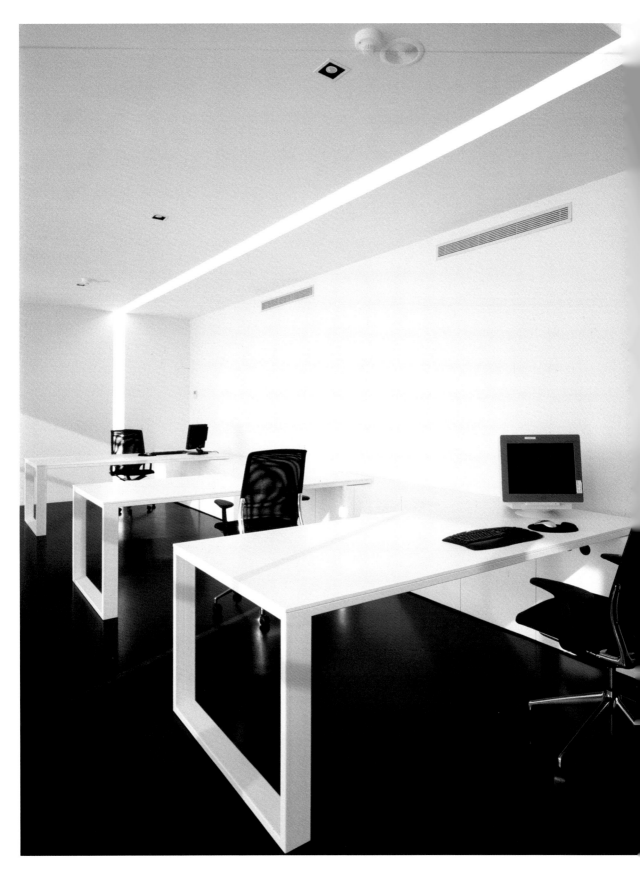

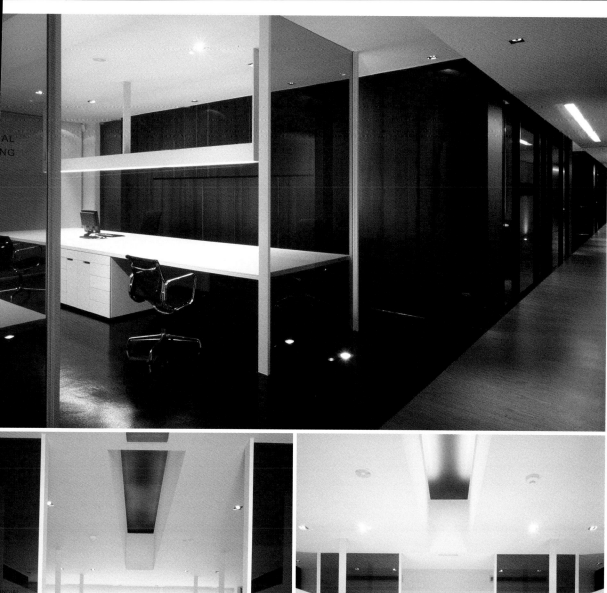
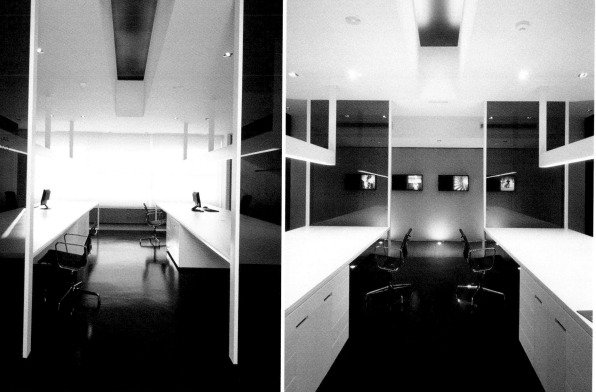

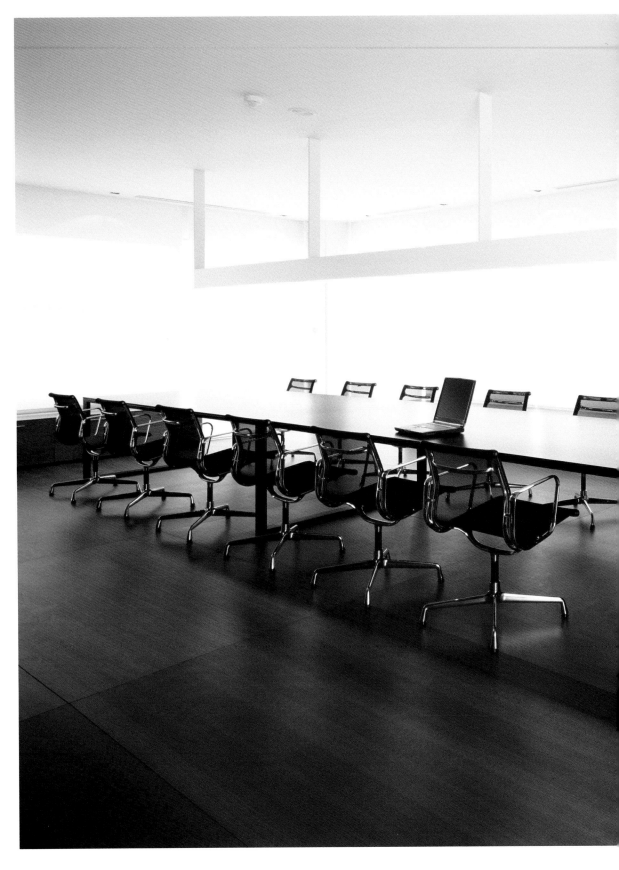

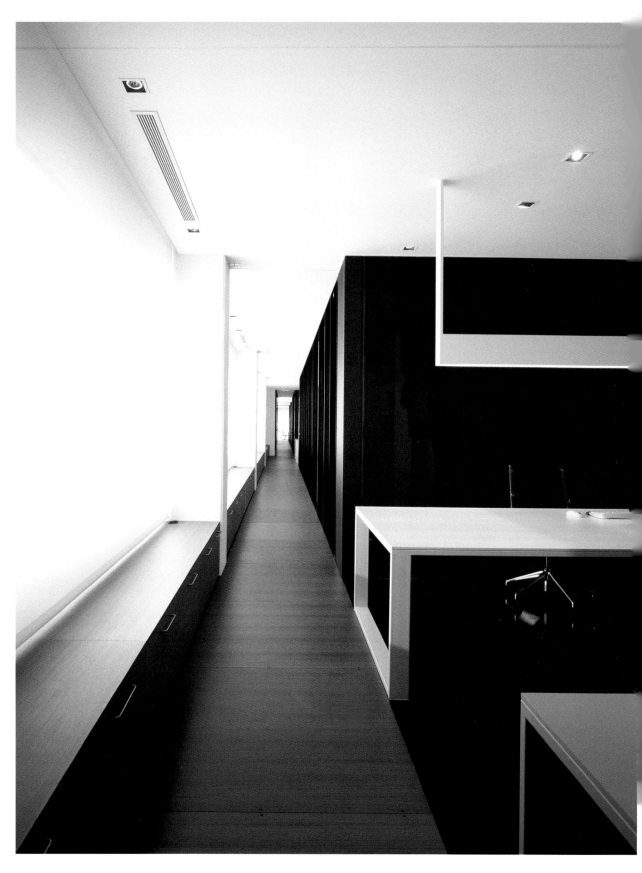

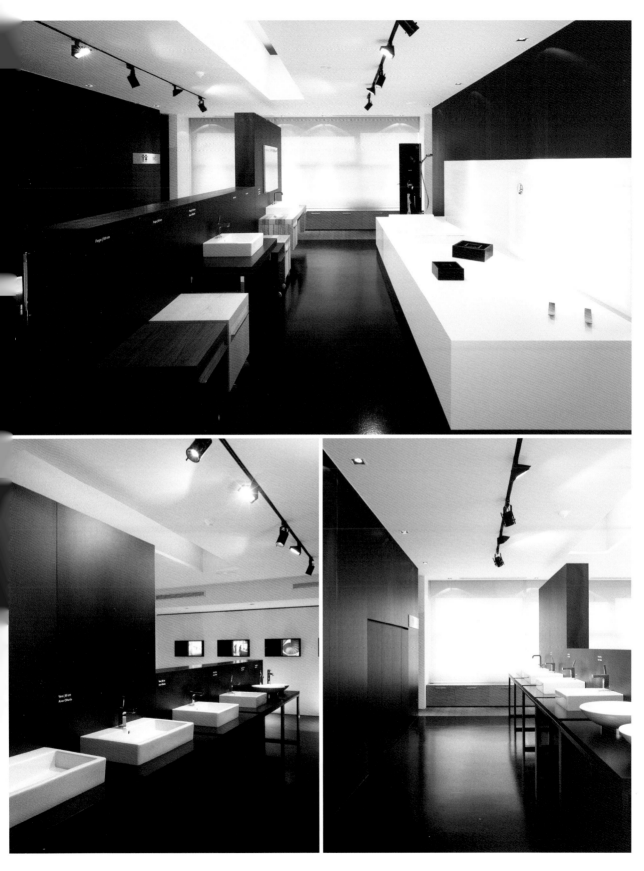

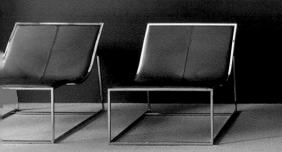

PBS

Professional BookKeeping Services

FRANCESC RIFÉ | BARCELONA
PBS OFFICES
Barcelona, Spain | 2004

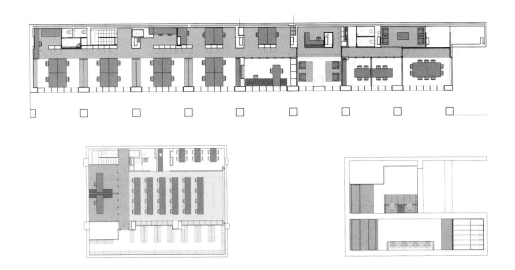

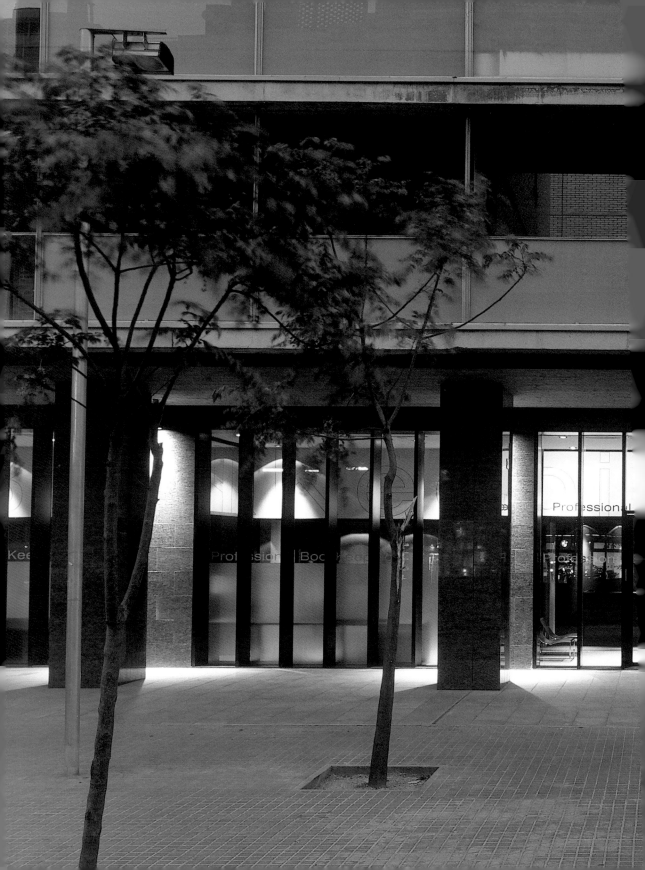

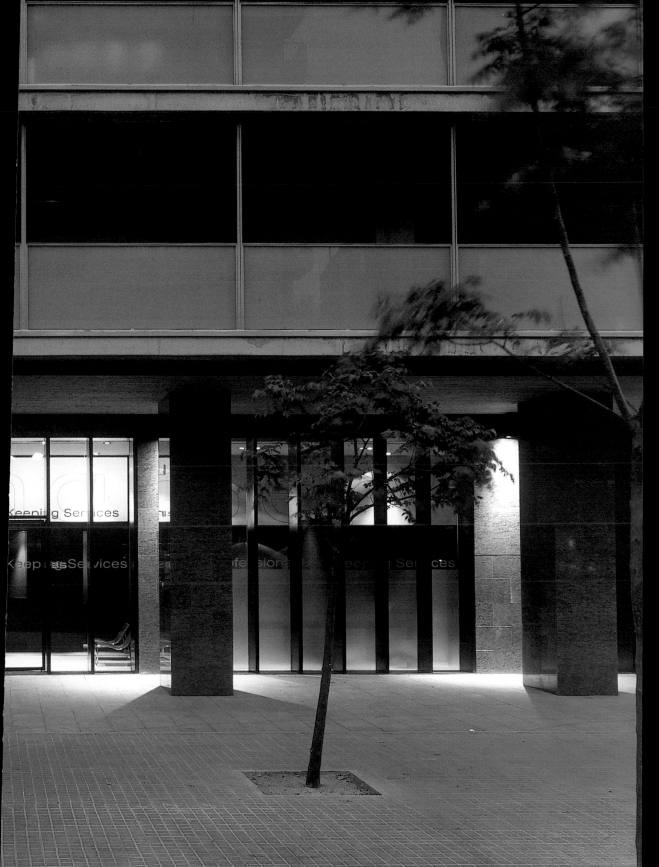

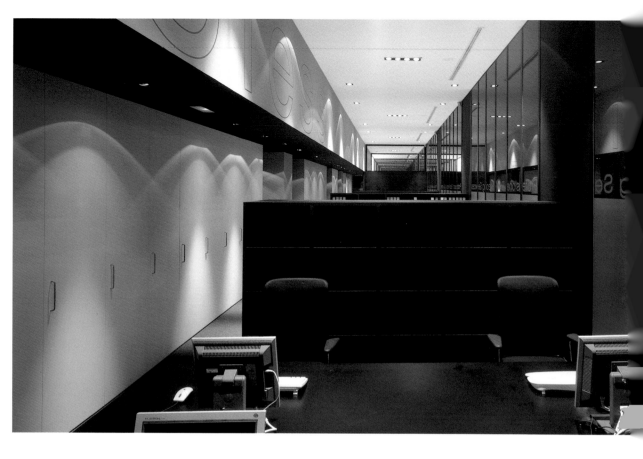

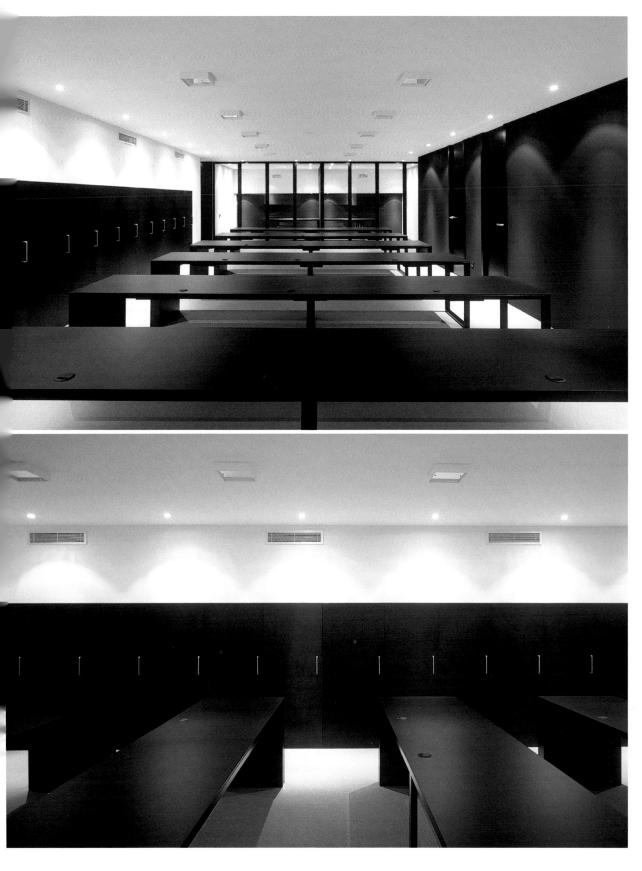

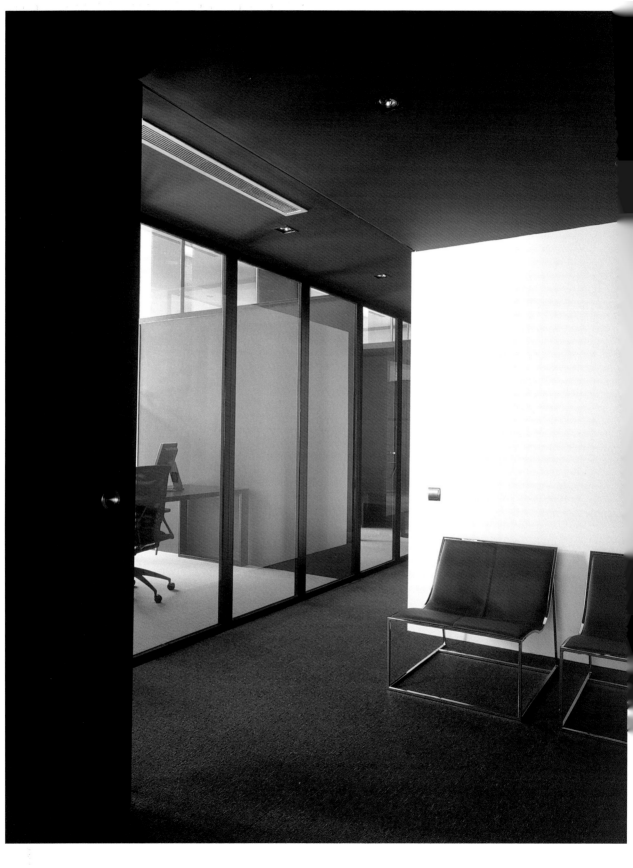

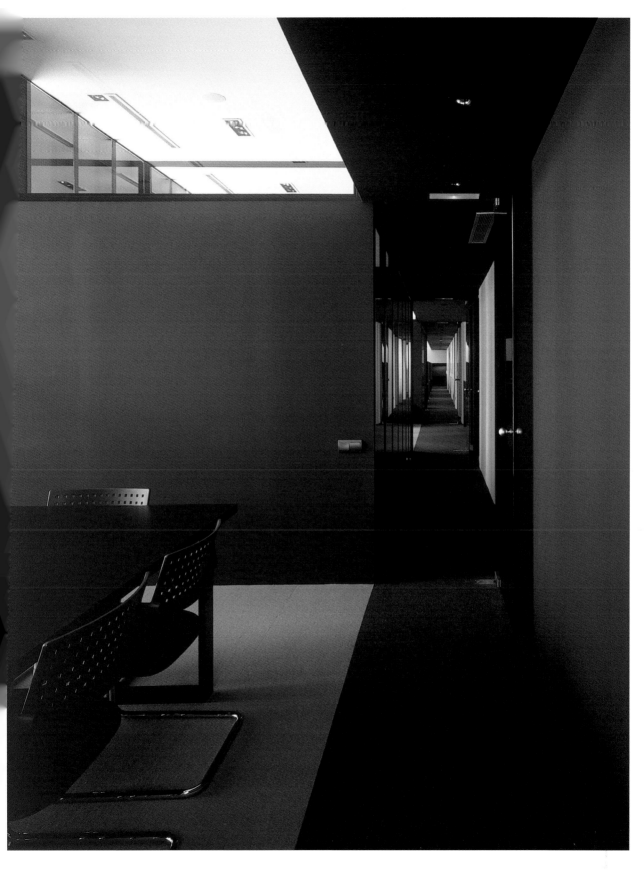

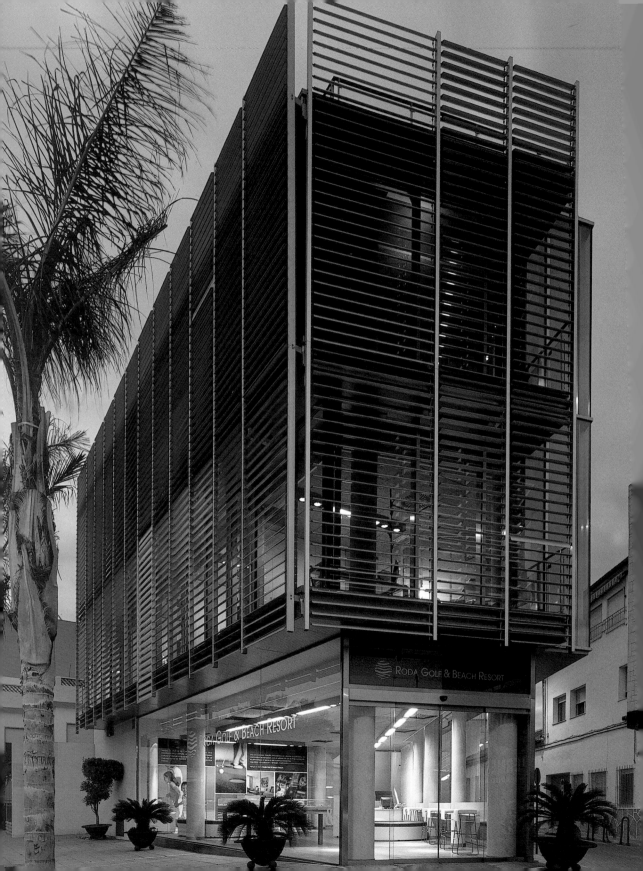

SALVADOR GRIÑÁN | MURCIA
RODA GOLF
Murcia, Spain | 2003

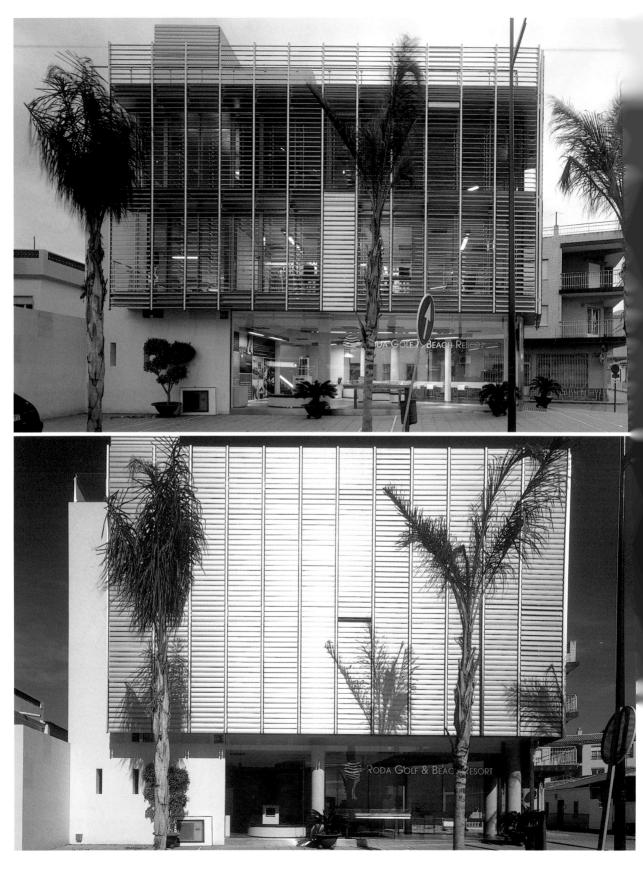

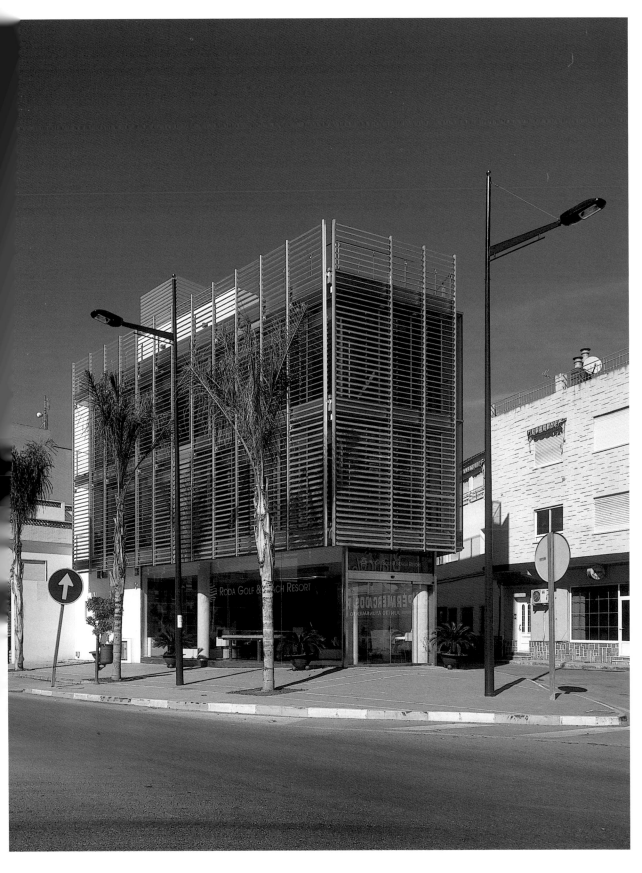

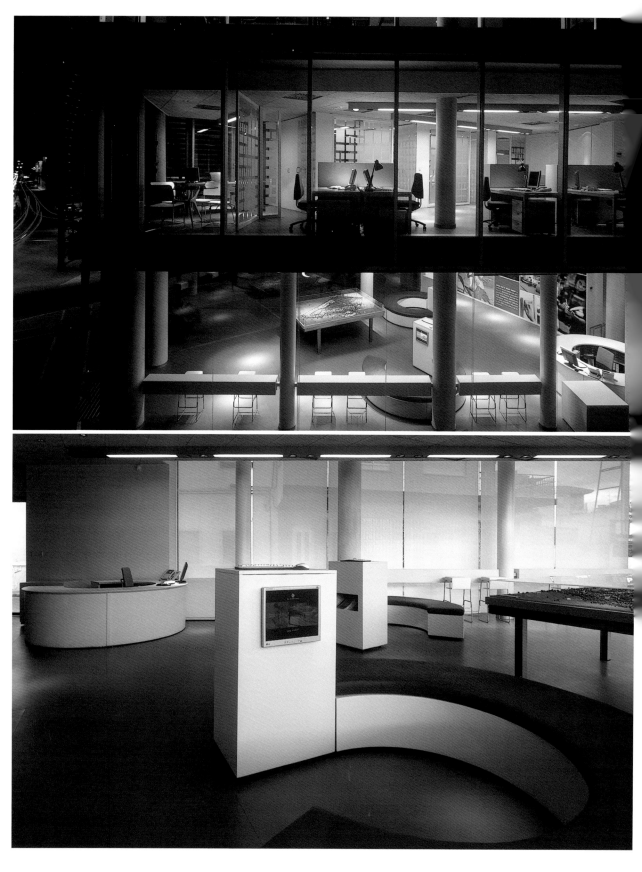

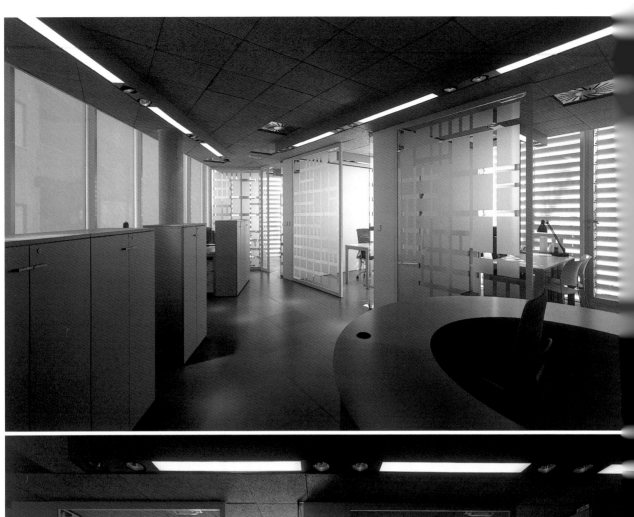
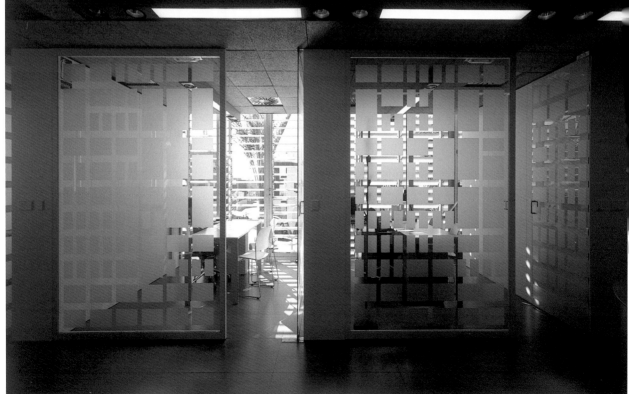

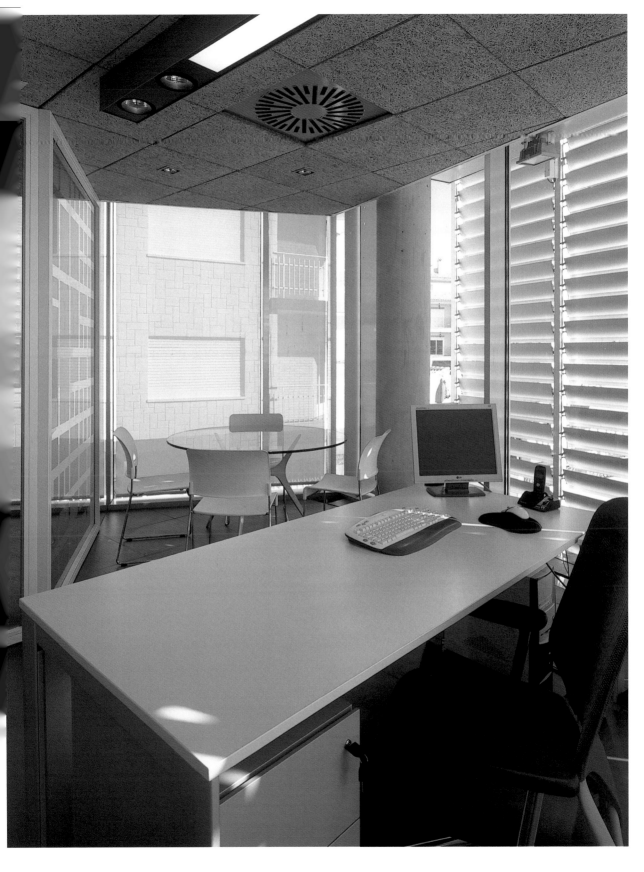

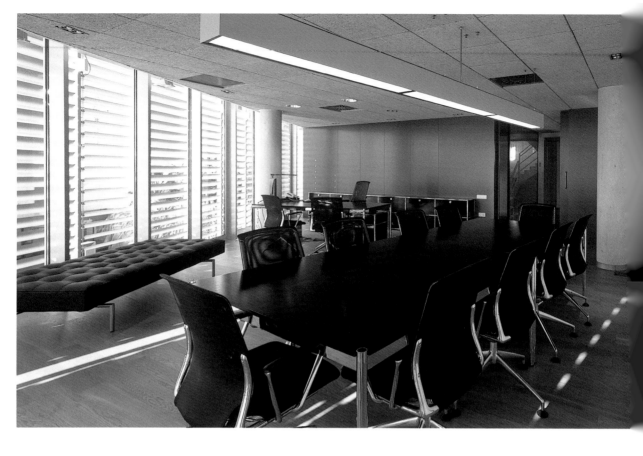

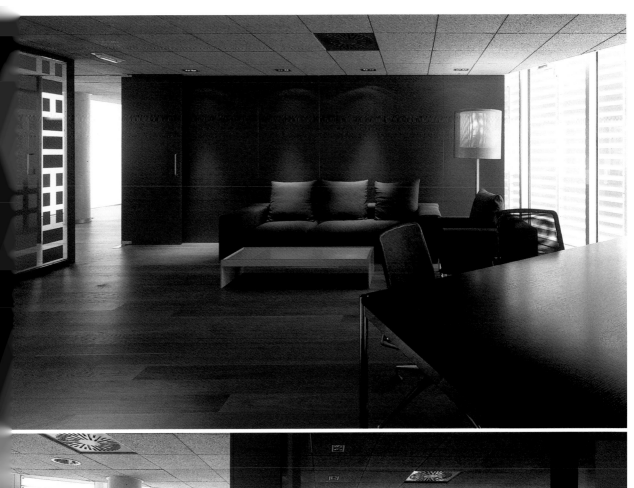
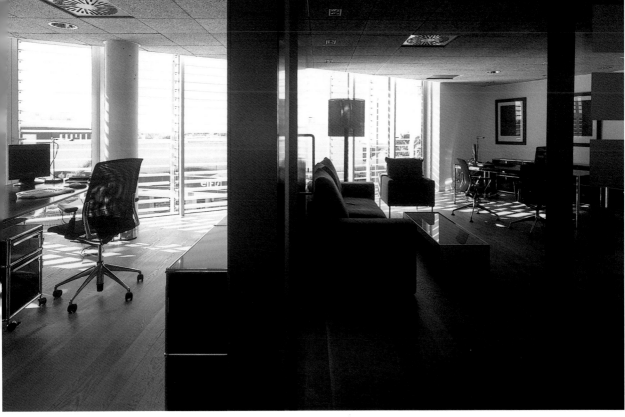

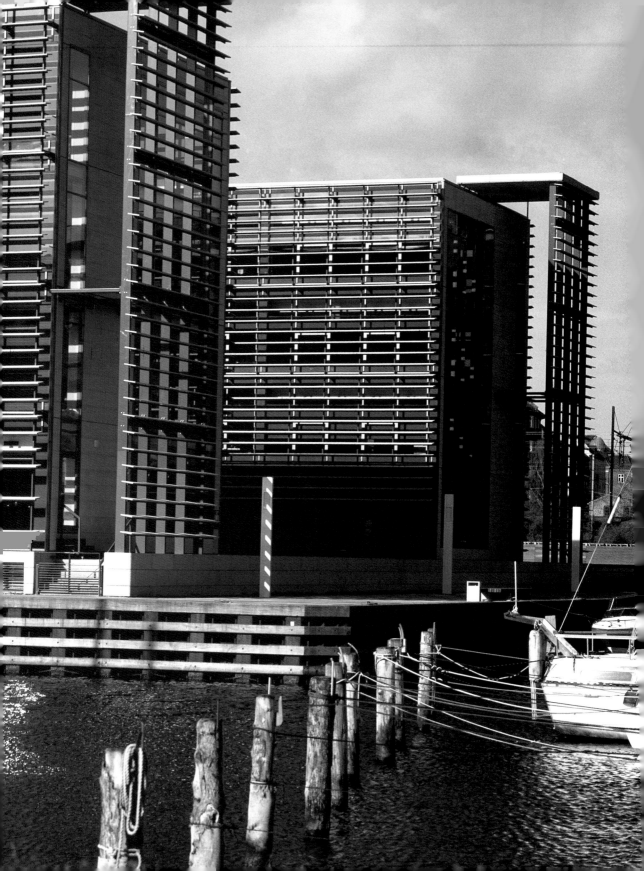

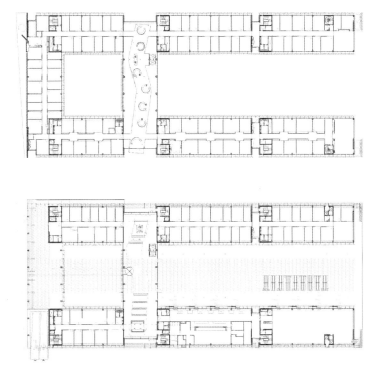

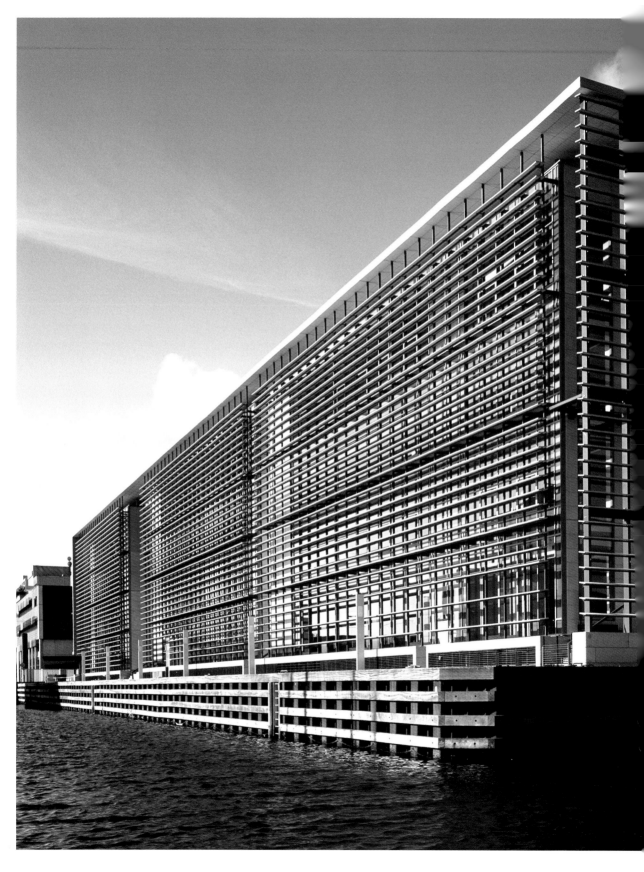

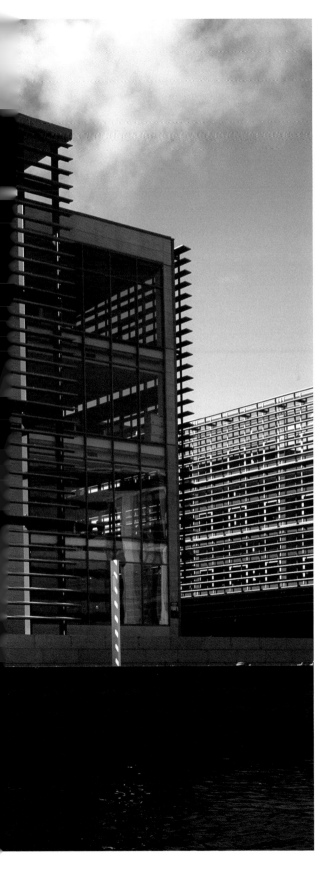

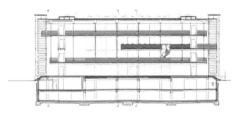

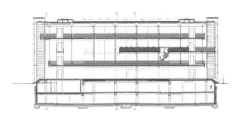

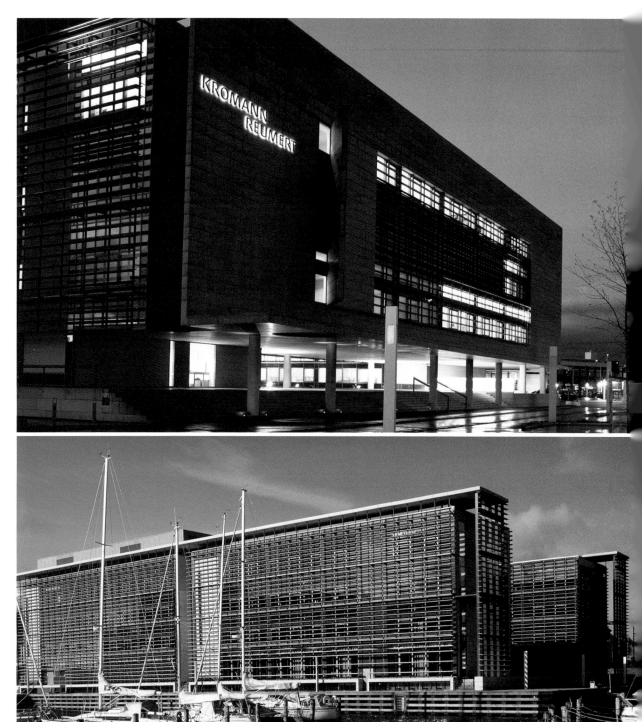

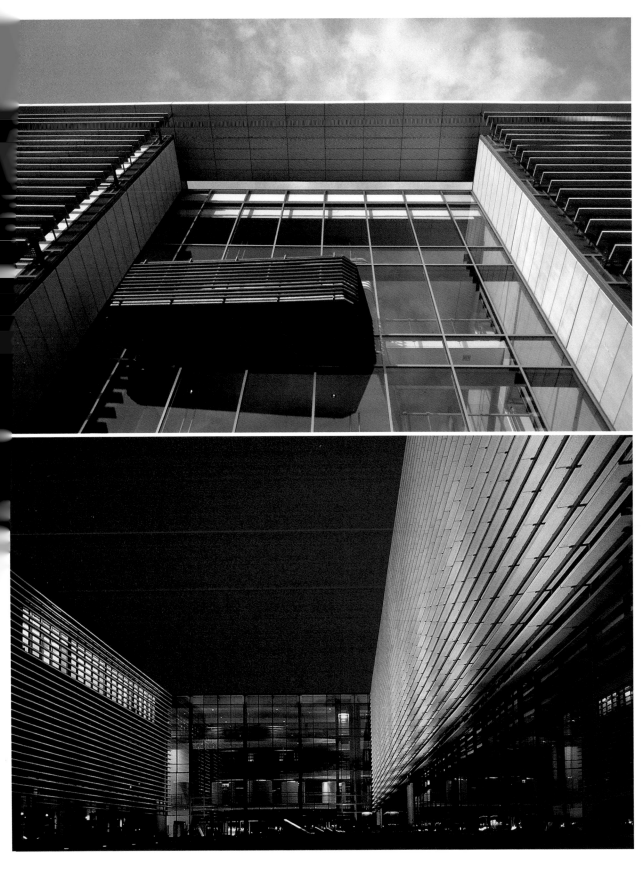

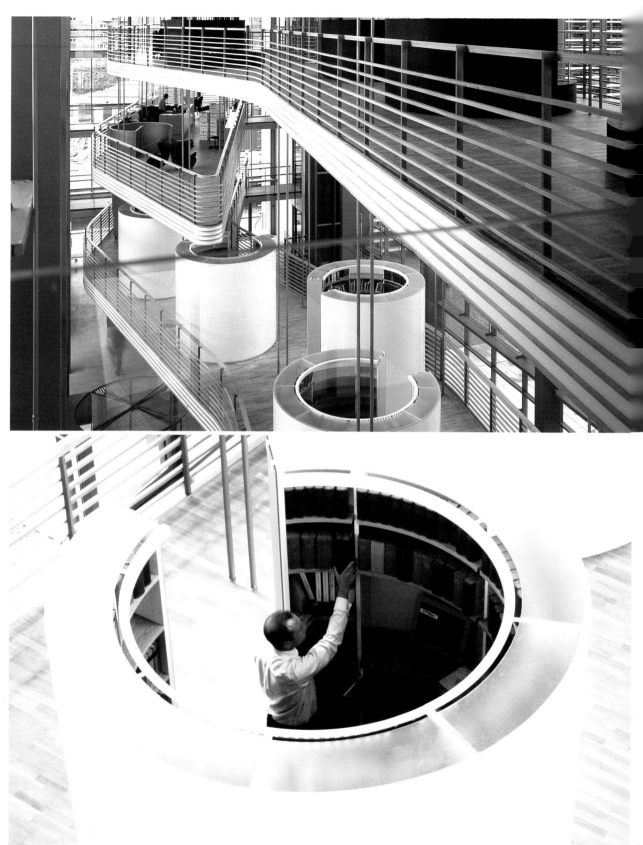

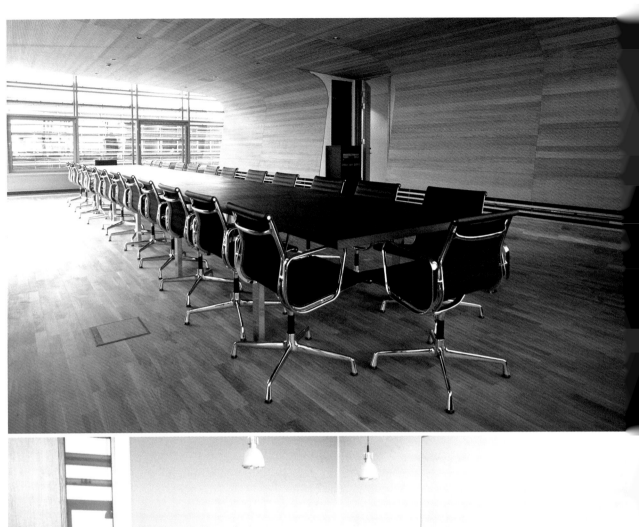

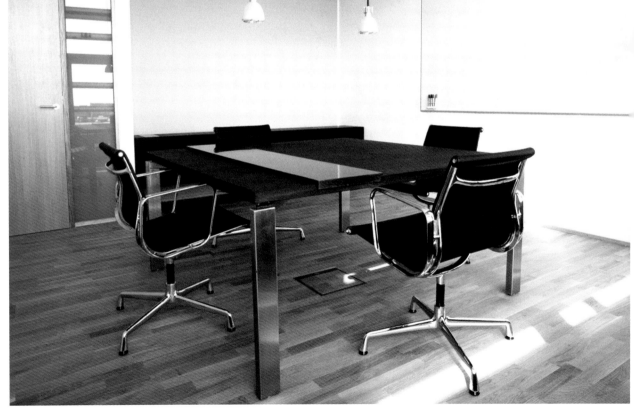

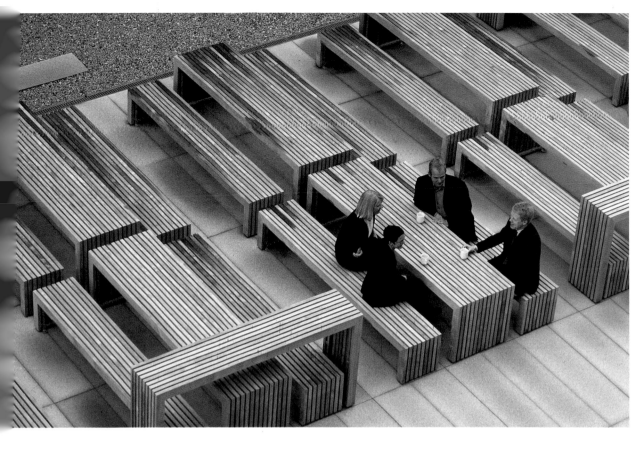

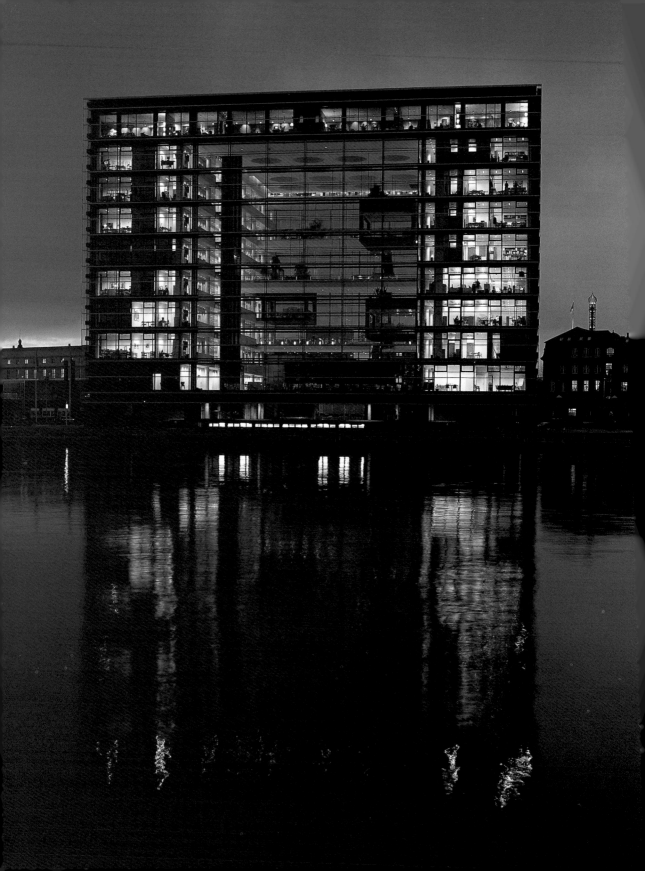

SCHMIDT, HAMMER AND LASSEN | AARHUS
NYKREDIT
Copenhagen, Denmark | 2001

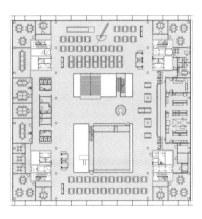

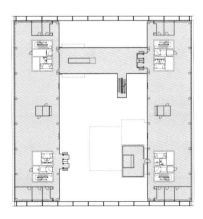

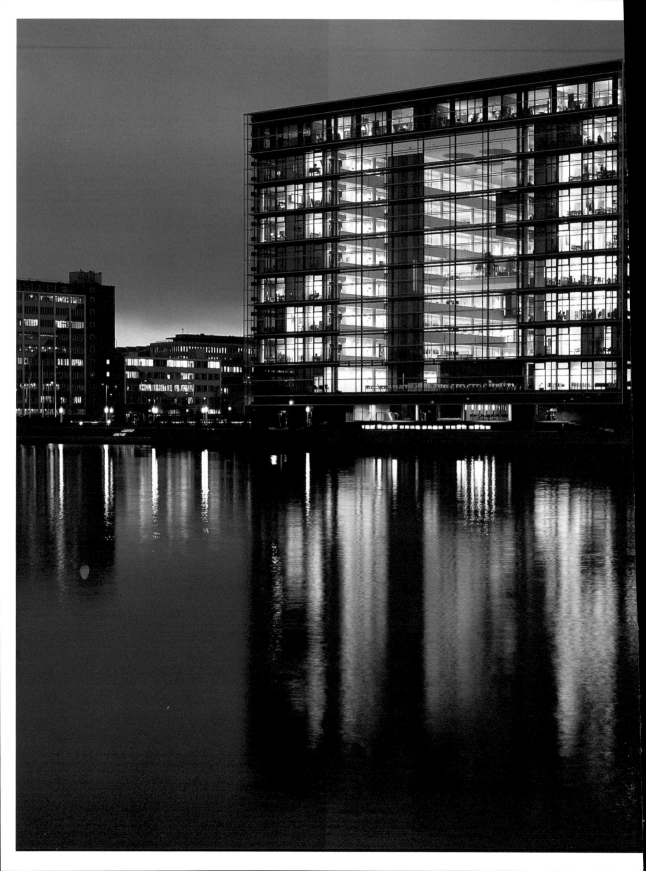

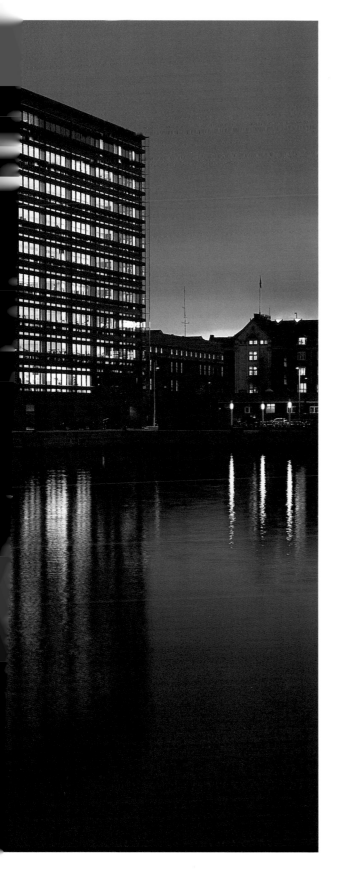

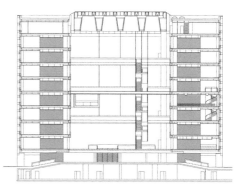

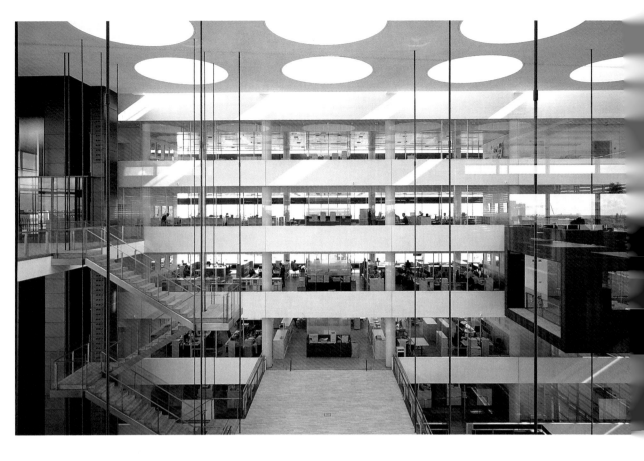

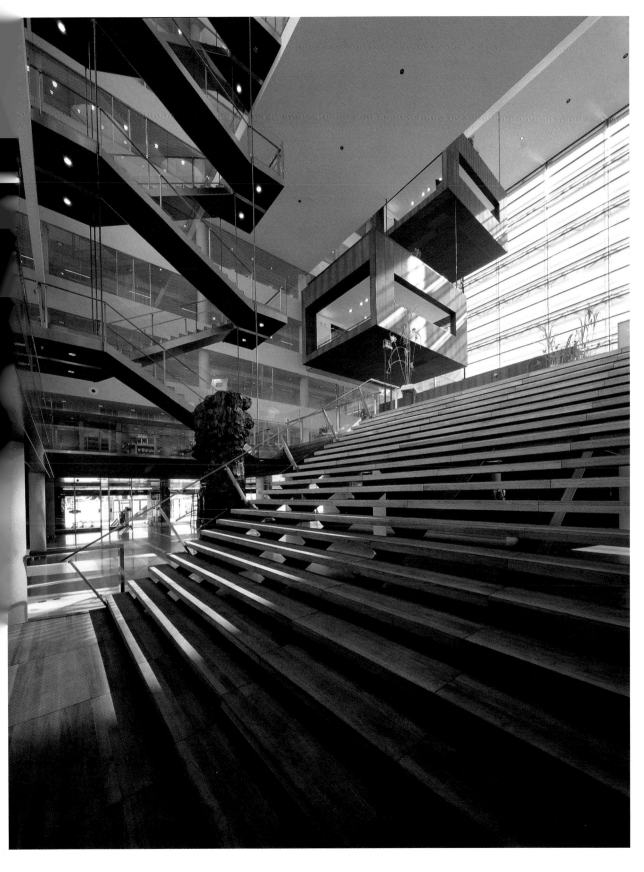

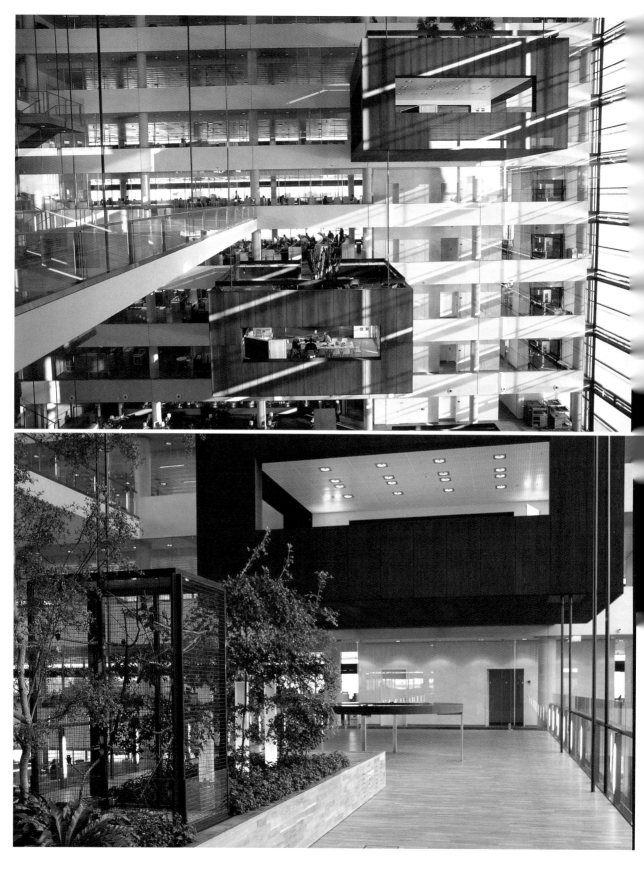

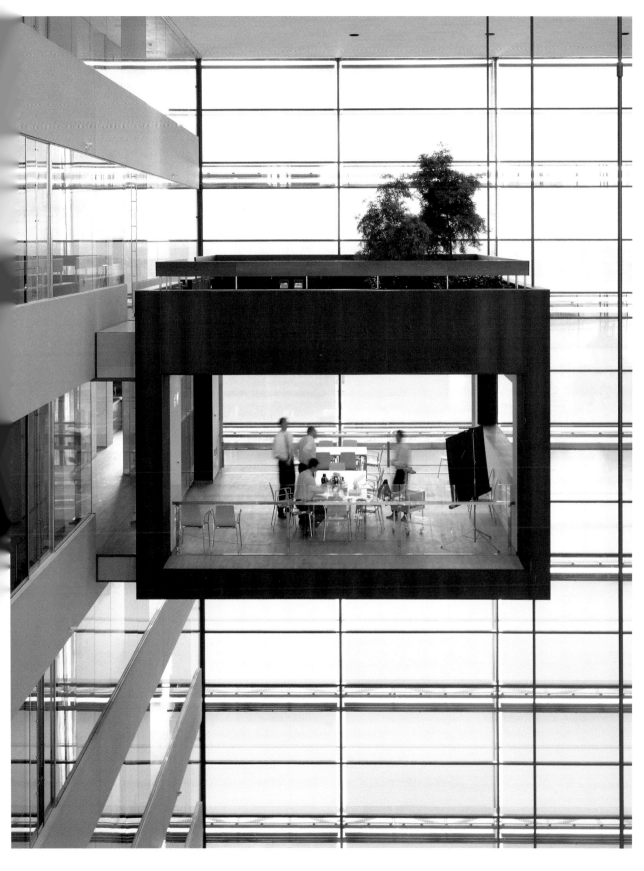

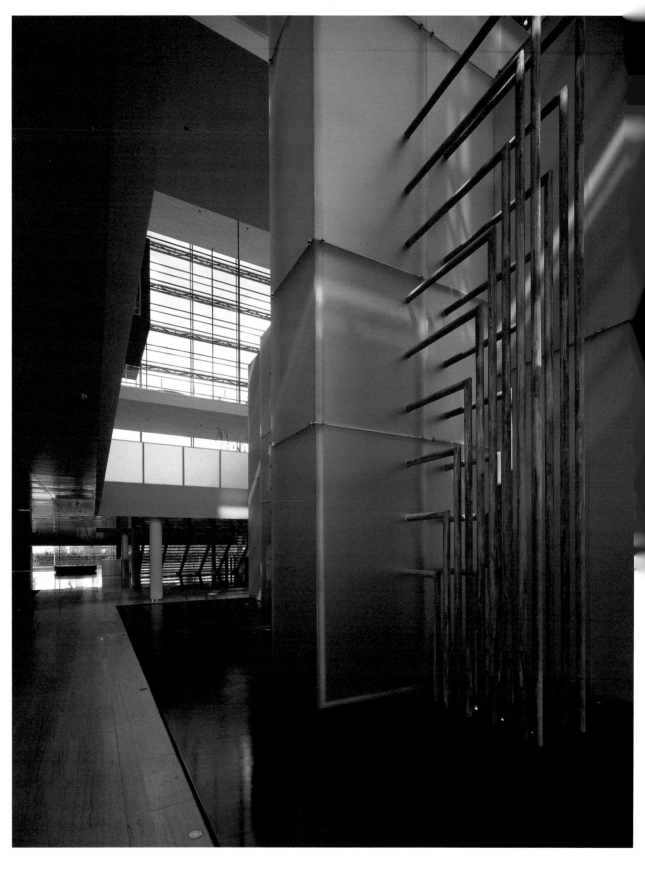

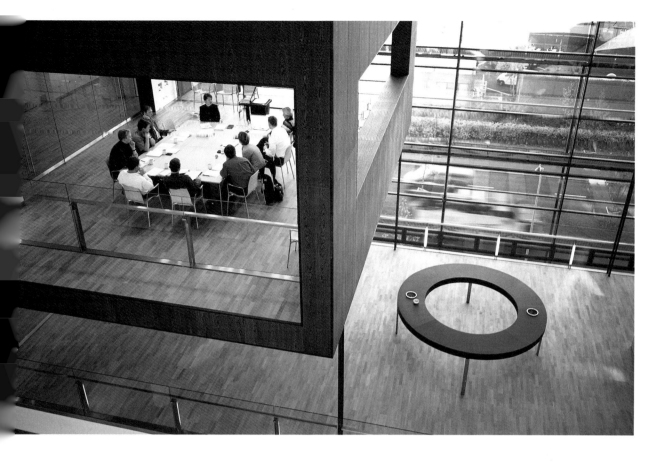

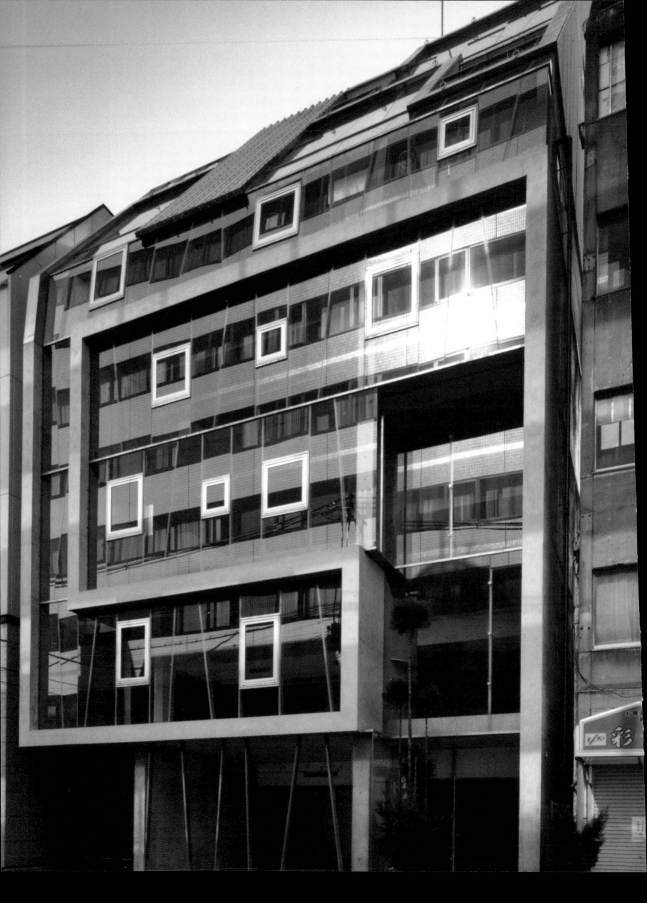

SHUHEI ENDO ARCHITECT INSTITUTE | OSAKA
GROWTECTURE S
Osaka, Japan | 2002

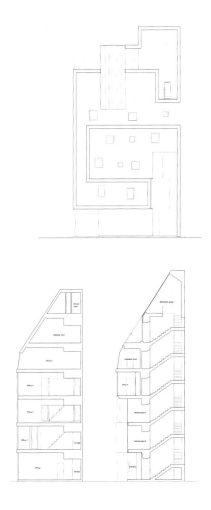

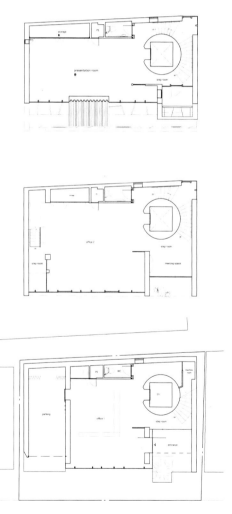

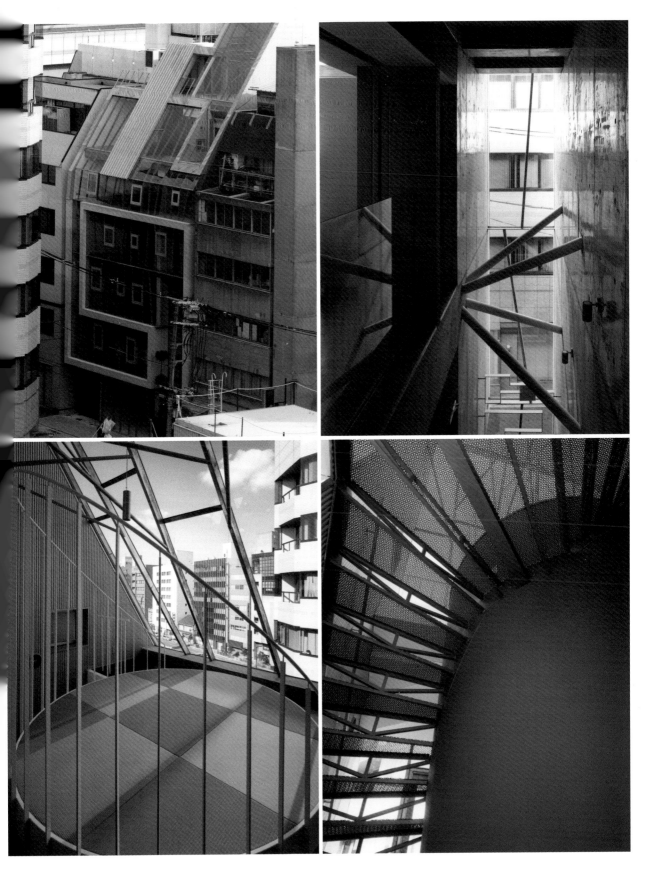

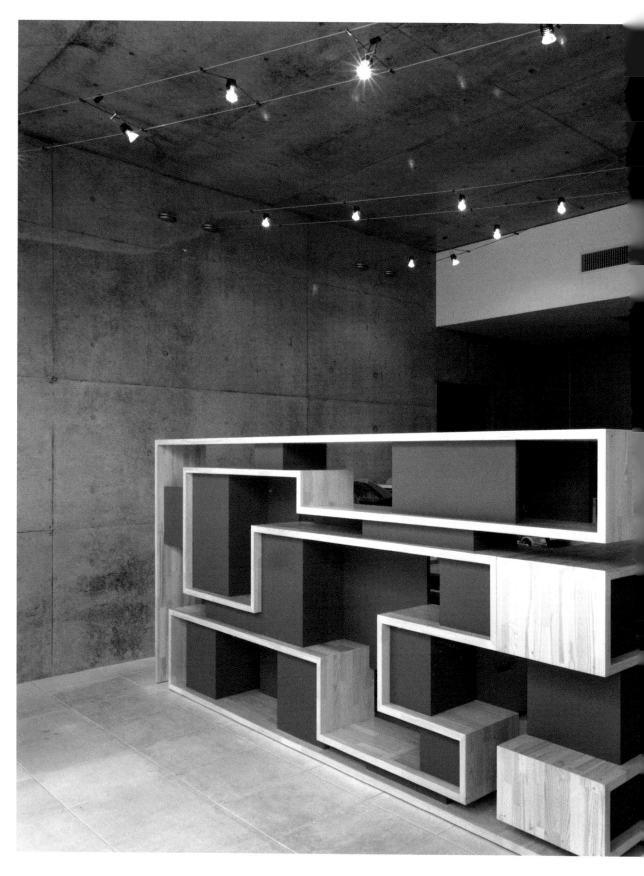

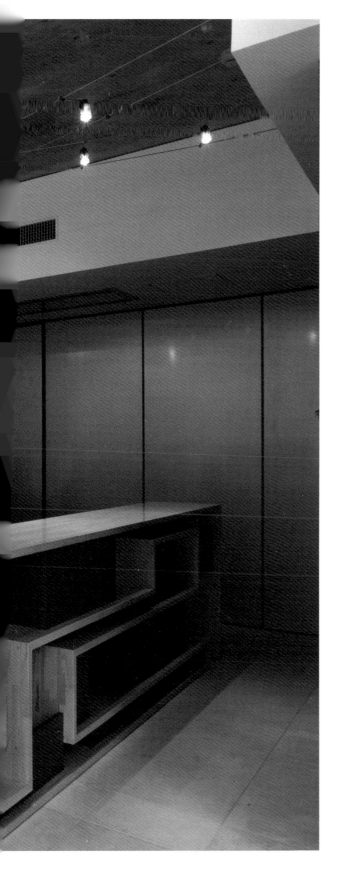

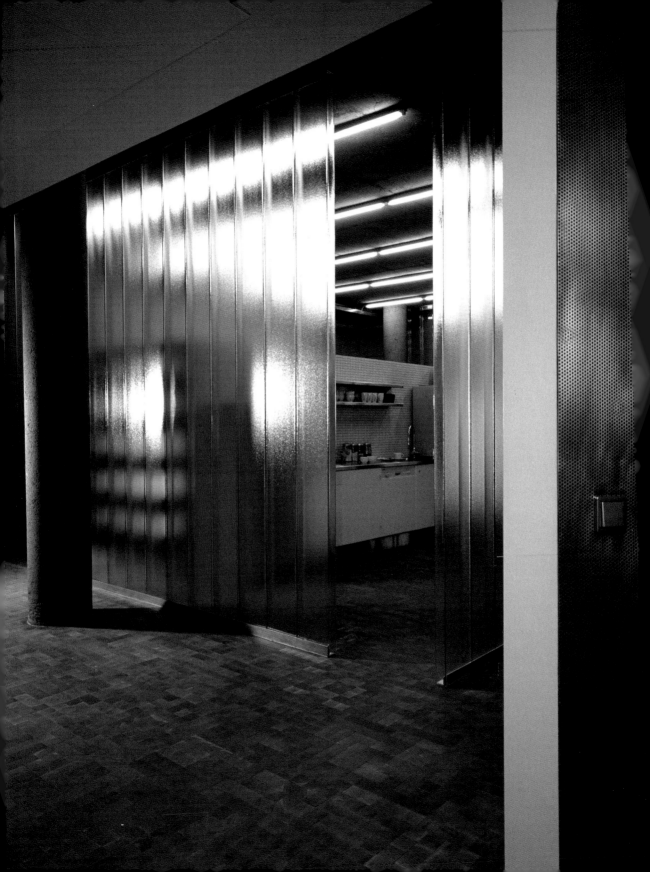

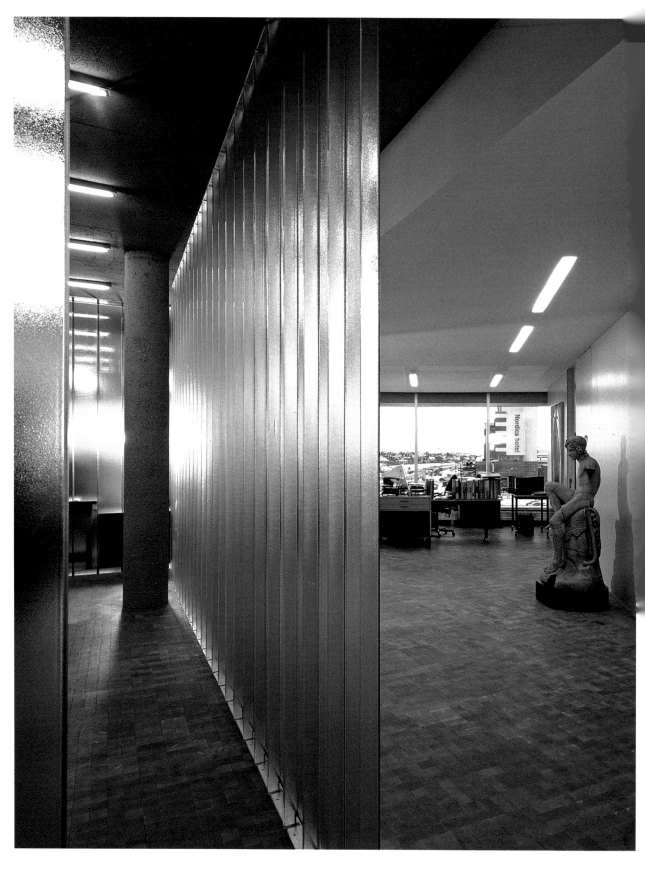

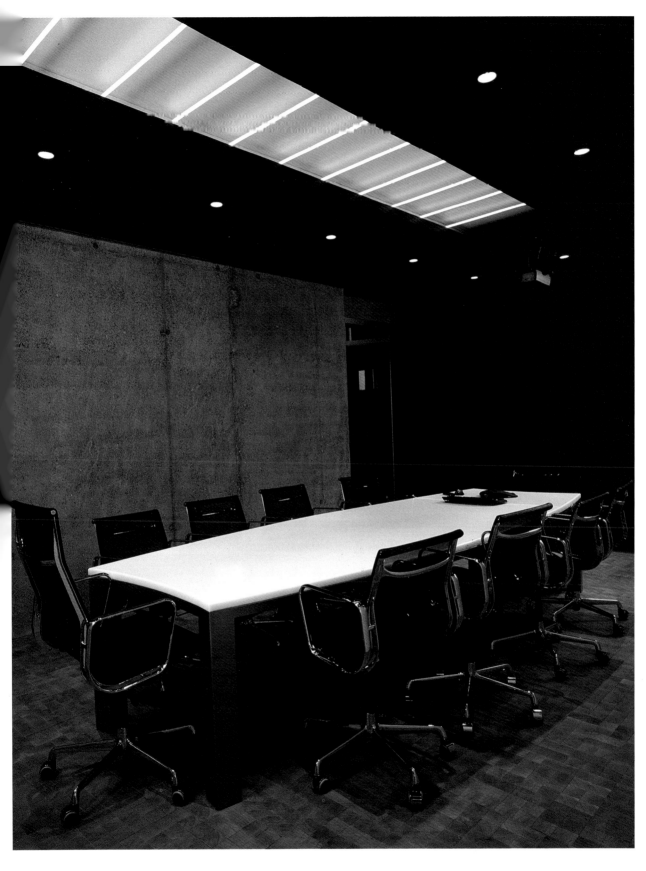

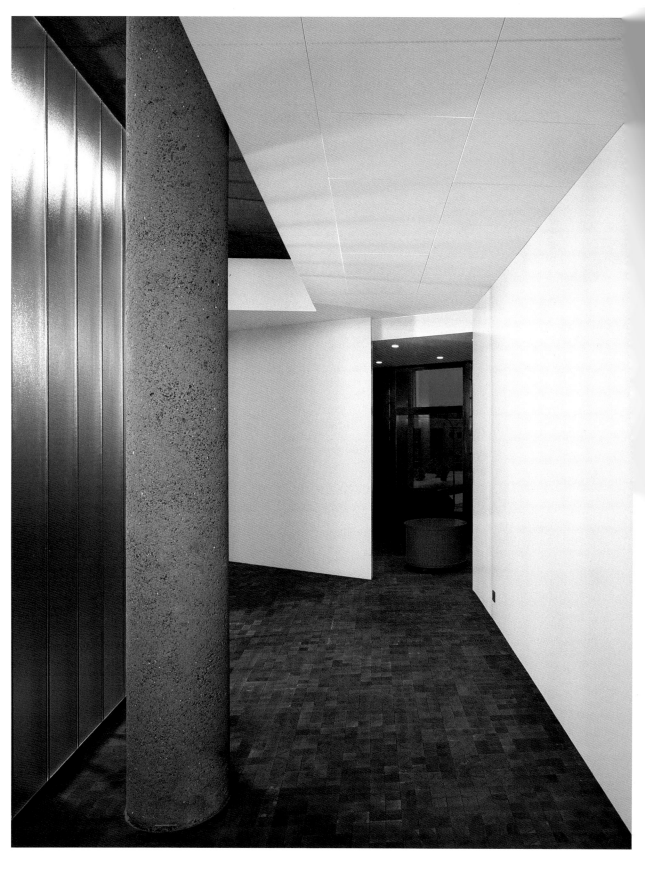

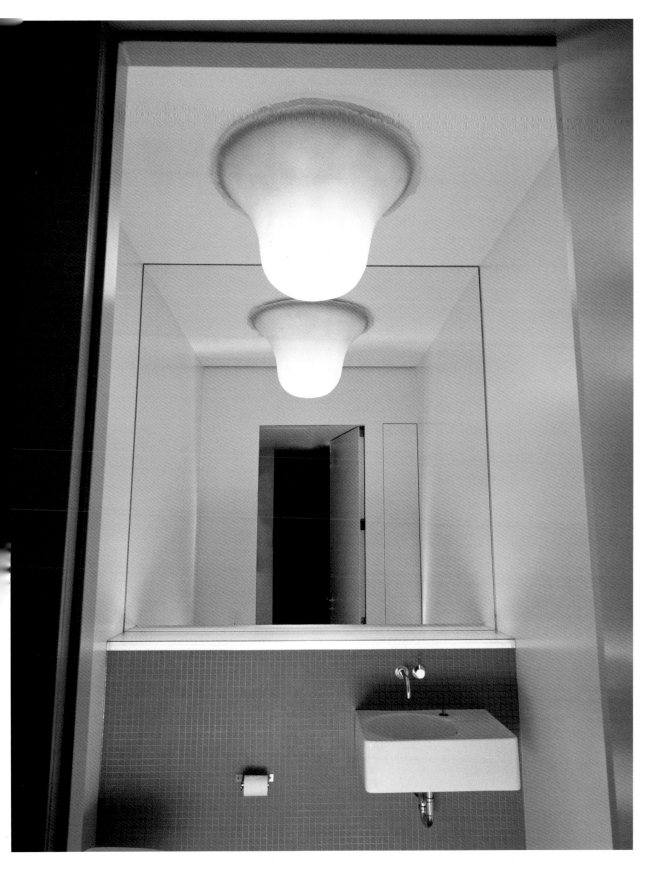

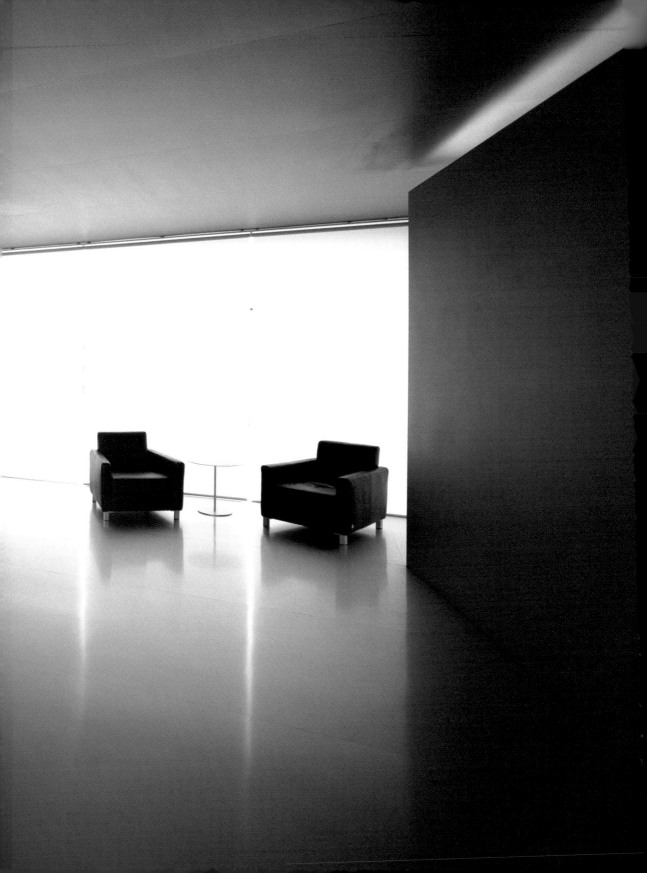

TAKASHI YAMAGUCHI & ASSOCIATES | OSAKA
METAL OFFICE
Kyoto, Japan | 2004

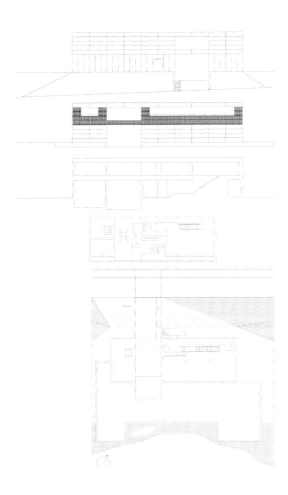

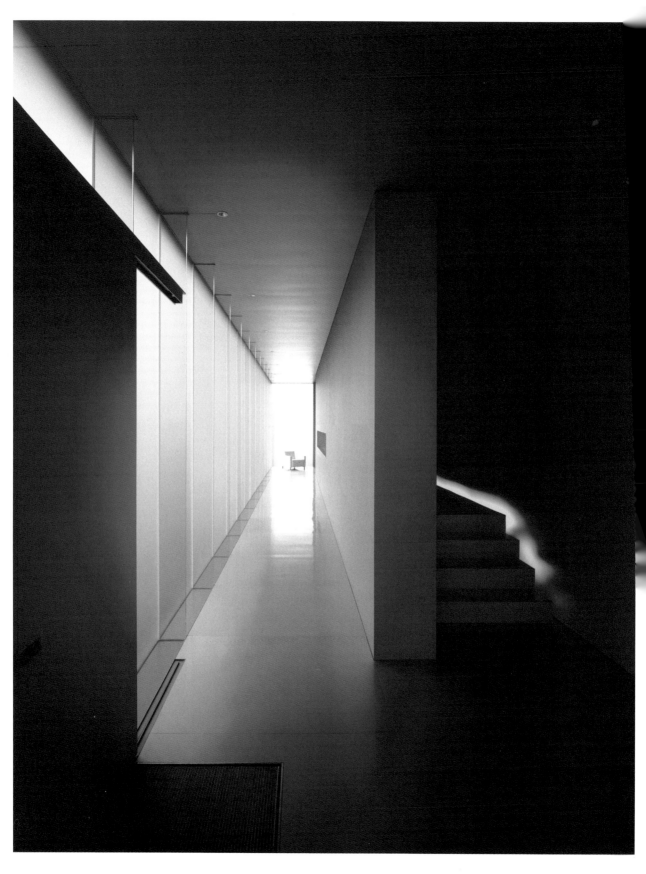

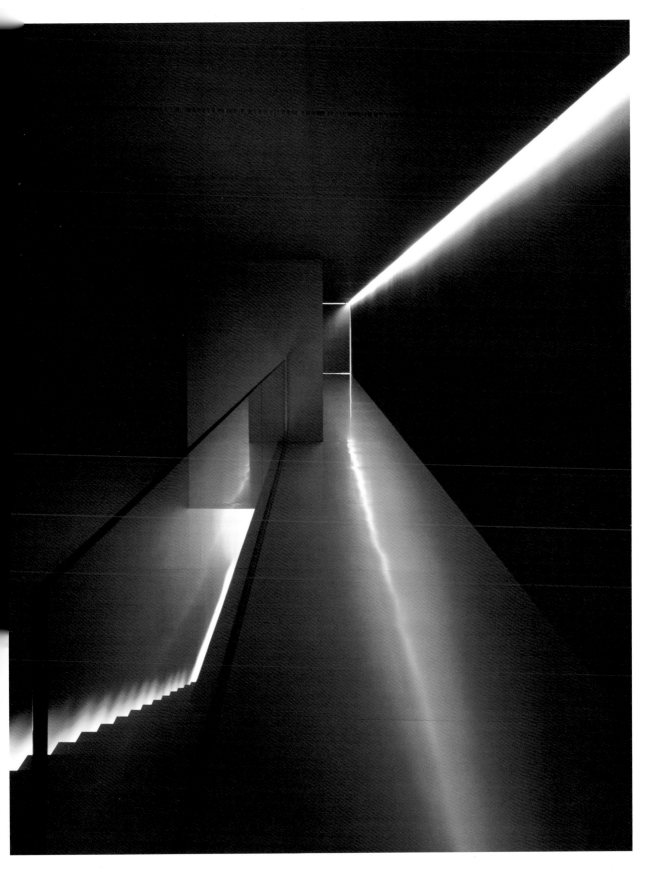

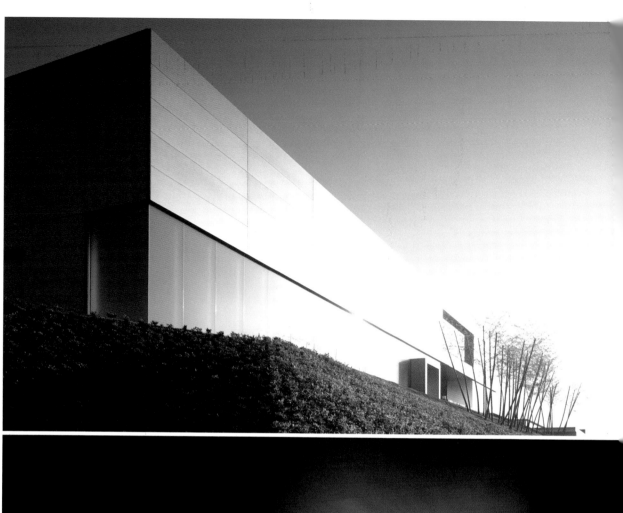

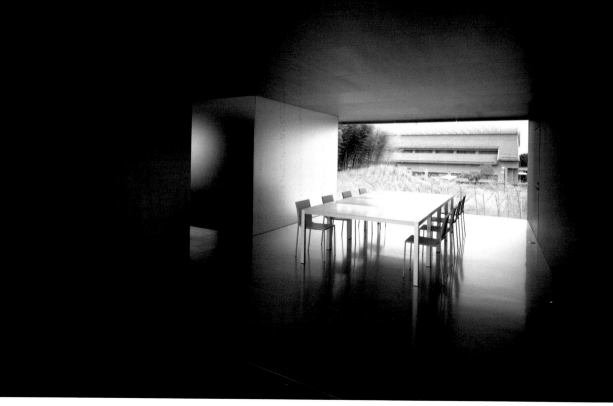

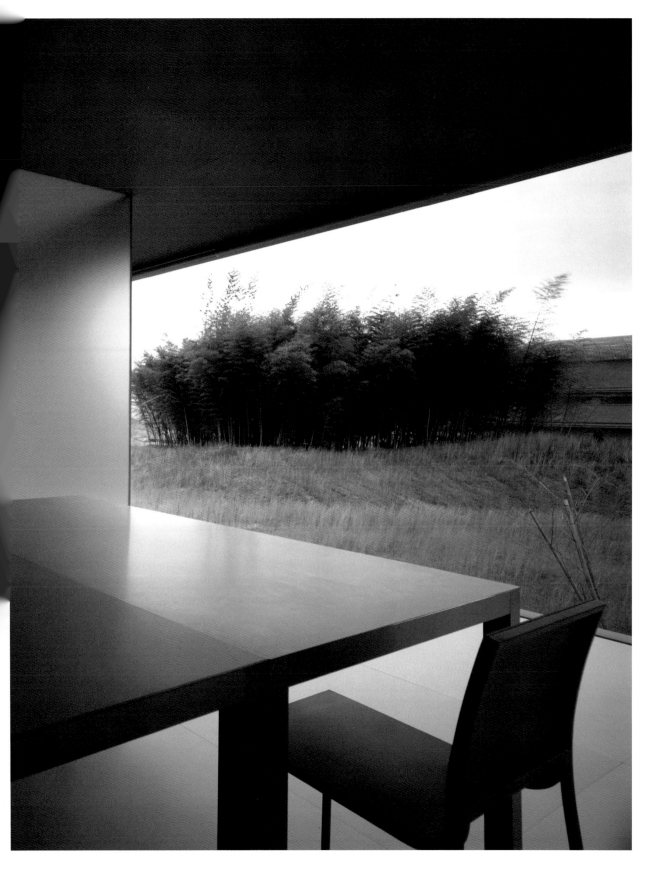

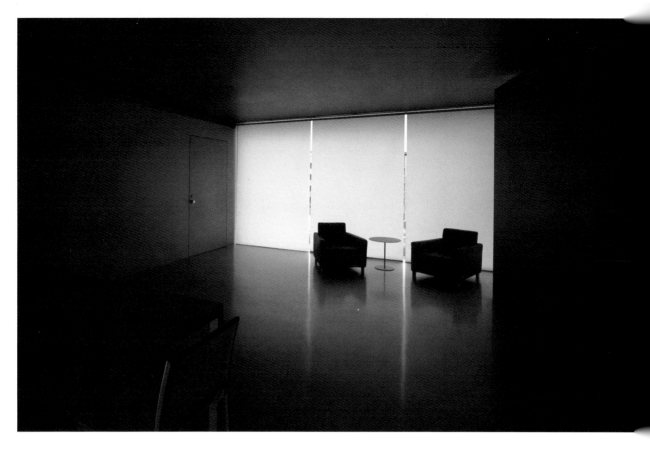

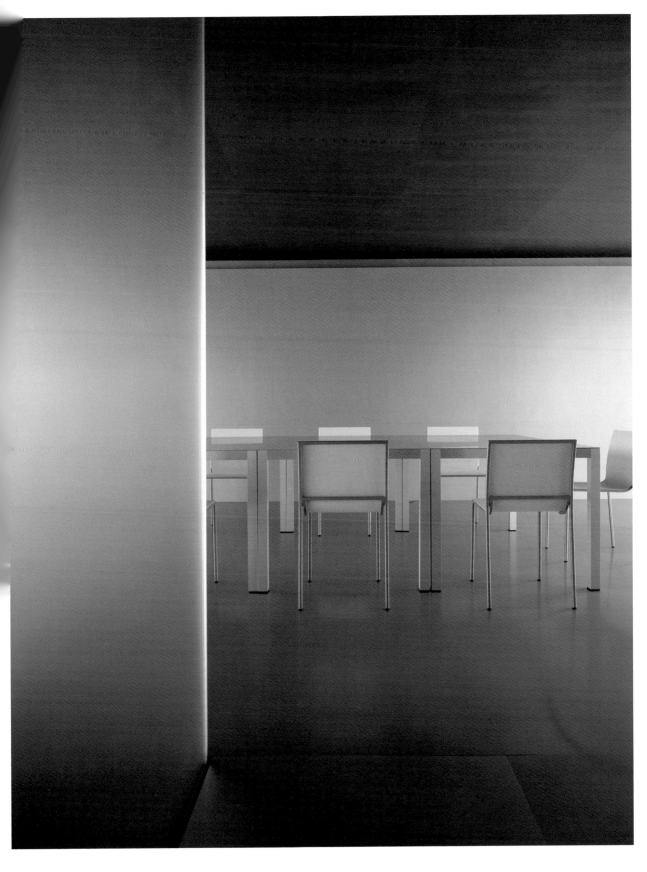

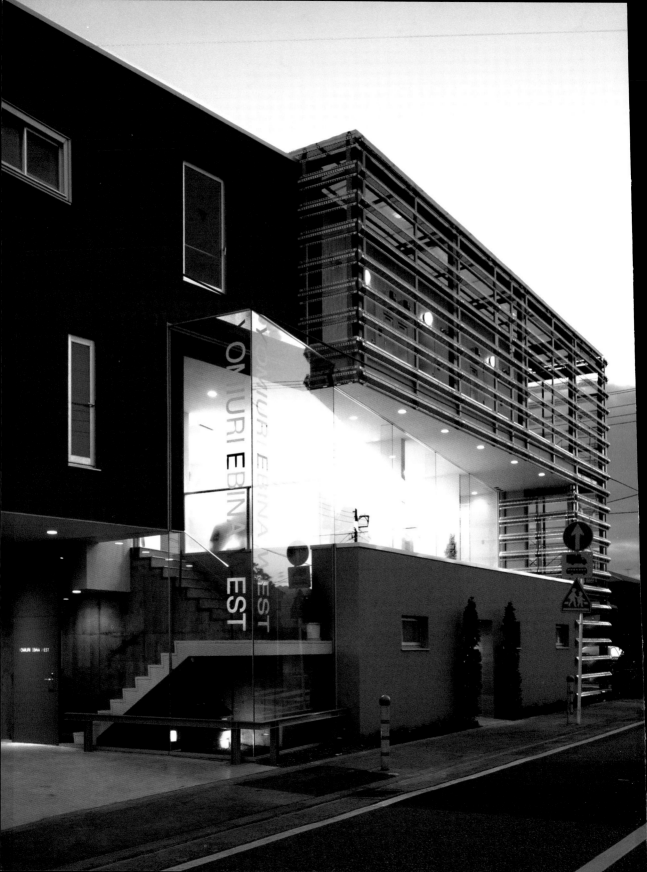

TELE DESIGN | TOKYO
NEWS COMPLEX BUILDING
Kanagawa Prefecture, Japan | 2004

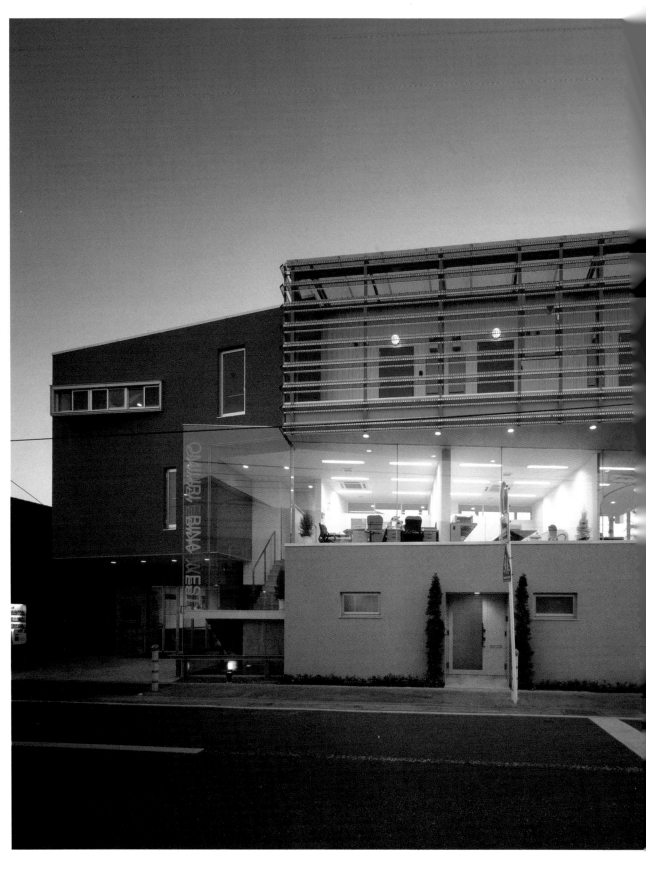

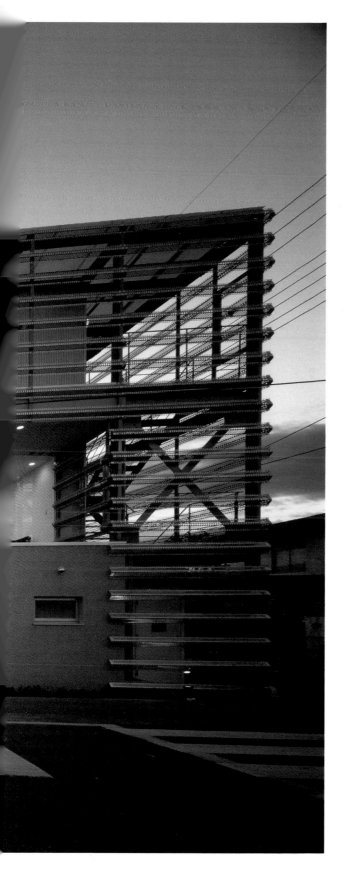

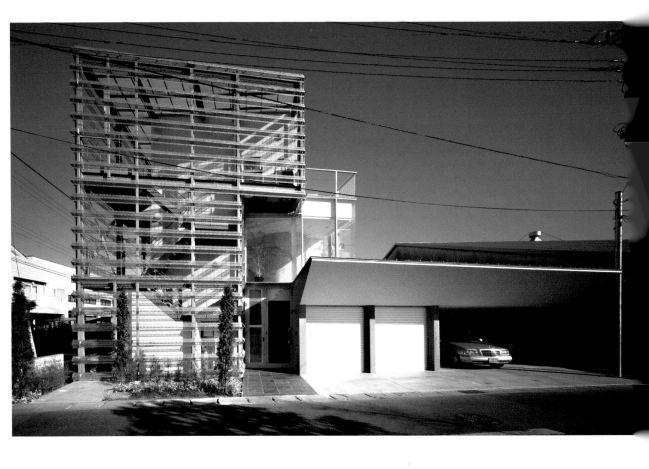

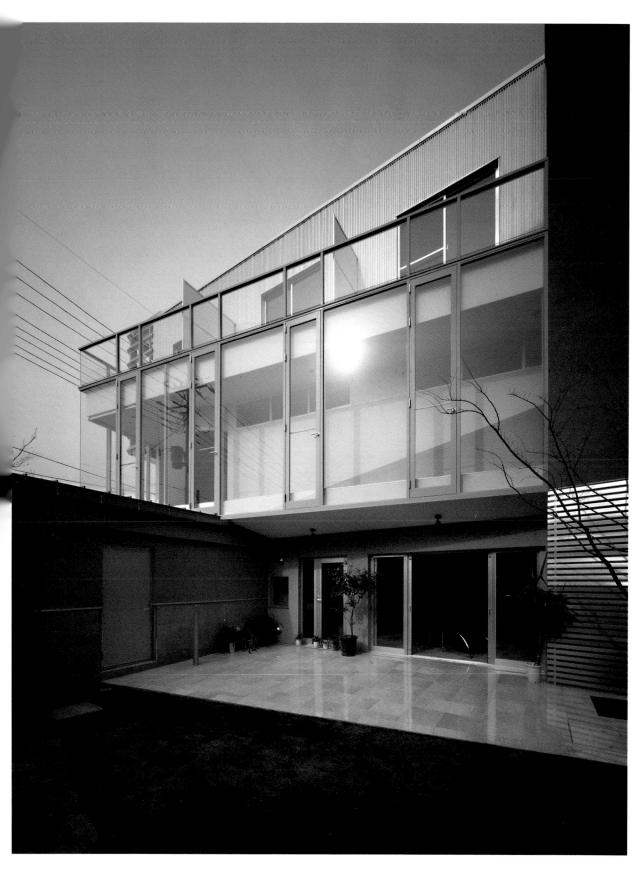

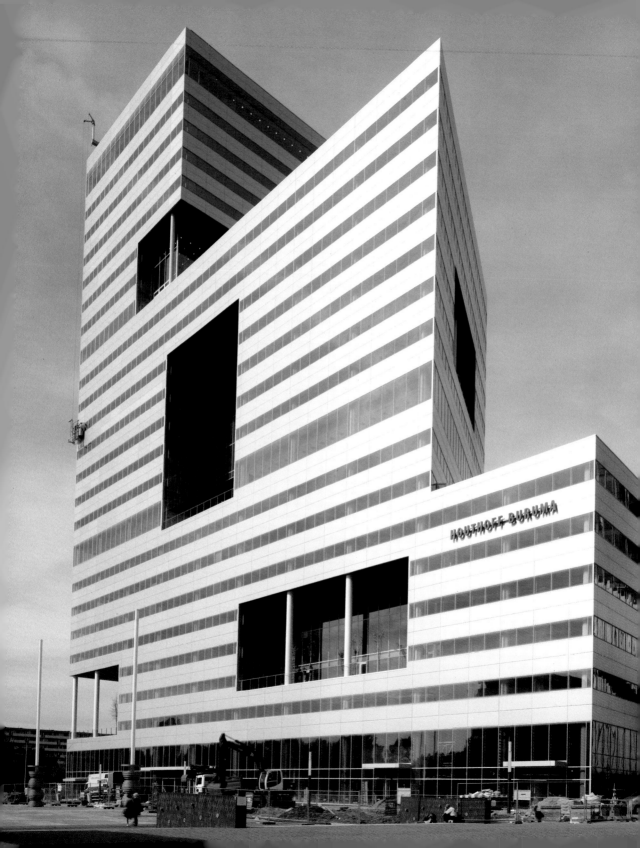

TOYO ITO & ASSOCIATES ARCHITECTS | TOKYO
MAHLER 4 BLOCK 5
Amsterdam, the Netherlands | 2005

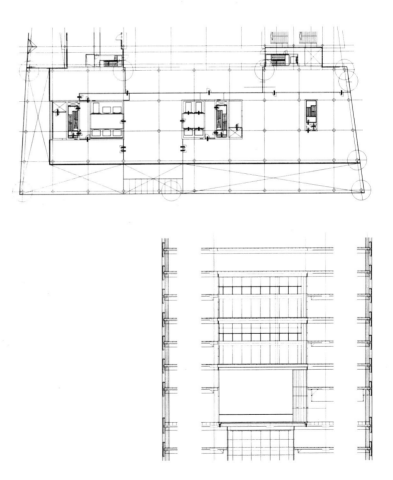

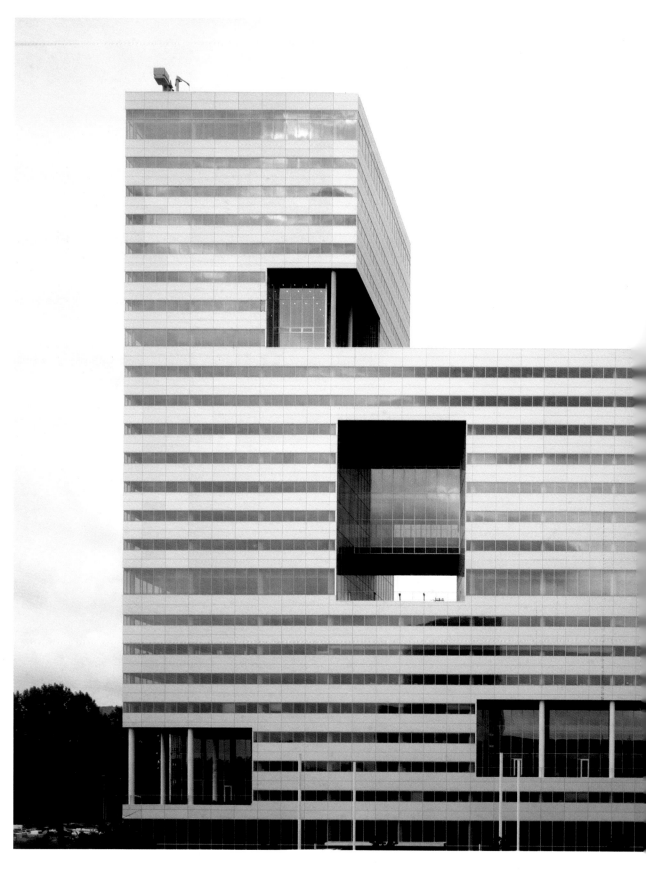

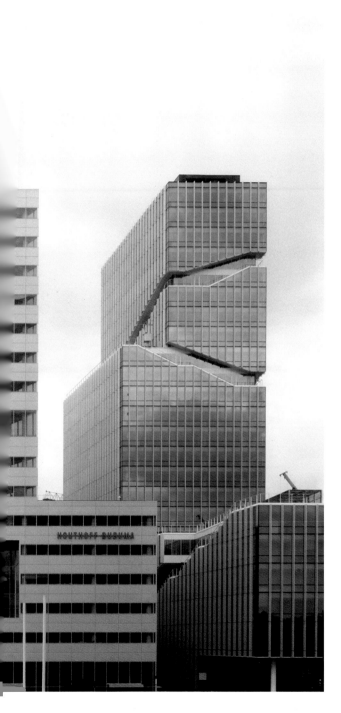

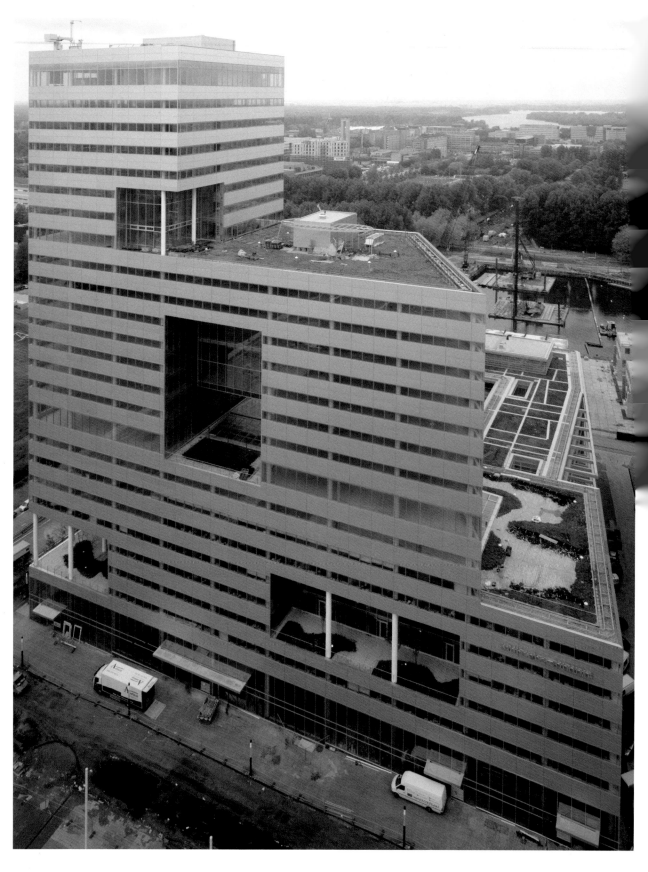

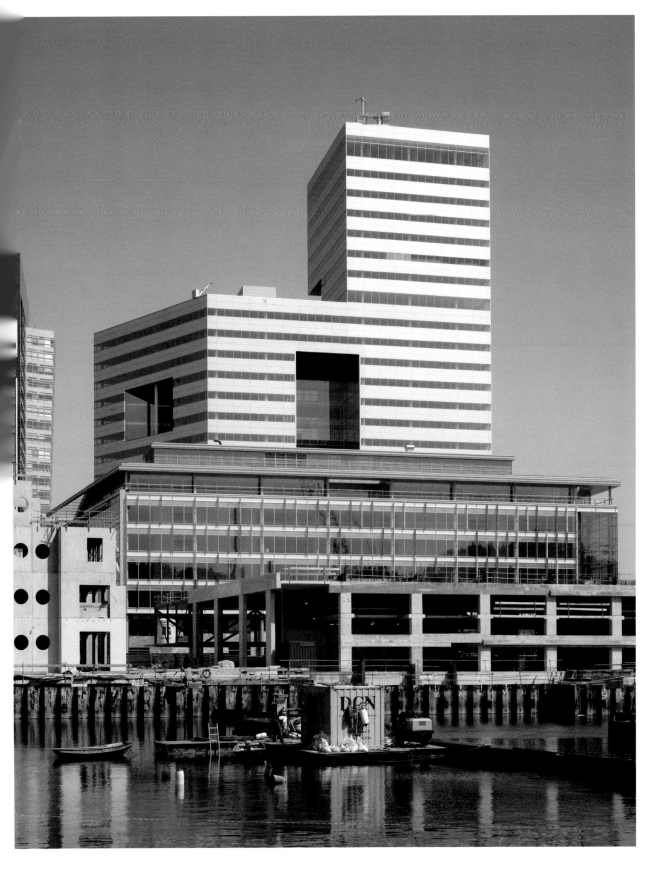

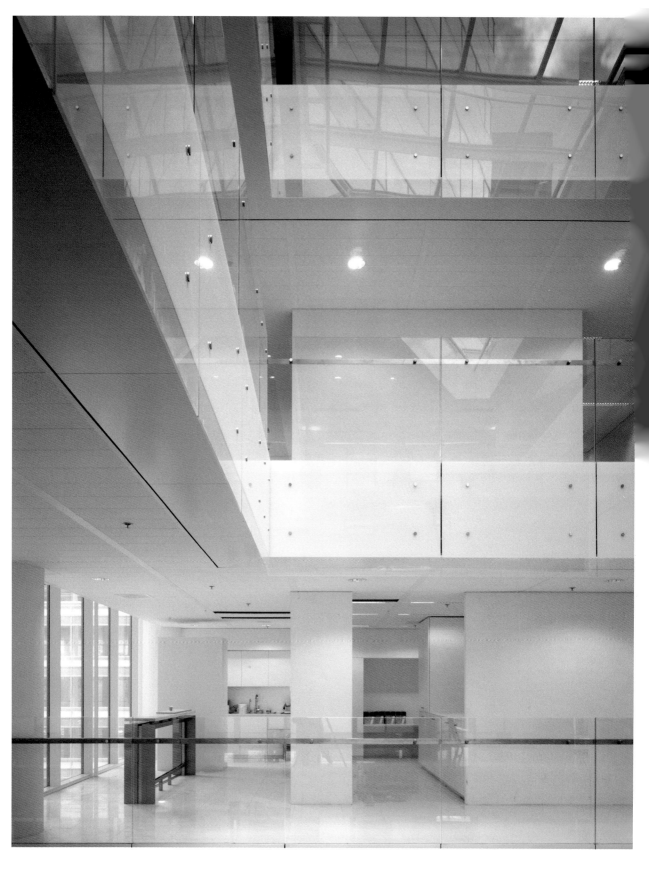

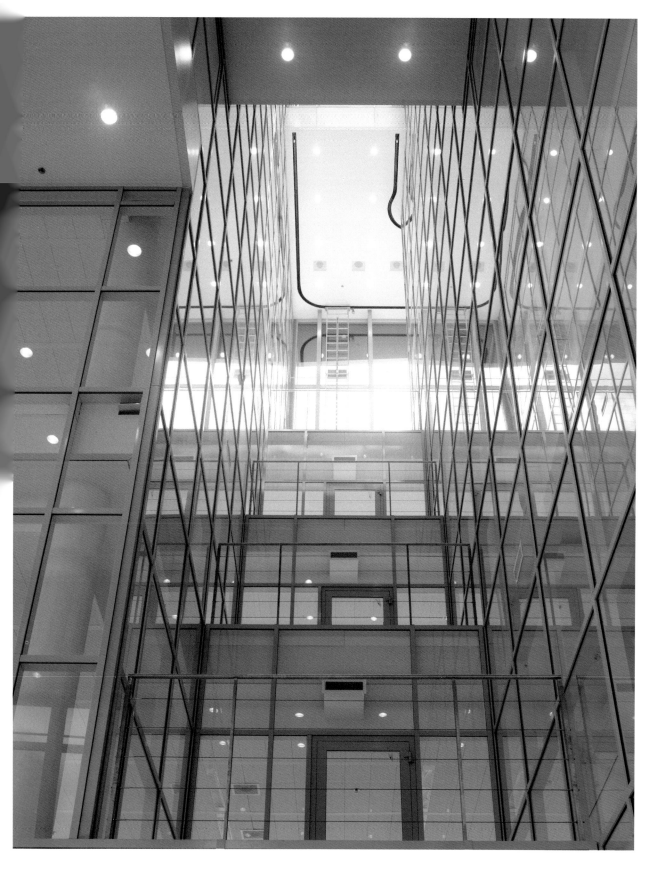

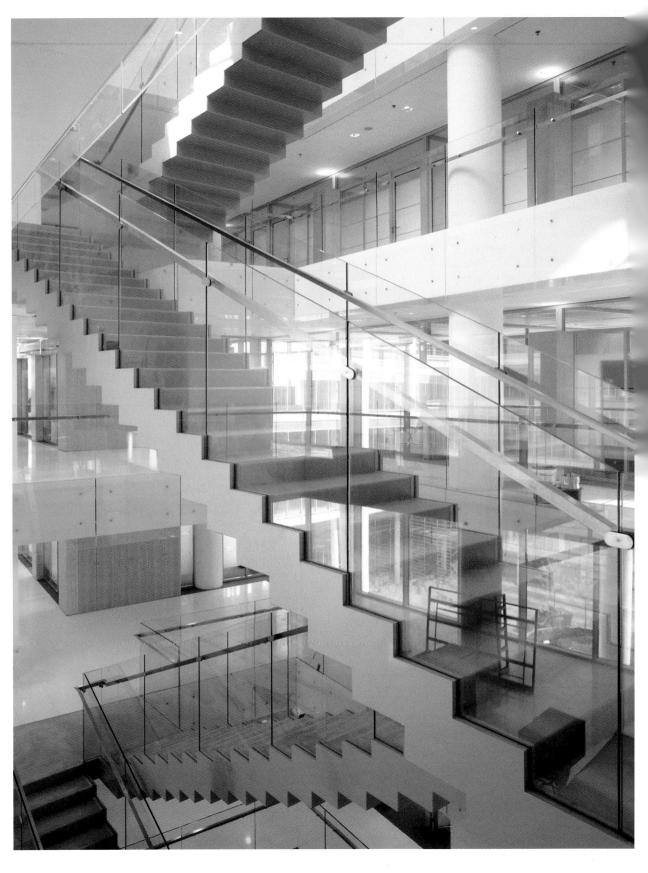

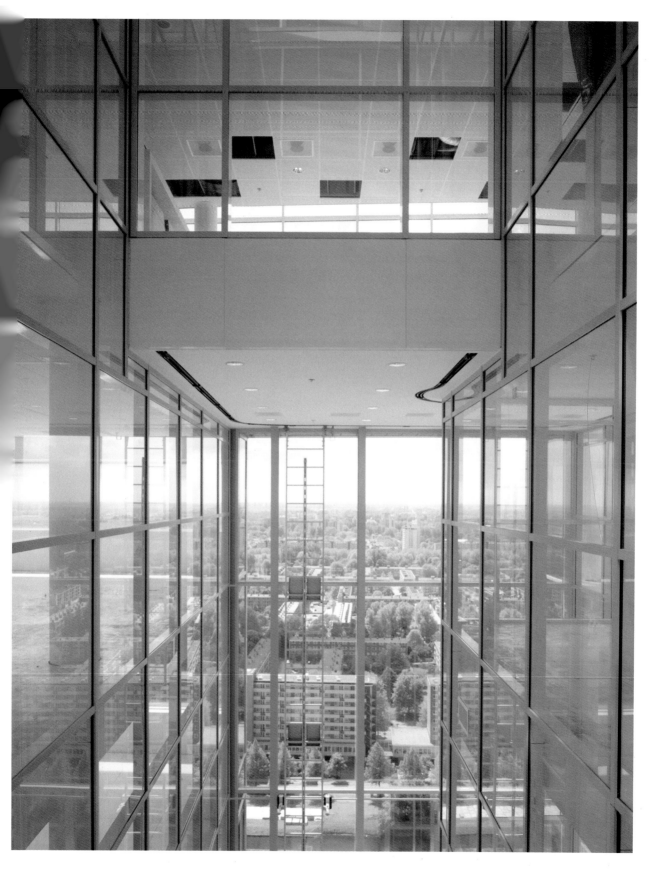

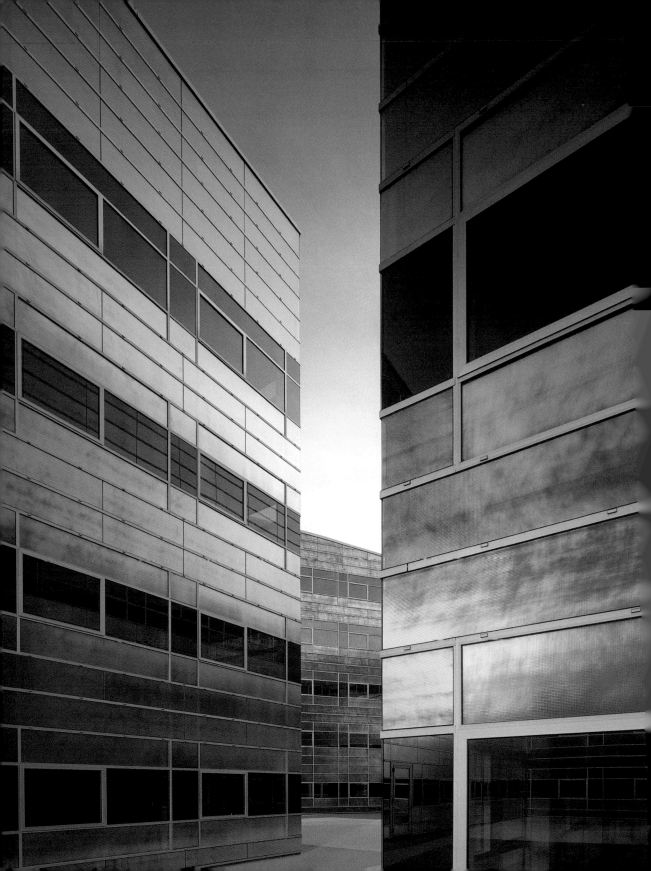

UN STUDIO | AMSTERDAM
OFFICES LA DEFENSE
Almere, the Netherlands | 2004

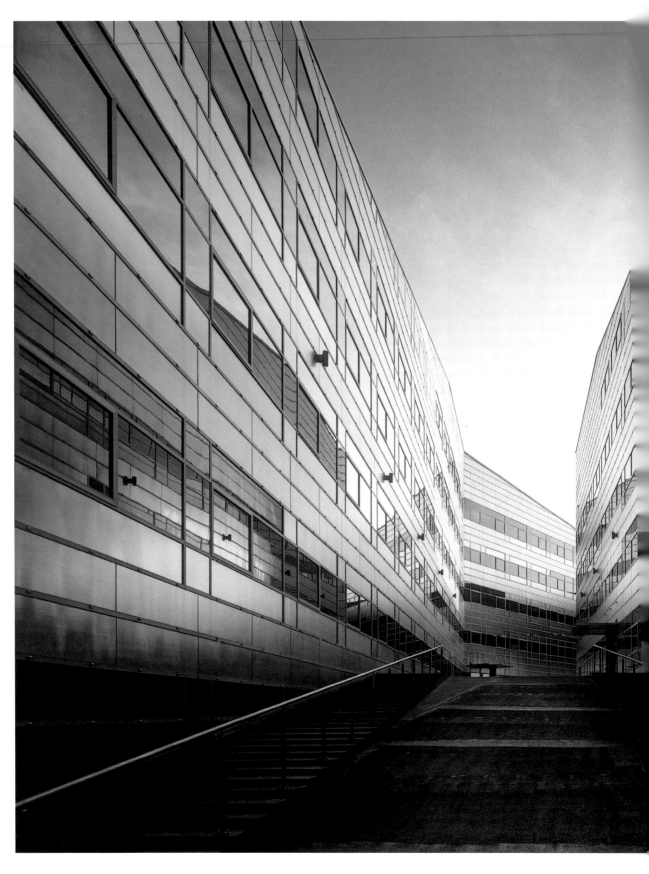

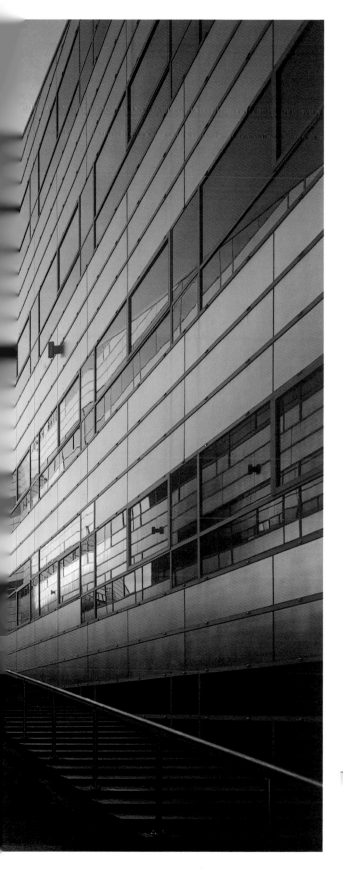

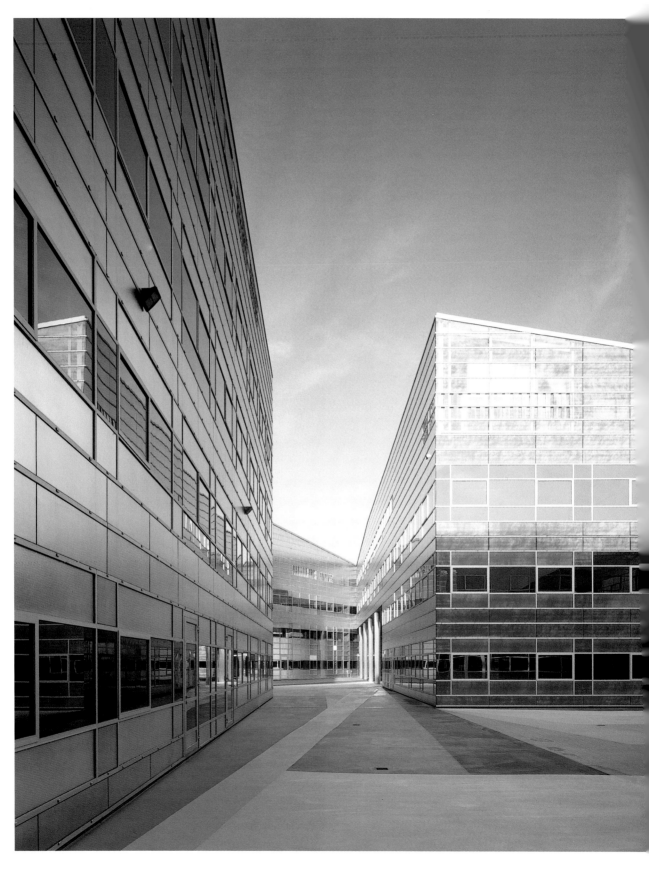

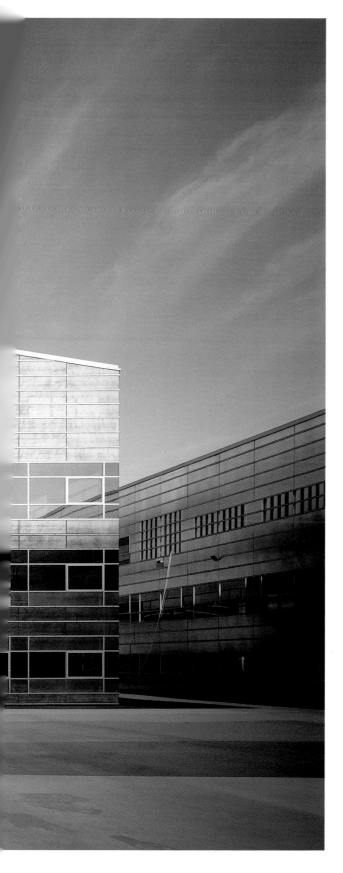

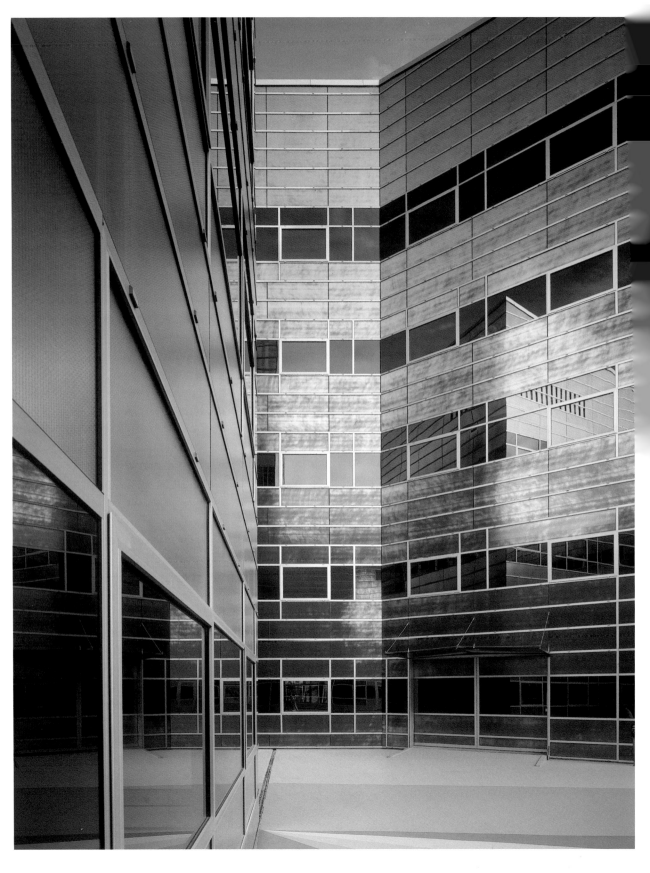

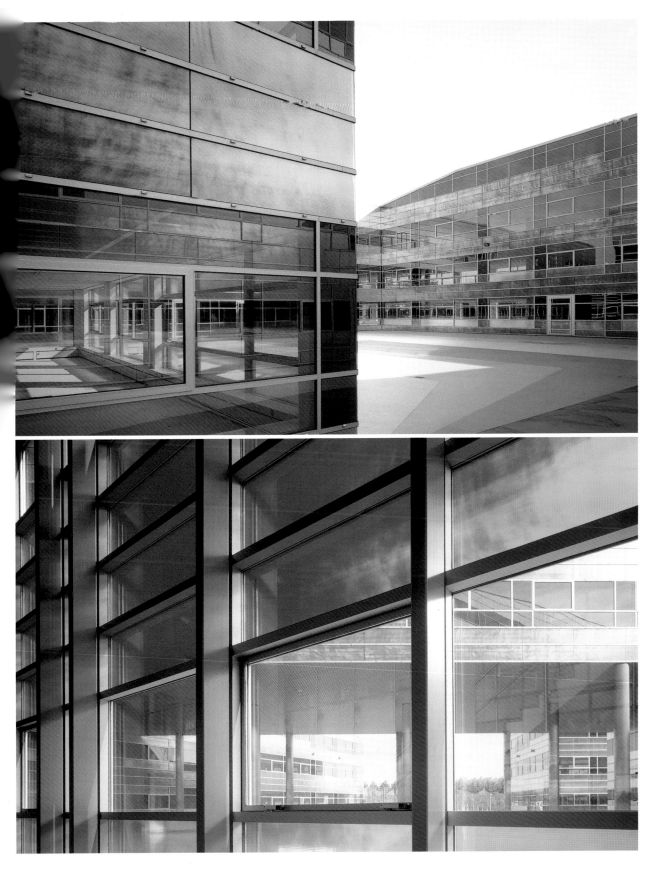

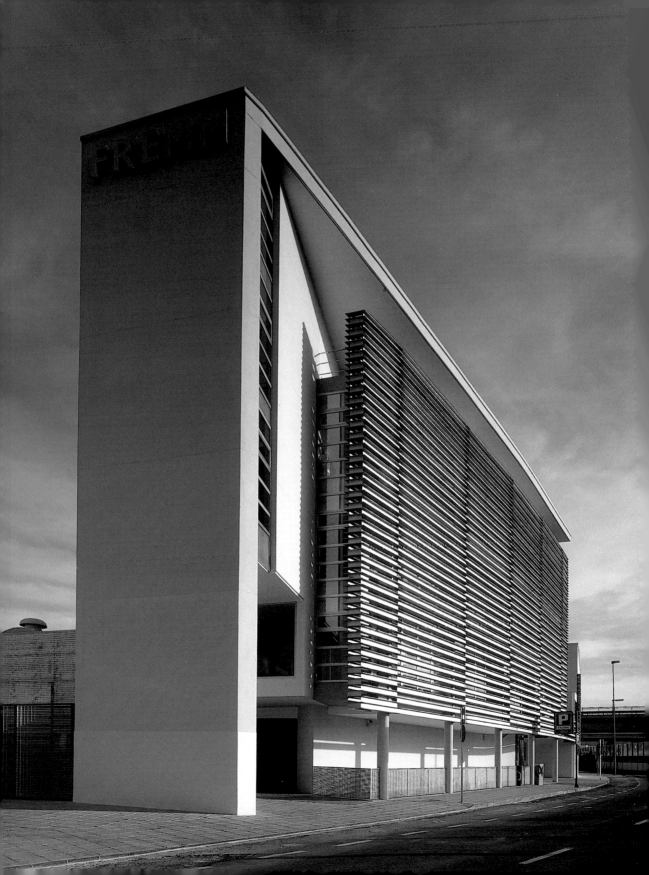

VICENTE MARTÍNEZ GADEA | MURCIA
FREM
Murcia, Spain | 2004

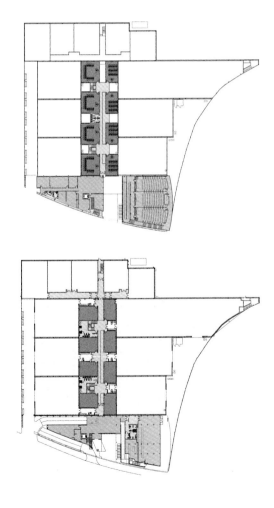

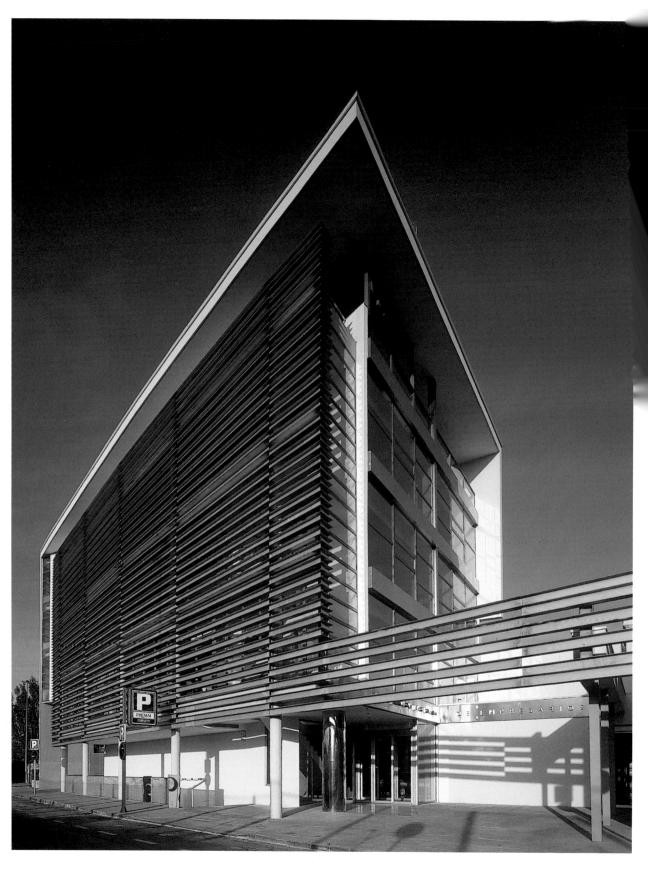

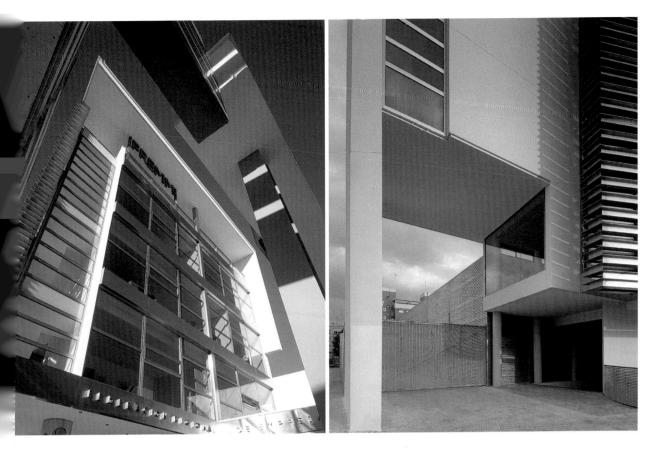

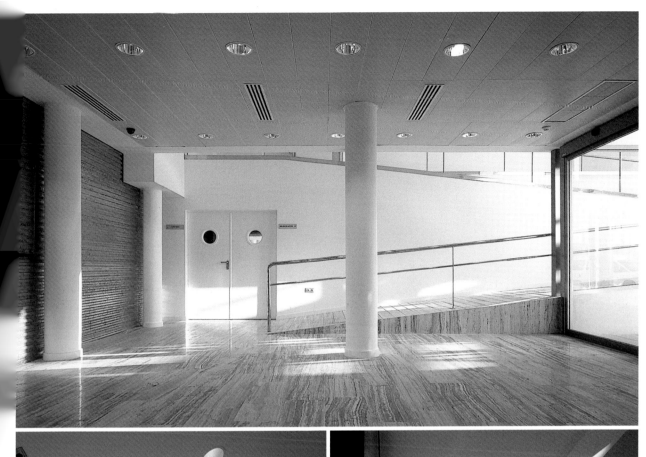

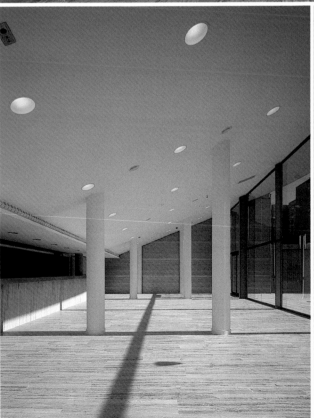

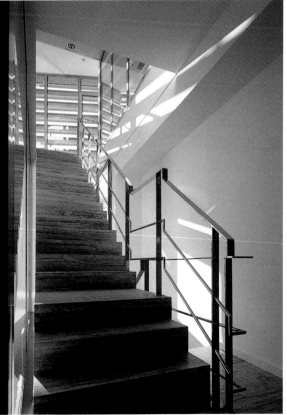

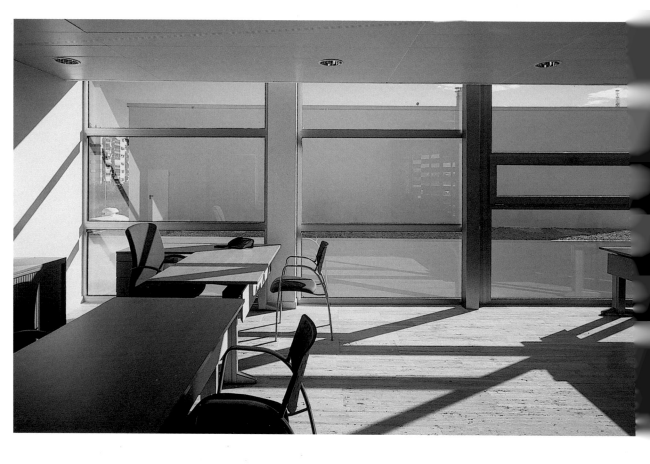

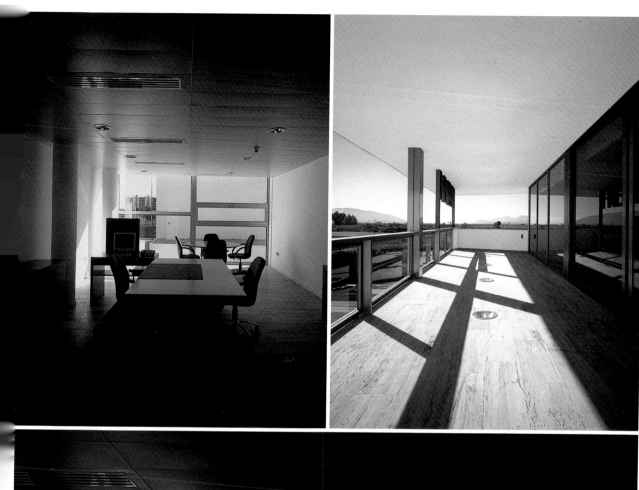

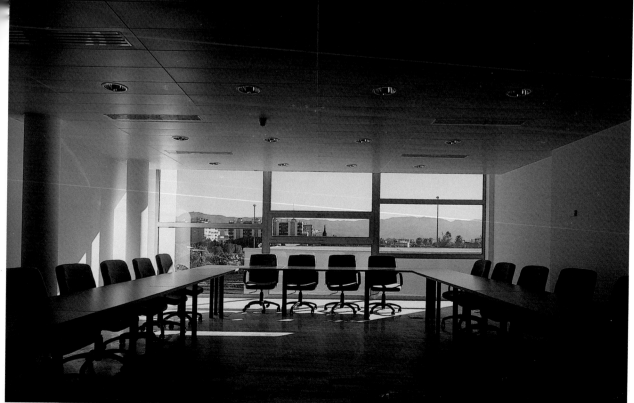

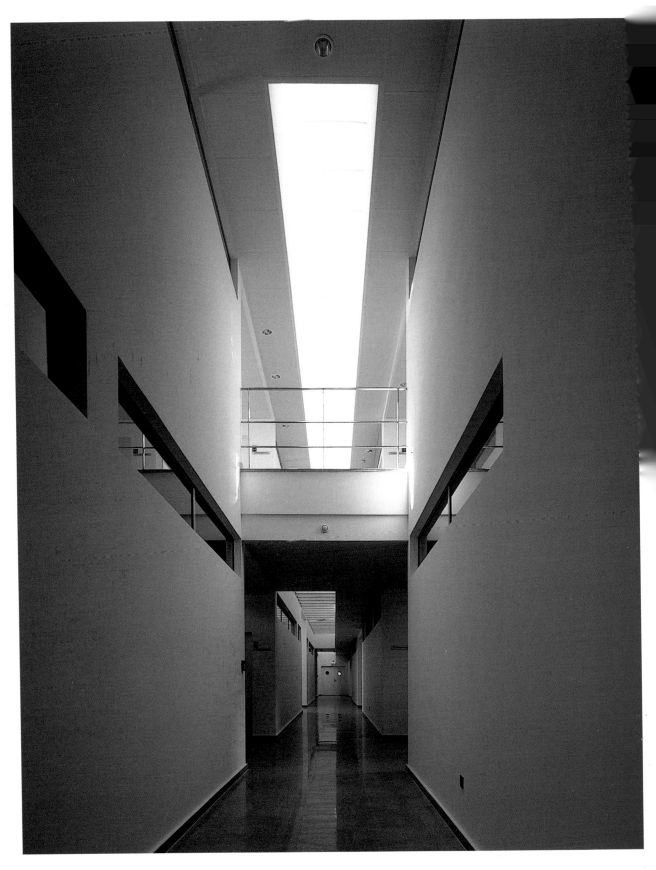

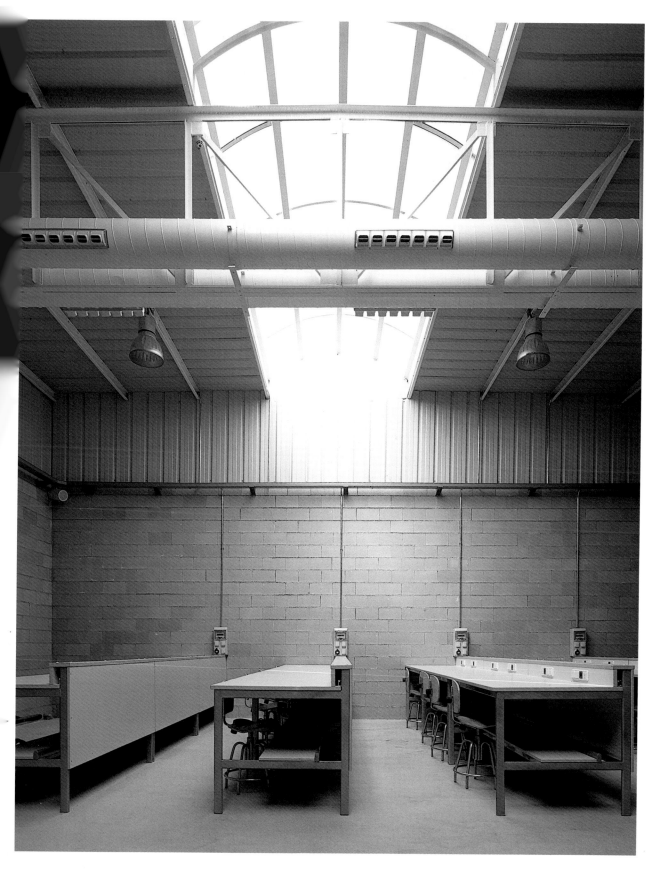

Aguirre & Newman
General Lacy 23, 28045 Madrid, Spain
P +34 913 191 314
F +34 913 198 757
www.aguirrenewman.es
Affinity in Sant Joan Nord
Photos: © Jordi Miralles

Agustí Costa
Plaça de la Creu 3 2on 2a, 08600 Berga, Spain
P +34 938 211 063
F +34 938 221 105
www.agusticosta.com
Institut de Sociolingüística Catalana
Photos: © Eugeni Pons

Architectengroep
Barentszplein 7, 1013 NJ Amsterdam, the Netherlands
P +02 0 530 4848
F +02 0 530 4800
www.dickvangameren.nl
Laakhaven Den Haag
Photos: © Rob't Hart

Arquitecture Studio
10, rue Lacuée, 75012 Paris, France
P +33 1 43 45 18 00
F +33 1 43 43 81 43
www.architecture-studio.fr
Wison Chemical
Photos: © Yongjin Luo / Wison

Arconiko Architecten
Scheepmakershaven 32, Rotterdam, the Nederlands
P +01 0 412 3181
F +01 0 404 7597
Indes
Photos: © Luuk Kramer

Atelier d'Architecture Chaix & Morel et Associés
16, rue des Haies, 75020 Paris, France
P +33 1 43 70 69 24
F +33 1 43 70 67 65
www.chaixmorel.com
Crystal Défense
Photos: © Alain Goustard

B720 Arquitectura
Josep Tarradellas 123, 08029 Barcelona, Spain
P +34 933 637 979
F +34 933 630 139
www.b720.com
Mestre Nicolau Office
Photos: © Rafael Vargas

Baas Arquitectes
Frederic Rahola 63, 08032 Barcelona, Spain
P +34 933 580 111
F +34 933 580 194
www.jordibadia.com
Ibercon
Photos: © Eugeni Pons

Barkow Leibinger Architects
Schillerstrasse 94, 10625 Berlin, Germany
P +49 30 31 57 12
F +49 30 31 57 29
www.barkowleibinger.com
Trumpf
Photos: © Werner Huthmacher

Broek en Bakema
Postbus 13084, 3004 HB, Rotterdam, the Netherlands
P +01 0 413 4780
F +01 0 413 6454
www.broekbakema.nl
Kropman
Photos: © Luuk Kramer

Buratti + Battiston Architects
Via Grigna 22, 20020 Busto Garolfo, Italy
P +39 033 156 9575
F +39 033 156 9063
www.buratibattiston.it
Unione degli Industriali della Provincia di Bergamo
Photos: © Gionata Xerra / Spazio

Cheeeeese!
6, place Jacques Forment, 75081 Paris, France
P +33 1 58 59 30 30
F +33 1 58 59 00 30
www.cheeeeese.com
Cheeeeese
Photos: © Jean-Marc Perret, Thierry Malty / Cheeeeese

Cho Slade Architecture
367 East 10th Street, 10009 New York, USA
P + 1 212 677 6380
F + 1 212 677 6330
www.sladearch.com
Third Point Management Company
Photos: © Jordi miralles

Cossmann de Bruyn
Comenuisstrasse 1, D-40545 Düsseldorf, Germany
P +49 211 559 0069
F +49 211 559 0068
A.T. Kearney
Photos: © Nicole Zimmermann

Driendl Architects
Mariahilferstrasse 9, 1060 Vienna, Austria
P +43 1 585 18 68
F +43 1 585 18 68
www.driendl.at
TT5 Twist Tower
Photos: © Pez Hejduk

Eduardo Gascón
Tusset 8 6è 1a, 08006 Barcelona, Spain
P +34 93 292 2208
F +34 93 292 2708
Sant Joan Nord, Affinity
Photos: © Jordi Miralles

Estudi Carme Pinós
Diagonal 490 3er 2a, 08006 Barcelona, Spain
P +34 934 160 372
F +34 932 181 473
www.cpinos.com
Torre Cube
Photos: © Luis Ramírez

Foster and Partners
Riverside Three 22 Hester Road, London, SW11 4AN, UK
P +44 207 738 0455
F +44 207 738 1107
www.fosterandpartners.com
30 St Mary Axe
Photos: © Nigel Young / Foster and Partners

Francisco Cavas
Cartagena 8, 1º F, 30700 Torre Pacheco, Spain
P +34 968 587 433
F +34 968 587 432
Polaris
Photo: © David Frutos

GCA Arquitectes Associats
València 289, 08009 Barcelona, Spain
P +34 934 761 800
F +34 934 761 806
www.gcaarq.com
Acesa
Photos: © Jordi Miralles
Zal
Photos: © Jordi Miralles

Gray Puksand
577 Little Bourke Street, Melbourne VIC 3000, Australia
P +61 3 92 21 09 99
F +61 3 92 21 09 98
www.graypuksand.com.au
Bourke Place Studio
Photos: © Shania Shegeydin
Medibank Private
Photos: © Shania Shegeydin

Hangar Design Group
Via Terraglio 89/b, 31021 Mogliano Veneto, Italy
P +39 041 593 6000
F +39 041 593 6006
www.hangar.it
Photos: © Alvise Silenzi, Photo lab HDG

Héctor Restrepo
Balmes 130 entl.jo., 08008 Barcelona, Spain
P +34 934 879 989
F +34 934 879 989
Zona
Photos: © Jordi Miralles

Jesús R. Ortín Avilés - José R. López Muñoz
Plateria 44 3º B, 30001 Múrcia, Spain
P +34 96 823 3937
F +34 96 823 3937
Polaris
Photos: © David Frutos

Kunath Trenkwalder Architects
Lindengasse 8/17, 1070 Vienna, Austria
P +43 1 585 1576
F +43 1 585 1576
www.kunathtrenkwalder.at
Education Center of the Socialist Democratic Party
Photos: © Pez Hejduk

Massimo Mariani Architetto
Via Don Minzoni 27, 51016 Pistoia, Italy
P +39 0 57 276 6324
F +39 0 57 291 2742
www.massimomariani.net
Bank Branch Office in Cerreto Guidi
Photos: © Alessandro Ciampi
BCC Fornacette Branch Office in Pontera
Photos: © Alessandro Ciampi

Murray O'Laoire Architects
Merriman House Brian Merriman Place, Lock Quay,
Limerick, Ireland
P +35 36 131 6400
F +35 36 131 6853
www.murrayolaoire.com
Mayo Institute of Technology
Photos: © Ross Kavanagh

Olson Sundberg Kundig Allen Architects
159 South Jackson Street, 6th Floor, Seattle WA
98104, USA
P +12 06 624 5670
F +12 06 624 3730
www.olsonsundberg.com
Olson Sundberg Kundig Allen Architects Office
Photos: © Benjamin Benschneider

Paul de Ruiter
Leidsestraat 8-10, 1017 Amsterdam, the Netherlands
P +0 20 626 3244
F +0 20 623 7002
www.paulderuiter.nl
Head Office Department of Water Management and
Traffic
Photos: © Rob't Hart

Pich Aguilera Arquitectes
Àvila 138 4art 1a 08018, Barcelona, Spain
P +34 933 016 457
F +34 934 125 223
www.picharchitects.com
22@
Photos: © Jordi Miralles, Toni Coll i Tort

Francesc Rifé
Escoles Pies 25 bxos., 08017 Barcelona, Spain
P +34 934 141 288
F +34 932 412 814
www.rife-design.com
Duravit
Photos: © Eugeni Pons
PBS Offices
Photos: © Eugeni Pons

Salvador Griñán
Cartagena 5, 30730 San Javier, Spain
P +34 968 334 035
F +34 968 334 067
www.sgmarquitectura.com
Roda Golf
Photos: © David Frutos

Schmidt, Hammer and Lassen
Åboulevarden 37, 5 Clemensborg, DK-8000 Aarhus,
Norway
P +45 8 620 1900
F +45 8 618 4513
www.shl.dk
Nykredit
Photos: © Jorgen True / Sputnik
Kromann Reumert
Photos: © Jorgen True / Sputnik

Shuhei Endo Architect Institute
Domus AOI 5F5-15-11 Nishitenma, Kita-ku Osaka
530-0047, Japan
P +81 6 6312 7455
F +81 6 6312 7456
www.paramodern.com
Growtecture S
Photos: © Yoshiharu Matsumura

Studio Granda
Smidjustigur 11b, Reykjavik 101, Iceland
P +35 4 562 16 61
F +35 4 552 6626
Skefjar
Photos: © Studio Granda

Takashi Yamaguchi & Associates
5F Fusui Bldg. 1-3-4 Ebisunishi, Naniwa-ku, Osaka
556-0003, Japan
P +81 6 6633 3775
F +81 6 6633 5175
www.yamaguchi-a.jp
Metal Office
Photos: © Takashi Yamaguchi & Associates

Tele Design
2-12-5 Open Studio Nope Mita, Minat-oku Tokyo,
108-0073, Japan
P +81 03 3769 0833
F +81 03 3769 9893
www.tele-design.net
News Complex Building
Photos: © Takeshi Taira

Toyo Ito & Associates Architects
Fujiya Bldg. 19-4 1-Chome, Shibuya, Shibuya-ku, Tokyo,
150-0002, Japan
P +81 3 3409 5822
F +81 3 3409 5969
www.toyo-ito.co.jp
Mahler 4 Block 5
Photos: © Luuk Kramer

UN Studio
Stadhouderskade 113, 1073 AX Amsterdam,
Netherlands
P +31 20 570 2040
F +31 20 570 2041
www.unstudio.com
Offices La Defense
Photos: © Christian Richters

Vicente Martínez
Calle de la Paz 17 30150, La Alberca, Spain
P +34 968 842 805
F +34 968 379 549
FREM
Photos: © David Frutos

Wolff Ollins
10 Regents Wharf, All Sanits Street London N1 9RL, UK
P +44 207 713 7733
F +44 207 713 0217
www.wolff-olins.com
Affinity in Sant Joan Nord,
Photos: © Jordi Miralles

copyright © 2005 daab
cologne london new york

published and distributed worldwide by
daab gmbh
friesenstr. 50
d - 50670 köln

p + 49 - 221 - 94 10 740
f + 49 - 221 - 94 10 741

mail@daab-online.de
www.daab-online.de

publisher ralf daab
rdaab@daab-online.de

art director feyyaz
mail@feyyaz.com

editorial project by loft publications
copyright © 2005 loft publications

editor Llorenç Bonet
layout Cristina Granero Navarro
english translation Matthew Clarke
french translation Michel Ficerai / Lingo Sense
italian translation Maurizio Siliato
german translation Martin Fischer
copy editing Alessandro Orsi

printed in spain
Anman Gràfiques del Vallès, Spain
www.anman.com

isbn 3 - 937718 - 36 - 2
d.l.: B - 32051 - 05